Penguin Books
Style and Civilization
Edited by John Fleming and Hugh Honour
BAROQUE

John Rupert Martin was educated at McMaster University and at Princeton University, where he took his Ph.D. in 1947, following service in the Canadian Army in the Second World War. Among his published works are a book on Byzantine illuminated manuscripts (1954), *The Portrait of John Milton at Princeton* (1961) and *The Farnese Gallery* (1965).

He has written four books on Rubens, including *The Ceiling Paintings of the Jesuit Church in Antwerp* and *The Decorations for the Pompa Introitus Ferdinandi*. His book on *Van Dyck as Religious Artist* was published in connection with an exhibition at Princeton in 1979. Dr Martin is now preparing a book to be called *Rubens and the Doctors*.

Dr Martin, who is a Past President of the College Art Association of America, is Marquand Professor of Art and Archaeology Emeritus at Princeton University. He is a member of the American Philosophical Society and a Fellow of the Royal Society of Arts.

John Rupert Martin

BAROQUE

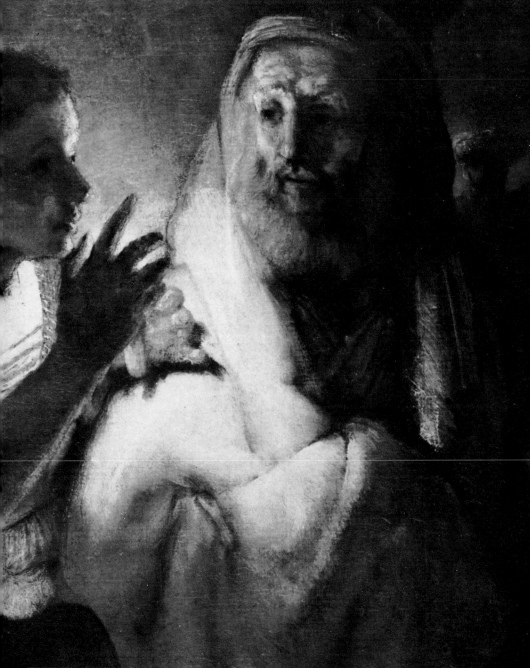

Penguin Books

PENGUIN BOOKS

Published by the Penguin Group
Penguin Books Ltd, 27 Wrights Lane, London W8 5TZ, England
Viking Penguin, a division of Penguin Books USA Inc.,
375 Hudson Street, New York, New York 10014, USA
Penguin Books Australia Ltd, Ringwood, Victoria, Australia
Penguin Books Canada Ltd, 10 Alcorn Avenue, Toronto, Ontario, Canada M4V 3B2
Penguin Books (NZ) Ltd, 182–190 Wairau Road, Auckland 10, New Zealand

Penguin Books Ltd, Registered Offices: Harmondsworth, Middlesex, England

First published by Allen Lane 1977
Published in Pelican Books 1989
Reprinted in Penguin Books 1991
10 9 8 7 6 5 4 3 2

Copyright © John Rupert Martin, 1977
All rights reserved

Made and printed in Great Britain by
Butler & Tanner Ltd, Frome and London

Except in the United States of America, this book is sold subject
to the condition that it shall not, by way of trade or otherwise, be lent,
re-sold, hired out, or otherwise circulated without the publisher's
prior consent in any form of binding or cover other than that in which
it is published and without a similar condition including this condition
being imposed on the subsequent purchaser

The title page shows
a detail of
Peter Denying Christ
by Rembrandt
(illustration 199)

TO BARBARA

Contents

Preface

This book originated from a paper on 'The Baroque from the Point of View of the Art Historian' which I read some twenty years ago at a meeting of the American Historical Association and which was subsequently published in *The Journal of Aesthetics and Art Criticism* (1955).

Amongst the many friends who have generously given me advice and information are Professors Jonathan Brown, William A. P. Childs, David R. Coffin, Roland M. Frye, Rensselaer W. Lee, Olan Rand, the late Wolfgang Stechow and David Wright. In preparing the successive drafts of the typescript I have benefited from the comments and criticisms of my students, amongst them Christine Armstrong, Micheline Moisan, Steven N. Orso, Charles Scribner III and above all Thomas L. Glen, who helped me to organize the Catalogue of Illustrations. For assistance in obtaining photographs I am indebted to Dr Stig Fogelmarck, Mrs Barbara Glen, Dr I. Grafe, Professor Carl Nordenfalk, Professor Seymour Slive, Mrs Shari Taylor and Professor Guy Walton.

I cannot adequately express my gratitude to the editors, John Fleming and Hugh Honour, who not only made innumerable suggestions for the improvement of the text but also drew to my attention pertinent examples, especially of architecture and the decorative arts, which effectively reinforced my argument.

J. R. M.
Princeton
September 1975

Introduction

The nomenclature of art history is regrettably imprecise and confusing. Of the many illogical terms that make up this peculiar vocabulary, 'Baroque' is surely one of the most misleading because, although the word may appear to describe a specific mode of artistic expression, it has in fact become ambiguous through being loaded with too many meanings. Yet while we may deplore the existence of such a verbal anomaly, it is obvious that the term cannot simply be banished from critical discourse. Let us begin, therefore, by defining how 'Baroque' is to be understood in this book – and how it is not to be understood.

The history and etymology of the word 'baroque' are interesting enough, but they are irrelevant to the subject that concerns us here. Since it does not appear to have been applied to the visual arts before the eighteenth century, and since it was not used as a stylistic term, as opposed to a term of abuse, until 1855,[1] it matters very little whether the word can be shown to derive from the Portuguese *barroco*, a 'rough or imperfectly shaped pearl', or from the syllogistic term *baroco*, the mnemonic name invented for the fourth mode of the second figure of formal logic, or from some other source altogether.[2]

Whatever connotations it may have had in the past (and these are far from being consistent), I do not conceive of the term 'Baroque' as designating an art that is extravagant, heavily ornate or bombastic – as calling up the idea of a 'lordly racket', in Erwin Panofsky's memorable phrase. Nor, on the other hand, do I hold with the view that 'Baroque' should be used only in a narrow stylistic sense to signify a particular artistic phenomenon – the 'style of 1630', more

often described as 'High Baroque'.[3] This definition of the term seems to me too restrictive and hence likely to create more problems of classification and interpretation than it solves.

The word 'Baroque', as I shall use it in this book, denotes, first of all, the predominant artistic trends of the period that is roughly comprehended by the seventeenth century. It is important to note at the outset that this is only a convenient approximation; for the epoch as a whole can certainly not be fitted into such a strait-jacket. The shift from Mannerism to Baroque was not sudden or abrupt but was complicated by considerable overlapping. Though the earliest manifestations of Baroque art appeared well before the year 1600, Mannerism was still a living force in many European centres during the first decades of the seventeenth century. The end of the Baroque is even less clear-cut than its beginning. There are works of art belonging to the eighteenth century that can be unequivocally called Baroque. Yet there is no doubt that in general the impetus of the Baroque had begun to slacken by the last quarter of the seventeenth century.

The period offers, it is true, a spectacle of works of art of quite astonishing variety, and it may seem futile to maintain that these products of different countries, different economic and political institutions and different forms of religious belief can have anything in common beyond mere contemporaneousness. If unity is to be discovered within this diversity, it is evident that what we must look for is not any well-defined uniformity of style, but the embodiment of certain widely held ideas, attitudes and assumptions.

The seventeenth century has a Janus-like aspect: an age of extraordinary advances in philosophy and science, and of sweeping changes in the economic sphere and in the development of the modern state: but an age characterized also by continuing theological controversy, by an intense concern for the personal religious experience and by a spirit of providentialism inherited from earlier Christianity. Looking as it does both to past and future, the period presents what Stechow has called 'a basically new and optimistic equilibrium of religious and secular forces'.[4] That equilibrium, the distinguishing signs of which are already apparent in the visual arts during the last years of the sixteenth century, was to be upset before the close of the seventeenth by the growing force of empirical science and the weakening of the metaphysical view of the world. The triumph of science and reason represented by Newton's *Principia* (1687) and Locke's *Essay concerning Human Understanding* (1690) also foretold the end of the Baroque.

In attempting to define the essential characteristics of Baroque art we may conveniently begin with naturalism. Verisimilitude, though it takes varying forms, is a principle to which all Baroque artists adhere.

It is indeed a factor in the very genesis of the Baroque, arising as it did in opposition to the elegant stylizations of Late Mannerism. It was not merely a careless remark by Caravaggio (who more than any other may be credited with inaugurating Baroque naturalism) that the competent painter is one who knows how 'to imitate natural things well' (*imitar bene le cose naturali*).[5] The great traditional subjects – mythology, portraiture and above all sacred art – were transformed and given new content by the naturalistic vision of the Baroque. And it was this same vision that made possible the extraordinary achievements of seventeenth-century artists in the fields of landscape, still life and genre. Even in the last years of the century, when academic rules introduced theoretical complications into the creative process, the profoundly naturalistic outlook of the Baroque was never supplanted, as witness the portraitists of the age of Louis XIV who, for all their ornateness and rhetoric, were firmly committed to the illusion of reality. It is to this naturalism that we must turn to find the most direct link between Baroque art and thought: the new emphasis on visual realism is unmistakably related to the secularization of knowledge and the growth of science in the seventeenth century.

One can hardly speak of Baroque naturalism without taking notice of Baroque psychology. The preoccupation with 'the passions of the soul' is to be observed both in the artists and in the philosophers of the period. In what we may call 'subject pictures', from simple genre pieces to multi-figured history paintings on a grand scale, the emotional range is prodigiously expanded. Portraiture likewise exhibits a positive enrichment of psychic content: Rembrandt is not alone among seventeenth-century masters in his capacity to endow the portrait with an intimation of spiritual as well as corporeal presence.

In the field of devotional art, the interest in extreme states of feeling led to profound changes in the representation of the visionary experience: Bernini's *Ecstasy of St Teresa* (to take the best-known example) may be understood not only as the illustration of a miraculous visitation – the reward of saintliness – but also as a penetrating insight into the psychology of mysticism, in which the self seeks to be released from human limitations and to be absorbed in the infinite. In the same way the great Catholic subjects of death and martyrdom are imbued with a new pathos and a new comprehension of suffering, cruelty and steadfastness.

It may seem paradoxical that some of the outstanding realists of the Baroque age – masters whom critics of the later nineteenth century hailed as 'forerunners of Impressionism' – should have painted allegorical subjects, often concealed beneath a naturalistic, genre-like exterior. But there is no inconsistency in this. For Baroque naturalism, though a powerful force, was qualified by a fundamentally metaphysical view of the world. Side by side with the growing

scientific mode of thought, the old emblematic and allegorical cast of mind still persisted.

That the great humanistic themes derived from classical antiquity should be adopted for the purposes of allegory is hardly remarkable. But the allegorical method was also applied, following a venerable tradition of scriptural interpretation, to the rendering of biblical subjects. In the seventeenth century the Old Testament was still regarded as a prefiguration of the New, and in the main artists adhered faithfully to this 'medieval symbolism' whereby Abraham's Sacrifice of Isaac, for example, was understood in a mystical sense to signify the Crucifixion.

It is now recognized that Baroque genre paintings, once regarded as simple transcriptions of everyday life, frequently contain allegorical or emblematic meanings. In the same way, a surprising number of still life paintings are found, on analysis, to embody a moralizing theme such as *Vanitas*, the abstract idea being made more real by being conveyed in the most immediate and concrete terms possible. Even landscape paintings may be made to carry symbolic allusions to human transience, as in Poussin's cycle of the *Four Seasons*.

Some of the most splendid allegorical creations of the Baroque epoch were devoted to the glorification of monarchy. Rubens's epic Medici Cycle, celebrating as it does the career of a notably inept queen, testifies to the firm hold that the doctrine of divine right still had on men's minds. The whole gigantic complex of Versailles was conceived as an image, in elaborate emblematic terms, of the splendour of the *Roi Soleil*.

The Copernican revolution brought in its train a sense of the infinite which was to permeate seventeenth-century art and thought. Nothing reveals more clearly the consciousness of infinity in this period than the interest in space, time and light.

The principle of coextensive space is an important one in Baroque art. It may be seen in its most obvious form in the various *trompe-l'oeil* devices employed by artists to dissolve the barrier imposed by the picture plane between the real space of the observer and the perspective space of the painting or, in the case of sculpture, in the statue that transcends the limits of the niche within which it stands. The desire to suggest an infinite prolongation of space also finds expression in the great illusionistic ceiling paintings of the period. As a result of such efforts to achieve an integration of real and fictive space, the observer becomes an active participant in the spatial-psychological field created by the work of art. Far from being merely a form of clever theatrical trickery, Baroque illusionism has a persuasive purpose — that of transferring the mind of the viewer from material to eternal things.

Naturalism and the concern with space are the chief determining factors in Baroque landscape. The Dutch panoramic view, with its prospect of an immense, far-reaching expanse, offers the most familiar example of spatial illusionism in landscape. But the continuity of space is often implied by other means, such as the suggestion that the scene presented to our view is only part of an infinitely larger totality.

We must not overlook, in this connection, the effect on art and artists of the expanding world of the seventeenth century. The taste for the exotic, in particular, may be understood as a reflection of the geographical discoveries of the age of exploration, which served to awaken new interests in distant lands and peoples. Yet Baroque art, though undoubtedly receptive to picturesque motifs from non-European sources, was not profoundly affected by the spirit of exoticism. Painters might include in their works authentic details of costume and setting, but the Baroque world-view was essentially unaltered.

The element of virtuosity in the Baroque architect's manipulation of space should not be allowed to obscure a more important fact, which is that the principle of coextensive space is quite as applicable to seventeenth-century architecture as to painting and sculpture. The principle may be seen in exemplary form in church façades by Pietro da Cortona, Bernini and Borromini, where the interpenetration of exterior and interior space is especially marked. It is the same controlled flow of space that gives to the monumental interiors of the Baroque period their distinctive character.

The idea of a spatial continuum is also fundamental to the art of stage design, which seeks to coordinate the perspective space of the theatre with the real space of the auditorium.

The suggestion of movement, which is characteristic of many works of painting and sculpture of the seventeenth century, may evoke the sense of time as well as of space. The fleeting glance, the momentary gesture, the changing aspects of nature tell of transience, mutability and time's swift flight. Time itself may be personified as Destroyer or Revealer: in the hands of such masters as Rubens, Poussin and Bernini the allegory of 'Truth revealed by Time' becomes one of the classic themes of Baroque art. The recurring cycle of day and night and the succession of the seasons offered to artists another way of dealing – whether in the guise of mythology or of landscape – with the infinity of time.

Light is one of the principal expressive means of the Baroque artist. It is understood, first of all, to be a necessary element of the naturalistic vocabulary; in subjects such as landscape and genre the realistic handling of effects of light is of fundamental importance.

It is typical of the Baroque outlook that divine illumination is also treated naturalistically. The conception of light as a phenomenon that is at once physical and supernatural was first formulated in powerful terms by Caravaggio and was soon adopted everywhere, even by painters who had little taste for that artist's personal style. In the decoration of churches real light is frequently introduced to denote divine intervention: the work of Bernini is full of this imaginative use of directed light.

Painters were able, through subtle contrasts of light and dark, to suggest a variety of other symbolic meanings, including, on the one hand, enlightenment, reason and truth, and on the other, evil, danger, blindness and death. The sun as the source of universal light was made the subject of innumerable emblematic images. The most complex programme of solar symbolism was that devised to glorify Louis XIV at the court of Versailles.

Closely related to the symbolic use of light to express inner illumination is the Baroque painter's ability to suggest consciousness and the life of the mind through a kind of personal radiance. This luminosity, which we might call the light of the soul, is seen in its richest and most poetic form in the portraits of Rembrandt.

No account of Baroque art can fail to take notice of the pervasive influence of classical antiquity. The knowledge of the ancient world, which had been steadily accumulating since the early days of the Italian Renaissance, was now very extensive, and almost all artists of the seventeenth century were affected in one way or another by the images and ideas of the Antique. Though it is true that at this period 'antiquity' was commonly understood to mean ancient Rome, Greek sculptures of the classical age were already being sought after by discerning collectors, and some artists were even prepared to affirm the superiority of Greek art over Roman.

The pioneers of Baroque classicism were the Bolognese painters led by Annibale Carracci who established themselves in Rome early in the seventeenth century. It was they who formulated that 'classical ideal' that was to be perfected by Nicolas Poussin, Algardi and Duquesnoy, and which was to take firm root in France through the work of sculptors such as Girardon. For all of these masters antiquity furnished an abundance of models.

The practice of copying ancient prototypes was not, however, confined to the 'classic' artists. Rubens and Bernini both drew freely upon the repertory of ancient marbles, transforming their models into new and more sensuous figures. Classical influence is of course much less obvious in the work of the naturalist Caravaggio and his immediate following. And in Spain and the northern Netherlands, where the magnetic force of the Antique was substantially weaker than in Italy, there are relatively few direct borrowings from classical sculpture:

even Rembrandt, who had a deep and abiding interest in antiquity, rarely employed a figure from ancient art.

The general progression towards classicism that is characteristic of European architecture in the seventeenth century was not due solely to the influence of antiquity. In the case of Inigo Jones in England and of Jacob van Campen in Holland the chief stimulus undoubtedly came from Palladio. But their works are no less classical for that.

While in France the classical doctrine in architecture was sustained by a formidable series of theoretical treatises, Italian architects (Borromini above all) took a much less authoritarian view of the ancient Orders. Few architects can have had so sympathetic an understanding of classical architecture as Bernini, who nevertheless handled antique details with great freedom. Bernini's imaginative adaptation of classical forms may be exemplified by the Colonnade of St Peter's. As compared to this monumental structure, the Colonnade of the Louvre, by Le Vau, Le Brun and Perrault, looks (for all its majesty) rather austere and doctrinaire.

I

*Style is a particular manner and skill in painting and drawing
which comes from the particular genius of each individual
in his way of applying and using ideas;
this style, manner or taste comes from nature and intelligence.*

Nicolas Poussin, *Observations on Painting*

The Question of Style

'Style' is one of the art historian's indefinable but indispensable terms.
Though we cannot hope to settle the problem of terminology, we can
at least begin by distinguishing between the personal style of an
individual artist, which is what Poussin refers to in the passage quoted
above, and the prevailing style of a school or period, as when we
speak of High Renaissance, Mannerism or Baroque.

MANNERISM AND BAROQUE

Some of the fundamental differences between the two periods may be
conveniently illustrated by juxtaposing typical works of painting,
sculpture and architecture of the sixteenth and seventeenth centuries.
As representatives of Mannerism I have chosen Salviati, Ammanati
and Vignola; Rubens and Bernini may speak for the Baroque. Let
Rubens have the first word.

In *The Descent from the Cross* of 1611–12 [1] grandeur of conception
and power of feeling unite to produce an air of epic tragedy. The
actions of the figures, from the two workmen at the top to the two
women kneeling at the foot, are natural and appropriate; we are
made to feel not only the grief and horror of those closest to Christ but
also the physical strain and effort involved in reverently lowering a
dead body to the ground. Though the scene takes place by night, the
compact group around the cross is illumined by a supernatural light
that gives special prominence to the white shroud and the collapsed
body of Christ, the livid, bloodless colour of which becomes even more

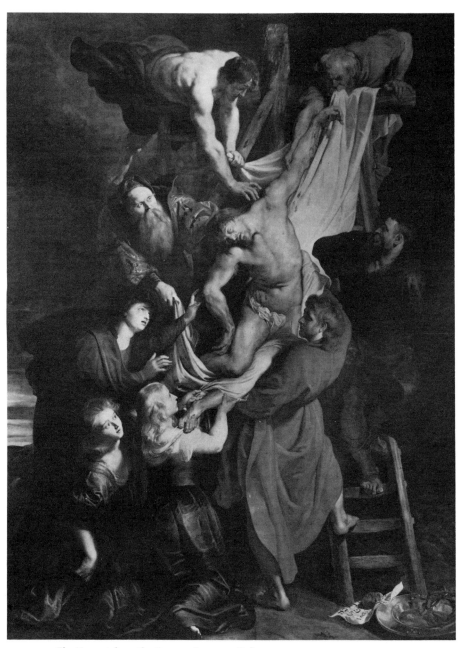

1. *The Descent from the Cross*, 1611–12. Rubens

pathetic by being set beside the strong and vital red of St John's mantle. It is useful, in judging the intent of the artist in a work such as this, to listen to the comments of a seventeenth-century observer. The French critic Roger de Piles says of Rubens's *Descent from the Cross*

that 'the painter has entered so fully into the expression of his subject that the sight of this work has the power to touch a hardened soul and to cause it to experience the sufferings endured by Jesus Christ in order to redeem it'.[1]

As compared to this Baroque conception of the subject, Salviati's elegant *Deposition* of about 1547–8 [2] may appear strangely inexpressive and detached. The composition is agitated and full of incidents, but there is little sense of dramatic unity. Despite their energetic and angular postures, the elongated figures have been arranged so as to create a decorative pattern, as if the painter had chosen to sidestep the rendering of strong emotions. The shallowness

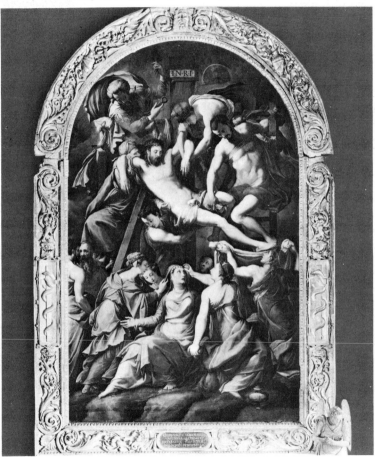

2. *The Deposition, c.* 1547. Salviati

of the space and the tendency of the forms to adhere to the vertical plane also have the effect of removing the event from the realm of flesh and blood. Mannerist refinement and artifice prevail over nature and feeling.

Bernini's *Fountain of the Four Rivers* of 1648–51 in the Piazza
Navona in Rome [3] shares with the paintings of Rubens [9] a robust
naturalism and a free deployment of forms in space. Four giant river
gods, representing the four quarters of the globe, are disposed in
lively attitudes on an irregular and deep-cut rocky base from which
streams of water gush forth. At the summit of this craggy mass there
rises, seemingly without adequate support, an immense and weighty
obelisk. For all its complexity and multiplicity of parts, the work
possesses a powerful unity, which can be felt building up from the
rough and 'haphazard' forms at the bottom to its climax in the soaring
obelisk. This spectacular and exuberant monument was not created
simply to adorn a Roman piazza. For the fountain – a papal com-
mission – was intended to symbolize the universal triumph of the

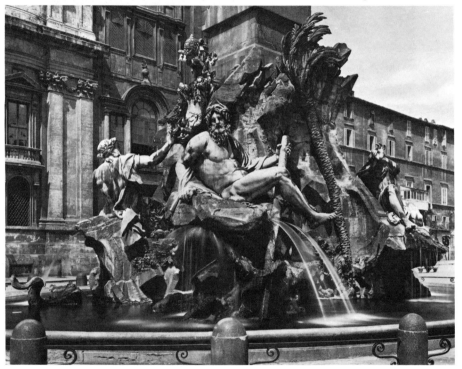

3. *The Fountain of the Four Rivers,* 1648–51. Bernini

church, and Bernini's bold and imaginative design is wholly in keeping
with this grand theme.

The Mannerist idea of a large public fountain may be exemplified by
Ammanati's *Neptune Fountain* in the Piazza della Signoria in Florence
[4]. The dominant feature is the gigantic marble figure of Neptune
standing on a high pedestal in the centre of the basin, round the
perimeter of which are placed figures in bronze. The effect of the
fountain with the water in full play must have been very different

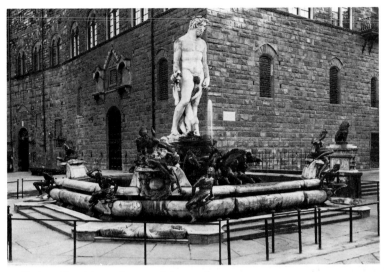

4. *Neptune Fountain*, 1560–75. Ammanati

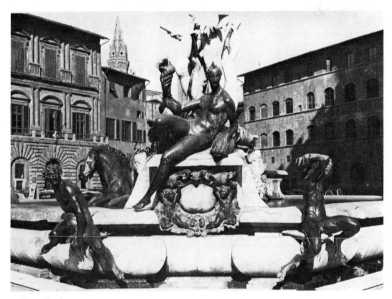

5. Detail of 4

from what we see today, when only a few jets are in operation; but
even so it can never have had the impressive visual unity of Bernini's
Baroque fountain. The huge Neptune, flat and ungainly and looking
as if he were intended to be seen only from the front, seems almost
unrelated to the bronze sea deities at the angles, which are moreover
disturbingly smaller in scale [5]. Yet these figures are the best parts
of the work. Slender, graceful, long-limbed, and posed in elegant and
extravagant attitudes, they are typical products of Mannerist fantasy.

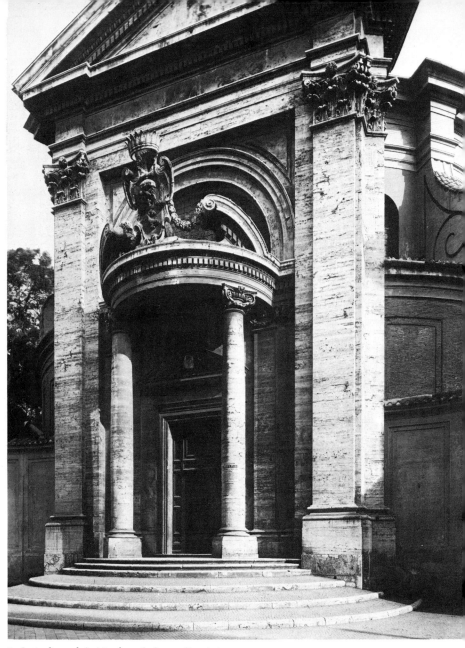

6. S. Andrea al Quirinale, 1658–70. Bernini

Bernini's church of S. Andrea al Quirinale [6, 6A], begun in 1658, might be described as a Baroque variation on the form of the ancient Pantheon, in which the cylindrical interior of the original has been converted into a domed oval. The façade of this little building presents an extraordinary composition of interlocking curvilinear movements, the oval form of the church itself being echoed in the reverse arc described by the low screen walls on either side. These contrary

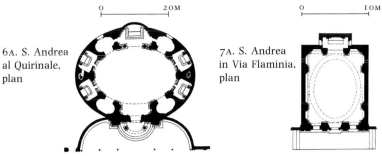

6A. S. Andrea al Quirinale, plan

7A. S. Andrea in Via Flaminia, plan

25

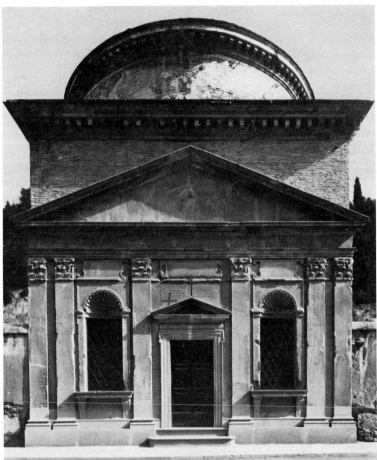

7. S. Andrea in Via Flaminia, 1550–53. Vignola

forces are stabilized by the monumental aedicule framing the entrance, from which a semi-circular porch with two free-standing columns and a crowning coat of arms seems to expand into the space of the forecourt.

The diminutive church of S. Andrea in Via Flaminia [7, 7A], built by Vignola in 1550–53, offers a Mannerist adaptation, in severe and simple terms, of the scheme of the Pantheon. The interior, as can be

deduced from the outside, consists of a rectangular space covered by an oval dome. The marked planarity of the façade stands in striking contrast to the spatial properties and to the dynamic movement and counter-movement of Bernini's S. Andrea. It is almost as if an elevation of the portico of the Pantheon had been drawn in projection on the flat face of the church.

THE ABSENCE OF STYLISTIC UNITY

To recognize the broad differences between Mannerist and Baroque is simple enough. But it is quite another matter to define 'Baroque style'. Let us admit at the outset that this is an impossible task. Not only is there no homogeneity of style in the Baroque period, but one is almost tempted to speak of the very diversity of styles as one of its distinguishing features.[2] The sober realism of the Dutch school [125] bears no resemblance to the high-flown imagery of the Roman Baroque [127], and neither shows any affinity to the noble classicism of the age of Louis XIV [62].

Attempts have been made, it is true, to define a coherent stylistic vocabulary for the Baroque period. The most brilliant of these is Heinrich Wölfflin's *Principles of Art History* (1915), a comparison of sixteenth- and seventeenth-century art from which the author drew five pairs of concepts. For Wölfflin the essential differences lay in the contrast between 'linear and painterly' modes of representation, between 'plane and recession', 'closed and open form', 'multiplicity and unity', and 'absolute and relative clarity'. Illuminating as these observations are, it is now evident that his categories have certain limitations. First of all, Wölfflin treated the sixteenth century as an artistic whole, making no distinction between that later phase of it which is now generally called Mannerism and the earlier, classic (or High Renaissance) phase. Yet it happens that the contrast between Baroque and Mannerism is more revealing and more significant than that between Baroque and High Renaissance; for the early Baroque movement took shape in opposition to the methods of Mannerism, not to those of the High Renaissance. Secondly, Wölfflin was interested in form rather than meaning and consequently tended to look on Baroque art, and especially Baroque painting, as an anticipation of Impressionism, without taking into account its specifically iconological content. Thirdly, his conception of a unified Baroque style was only arrived at by neglecting such artists as Poussin, though it must be obvious that a comprehensive system that fails to make provision for a major figure (no matter how inconvenient) is on that score alone defective.

The problem of the Baroque may be somewhat simplified, if not fully resolved, by viewing the lack of stylistic uniformity as the result

not only of national differences, but of a process of evolution. The broad stages of this sequence are succinctly described by Jakob Rosenberg in his book, *Rembrandt, Life and Work*. 'The development of Baroque painting', he writes, 'may be traced according to generations, and its leading international representatives during the course of the century were Caravaggio (at the side of the Carracci), Rubens, and Poussin. This means that Italy's initial leadership did not last throughout the century but was succeeded by that of Flanders and France'.[3]

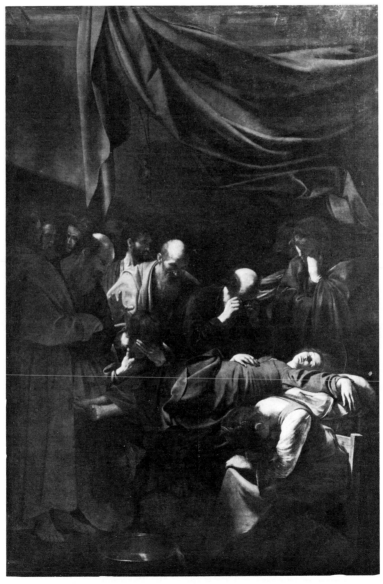

8. *The Death of the Virgin*, 1605–6. Caravaggio

To look at the Baroque in this way, as a succession of phases in an international development, is especially useful in dealing with the representational arts. The first or 'Early Baroque' phase, essentially a naturalistic one, originated in Italy, and its pioneering figure was beyond doubt Caravaggio [8], an artist whose influence, during the second and third decades of the century, had a decisive effect on many French, Netherlandish and Spanish (as well as Italian) artists [40].

The second generation, often called 'High Baroque', found its fullest realization in the sensuousness and colourism of Rubens [9];

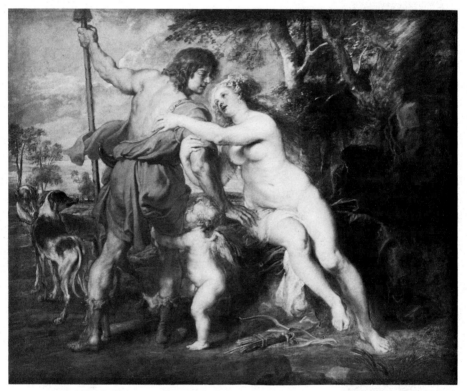

9. *Venus and Adonis, c.* 1635. Rubens

to this phase also belong the great achievements of the Italian masters Guercino [178], Pietro da Cortona [127], Bernini [193] and Borromini [84] in the fields of painting, sculpture and architecture. The qualities of luxuriousness and sensuality that are characteristic of this phase are equally conspicuous in the decorative arts: a particularly fine example may be seen in the salt-cellar by Georg Petel in Stockholm [10]. Though such works are often regarded, because of their exuberance and voluptuousness, as typical of the Baroque period as a whole, they should be viewed in their proper stylistic context, that is to say as products of the sensualistic stage of the Baroque.

10. Salt-cellar, *c.* 1627–8. Petel

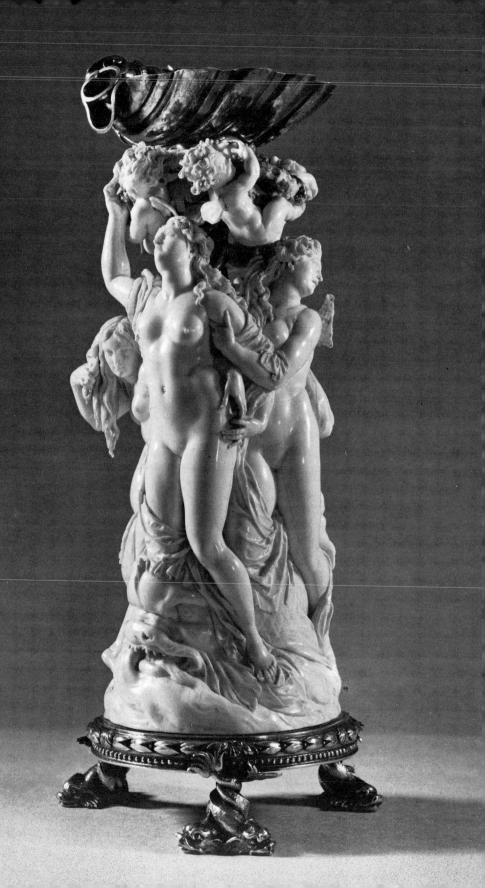

The third or classicistic phase, in which the opulent and emotional qualities of the 'High Baroque' were supplanted by a more rigorous order, clarity and composure, had its beginnings in Rome in the early 1630s. The growing strength of the classicists, and the challenge that they offered to the more flamboyant Roman artists, may be reflected in a controversy that arose in the Accademia di San Luca at this time. The leading figures in this dispute are generally believed to have been Andrea Sacchi and Pietro da Cortona.[4] It was not Sacchi, however, but Poussin – the most rational and most disciplined master of the

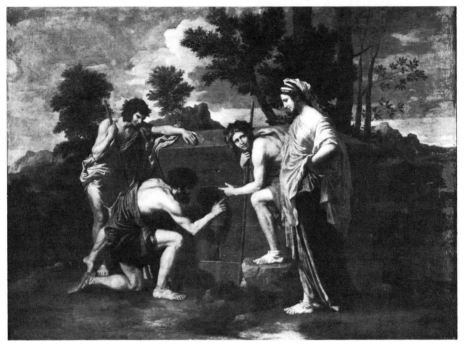

11. *The Arcadian Shepherds, c.* 1640. Poussin

seventeenth century – who was to become the chief representative of this third phase [11]. Baroque classicism won its greatest victories in French art and architecture, but the effects of an international classicizing trend are also perceptible in the works of 'realists' such as Velazquez in Spain and Vermeer in Holland, whom no one would think of equating with true 'classics' of the stamp of Raphael or Poussin.

If a fourth, 'Late Baroque' stage can be distinguished, it is that of the later Louis XIV style, with its decorative reworking of the classic vocabulary [12]. The great Baroque masters had by this time all lived out their lives; the earliest Rococo artists had not yet come upon the scene.

12. *Cardinal de Bouillon*, 1708. Rigaud

Even in the highly individual art of Rembrandt it is possible to see reflected the main phases of the Baroque. The *Money-Changer* of 1627 [13], with its striking illusion of candlelight and its interest in a human oddity, gives clear evidence of the young painter's debt to Caravaggio and the naturalist movement of the Early Baroque. The *Blinding of Samson* of 1636 [196], a product of the most sensual period in the artist's life, is unmistakably Rubenesque in its passionate energy and violence. The *Supper at Emmaus* of 1648 [14], though it does not derive directly from Poussin's pure form of classicism, is nevertheless to be associated with that tendency towards classic calm and frontality that is characteristic of the mid seventeenth century. Yet Rembrandt, though he responds to the successive shifts

in style that mark the development of the Baroque as a whole, is never shaken from his own course. The methods of Caravaggio and Rubens (to say nothing of the many other artists by whom he was influenced) offered powerful stimulants at appropriate moments in his career, but these were invariably modified to suit his own aesthetic ends. The works of the later style, for example *Bathsheba with King David's Letter* [54], lacking as they are in any sort of Poussinesque idealization, can only be called 'classical' by virtue of their form and content — breadth

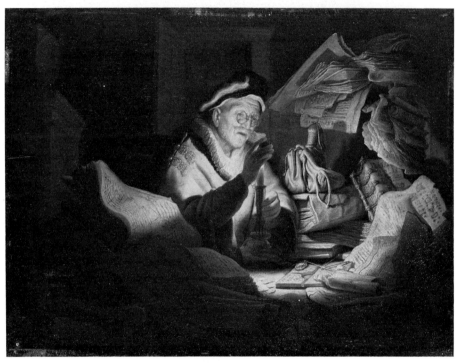

13. *The Money-Changer*, 1627. Rembrandt

and stability of composition engendering lasting dignity and solemnity. It is a fallacy to think of the development of the Baroque — or of any cultural phenomenon — as corresponding to the stages of human life, from youth to old age and death. But in the case of Rembrandt there is a remarkable parallel to be drawn between the biography of the artist and the course of Baroque art.

THE PROBLEM OF CLASSICISM

A great deal of ink has been spilt over the nature and meaning of classicism in French and Italian art of the seventeenth century. In Rome, as might be expected, a vital current of classicism manifested

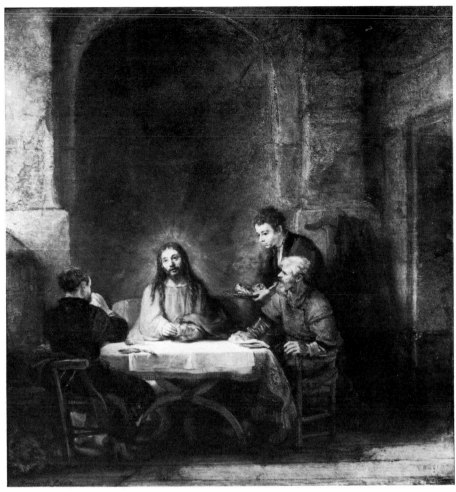

14. *The Supper at Emmaus,* 1648. Rembrandt

itself at the very outset of the Baroque, in the works of Annibale
Carracci [21] and his followers [207]. A new phase began in the
1630s, with the emergence of artists such as Andrea Sacchi, François
Duquesnoy and Alessandro Algardi; and it was at this time too that
classical art theory began to be defended more vigorously, if we may
judge from the controversy in the Roman Academy of St Luke that
has already been mentioned. But the real force of the classical spirit
was not felt, as has also been noted above, until about the middle of
the century, when the movement, aided no doubt by the authority of
Poussin, began to take on international dimensions.

The more we inquire into the place of classicism in seventeenth-
century art, the more we are likely to treat with scepticism the view

that this whole complex period can be reduced to a dialectical inter-play between two opposed principles, that is to say between 'Baroque' and 'Classicism'. Since, according to this view, the two categories are mutually exclusive, it follows that whereas S. Agnese in Piazza Navona [84] may be called 'Baroque', Versailles, on the other hand [112], can only be called 'Classical'. Implicit in this over-simple formula is the belief that classicism (especially French classicism) represents something alien to the spirit of the age – that it should be looked on as a kind of resistance movement, so to speak.

Another expression of the rigid Baroque–Classic polarity is the myth of a fundamental antithesis between the art of Poussin and that of Rubens, a myth that might appear to be substantiated by the famous quarrel between the 'Poussinists' and the 'Rubenists' in the French Academy of the late seventeenth century.[5] But that controversy arose only after the deaths of the two artists and cannot by any stretch of the imagination be thought to reflect opinions held by them. Nor should we accept uncritically the idea that there was an irreconcilable difference between the attitudes of Bernini and Poussin. The sympa-thetic comments made by the former artist on the work of his French colleague ('a great history painter and a great painter of mythology')[6] are in themselves sufficient to show that there is no basis in fact for such a belief.

It is a mistake to consider French art and architecture of the seven-teenth century as wholly, or even predominantly, classical. For there were other stylistic tendencies at work – at least until the narrow doctrines of the Academy began to stifle freedom of expression. The peasant pictures of the brothers Le Nain have obvious affinities to the naturalist currents in Italy, Spain and the Netherlands; the noc-turnes of Georges de La Tour are part of the history of the Caravag-gesque movement; and the broad curving wings of Louis Le Vau's Collège des Quatre Nations in Paris were plainly inspired by the Roman church façades of Borromini and Pietro da Cortona. We may best understand the Baroque if we see it as embracing certain diver-gent tendencies – realistic, dynamic, classical – which, taken to-gether, contribute to its many-sidedness. And seventeenth-century classicism, in turn, may best be understood as an integral part of the Baroque whole.

THE CONSCIOUSNESS OF PERSONAL STYLE

Style must be considered in the particular as well as in the general sense. When we speak of the diversity of styles in the Baroque epoch, we are thinking not only of the different modes favoured by this or that school or generation, but also of the personal characteristics of individual artists. Rembrandt, though he may reflect the stylistic

trends of Baroque painting as a whole, is always Rembrandt. There is nothing anonymous or self-concealing about his style: it is recognizably, even inimitably, his.

The consciousness of style — especially the cultivation of a distinctive personal manner — is characteristic of the Renaissance as well as of the Baroque. The difference is one of degree. For there is in the seventeenth century an intensified 'style-consciousness' that gives rise to such aesthetic phenomena as the 'bizarre and extravagant' architecture of Borromini [155] and the 'unfinished' works of Rembrandt.

Style, in the sense used here, is the visible manifestation of the artist's faculties of imagination and execution. This is quite obviously true of magisterial personalities such as Bernini and Rubens, whose distinctive styles never allow us to forget the mind and hand of the creator. But the role of imagination in this process was also acknowledged by artists of a more conservative bent, whose manner might deceive us into thinking of them as self-effacing. The remarks by Poussin quoted at the beginning of this chapter show what importance he attached to 'particular genius' in the shaping of an artist's style. It is characteristic of the very greatest masters that they achieve their most personal and most profound form of expression in the late style, that climactic stage in an artist's career when, full of years and experience and freed from conventional restraints, he gives full rein to his powers of invention. The austere grandeur of the *ultima maniera* is quite as evident in the late works of Poussin as in those of Bernini and Rembrandt.

THE DRAWING AND THE SKETCH
AS THE QUINTESSENCE OF ARTISTIC STYLE

The emphasis on the imagination and the belief in the special genius of the artist undoubtedly go far to account for the increased interest in the drawing as the direct expression of the original idea, untrammelled by tedious detail and finish. It is significant that some of the greatest Baroque painters cultivated the drawing as an art form for its own sake. Looking at the pen and wash drawings of Guercino [15] and Rembrandt [16], we may easily understand why such pieces were bought up in large numbers by amateurs and artists alike. Among the many works by other artists in Rembrandt's extensive collection, we read of a book of drawings 'by the leading masters of the whole world', a large volume of drawings by Adriaen Brouwer, another containing drawings of 'Roman buildings and views by eminent masters', two books of drawings by Pieter Lastman, and so forth.[7] The English court painter Sir Peter Lely (1618–80), who amassed one of the greatest private collections of his day, owned not

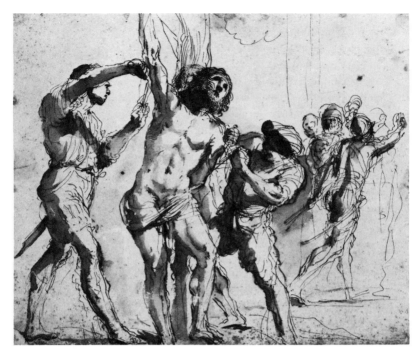

15. *The Martyrdom of St Bartholomew, c.* 1636. Guercino

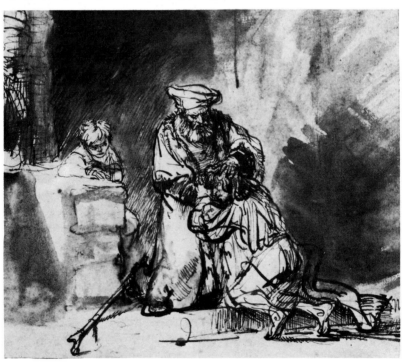

16. *The Return of the Prodigal Son, c.* 1642. Rembrandt

less than three thousand drawings. The inventory of the collection of the Parisian banker Everhard Jabach (1671) lists more than five thousand drawings, most of which were purchased by King Louis XIV.

Even the slow and laborious medium of etching, in which the process of drawing the design with the needle is separated by several removes from the finished print, could be handled by a master such as Rembrandt with the same freedom and spontaneity as a pen drawing. There are prints by Rembrandt, like that containing various studies of heads, with Saskia lying ill in bed [17], which show, in the words of Christopher White, 'how he treated the etching plate like a piece of paper used for making a number of rapid sketches'.[8] One might have thought that such experimental etchings, like the drawings that they so closely resemble, were things to be kept in the artist's sketchbook as private materials for study. Yet the fact is that prints of this kind were valued precisely because of their directness and immediacy and so found their way into the cabinets of connoisseurs.

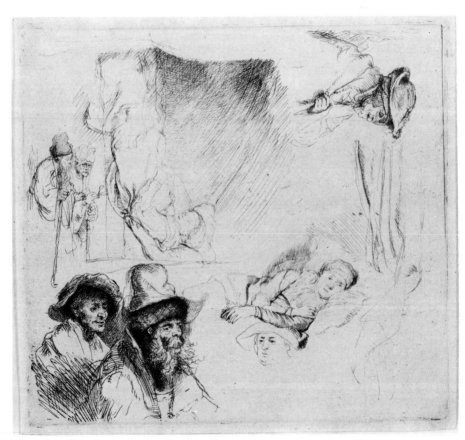

17. *Studies of Heads*, c. 1641–2. Rembrandt

It was another sign of 'style-consciousness' that the seventeenth century placed so much value on the preparatory oil sketch. The chief credit for this aesthetic re-evaluation must go to Peter Paul Rubens, whose facility and spontaneity of execution raised the oil sketch in the eyes of critics and collectors from the level of a mere preliminary exercise to that of an independent work of art [18]. The

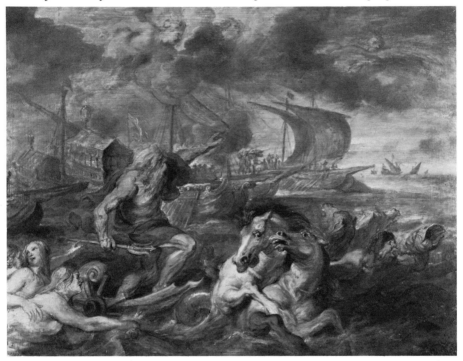

18. *The Voyage of Prince Ferdinand from Barcelona to Genoa*, 1634–5. Rubens

significance of Rubens's sketches was recognized by Roger de Piles, who in 1677 wrote that the Flemish master 'was so practised in every aspect of his art that he painted as much as he drew. It is for this reason that one sees almost as many little paintings by his hand as large ones, of which they are the first thoughts and sketches. Some of his sketches are very slight and others rather finished, according to whether he knew more or less clearly what he had to do or whether he was in the mood to work. There are even some which served him as originals: for whenever he had studied from nature the objects that he had to represent in the large work, he would only make such changes as he found appropriate'.[9]

2

Nature is not at variance with art, nor art with nature;
 they being both the servants of [God's] providence . . .
Nature hath made one world, and Art another.
 In briefe, all things are artificiall, for Nature is the Art of God.

Sir Thomas Browne, *Religio Medici* (1643)

Naturalism

The whole art of the Baroque expresses an acceptance of the material world, through the realistic representation of man and nature, through the affirmation of the senses and the emotions and through a new perception of space and infinity. Its tendency is towards externalization, its outlook is fundamentally one of optimism and expansiveness. The Baroque artist takes it for granted that his work must bear the semblance of reality.

From one point of view, the new naturalism may be interpreted as a reaction against the sophistications of Late Mannerism, which by the close of the sixteenth century had lost their charm and become stale and uninviting. The belief that a renewed study of nature offered to artists an essential corrective after the 'perverse' artificiality of Mannerism was in fact very widely held in the seventeenth century. (For it must be remembered that what we regard as a normal historical development was frequently pictured by contemporary critics in moralizing terms, as if it represented a triumph of virtue over vice.) In a *Treatise on Painting* written before 1615, Giovanni Battisti Agucchi spoke of the decline of art that followed the heroic epoch of the early sixteenth century (the High Renaissance), at which time there sprang up 'various manners that were far from the true and lifelike'. It was the Carracci of Bologna, he went on to say, who eventually rescued painting from its sorry plight and put the profession back on the right path; and Agucchi found it especially significant that in the Academy founded by these artists there was 'continuous study of nature, not only of live models but often of cadavers'.[1] These

40 sentiments were to be echoed many years later by the influential critic Giovanni Pietro Bellori (1672), who, in addition to singling out Annibale Carracci as the principal reformer of modern painting, had the insight to perceive that Caravaggio, of whose work he did not much approve, had likewise played an important part in the overthrow of Mannerism. The contribution made by the latter artist was summed up by Bellori in these words:

> There is no doubt that Caravaggio was useful to painting, coming as he did at a time when realism was not much in fashion and when figures were made according to convention and manner and satisfied more the taste for gracefulness than for truth. Thus Caravaggio, by avoiding all prettiness and vanity in his colour, strengthened his tones and gave to his figures flesh and blood.[2]

In Holland, the shift from Mannerism to Baroque was interpreted as a victory of reason over capriciousness. The Dutch poet and painter Gerbrand Adriaensz Bredero (1585–1618) explicitly defined the naturalist's creed when he wrote:

> For, as a painter, I have adhered to the artist's motto which says: they are the best painters who come closest to life, and not those who consider it a spirited thing to select poses that are unnatural, and to twist and bend the limbs and bones, which they often foreshorten and contort unreasonably and beyond the limits of propriety.[3]

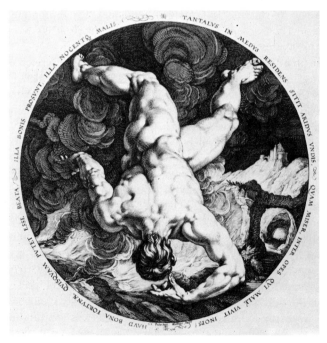

19. *The Fall of Tantalus*, 1588. Goltzius

Bredero's censure was plainly directed at the more extreme forms of Dutch Mannerism of the late sixteenth century [19]; the remedy, it seemed clear, lay in the new realism practised by artists of the generation of Frans Hals [96].

The history of art can show innumerable forms of naturalism, none of which was created without recourse to artistic conventions of one sort or another. Absolute naturalism, in any period, is a will-o'-the-wisp: the notion of the work of painting or sculpture as a purely objective and artless transcription of reality has no more validity as applied to the Baroque of the seventeenth century than to the Realism of the nineteenth. The very diversity of styles in the Baroque period, even in the work of the most thoroughgoing naturalists, ought to have been enough (one might think) to discredit the idea of pure 'imitation of nature'. But the myth of the artist—copyist was kept alive by the authority of the ancient writers and their stories of Demetrios, the sculptor who preferred lifelikeness to beauty, and of Peiraïkos, the painter of mean and vulgar subjects from everyday life.

FORMS OF NATURALISM

The naturalism of Caravaggio [8], which was to have momentous consequences for the whole of European painting, was the first great liberating force in Baroque art. His realistic, un-idealized rendering of living models and his powerful chiaroscuro appeared to countless young artists of the early seventeenth century to offer a vigorous and positive alternative to the crumbling remains of Late Mannerism. Caravaggio's unwavering dedication to naturalism was recognized by both artists and critics from the very start. In Holland, as early as 1604, Karel van Mander quoted Caravaggio as saying 'that all works, no matter what or by whom painted, are nothing but bagatelles and childish trifles . . . unless they are made and painted from life, and that there can be nothing . . . better than to follow Nature'.[4] Not long afterwards Agucchi, searching for a precedent in antiquity, suggested that Caravaggio should be compared to the sculptor Demetrios, 'because he has left behind the Idea of beauty, being disposed to follow similitude in everything',[5] and the same comparison was revived some fifty years later by Bellori. By this time, however, the classical theory of art was everywhere in the ascendant, and Bellori's adherence to it was so unquestioning that he could not contemplate the work of Caravaggio without expressing grave reservations. He was thus led to say of the artist that 'when the model was taken away from his eyes, his hand and imagination remained empty'. Of *The Death of the Virgin* [8] he remarked that the Madonna resembled too much 'the swollen corpse of a woman'.[6] Even when allowance is made for his stubborn classical bias, it hardly seems credible that

20. The Farnese Gallery, c. 1597–1604

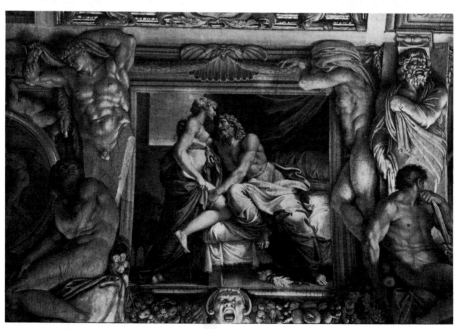

21. *Jupiter and Juno*, 1597–1600. Annibale Carracci

Bellori can be speaking of an altarpiece that now appears to us as
one of the most moving creations of the early Seicento. But what
Bellori could not forget was that this extraordinary work had been
rejected for reasons of decorum by the fathers of the church for which
it had been painted.

Bellori had no fault to find with Caravaggio's contemporary
Annibale Carracci, whose Farnese Gallery [20, 22] he recognized as a
masterpiece in the grand manner, replete with appropriate echoes of
Michelangelo, Raphael and classical antiquity [21]. Yet these frescoes
of the loves of the gods do not impress us so much by their noble and
exalted idealism as by their vivid semblance of life and their markedly
sensual quality. It is significant that the same critic who felt bound to

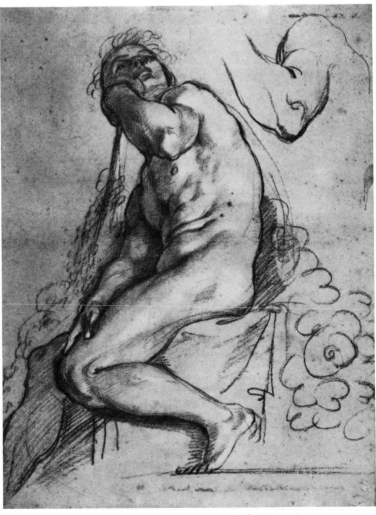

22. Study for the Farnese Ceiling, c. 1598. Annibale Carracci

disparage Caravaggio's naturalism took pains, in discussing the art of Carracci, to emphasize only its classical aspect: in his attempt, that is to say, to depict Carracci as a pure reincarnation of Raphael and the Antique, Bellori found it expedient to overlook certain early genre subjects, both in the form of paintings and drawings, which reveal a sympathetic observation of everyday domestic existence [23]. But

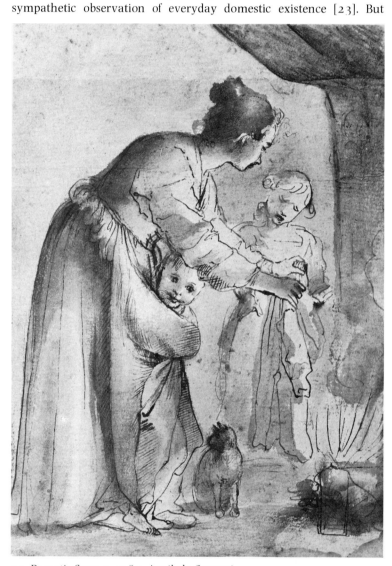

23. *Domestic Scene, c.* 1585. Annibale Carracci

that intimate contact with humanity is also present, though overlaid by a classicizing exterior, in the monumental frescoes and altarpieces painted by Carracci in his later, Roman years.

Rubens might be said to have followed the example of Annibale Carracci in infusing a vigorous realism into the art of history painting. The revitalization of the classical tradition, which we have come to see as one of Rubens's greatest accomplishments, would not have been possible without a thorough knowledge of ancient and High Renaissance art on the one hand and a readiness to exploit the potentialities of the new naturalism on the other.

The French critic Roger de Piles (1677) makes some interesting comments on the significance of Rubens's naturalism:

> He was so strongly persuaded that the aim of the painter was to imitate nature perfectly, that he did nothing without consulting her, and there has never been a painter who has observed and who has known better than he how to give to objects their true and distinctive character ... And he carried this knowledge so far, with a bold but wise and skilful exaggeration of these characteristics, that he rendered painting more alive and more natural, so to speak, than nature itself.[7]

Rubens's attentiveness to nature was not to everyone's liking. Bellori, the unrelenting guardian of taste, found it particularly distressing that the artist, in working from the best models of the past, transformed them so drastically. 'Though he had the highest admiration for Raphael and the antique', Bellori wrote, 'he never imitated either in any part, and though he may have wished to follow the lineaments of the statues of Apollo, of Venus, or of the Gladiator, he altered them so much by his style that he left no form or vestige of these statues by which they might be recognized.'[8]

It may seem puzzling that the works of Rubens, who professed such veneration for the monuments of antiquity and repeatedly made use of them in his art, look so unclassical. But the artist's decision to avoid literal copying of sculptural models was not due, as Bellori assumed, to an error in judgement or to a deficiency in draughtsmanship, but to a desire to maintain consistency of style and to be more lifelike. Rubens himself was very explicit on this point. In his treatise *On the Imitation of Statues* (a practice which in general he advocated) he warned young painters against reproducing their cold and stony lustre: 'Those who, instead of painting flesh, only represent marble in colour, offer an affront to Nature.'[9] These were no idle words, as Rubens's sensuous rendering of the nude makes very clear. Andromeda [24], chained to a rock to be devoured by a sea-monster, is not yet aware that she is to be delivered from her fate by the hero Perseus. The rhythmic pose and proportions derive unquestionably from a Graeco-Roman Venus, but nothing could be further from the effect of frigid, lifeless stone. The figure of the helpless victim acquires a special pathos through the warm and glowing luminosity of the flesh, and the restless movement of the body only heightens the mood of suspense.

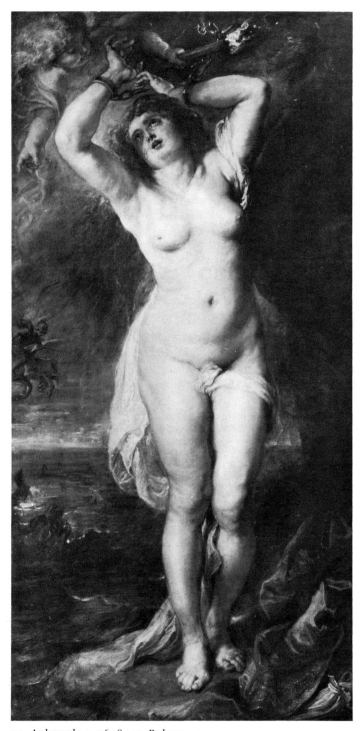

24. *Andromeda, c.* 1638–40. Rubens

The complaint that Rubens's rendering of anatomy was too realistic was heard in France as well as in Italy. In 1622 the antiquarian Nicolas-Claude Fabri de Peiresc wrote to the artist from Paris to describe the reactions of members of the French court to certain designs by Rubens for the tapestry series representing *The History of Constantine*. Of one of these sketches [25] Peiresc said:

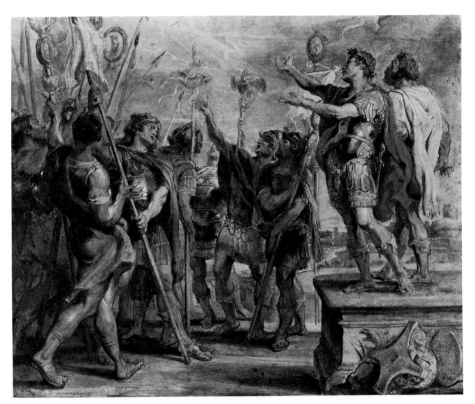

25. *The Allocution of Constantine*, 1622. Rubens

The *Allocution*, which was greatly to my taste for the exactness of the antique military costumes, found many critics, but only because of your manner of drawing the legs in a curve rather than straight as is customarily done. I remember very well that you once told me . . . that this effect certainly appeared in nature, and the critics cannot deny the truth of the effect of nature. But they say . . . that since the ancient sculptors avoided it, as well as Michelangelo, Raphael, Correggio and Titian, it seems that it still ought to be avoided today.[10]

Rubens's reply to this letter is unfortunately not recorded. But the criticism, in any event, went unheeded: in the completed tapestry of *The Allocution of Constantine* the legs of the figures are no less bent than in the preliminary oil sketch.

Perhaps the most striking proof of the concern felt by Baroque artists that their figures should appear to be animated by the pulse of life is to be found in the work not of a painter but of a sculptor. The frank sensuousness of Bernini's *Truth Unveiled* [26] effectively refutes Rubens's strictures on the inherent coldness and intractable quality of marble. By giving to his work this astonishing illusion of soft flesh, of shining translucent skin and of supply moving surfaces, the artist transcends the limits of sculpture to achieve, paradoxically, a Rubens in stone. Bernini himself freely acknowledged that it was by emulating

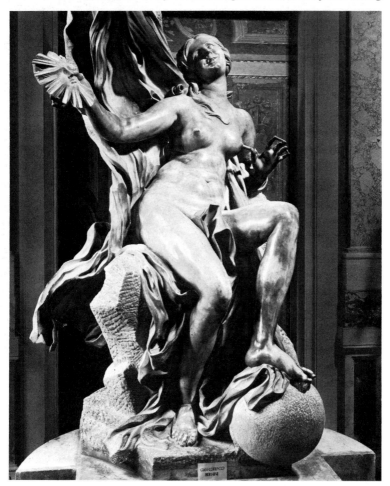

26. *Truth Unveiled*, 1646–52. Bernini

the effects of painting that he was able to give to his works their 'marvellous softness'. Speaking of the skill that was required 'to render marble flexible, so to speak, and to know how to combine painting and sculpture', he remarked that most sculptors 'lacked the courage

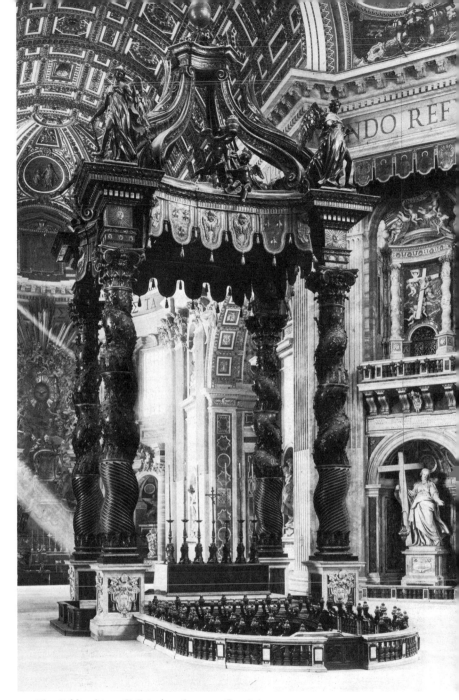

27. The Baldacchino, St Peter's, 1624–33. Bernini

to make the stone as obedient to the hand as if it were so much dough or wax'.[11]

This sensuousness is at times perceptible in works of architecture as well as in painting and sculpture. Pevsner has observed that there

is something in the advancing and retreating surfaces of Roman church façades of the mid seventeenth century that evokes the action of the human body.[12] The rhythmic undulations of Borromini's S. Carlo alle Quattro Fontane [155] bear a curious relation to the voluptuous movement of nude flesh in the paintings of Rubens and the sculptures of Bernini. It is just this pliability of surface that Rubens alludes to in his essay *On the Imitation of Statues* when he speaks of 'the hollows which change according to the movements of the body and which because of the flexibility of the skin are either distended or contracted'.[13] In this sense too Bernini's Baldacchino in St Peter's [27] may be described as 'corporeal', for the moving, swelling contours of the twisted bronze columns topped by the resilient volutes of the crown give rise to an impression of pulsating energy and life.

Baroque naturalism reaches its zenith in the art of Velazquez, whose biographer Palomino (1724) can pay him no higher tribute than to say of his works that they are 'not painting, but truth'.[14] This master, who was educated in the humanist tradition and certainly had a sympathetic understanding of pagan mythology, generally ignored the language of classical idealism even when he addressed himself to the fables of the gods. In *The Drinkers* [28] the god of wine mingles with common mankind in much the same way that Caravaggio's Christ sits at table with his disciples in an ordinary roadside inn [121]. Bacchus, who is placing a wreath on the head of a soldier, is sur-

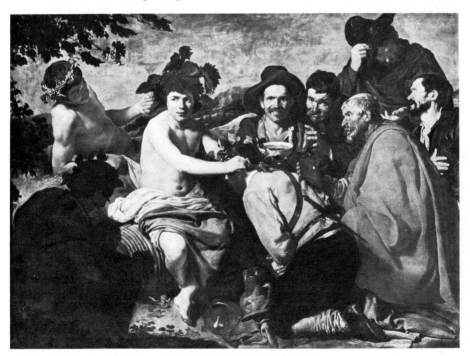

28. *The Drinkers* (or *The Triumph of Bacchus*), 1628–9. Velazquez

rounded by poor and ragged peasants whose faces and attitudes show
that they look on him as a god who, through the gift of wine, can
bring deliverance from misery and hardship [29].

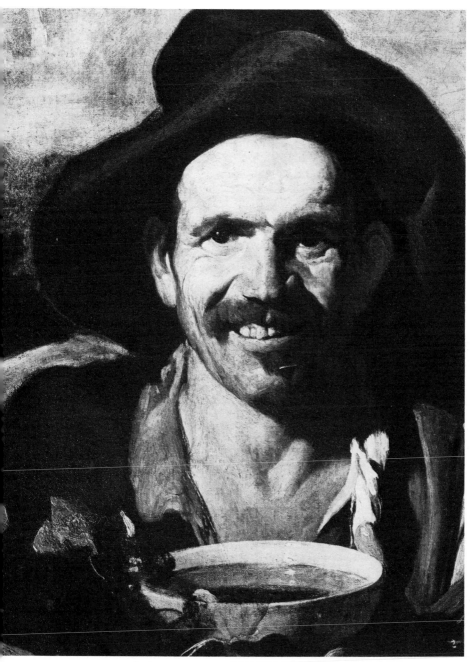

29. Detail of 28

The impact of Rembrandt's realism, like that of Caravaggio, can best be gauged by reading the remarks of critics who were troubled by what seemed to them to be a wilful disregard for the classical system of proportions. In the later seventeenth century, when Dutch taste was growing increasingly refined and classicistic, Rembrandt's interpretation of the female nude, as in the famous etching of the

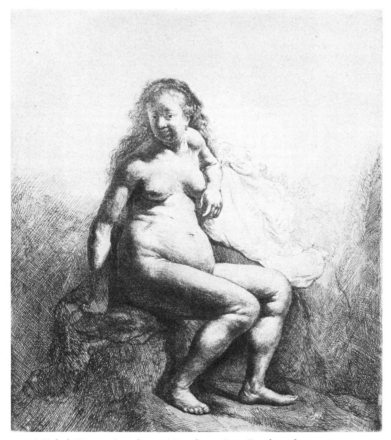

30. *A Naked Woman Seated on a Mound*, *c.* 1631. Rembrandt

Naked Woman Seated on a Mound [30], was thought offensive in the extreme. Andries Pels (1681) lamented that instead of choosing a 'Greek Venus' for his model he had drawn a washerwoman with sagging breasts, knobby hands and the marks of garters on her legs.[15] In his biography of the artist, Arnold Houbraken (1718), reviving a mode of criticism that had earlier been directed against the arch-naturalist Caravaggio, summed up Rembrandt's failings in these words: 'He did not want to be bound by the rules of others and still less to follow the illustrious example of those who had earned ever-lasting fame for themselves by choosing to represent the Beautiful;

he was satisfied with following life itself as it presented itself to him, without making further selections.'[16]

In France, the seventeenth century witnessed the emergence of the *'peintres de la réalité'*. The peasant pictures of Louis Le Nain [31] are among the most remarkable documents of Baroque naturalism in that they combine unidealized observation of simple humanity with an almost classical gravity and calm. Though his subjects are country folk who lead a life of toil, Le Nain prefers, whenever possible, to show

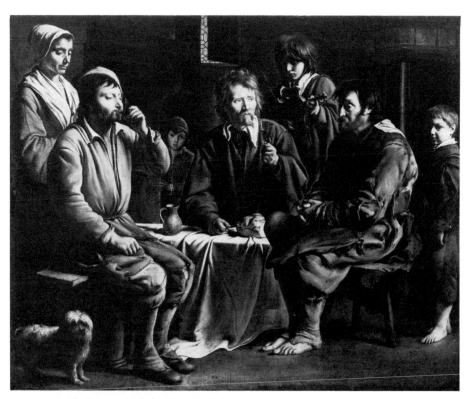

31. *The Peasants' Meal*, 1642. Le Nain

them at rest, so that they may be given attitudes of dignity and composure. A comparable spirit of realism tempered by simplicity pervades the solemn and mysterious nocturnes of Georges de La Tour [56]. It reappears in still another guise in the beautiful votive picture by Philippe de Champaigne, the so-called *Two Nuns of Port Royal* [189], painted to record the artist's thankfulness for his daughter's recovery from a serious illness.

It is easy to dismiss Nicolas Poussin as an austere and icy classic having no contact with the common run of men. His well-known antipathy to the more drastic forms of Baroque realism may be

summed up in the remark attributed to him, probably correctly, by Félibien, which was that 'Caravaggio had come into the world to be the ruin of painting'.[17] Yet as an artist of the seventeenth century Poussin was not untouched by the currents that stirred the minds of the leading artists of his day, no matter how much he might strive to suppress in his own work the momentary, the accidental, the impromptu. Even in the aloof and stately *Holy Family on the Steps* (Washington, National Gallery) there is something that accords very well with the controlled and sober naturalism of Le Nain and La Tour. Nor is it true that Poussin found no stimulation in the world around him. We know that he was a keen student of human behaviour. 'When he walked through the streets,' Félibien reports, 'he observed all the actions of the people whom he saw, and if he came across some that were unusual he noted them in a book which he carried with him for this purpose.'[18] These hasty sketches were of course not intended to be used directly as studies for paintings. They formed part of the artist's rich store of experience, from which he made those distillations of human psychology that are seen in *The Israelites Gathering the Manna* [60] and other history paintings of this kind.

SACRED ART AND NATURALISM

The metamorphosis of religious imagery must be reckoned as one of the most important consequences of the new naturalism in Baroque art. In the general reaction against the abstract and precious tendencies of Late Mannerism, the sacred personages of Scripture and the Lives of the Saints were now to be made accessible to the faithful as beings of flesh and blood.

The *Spiritual Exercises* of St Ignatius of Loyola are customarily, and I think rightly, said to have contributed to the realistic quality of Baroque religious art. The purpose of the book is to enable the exercitant, through a series of meditations and contemplations, to order his life according to the will of God. The first week is devoted to the contemplation of sins; the second to the life of Christ; the third to the Passions; and the fourth to the Resurrection and Ascension. The *Exercises*, first published in Latin in 1548, began to be more widely read after the appearance in 1599 of the definitive Directory (the instructions for those giving the Exercises to others), and their influence on art reached its height in the seventeenth century. It is true that Ignatius nowhere speaks of art, but we can readily imagine how painters of the stamp of Caravaggio took encouragement from the author's practice of calling upon the experience of the senses to give reality to the scenes to be contemplated. A particularly striking feature – and one that surely fired the imagination of artists – is what Ignatius calls 'composition, seeing the place,' the aim of which is 'to

see with the eye of the imagination the corporeal place where the object one wishes to contemplate is found'.[19]

The 'secularization of the transcendental' (to use Friedlaender's term)[20] was not long in manifesting itself in Spain, where painters and sculptors seized upon realism as a means of bringing the beholder into a state of mystical communion with the divine. In the polychrome Crucifix of 1603–6, known as the *Christ of Clemency* [32], Juan Martínez Montañés created one of the most lifelike and at the same time most moving sculptures in all Spanish devotional art. It is an

32. *Christ of Clemency*, 1603–6. Montañés

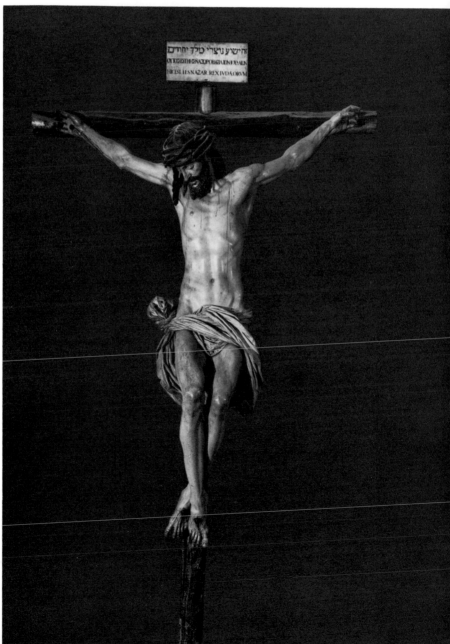

essential part of the meaning of this work that it addresses itself to the individual worshipper kneeling before it: only from a position directly beneath can it be seen, for instance, that the eyes of the Crucified are open [33]. This was in fact the intention of the donor, whose instructions, as set forth in the contract, were followed by Montañés to the letter. The Saviour, it was specified, should be represented as still living, 'with the head inclined towards the right side, looking at any person who might be praying at the foot of the Crucifix, as if Christ

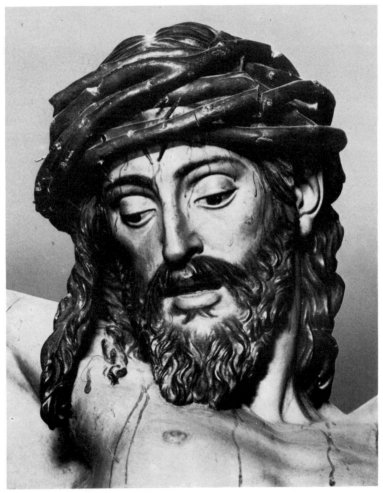

33. Detail of 32

himself were speaking to him and reproaching him because what he is suffering is for the person who is praying; and therefore the eyes and face must have a rather severe expression, and the eyes must be completely open'.[21] What we cannot fail to observe is how closely

this work parallels the intentions of St Ignatius in the *Spiritual Exercises*. In the first Colloquy, for example, Ignatius writes:

> Imagining Christ our Lord present before me on the Cross, to make a colloquy with Him, asking Him how it is that being the Creator, He has come to make Himself man, and from eternal life has come to temporal death, and in this manner to die for my sins. Again, reflecting on myself, to ask what have I done for Christ, what am I doing for Christ, what ought I to do for Christ.[22]

The search for ways in which the supernatural might be brought more vividly within the realm of human experience led to fresh interpretations of biblical subjects, especially those involving the encounter

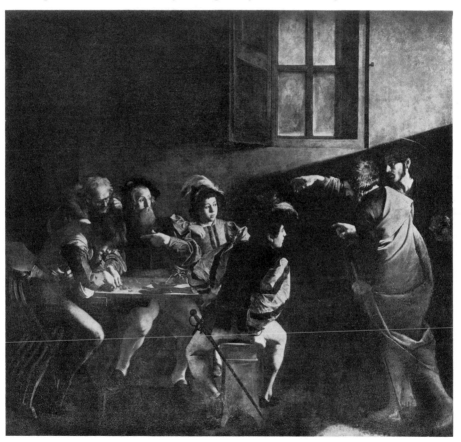

34. *The Calling of St Matthew, c.* 1598–1600. Caravaggio

of the mortal and the divine. A typical transformation is that worked by Caravaggio on the theme of the Calling of Matthew, which in the sixteenth century had offered to Netherlandish artists such as Jan van Hemessen a pretext for representing the greed and immorality of

tax-gatherers. Though such works were probably known to Caravaggio, it is significant that he suppressed any temptation to make of the subject a mere caricature of human weakness. In the great canvas of the Contarelli Chapel [34], the drama of Christ's call to Matthew juxtaposes the temporal and the eternal – the life of avarice and the apostolic mission, the darkness of the world and the light of the spirit. In his determination to translate the biblical event into the terms of ordinary experience, Caravaggio actually carries his 'naturalism' to the point of inconsistency: for whereas Christ and his disciple are clothed in the antique tunic and cloak, Matthew and his worldly companions at the counting-table wear modern dress (see Fig. 2, p. 317).

Caravaggio is, as always, laconic when it comes to describing the setting in which the scene is laid. Most writers assume that it is a room which Christ has just entered from the right side. But there are in fact several precise indications that the *mise en scène* is an outdoor one: Matthew's table has been set up in a street, and the wall behind him is the outside of a building, the corner of which is visible directly above the old man wearing spectacles; Christ, whose feet are pointed to the right, has walked past the group at the table and is on the point of leaving the scene altogether; at this moment, however, as if prompted by the disciple at his side, he turns his head sharply and extends his hand to summon Matthew.

We can easily understand how the gospel story of the Supper at Emmaus, in which Christ's identity is suddenly revealed to two un-suspecting disciples, proved so stimulating to the imaginative powers of painters such as Caravaggio [121], Rubens and Velazquez. The classic statement of the Emmaus miracle in the seventeenth century is Rembrandt's painting of 1648 [14]. It is possible that he was drawn to the subject because it offered to a Protestant artist an acceptable substitute for the Last Supper, but his interpretation of it is nevertheless a consistently Baroque one. The majestic niche that rises above Christ and the mysterious light that surrounds him somehow suggest, even to the twentieth-century unbeliever, the intrusion of a divine presence into the everyday world, and the decidedly proletarian aspect of the two disciples only underlines the universal significance of the miracle as an event applicable to all mankind.

Although Caravaggio might think it appropriate to include persons in modern dress in a biblical scene [34], this kind of deliberate ana-chronism could only have seemed abhorrent to a scrupulous history-painter such as Poussin, whose pictorial realism took the form of archaeological accuracy. Instead of attempting to persuade the observer that what he sees is taking place (or might take place) here and now, Poussin sought to anchor the sacred story in its proper place and time by paying careful attention to details of costume, architec-

ture, furniture and so forth. His interest in archaeology owed a good deal to the encouragement of his friend and patron, the antiquarian Cassiano dal Pozzo, who had built up an immense collection of drawings of ancient works of art which he called his 'paper museum'. When Poussin painted the cycle of *The Seven Sacraments* for Chantelou, he endeavoured to recreate the visible appearance of the world of primitive Christianity, in order to invest these solemn scenes with the greatest possible verisimilitude. In *Penance* [35], which is repre-

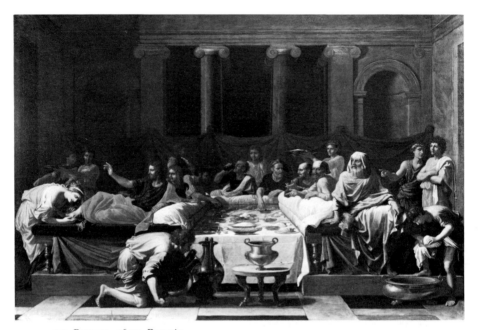

35. *Penance*, 1647. Poussin

sented by the feast in the house of Simon at which Mary Magdalene washed the feet of Christ, the guests, who it goes without saying are dressed in apostolic garments, lie on a couch, or a triclinium, in the authentic Roman manner. This is Poussin's method of 'composition, seeing the place'.

LANDSCAPE, STILL LIFE, GENRE

Three subjects were raised in the seventeenth century to a position of importance that they had not previously enjoyed. Landscape, still life and genre were not 'invented' by the Baroque. All three were recognized as established though minor branches of painting in the age of Mannerism; for it was at this time, both in Italy and in the north, that the influence of ideas from ancient writings accelerated the

rise of such specialized categories of subject-matter. Still, it was not until the new empiricism had liberated them from their lowly artistic place, whether as symbol, decoration or mere curiosity, that they emerged from the shadow of history painting to be treated to a kind of apotheosis.

Gombrich has pointed out that the growth of landscape painting in the sixteenth century probably owed more to a careful reading of ancient authors than to a strong feeling for nature.[23] Flemish paintings of fantastic mountain scenery, to take one example, were often called *parerga*, a term borrowed from Pliny, meaning mere by-works. The shift from Mannerist artificiality to a fresh observation of nature, already in progress before 1600, brought about a dramatic change in the conception of outdoor subjects. Within a short space of time the two principal modes of Baroque landscape had taken on their definitive shape in Italy and the Netherlands.

Annibale Carracci's luminous *Flight into Egypt* [36] is the archetypal classical landscape, later to be emulated with variations by Domenichino, Poussin and Claude. Though the Holy Family remains promi-

36. *Landscape with the Flight into Egypt, c.* 1604. Annibale Carracci

nent because of its placing in the middle foreground, the small scale of the figures in relation to the spacious natural setting at once establishes a new priority in which landscape takes first place and history second. It is to be sure an ideal nature that Carracci brings to life in this canvas – a nature enriched and completed by man and the works of man. Yet the underlying assumption is an authentic Baroque one: the painter implicitly acknowledges that man is no longer the unassailable centre of creation and that there are other aspects of the world that may have a legitimate claim on his attention.

37. *Landscape with Dunes near Haarlem*, 1603. Goltzius

In Holland, the transition from Mannerist to Baroque landscape may be followed with paradigmatic clarity in the drawings of Hendrick Goltzius. This virtuoso draughtsman, who during the last decade of the sixteenth century had produced views of mountain scenery of a highly personal and extravagant kind, began shortly after 1600 to make panoramic drawings of the countryside near Haarlem [37], which in their topographical exactness and feeling for aerial perspective anticipate in an astonishing way the fully developed tradition of Dutch landscape painting [140]. For the first time, the representation of nature – without the support of religious or mythological subject-matter – was promoted to the rank of high art.

It is a far cry from the world of Dutch realism to the idyllic landscapes of Claude Lorrain, in which nature is seen as if in a dreamlike vision, a nostalgic glimpse of a vanished past, suffused with a golden or silvery haze [202]. Yet Claude's mastery of effects of light, and his magical ability to suggest the fleeting moment, whether at dawn, at midday or at twilight, were not achieved without the most rigorous study of natural phenomena. His biographer Joachim von Sandrart (1675), who had known Claude in Rome, gives a revealing account of the artist's method:

> He tried by every means to come close to nature, lying in the fields before daybreak and until nightfall in order to learn to represent very exactly the red morning sky of sunrise, sunset and the evening hours. When he had carefully contemplated one or the other in the fields, he immediately mixed his colours accordingly, hurried home and applied them to the work he had in mind with much greater naturalness than anyone had ever done before.[24]

The evolution of the Baroque still life follows a pattern very like that of landscape. The humanists of the sixteenth century had given their blessing to Mannerist paintings of still life, which were especially popular in Italy and the Netherlands, because they appeared to be consonant with their ideas about the revival of antiquity. Had not Pliny said of the Greek painter Peiraïkos that he was famous for his pictures of barbers' and bootmakers' shops and of foodstuffs? Even so, it was not until about the year 1600, as Charles Sterling has put it, that 'the North joined with Italy to raise the painting of objects from the level of mere decoration, whether of walls, furniture or books, to the status of an independent picture'.[25] In Flanders, Holland, Italy, France and Spain, still-life masters were busy painting flower-pieces, baskets of fruit, musical instruments, household vessels of every sort, tables laden with food, heaps of dead game and fish [101, 104]. And these inanimate objects were represented not only with the utmost realism but with all the dedication and seriousness that had once been reserved for the human form. Perhaps this was what Caravaggio meant when he remarked to one of his early patrons that 'it took as much craftsmanship for him to paint a picture of flowers as one

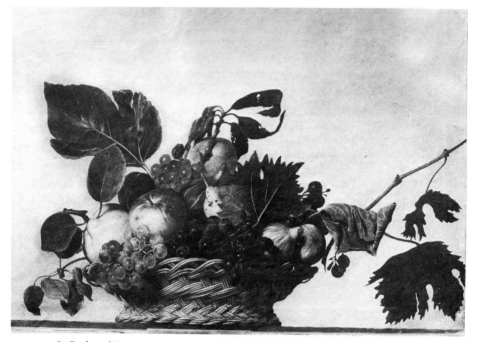

38. *Basket of Fruit*, c. 1596. Caravaggio

of figures'.[26] The *trompe-l'oeil* realism of his *Basket of Fruit* [38], which extends to such imperfections as shrivelled leaves and worm-holes in

the apples, may be taken both as the naturalist's repudiation of the
ideal and (on another level) as an intimation of transience and decay
in all living things.

The origins of Baroque genre, like those of landscape and still life,
go back to the Mannerist period. Yet there is nothing in the earlier
history of the subject to prepare us for its dramatic flowering at the
outset of the Baroque. At this moment, it seems, the genre piece pre-
sented itself as the naturalist theme *par excellence*, to be avidly taken
up by artists everywhere. In Italy, the genre subject early claimed the
attention of Caravaggio and Annibale Carracci [23]; in Spain, it made
possible the solemn *bodegones* of the young Velazquez, painted before
his employment at the court of Philip IV put an end to 'uncouth'
pieces of this sort; in Antwerp, Adriaen Brouwer developed a type of
rough low-life genre [39] that was widely imitated in the Northern as
well as in the Southern Netherlands; in France, rural subjects were
treated by Louis Le Nain, not in a spirit of rowdiness but with dignity
and restraint [31]. But it was in the Protestant bourgeois society of
Holland that the genre picture celebrated its greatest and most
enduring triumph [45].

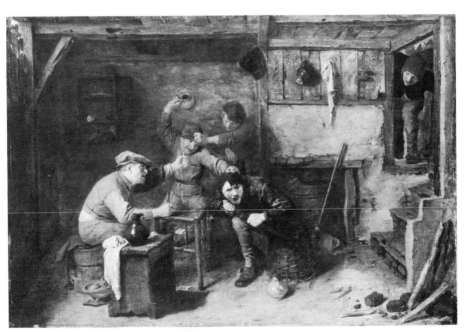

39. *Peasants Fighting over Cards, c.* 1632. Brouwer

The idea, still occasionally encountered in the literature on this
subject, that the Dutch painters of the seventeenth century stripped
the genre picture of all its earlier moralizing and allegorical content

64　　and turned it into a vehicle of pure and unprejudiced observation of life is no longer tenable. This view, which was formulated in the Positivist atmosphere of the nineteenth century and argued with great persuasiveness by critics such as Théophile Thoré, rested on the assumption that the integrity, and indeed the sole justification, of Dutch art lay in its realism. The French painter Eugène Fromentin (1876) went so far as to speak of 'total absence of subject' as a characteristic of the entire Dutch school, of which he said that 'it was content to look around it, and to dispense with imagination'.[27]

When we survey the vast body of Dutch genre painting, we are not struck, as Fromentin claimed to be, by its 'absence of subject' but rather by its coherent iconographic structure. We discover, for example, that certain themes recur with such frequency as to show that they have become established types – the 'Merry Company' [40], the 'Girl reading a Letter', the 'Music Lesson', and so forth. The

40. *The Merry Company*, 1620. Honthorst

existence of a basic repertory of themes, far from supporting the notion of untrammelled realism, testifies to the need to order the casual and scattered impressions of daily life and social intercourse into a set of familiar pictorial patterns, very often of an axiomatic or emblematic character.

Yet if Dutch genre is not (as it once appeared to be) simply a mirror of reality, it still stands as one of the most extraordinary achievements

of Baroque naturalism. No other seventeenth-century school of painting can offer so comprehensive and so faithful a portrait of a whole society — bourgeois citizens, peasants and soldiers; their dress, daily occupations, amusements, graces and foibles; their homes, gardens, taverns and guardrooms. In these scenes of everyday life, as in the paintings of landscape, the highest taste and craftsmanship in the art of picture-making are put at the service of the most penetrating powers of observation.

SCIENCE AND PHILOSOPHY

The strictly art-historical view of the Baroque, that it arose as a form of positive response to the disintegration of Mannerism, need not be taken as exclusive. Considered from the standpoint of the history of ideas, the emergence of a new visual realism about the year 1600

41. Title-page of Bacon's *Instauratio Magna* (*Novum Organum*), 1620, de Passe

presents a rather different aspect – though the two positions are not necessarily irreconcilable. That the artistic vision of the age in which science assumed a predominant role should have been shaped by a concern for verisimilitude in the rendering of the material world can hardly be thought accidental. Seen in this light, Caravaggio and Frans Hals, Velazquez and Vermeer, are true compeers of Galileo and Kepler, of Harvey and Descartes.

The chief apologist for the secularization of knowledge in the early seventeenth century was Francis Bacon, who looked on himself as the Columbus of the new world of the intellect. When in the *Novum Organum* of 1620 Bacon writes of the experimental method in science, he expresses himself in words that might almost be taken as an aesthetic statement (like that of Bredero quoted above) affirming the superiority of Baroque realism to Mannerist fantasy:

> Those, therefore, who propose not to conjecture and guess, but to discuss and know; who are resolved not to invent grotesques and fables of worlds, but to look into and as it were to dissect the nature of this real world, must consult only things themselves.[28]

And in the same manner, the title-page of the *Novum Organum* by Simon de Passe [41], which represents a ship in full sail passing through the Columns of Hercules, the *ne plus ultra* of the Old World, to set out on a voyage of discovery, might serve as a symbol of the expanding horizons of the Baroque era, in art as well as in science.

No one would seriously maintain that Baroque artists were 'scientific'. It is not a question, for example, of an increase in the number of anatomical pictures (though there are, to be sure, some important works of this kind), nor of a specialized knowledge on the part of artists of the laws of mathematics and optics, but only of the way in which certain scientific developments affected the mental habits, and in turn the art, of the seventeenth century.

We shall do well to remember, in this connection, that some of the most significant advances in the physical sciences occurred in the previous century. The *De Revolutionibus* of Copernicus, which over-threw the Ptolemaic system and laid the foundations of modern astronomy, was published in 1543. Yet the Copernican world-view did not find wide acceptance until after 1600 – about the time that one begins to detect the hold exerted by space on the imagination of Baroque artists. Moreover, the tremendous discovery by Copernicus which dethroned the earth from its position at the centre of the universe was by no means the sole achievement of sixteenth-century science. Less world-shaking in their implications, but more intimately connected with the representational arts, were the great illustrated volumes dealing with such subjects as anatomy, botany and zoology – products of the new emphasis on the observation of nature. The rapid

advance of the descriptive sciences in the sixteenth century was facilitated, as Ivins and Chastel have shown,[29] by the publication of books with illustrative plates of a high degree of accuracy. Without the famous woodcuts attributed to Jan Stephan van Calcar, the *De Humani Corporis Fabrica* of Vesalius, which appeared in the same year (1543) as the *Revolutions* of Copernicus, could not have made so fundamental a contribution to the study of exact anatomy. To the same period belongs the great herbal of Leonhard Fuchs (1542), with magnificent woodcuts of plants after drawings by Albrecht Meyer. At the close of the century the *Ornithologia* of the Bolognese naturalist Ulisse Aldrovandi was published in three volumes in 1599 and likewise furnished with admirable engravings. The plates in these and other scientific works are expressions of the increasingly empirical state of mind that fathered the naturalism of Baroque art. It cannot, however, be sufficiently emphasized that the change-over from Mannerist to Baroque occurred only when this kind of visual realism began to be applied not to illustration alone but to the arts of painting and sculpture.

In this connection, it should not escape our notice that the spirit of Baroque realism also penetrated the decorative arts, especially in the rendering of floral motifs. The Dutch silversmith who made the magnificent dressing-case now in the Gemeentemuseum at The Hague [42] was not content to create a purely conventional floral ornament but took care to ensure that the embossed flowers should be botanically correct and that they should twist and turn on their stems as freely as the blooms in a painted flower-piece [104].

42. Silver Dressing-Case, 1665–79

43. The Cosimo Panel, 1682. Grinling Gibbons

The most audacious master of illusionism in the so-called minor arts was Grinling Gibbons, the English wood-carver whom John Evelyn called 'our Lysippus'. Gibbons's masterpiece is the great lime-wood panel sent by King Charles II in 1682 to Cosimo III, Grand Duke of Tuscany [43]. In this 'extraordinary fine peece of carved worke', the attributes of the arts and princely pomp are surrounded by a profusion of acanthus scrolls, flowers, shells, walnuts and other natural forms, all of astonishing delicacy and lifelikeness. At the top two billing doves perch on a spray of roses, beneath which there appears, inexplicably, a lace cravat.

The effects of astronomical observation are already perceptible in works of art of the early seventeenth century. Adam Elsheimer, painting the *Flight into Egypt* as a nocturnal scene [44], is not content to suggest the appearance of the starry sky by a random scattering of flecks of light, but gives a careful and convincing rendering of the Milky Way and the constellations of the northern hemisphere including that of the Great Bear; and the moon, instead of being simply a

44. *The Flight into Egypt*, 1609. Elsheimer

flat disc, shows the dark patches that early stargazers took to be oceans. In *Paradise Lost* (1667), Milton imagined Galileo training his telescope on the moon 'to descry new Lands, Rivers or Mountains in her spotty Globe'. But Galileo's observations of the moon had attracted

attention long before Milton's day. The pits and craters of the lunar surface revealed by his 'optic glass' were accurately represented by Galileo's friend Ludovico Cigoli in a fresco of the *Assumption of the Virgin* (1612), in which the moon appears beneath the Virgin's feet.[30]

Another form of 'optic glass' – the camera obscura – likewise aroused the interest of painters and scientists. Kepler employed such a device to make a drawing of a landscape, a task which he carried out (as he himself said) 'not as a painter but as a mathematician'. That Vermeer of Delft made use of the camera obscura seems now to be definitely established. In paintings such as the *Maidservant Pouring Milk* [45], there are conspicuous 'circles of confusion' and 'halation' of highlights, effects that can best be explained as optical phenomena observed by the artist on the viewing-screen of a camera obscura.

45. *A Maidservant Pouring Milk, c.* 1660. Vermeer

The influence of science on the outlook of the Baroque artist was reinforced by the naturalist philosophies current in the sixteenth and seventeenth centuries. The new respect for God-created things, whether in a painting of landscape or of still life, hints at the pervasive spirit of pantheism, which sees in nature a direct manifestation of the divine. Nowhere is this animistic conception of nature more evident than in those works of Jacob van Ruisdael in which trees, not men, play a heroic role, contending with one another and at length falling into decay in an unending cycle of life, struggle and death [46].

46. *Two Peasants and their Dog, c.* 1650–55. Ruisdael

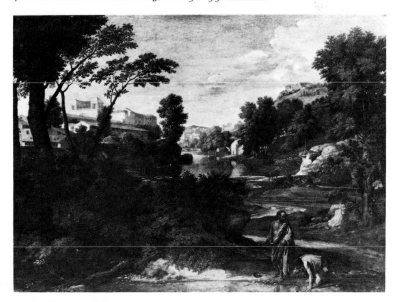

47. *Landscape with Diogenes,* 1648? Poussin

The revival of Stoicism likewise opened the eyes of many painters to a new awareness of the relation of man and nature. Rubens owed his deep interest in the teachings of Seneca and the ancient Stoics to his early acquaintance with the great humanist Justus Lipsius, who edited the complete works of Seneca in 1605.[31] Poussin was similarly inspired by the Neo-Stoic ideas of Montaigne and other French writers who sought to conduct their lives according to nature and reason. In the *Landscape with Diogenes* [47] Poussin illustrates the story of the philosopher who, intent on living a life of utter simplicity, throws away his drinking-bowl when he sees a boy using his hand to scoop up water from a stream. It is characteristic of the Baroque way of thinking that this act of Stoic renunciation should be given universal significance by being placed within a spacious and richly ordered natural setting. In a larger sense, the theme of the picture becomes, as Anthony Blunt has put it, 'the harmony of nature and the virtue of man'.[32]

3

The principal use of prudence or self-control
 is that it teaches us to be masters of our passions,
and to so control and guide them
 that the evils which they cause are quite bearable,
and that we even derive joy from them all.

Descartes, *Traité des passions de l'âme* (1649)

The Passions of the Soul

The Baroque sensualization of experience had its subjective as well as its objective side. The portrayal of the inner life of man, which had not been a matter of much concern to the Mannerists, suddenly came to the fore in the early seventeenth century.

The method of expressing the passions through gesture and facial aspect was of course not an invention of the Baroque but had already been formulated by Renaissance artists and theorists who took their inspiration from the writings of Aristotle and the ancient rhetoricians; both Alberti and Leonardo had considered the study of expression to be of fundamental importance to the history-painter.[1] With Raphael, in such works as the tapestry cartoons, the Renaissance conception of the rendering of the emotions was brought to its highest development. What chiefly distinguishes the Baroque attitude from that of the Renaissance is the urge to expand the range of sensual experience and to deepen and intensify the interpretation of feelings.

The resurgence of the passions in the artistic domain may be regarded as one of the consequences of Baroque naturalism, which at the same time that it gave closer scrutiny to human actions and physiognomy, led to a deeper interest in the emotional life. There is an obvious parallel, too, with the rise of the science of psychology, which in the seventeenth century was still understood to be that part of the study of man which treats of the soul. The problem of the passions became an engrossing subject for philosophers who sought to define their role in human destiny. The materialist view of the emotions is

stated in its most extreme form by Thomas Hobbes in the *Leviathan* (1651). For Hobbes 'the desires, and other passions of men, are in themselves no sin'. In the working of the passions may be seen evidence of man's 'perpetual and restless desire of power, after power that ceaseth only in death'. For it is the acquisition of power that alone constitutes human happiness. 'Continual success in obtaining those things which a man from time to time desireth, that is to say, continual prospering, is that men call Felicity; I mean the felicity of this life.'[2]

THE EXPRESSIONS OF FEELINGS AND STATES OF MIND

In the earlier years of the seventeenth century it was generally the most lively and spontaneous emotions that artists sought to capture in their works. The Dutch genre painters, for example, became so adept at suggesting a kind of boisterous cheerfulness in their subjects that one can almost hear the laughter bursting from these merry faces [96]. Efforts to register the expression of emotions of a less pleasant sort (especially surprise, horror or pain) are often ingenuous, the result, no doubt, of practising a series of frightful grimaces before a mirror. Rembrandt's etching of 1630, showing the artist 'open-mouthed and staring' [48] is a typical and amusing specimen of this

48. *Self-portrait,*
1630.
Rembrandt

procedure. To the same category belongs Caravaggio's *Boy Bitten by a Lizard* (Florence, Collection Roberto Longhi), which, though the meaning is probably symbolic,[3] nevertheless suggests convincingly the sudden pain and shock experienced by the boy as the reptile fastens its teeth on his finger.

But these juvenile experiments in self-observation are only the indispensable first steps leading to a more searching exploration of the emotional life. How such studies could be transmuted into works of great dramatic power may be illustrated by Bernini's *David* of 1623–4 [49], in which the knitted brow and tightly compressed lips tell of the fierce resolve of the young hero as he summons all his forces to confront and overwhelm his terrifying opponent.

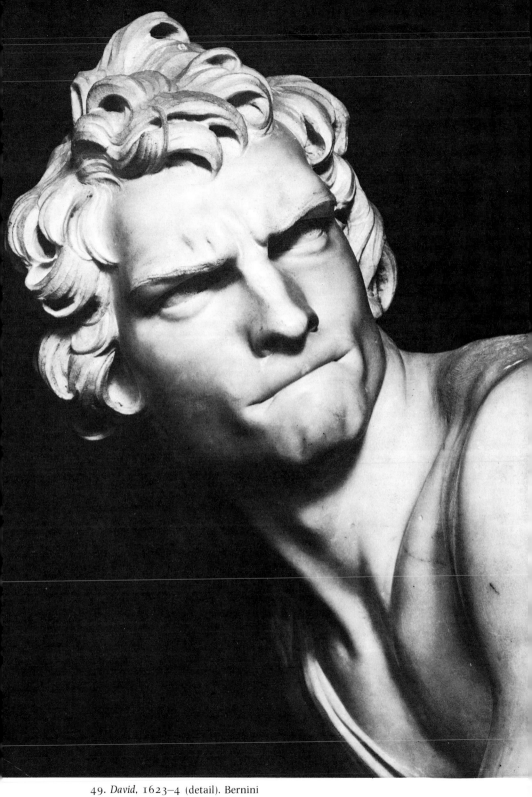

49. *David*, 1623–4 (detail). Bernini

50. *Milo of Crotona*, 1671–82. Puget

A work of sculpture that is often compared to the *David* for its intense emotionalism is Pierre Puget's *Milo of Crotona* [50]. The Greek athlete Milo, attempting to split open the trunk of a tree, was trapped when the wood closed upon his hand and in this helpless state was set upon and devoured by wild beasts. The principal forms are disposed in an almost geometrical configuration that gives particular prominence to the extended left hand. The upturned face with its agonized expression tells of the pain and anguish of the victim as the lion bites and claws at his flesh. But much of the pathos of this extraordinary work derives from the emphasis on the hand caught fast in the cleft of the tree. In the artist's preparatory drawing [51] the execution is so vehement and the forms so obscured by shadow that one would hardly have taken this to be a study for a marble sculpture.

51. Study for *Milo of Crotona, c. 1672*. Puget

Bernini's *David* was executed when the sculptor was not twenty-five years old. Rembrandt was of about the same age when in 1629 he painted *Judas Returning the Thirty Pieces of Silver* [52; cf. 53], a work of which Constantijn Huygens wrote that the greatest artists of antiquity could not have equalled the things 'that this young man, a Dutchman, a miller, a beardless boy, has done in summing up

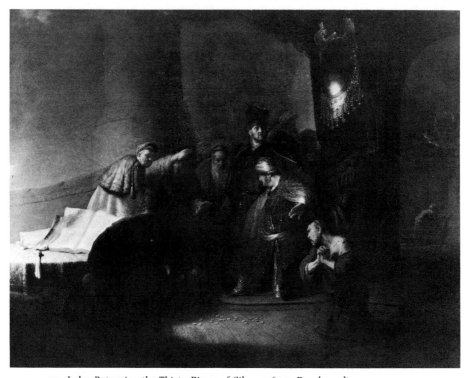

52. *Judas Returning the Thirty Pieces of Silver*, 1629. Rembrandt

53. *Man Wringing his hands*, 1634. Van Vliet

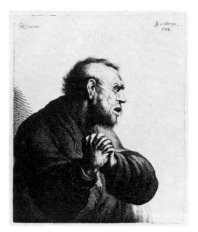

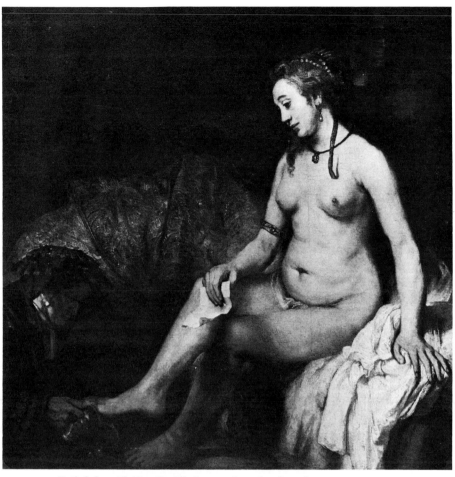

54. *Bathsheba with King David's Letter*, 1654. Rembrandt

varied emotions in one figure and depicting them as a single whole'.[4]
It is in fact one of the paradoxes of Rembrandt that this artist, whose
early reputation largely rested on his skill in rendering the most
violent emotions, should in time have rejected the imagery of turbu-
lence and outward show and instead begun to explore the innermost
recesses of the human psyche. In 1654, in his interpretation of the
biblical story of Bathsheba's adultery [54], Rembrandt goes so far as
to omit the figures both of King David spying upon the girl from the
roof of his palace and of the messenger who delivers the fateful letter.
In thus reducing the narrative elements of the episode almost to the
point of unintelligibility, the artist concentrates his attention upon
two persons – the old serving-maid drying her mistress's feet, who
knows nothing of what is taking place, and Bathsheba herself, who,
having read David's letter, sits pondering the decision that she must

make. To most artists this subject afforded an occasion for the sensuous display of an opulent female form. Rembrandt, however, though his *Bathsheba* is unquestionably one of the finest nudes in Baroque art, brings to light the tragic inner meaning of the story, so that we become conscious not only of the conflicting emotions in the young woman's mind but also of her psychological isolation – the loneliness that besets the individual at a moment of crisis.

The power of love resounds throughout Baroque art. Whether in erotic subjects from classical mythology, in Old Testament stories of lust and violence, or in genre scenes purporting to be from actual life, the relations between the sexes and the effects of carnal passion are represented with candour and insight. One thinks of Annibale Carracci's fresco of *Jupiter and Juno* on the Farnese ceiling [21], where, as if to illustrate love's universal sovereignty, the king of the gods is pictured gazing amorously into the eyes of his bride as he draws her into his embrace. Did Rubens recall this extraordinary work when he painted his *Venus and Adonis* [9]? The two lovers form a somewhat similar pyramidal group, and the melting look on Venus's face as she caresses the impatient Adonis bears some resemblance to the ardent expression of Carracci's Jupiter. The comparison must not be pressed too far, however, for Venus fears that Adonis, in leaving her, may be going to his death, and Rubens makes us aware that her feelings of love are mixed with anguish as she tearfully pleads with Adonis to remain.

The bourgeois counterpart to these loves of gods and heroes is the amusing *Oyster Breakfast* by Frans van Mieris [55]. A gallant gentleman, smiling confidently and placing his hand in mock sincerity upon his heart, proffers a plate of oysters to a young woman in négligé, whose silly expression shows that she has had too much to drink and has relaxed her guard. The inevitable outcome of this amorous exchange is broadly hinted at by the curtained bed behind the couple. 'Who,' asks Robert Burton in the *Anatomy of Melancholy* (1621), 'can reckon up the dotage, madness, servitude and blindness, the foolish phantasms and vanities of Lovers, their torments, wishes, idle attempts?'[5]

Telltale looks and gestures are not the only means by which feelings may be communicated; very often it is the utterly motionless, expressionless figure that lays bare the working of the soul. The repentant Magdalen in Georges de La Tour's painting [56] sits staring hypnotically at the lamp-flame, oblivious of the skull that she holds in her lap and of the books, scourge and cross lying on the table. The enclosing darkness, the silence and the utter stillness transmit with extraordinary clarity the state of mind of the penitent sinner. Even the secular world of Dutch genre painting can furnish some surprising

55. *The Oyster Breakfast*, 1661. Van Mieris the Elder

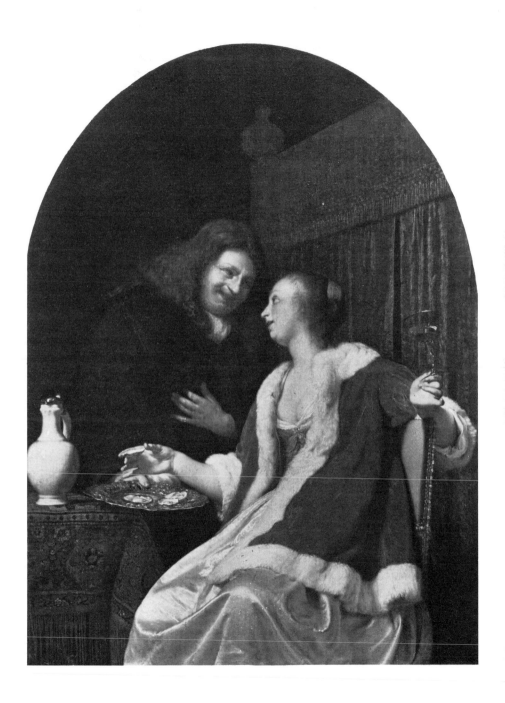

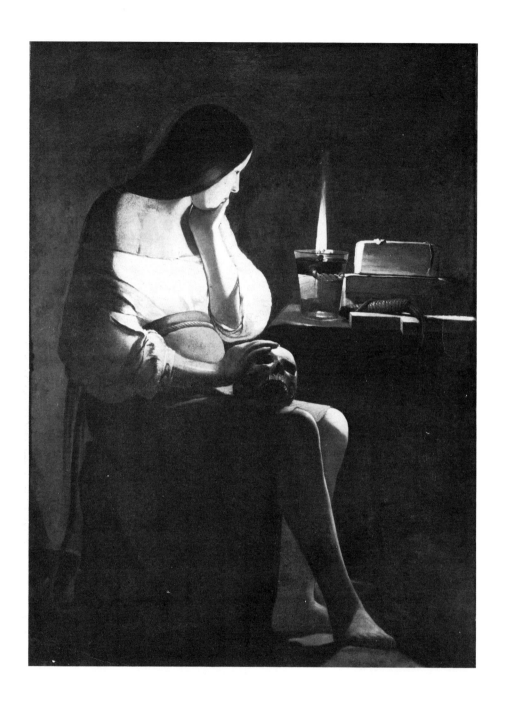

56. *St Mary Magdalene Meditating, c. 1636–8.* La Tour

insights of this kind. The so-called *Paternal Admonition* by Gerard ter Borch [57] appears in reality to be a scene in a brothel, where an officer, seated at a table beside a deceptively respectable procuress, holds up a gold coin which he is offering to the girl who stands

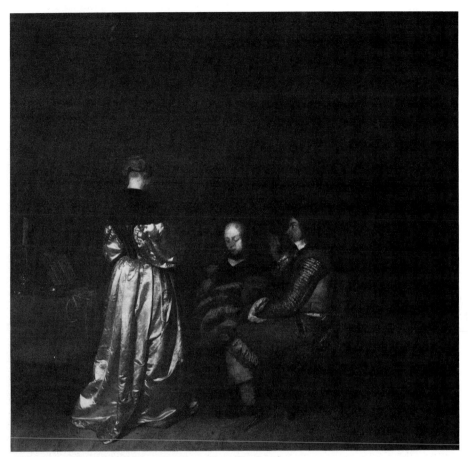

57. *'The Paternal Admonition'*, c. 1654. Ter Borch

motionless before them. The young woman's back is turned to us so that we see nothing of her face. Yet there is something in the lowered head and meekly folded arms of this beautiful figure that conveys an unmistakable sense of resignation and shame, and the gleaming brilliance of the satin dress seems only to make more pathetic the situation in which she finds herself.

THE DEMANDS OF HISTORY PAINTING

The Baroque multi-figured composition, which in Italy and France was regarded as the unrivalled medium for exhibiting the passions of

the soul, may be said to begin with Annibale Carracci's great canvas of 1595, *St Roch Distributing Alms* [58]. In this complex but beautifully ordered work, aptly described by Bellori as 'a perfect action of natural movements',[6] the artist sets forth the different responses of the poor and destitute to the unexpected charity of the saint. Since universality is one of the aims of this kind of history painting, Annibale is careful to include persons of all ages and to emphasize the presence of the strong as well as the weak and helpless. In the dense crowd of people pressing forward to catch the coins distributed by St Roch, an old woman with slippers and a stick turns her head to scowl at a young man carrying a child who attempts to push her aside, and a blind musician clutching his violin places one hand on the shoulder of a boy

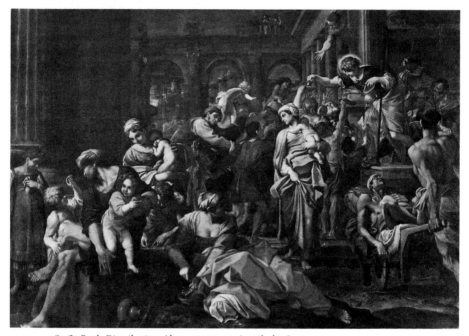

58. *St Roch Distributing Alms*, 1594–5. Annibale Carracci

who acts as his guide. Directly beneath the saint a sick man, pale and haggard, is brought to the scene in a wheelbarrow pushed by a muscular athlete (Fig. 4, p. 321). The stable triangle of figures at the left is made up of the fortunate ones who have already received alms; the boy in the middle who is busily counting his coins might almost be taken as an anticipation of the avaricious youth in Caravaggio's *Calling of St Matthew* [34].

Carracci's skill in the rendering of the *affetti* on a grand scale was not lost upon Rubens, whose *Miracles of St Francis Xavier*, painted about 1616–17 for the high altar of the Jesuit Church in Antwerp, is

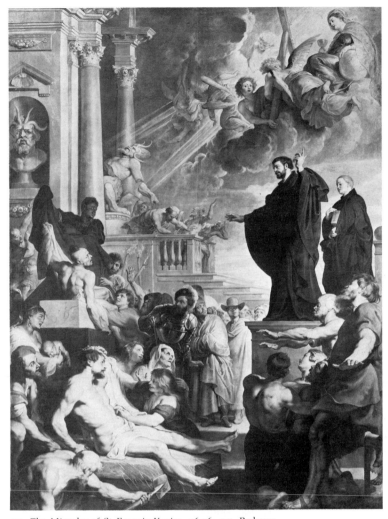

59. *The Miracles of St Francis Xavier,* 1616–17. Rubens

charged with even greater energy and passion [59]. The wave of
emotion built up by the surging crowd serves only to intensify the
feelings of terror, amazement, hope and joy that may be read in the
faces and actions of the sufferers and onlookers. Dominating over this
scene of turmoil is the serene and commanding figure of Francis
Xavier, whose divine powers are made manifest by the celestial
apparition above his head. Rubens took the problem of expression
seriously enough to set down some detailed notes on the subject. We
learn from Roger de Piles (1677) that amongst the papers left by the
artist there was 'a very curious study of the principal passions of the

soul and of actions drawn from the descriptions of the poets, with appropriate illustrations in pen after the best masters, especially Raphael'. These drawings included 'battles, tempests, recreations, love scenes, tortures, various deaths and other similar passions and occurrences'.[7]

The Stoical severity and reflective cast of mind of Nicolas Poussin might seem to have precluded any concern on his part with the emotions. Yet no master of Baroque history painting gave closer attention to the problems of psychological interpretation. His rational approach to narrative was very well suited to a precise exposition of human actions and feelings. Poussin himself remarked, in a conversation with Félibien: 'Just as the twenty-four letters of the alphabet serve to form our words and to express our thoughts, so do the lineaments of the human body serve to express the various passions of the soul and to make outwardly visible what is in the mind.'[8] In employing facial expression and gesture to convey his meaning in the most unequivocal fashion, Poussin was not only following the methods of Leonardo, Raphael and Carracci; he was also adapting to painting the technique of the ancient rhetoricians, who defined persuasion as the proper business of the orator. There is a passage in Poussin's notes on painting that is taken almost verbatim from the *Institutio oratoria* of Quintilian:

Of action. There are two instruments which affect the souls of the listeners, action and diction. The first is so valuable and efficacious in itself that Demosthenes gave it first place over all the other devices of rhetoric, and Marcus Tullius [Cicero] calls it the language of the body. Quintilian attributes such strength and such power to it that he regards conceits, proofs and effects as useless without it. And without it lines and colour are likewise useless.[9]

The mention of 'lines and colour' is especially revealing, for it shows that Poussin was seriously endeavouring to apply the theory of rhetoric to the practice of painting. This was plainly his intention in *The Israelites Gathering the Manna* [60], concerning which he wrote to his friend, the painter Jacques Stella:

I have found a certain distribution . . . and certain natural attitudes, which show the misery and hunger to which the Jewish people have been reduced, and also the joy and happiness which have come over them, the astonishment which has struck them, and the respect and veneration which they feel for their law-giver, with a variety of women, children and men, of different ages and temperaments, things which will not, I believe, be displeasing to those who know how to read them.[10]

The painting is, in fact, to be read like a book. The narrative begins, as the artist himself indicates, at the left side, where the Israelites have not yet realized that the lifegiving manna has fallen and where a

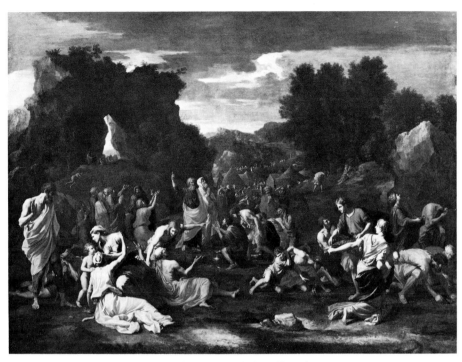

60. *The Israelites Gathering the Manna*, 1638–9. Poussin

young woman pushes her child aside in order to give her breast to her famished mother, while a man beholds this act of filial piety with astonishment [61]. As we follow the action across the canvas, we see

61. Detail of 60

other figures greedily gathering the precious food and two boys fight-
ing over a jar of manna, which in their excitement they have over-
turned. Only in the centre, where Moses and Aaron stand – the one
pointing to heaven and the other with hands clasped in prayer – do
the people kneel in attitudes of reverence and thanksgiving.

THE PASSIONS SYSTEMATIZED

The interest in psychological interpretation shown by many Baroque
artists received a kind of scientific sanction when Descartes published
his *Treatise on the Passions of the Soul* in 1649. This work was probably
not known to Poussin – though he would certainly have approved of
the philosopher's rational analysis of the subject – but it was assidu-
ously studied by Charles Le Brun. Its influence, together with that of
Poussin, is clearly perceptible in *The Queens of Persia at the Feet of*

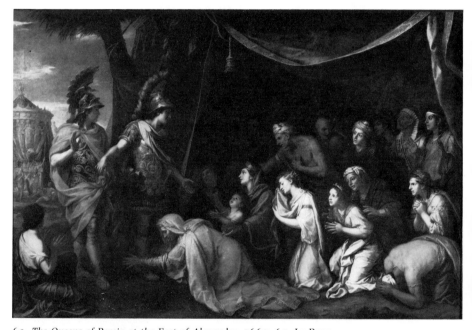

62. *The Queens of Persia at the Feet of Alexander*, 1660–61. Le Brun

Alexander, painted by Le Brun for Louis XIV in 1661 [62]. After the
defeat of Darius at the Battle of Issus, the family of the Persian king
fell into the hands of the victorious Alexander the Great, who treated
them with the utmost kindness and respect. The picture illustrates
the moment when Sisygambis, the mother of Darius, having mistaken
Hephaestion for Alexander, kneels at the feet of the Conqueror and
begs his pardon, while her daughter and other members of the royal
household look on with apprehension.

In the figure of Alexander, who was of course understood to signify Louis himself, Le Brun has attempted the impossible. For it was his intention, as Félibien confirms, to make visible through the actions of the prince not only his youth, gentleness, valour and the like, but four different and concurrent affections: his *compassion* for the Persian princesses, as revealed by his look and countenance; his *clemency*, as indicated by the gesture of his open hand; his *friendship* for Hephaestion, which is expressed through the placing of his other hand on his companion; and the *civility* that he shows to his royal captives by standing with one leg drawn back. 'The painter does not make him bow more deeply,' Félibien explains, 'because he has represented him at the moment when he approaches the ladies; because this was not a custom of the Greeks; and finally because Alexander could not bend much, for the reason that in the last battle he had been wounded in the thigh.'[11]

63A, B. *Hope* and *Fear*, from Le Brun's *Conférence sur l'expression* (1698)

Le Brun's close reading of Descartes is especially evident in the group of persons comprising the family of Darius and their attendants, where he has sought to analyse a variety of emotional reactions, ranging from sorrow to astonishment. Some of the figures from this work were, in fact, repeated by Le Brun in the illustrations for his famous lecture on expression, delivered some years later at the Royal Academy of Painting and Sculpture, which was openly modelled on Descartes's treatise and in which he attempted to reduce the rendering

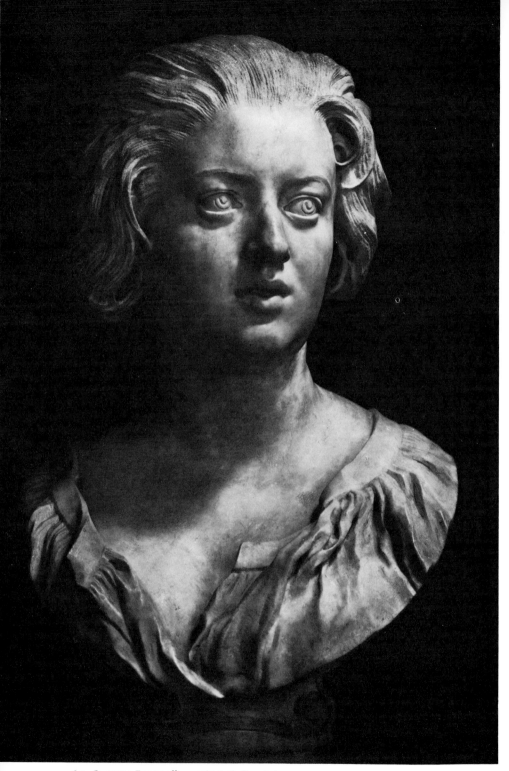

64. *Costanza Buonarelli, c.* 1635–6. Bernini

of the emotions to a systematic catalogue. Amongst these illustrations, which were engraved from Le Brun's designs for the published edition of 1698. the types of 'hope' and 'fear' [63A, B] can be seen to be copied from two of the kneeling princesses in the right-hand section of the painting. Le Brun's description of these emotions is based directly on the Cartesian system of paired opposites, in which hope is defined as 'a disposition of the soul to persuade itself that what it desires will come to pass', whereas 'fear is another disposition of the soul which persuades it that this will not happen'.[12] 'The Motion of Fear', Le Brun writes, 'is expressed by the Eye-brow a little raised next the Nose, the Eye-ball sparkling in an unquiet Motion, and situated in the middle of the Eye; the Mouth open, being drawn back, and more open at the Corners, than in the middle, having the under Lip more drawn back than the upper; the Complexion redder than even in Love or Desire, but not so beautiful, inclining to livid, with the Lips of the same Colour and dry.'[13]

PORTRAITURE

Verisimilitude — the semblance of reality — is an essential ingredient in Baroque portraiture. But that fundamental naturalism does not suffice to explain what might be called the sense of presence imparted by the greatest portraits of the seventeenth century. We are not concerned here with such superbly autocratic images as Bernini's marble bust of Louis XIV [108], with the subtle flattery and grace of Van Dyck's portraits of Charles I, nor with the stiff and ceremonial restraint of Velazquez's portraits of Philip IV. In these and other royal portraits the Baroque urge to explore the inner man was effectively thwarted. Majesty, lying beyond the reach of ordinary mortals, was in this respect inhibiting, and the seventeenth-century aristocratic portrait became all too often the image of vanity and power.

It was generally when he was confronted by commoners, whether rich or poor, that the Baroque artist was able to penetrate the mask of mere outward appearance. One thinks at once of Bernini's astonishing portrait bust of *Costanza Buonarelli* [64]. Here there is no barrier between the subject and the observer, and the impact of the young woman's sensual vitality is almost overpowering. Rubens created a more modest but no less striking image of youthful vivacity in his portrait of Susanna Fourment, the so-called *Chapeau de Paille* [65], in which the very large eyes (the windows of the soul) heighten the sense of psychological contact. As to Velazquez, it does not diminish the stature of this great court artist to say that he painted some of his most sympathetic and revealing portraits when he was freed from the stifling restrictions of Spanish court ceremonial. Looking at the

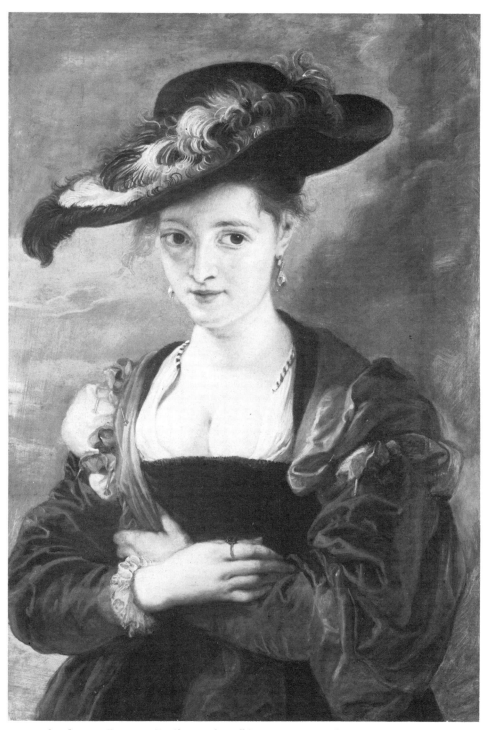

65. *Susanna Fourment (Le Chapeau de Paille), c.* 1620–25. Rubens

portrait of his assistant, *Juan de Pareja* [66], we are struck by its directness and immediacy, and we are conscious too that the proud and dignified bearing of the sitter has nothing to do with courtly arrogance but is one of the marks of his individuality.

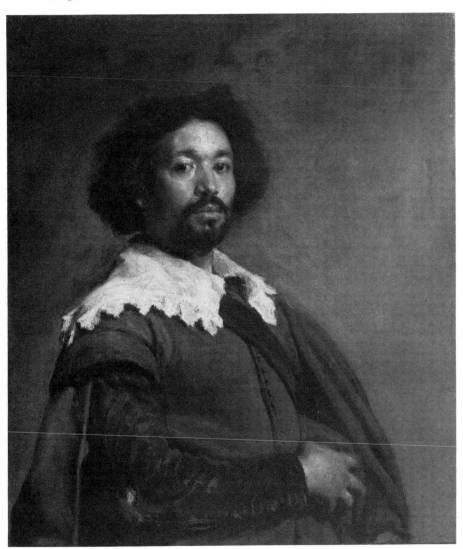

66. *Juan de Pareja*, 1649–50. Velazquez

The bourgeois society of the Dutch Republic produced, in Frans Hals and Rembrandt, two of the supreme portraitists of the Baroque era. The matchless technical resources of Hals are perfectly adapted to express the confident mood of Holland in the earlier years of the seventeenth century: the dash and exuberance of his *Laughing*

Cavalier, or of the officers in his Militia Companies, are immeasurably heightened by the skilfully obtrusive brushwork, which seems to sparkle and crackle in its spontaneity. It is true that these works, in which the artist seeks to give a purely momentary impression, are not notable for their psychological depth. Yet it did not lie beyond Hals's powers to enter into the inner life of his subjects, as he showed in that extraordinary group portrait of the last years, *The Women Regents of the Old Men's Home* [67]. The penetrating characterization of these

67. *The Women Regents of the Old Men's Home, c.* 1664. Hals

stern and unsmiling women, overtaken (like the painter himself) by old age and decline, is deeply moving [68].

Rembrandt, in whose work portraits form the largest category, went far beyond any of his contemporaries in expanding the subjective range of portraiture. After 1640 it was chiefly the activity of the mind that he set himself to encompass, in portraits as in history painting. In the etching of the Mennonite preacher Cornelis Anslo, of 1641 [69], Rembrandt seeks to achieve a 'speaking likeness'. Seated at his desk with one hand holding a pen and resting on a book, Anslo gestures with the other towards the Bible propped before him and turns his head as he addresses an unseen listener. That Rembrandt is appealing to our sense of hearing as well as of sight is confirmed by the verses written by the poet Vondel in connection with this very portrait:

68. Detail of 67

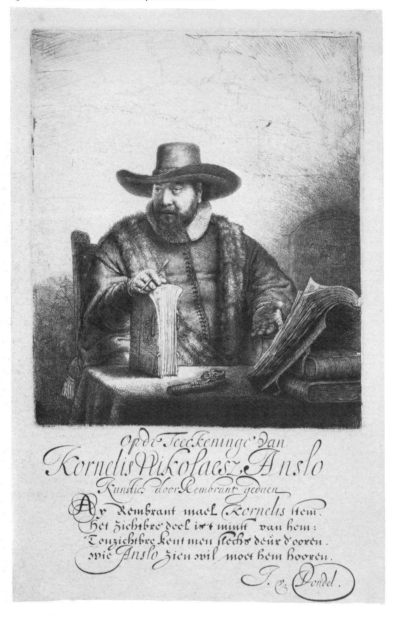

O, Rembrandt, paint Cornelis' voice.
The visible part is the least of him:
The invisible one learns only through the ears.
He who would see Anslo must hear him.[14]

The famous portrait of Jan Six [70] represents, on a purely descriptive level, a dignified citizen who may be assumed, because he has put

on his hat, has thrown his cloak over one shoulder and is drawing on
his gloves, to be about to go out. But these trivial actions, performed
so abstractedly, are of importance only in that they contribute to the

70. *Jan Six*, 1654. Rembrandt

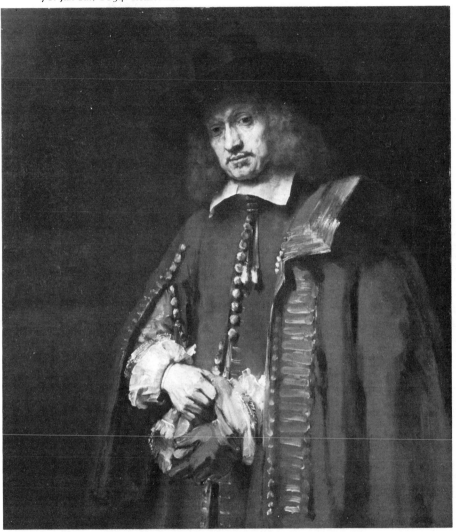

dominant impression of a man wrapped in thought. This impression
is of course established first of all by the attitude and the facial
expression: the head slightly inclined, the mouth and lowered eyes
suggesting a state of preoccupation. But it is the subtle play of light
and shade round the face that does most to evoke a mysterious aura
of consciousness. We are aware, as in the *Bathsheba* [54], of a mind
full of thoughts and reflections.

71. *Gabriele Fonseca, 1668–c. 1675.* Bernini

It is with something of a jolt that one turns from these portraits of sober Dutch Protestants to the unreserved emotionalism of Bernini's last portrait, the *Gabriele Fonseca* [71]. This is not, it should be noted, a wholly independent work of art but a sculptured bust forming part of the decoration of a chapel in the Roman church of S. Lorenzo in Lucina. The strongly individualized features may leave no doubt in our minds that this is indeed a faithful likeness of the subject. Yet there is also present a quality of psychic disturbance that takes the work quite out of the category of pure portraiture and translates it into that of religious ecstasy. The vehemence of the facial expression, the tormented clenching of the hands and the strained posture of the body within its confining niche reveal in the most vivid and astonishing fashion the state of mind of one who is consumed by the ardour of divine love.

We must not leave the subject of portraiture without recollecting that caricature, in the modern sense of comic exaggeration of physiognomic traits, was born at the same moment as Baroque art itself. For it has been shown that both the name and the practice of caricature were invented by Annibale Carracci and his circle in the last decade of the sixteenth century. Portrait caricatures were made by some of the most exalted artists of the Italian Baroque, amongst them Bernini [72]. Slight and hastily executed though such drawings are, it remains true that they spring from the same sympathetic feeling for human individuality that informs his most inspired works of portrait sculpture.

72. *Cassiano dal Pozzo.* Bernini

73. *The Vision of St Francis, c.* 1597–8. Annibale Carracci

VISION AND ECSTASY

The representation of the mystical experience is a recurrent theme in Baroque devotional iconography. One of the most typical forms of Catholic ecclesiastical art of this period is the altarpiece depicting, in intensely emotional fashion, a saint in a state of trance, wholly overcome by the awful presence of the divine. It is not enough to ascribe these mystical visions to the teachings of the Catholic Counter-Reformation: for the Mannerist art of the period following the Council of Trent, when the attitude of the Church was austere and even iconoclastic, produced nothing comparable to them. The phenomenon that we are concerned with here arose only during the later phase of the Counter-Reformation – the more realistic, more emotional phase

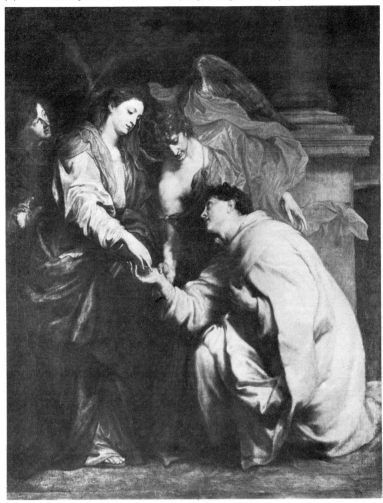

that began, like the Baroque itself, in the last years of the sixteenth century. Yet we may also feel that Baroque ecstasies were not motivated solely by religious sensibilities, but that artists perceived in these subjects, over and above their specifically devotional purpose, an opportunity to explore the psychology of mysticism, and that they brought to this task, following the example of the ancient rhetoricians, a practical knowledge of the art, or technique, of persuasion.[15]

The anticipatory role of Annibale Carracci in this, as in other Baroque developments, may be exemplified by his *Vision of St Francis* [73], in which an angel acts as intermediary between the saint and the miraculous apparition of the Madonna and Child. The artist's indebtedness to the effusive sentiment of Correggio is obvious. Yet

the intensity of feeling conveyed by the face and attitude of St Francis, as he kneels in rapture before the Virgin, illuminates in a wholly new manner the meaning of mystical surrender and belongs without question to the affective vocabulary of the Baroque.

A generation later, Van Dyck adopts a similar iconography, and a similarly heightened emotionalism, for his *Vision of the Blessed Herman Joseph* [74]. Guided and encouraged by an angel, the monk gazes with ardour and longing at the Virgin, who places a ring in his hand as a sign of mystic marriage and divine love.

Now divine love, as the Baroque artist interprets it, shares something (at least in its outward manifestation) with its earthly counterpart, and it is an inevitable consequence that many representations of ecstatic visions contain more than a suggestion of a sublimated erotic experience. This certainly applies to Giovanni Lanfranco's brilliant *Ecstasy of St Margaret of Cortona*, of about 1620 [75]. The excited

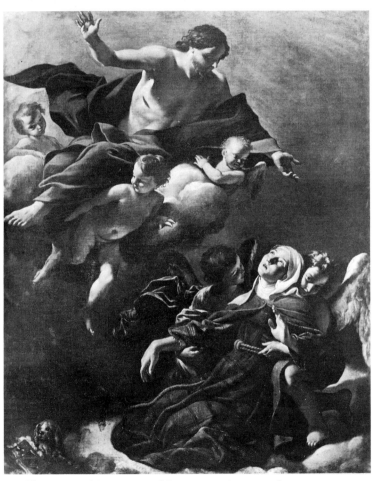

75. *The Ecstasy of St Margaret of Cortona*, 1618–20. Lanfranco

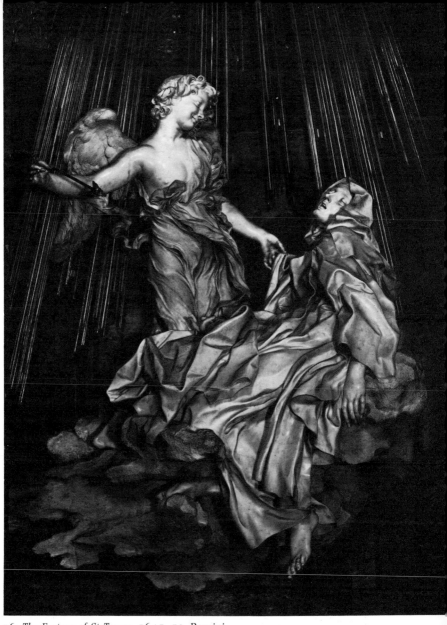

76. *The Ecstasy of St Teresa,* 1645–52. Bernini

movement of the rumpled draperies and the swift, flickering play of light and dark tell of the vehement emotions that have overwhelmed the nun in her trance-like state. The expressive potentialities suggested by Lanfranco's painting were to be fully realized by Bernini in his *Ecstasy of St Teresa* of about 1650 [76]. The sculptor has followed with remarkable fidelity the account of the vision written by the great Spanish mystic herself, in which she describes the angel who thrust a golden spear into her heart, leaving her 'all on fire with a great love of God'.[16] The collapsed attitude of the saint, the turbulent agitation

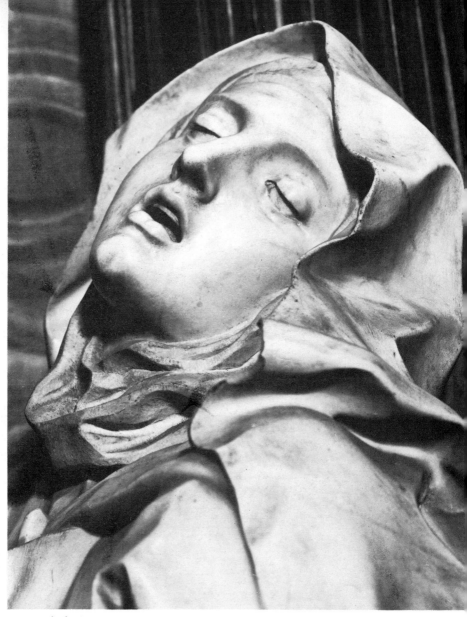

77. Detail of 76

of her garment and the passionate expression of the face – the mouth open as if moaning – unite to produce an unforgettable image of bodily and spiritual transport [77]. No other artist has succeeded in thus crystallizing in concrete form the whole range of the ecstatic experience – the mystic's sense of withdrawal from the world, the alternating states of pleasure and pain, the expansion of the self that comes through union with the divine. And all of this is rendered with a realism that goes beyond mere virtuosity to bring what is limitless and incomprehensible into the realm of the visible and tangible.

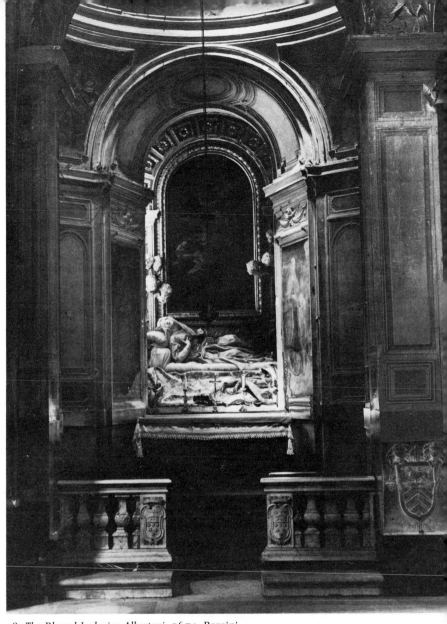

78. *The Blessed Ludovica Albertoni*, 1674. Bernini

Bernini's capacity to achieve a fusion of opposites – pleasure and pain, the temporal and the infinite, the pictorial and the sculptural – is employed even more imaginatively in *The Blessed Ludovica Albertoni*, a work of the master's last years [78]. For what we witness in this extraordinary sculpture is the death agony of the Blessed Ludovica, with which is mingled joyful anticipation of everlasting life [79]. Bernini was thus able to realize, through insight and sheer intuition, that blend of passions that Le Brun vainly laboured to suggest in his *Alexander* [62] by means of a systematic study of expression.

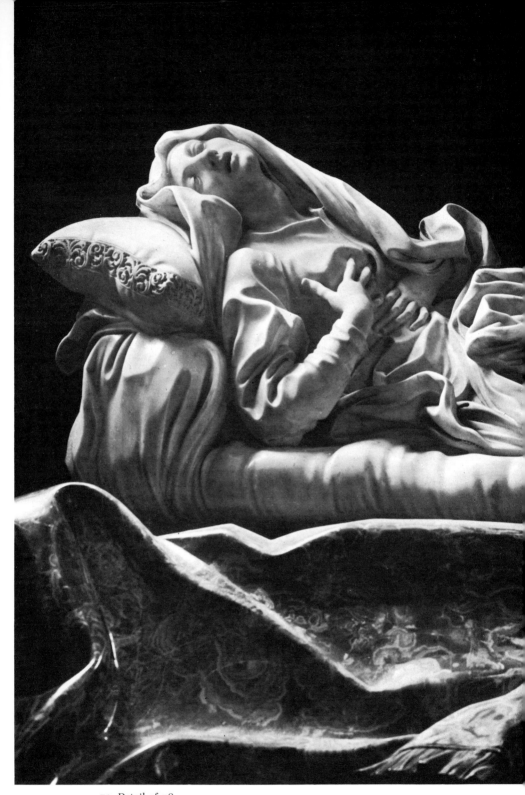

79. Detail of 78

Among the most extraordinary images of mystical rapture is Pierre Puget's statue of *The Blessed Alessandro Sauli* [80], who was venerated for his good works during the plague of 1580. The tall figure, enveloped in a bishop's cope, is drawn upwards in a spiral movement that seems to carry him out of the material world into an ethereal realm. His attributes, a book to signify his learning and a jar full of coins as a sign of his charity, lie neglected at his feet. While an infant angel supports the crosier which has slipped from his grasp, Sauli lifts his hand in a passionate appeal to heaven and turns his face up

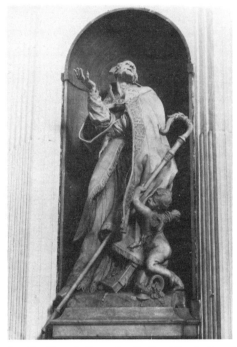

80. *The Blessed Alessandro Sauli*, 1665–8. Puget

to the light with a look of unutterable longing, throwing his head back so sharply that the episcopal mitre is almost lost to sight.

MARTYRDOM

The great Counter-Reformation subjects of death and martyrdom, which in the sixteenth century enjoyed special favour as examples to be held up to the devout, became from the first moments of the Baroque a vehicle for the portrayal of extreme states of feeling. We may illustrate this by considering the representation of episodes from the passion and death of Christ. It is worth noting, for example, that the differences that may be thought to exist between the classicism of

Annibale Carracci's *Pietà* in Naples and the naturalism of Caravaggio's
Entombment of Christ in the Vatican are in the end submerged in the
preponderant pathos that the two works have in common.

Rubens's epic *Raising of the Cross* [81] sounds the full diapason of
tragic emotions. In the central panel, the helplessness of the victim,
whose hands and feet are already nailed to the cross and whose face
is turned heavenwards with a look of both anguish and submission,
is effectively contrasted with the brutal energy of the soldiers struggling
to heave the cross, with its living burden, into an upright position.

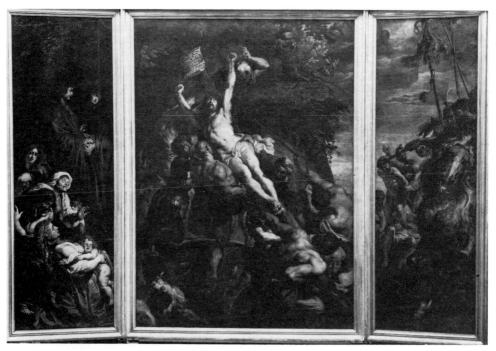

81. *The Raising of the Cross*, 1610–11. Rubens

The grand spectacle of Christ's sacrifice is completed by the wings of
the triptych, showing on one side the cold, military efficiency of the
Roman commander who directs the operation and on the other the
sorrowful reactions, ranging from mute grief to terror, of the followers
of Christ.

The *Raising of the Cross* sums up the special character and emphasis
of the Baroque scene of martyrdom. The faith and heroism of those
who remained steadfast in the face of torture and death are not less
honoured; but to the desire to glorify the martyr is joined a deepened
interest in the psychology of pain and suffering. The unspeakable
agony of dismemberment, the cruelty (or, what is even worse, the
callous indifference) of the executioners, the shock and horror felt by

the onlookers, these things are given particular prominence in seventeenth-century martyrdoms.

The same juxtaposition of heroic fortitude and bloodthirsty cruelty characterizes Ribera's *Martyrdom of St Bartholomew* [82]. His torturers have tied the saint's wrists to a cross-bar and are vigorously pulling at ropes to hoist him into a vertical position. Seen thus, with face upturned and arms pinioned above his head, the martyr's posture resembles that of Christ being raised on his cross [81]. To the racking

82. *The Martyrdom of St Bartholomew, c.* 1638. Ribera

pain endured by the victim is added the agony of suspense, for it is obvious that the bystanders at the right, who are leering at the defenceless naked body of the saint, are eager to begin their grisly work of stripping off his skin. Van Dyck builds up a similar pathos in his interpretations of the martyrdom of St Sebastian (Paris, Louvre and

83. *The Martyrdom of St Lieven, c.* 1633. Rubens

Munich, Alte Pinakothek). Instead of representing the saint transfixed by arrows – the traditional iconography – Van Dyck fastens upon the tense and harrowing moment when the nude victim, knowing fully what is in store for him, is prepared for execution by being bound to a tree by bullying soldiers. [17]

The many scenes of cruelty and bloodshed in Baroque religious art remind us, however, that it was not only the expectation of torture that caught the imagination of artists and patrons. In his drawing of *St Bartholomew* [15], Guercino shows the executioners flaying the skin from their victim with knives. Poussin, in his *Martyrdom of St Erasmus* (Rome, Vatican), did not flinch from representing the saint's intestines being wound out on a windlass, and the torturer in Jordaens's *Martyrdom of St Apollonia* (Antwerp, Augustijnenkerk) wrenches out the heroine's teeth with pincers. But these works pale beside the furious martyrdoms of Rubens's last years – the *Crucifixion of St Peter* in Cologne, the *Crucifixion of St Andrew* in Madrid, the *Death of St Thomas* in Prague, and (the most violent and terrible of all) the *Martyrdom of St Lieven* in Brussels [83]. Legend tells that Lieven, Bishop of Ghent, was murdered by bandits who tore out his tongue and threw it to the dogs. The hideous act is transfigured by the pictorial splendour, the blazing colour and the tempestuous movement of the composition, so that the death agony of the saint seems almost to approach the exalted state of mystical ecstasy. And indeed it is generally true of the saints in these and other Baroque martyrdoms that, like the great mystics, they have achieved a union with God which transports them beyond the world of mortal suffering and enables them to bear their torments unflinchingly.

ARCHITECTURE

The Baroque concept of art as persuasion was applied to architecture as well as to the figurative arts. Who, looking at the great façade of S. Agnese in Piazza Navona, or that of S. Maria in Campitelli, will deny that the authors of these churches understood the power of architecture to move the soul of the beholder? Borromini disposes the forms of S. Agnese [84] in a grand antiphonal relationship, the recessive movement towards the central portal being answered by the powerful convex mass of the dome, which seems also to assert its authority over the towers at the flanks. The façade of S. Maria in Campitelli, by Carlo Rainaldi [86], achieves its effect through boldly projecting forms and a thrusting verticality: monumental columnar screens appear to have been set one in front of the other, and the massive reiterated pediments jut forward into space in a manner that is at once majestic and inviting.

84. S. Agnese in Piazza Navona, Rome, 1653–5. Borromini.

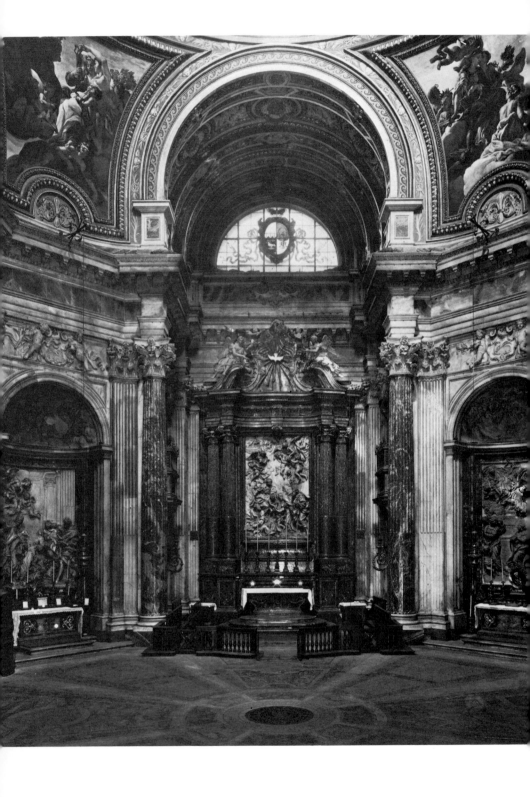

The interiors of these two churches, though very different, are
designed to produce an even more intense emotional response in the
observer. S. Agnese, built for Pope Innocent X and the Pamphili family,
appropriately presents a spectacle of magnificence and colour [85,
85A]; the provocative space that opens beneath the towering cupola is
decorated with a profusion of marble reliefs, gilt stuccoes and frescoes.

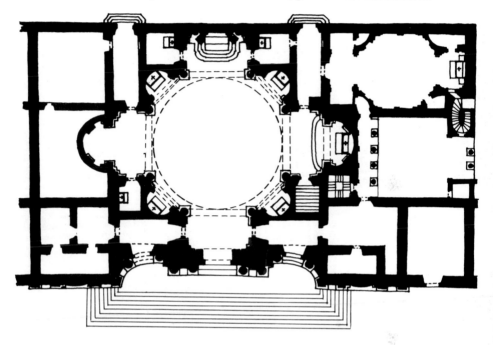

85 and 85A. S. Agnese in Piazza Navona, interior and plan.

86. S. Maria in Campitelli, Rome, 1663–7. Rainaldi

S. Maria in Campitelli, on the other hand, was erected as a votive
church to celebrate the end of the plague of 1656, and it is therefore
fitting that it should create an atmosphere redolent of mystery and
drama [87, 87A]. To the visitor standing within the church, the vast,
half-shadowed space of the nave seems to be progressively narrowed
by groups of columns so as to direct his attention to the luminous
area of the sanctuary, which receives its light from the dome. And
beyond that lies the suddenly darkened apse with a venerated image
of the Virgin Mary, to which was attributed the miraculous cessation

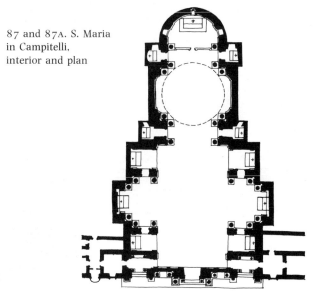

87 and 87A. S. Maria
in Campitelli,
interior and plan

of the plague. It is almost as if the creators of these Baroque interiors were consciously trying to conform to the recommendation of the theologian Joannes Molanus, who wrote in 1594: 'Let the Christian think, when he enters the temple, that he is entering a kind of heaven on earth, where God fills the whole edifice.'[18]

Baroque architecture was brought to its highest emotional pitch in Spain and southern Germany in the eighteenth century. There is something positively hallucinatory in the excesses of the Transparente in Toledo Cathedral [195]. A similar sensationalism fills the Bavarian churches of the brothers Asam. In the interior of the abbey church at Weltenburg [88] spatial illusionism and dramatic lighting are all-important. The inner dome that crowns the oval nave is cut off so that one looks through it to a higher painted ceiling, which receives its light from concealed windows. But the most extravagant illusion is reserved for the high altar within its darkened chancel, where St George on horseback, all in shining silver, rides through a light-filled archway to slay the dragon and rescue the princess. It is a gorgeous spectacle, and one that is calculated to raise the religious passions of the worshipper to new heights of ardour and excitement.

88. The Abbey Church, Weltenburg, 1717–21. Asam

4

Before the knowledge of letters
God was known by Hieroglyphicks:
And, indeed, what are the Heavens,
the Earth, nay every Creature,
but Hieroglyphicks *and* Emblemes *of His Glory?*

Francis Quarles, *Emblemes* (1635)

The Transcendental View of Reality and the Allegorical Tradition

In insisting on the importance of Baroque naturalism we must guard against oversimplification. We shall gain only a one-sided and distorted view of the Baroque if we confuse the realism of the seventeenth century with that of the nineteenth. The gulf between Velazquez and Manet is fully as wide as that which separates Descartes and Darwin.

What must be taken into account in any consideration of the Baroque is the equilibrium of the secular and the religious. The naturalism of seventeenth-century art is inextricably bound up with a metaphysical view of the world. It is for this reason that the familiar objects of visible reality may be looked on as emblems of a higher, *invisible* reality. But that transcendent world can in turn only be apprehended through the faithful rendering of things seen. In this sense, naturalism may even be said to play an ancillary role, its function being to reveal the spiritual through the medium of the senses.

This attitude, it is hardly necessary to say, was not peculiar to artists. Many of the leading scientists of the seventeenth century entertained mystical notions about the physical universe which they were seeking to describe in mathematical terms. Johannes Kepler, the

great astronomer whose three planetary laws provided essential corrections to the Copernican hypothesis, was nevertheless capable of seeing in the relation between planetary periods and distances an illustration of the music of the spheres; and it was this same allegorico–naturalistic approach that led him to interpret the sun, the fixed stars and the planets as symbols of God the Father, the Son and the Holy Spirit.[1] Descartes, the 'founder of modern philosophy', was firmly convinced that the decision to devote his life to mathematical and philosophical studies was the result of a visionary experience in his youth, an experience very like that of mystical ecstasy. In the course of this vision, which occurred on the night of 10 November 1619 (a date that Descartes never forgot), illumination came to him from 'the spirit of truth'.[2] The study of anatomy, even after Harvey's discovery of the circulation of the blood (1628), was still coloured by theological ideas. In his *Religio Medici* (1643) Sir Thomas Browne spoke for many of his fellow physicians when he wrote that 'sometimes and in some things there appears to mee as much divinity in Galen his Booke *De usu partium*, as in Suarez *Metaphysicks*'.[3] The anatomical theatre at Leiden [89], where Browne had studied medicine, was established in what had formerly been a convent chapel, and the numerous skeletons of men and animals that were displayed there plainly served a religious and moralizing purpose as well as a didactic and scientific one. Two skeletons standing on either side of a tree

89. *The Anatomical Theatre at Leiden*, 1610. Swanenburgh after Woudanus

represented Adam and Eve, through whose sin death came to man-
kind; others held banners with Latin mottoes intended to remind the
visitor of the transience and vanity of earthly life. It was in this setting
that dissections were performed by Dr Pieter Paauw, the chief
anatomist of Leiden.

The allegorical habit of mind was too deeply ingrained in the intel-
lectual life of the seventeenth century to be quickly dislodged by the
rigorous objectivity of science. The inveterate disposition to look for
symbolic meanings in nature and art goes far to explain the vogue of
the emblem book and the iconological handbook. The typical emblem
book, following the pattern established by Andrea Alciati's *Emblematum
Liber* of 1531, is a compilation of witty conceits and symbols designed
to appeal to a cultivated élite. Each emblem consists of a motto, a
picture and an epigram. In the seventeenth century there is hardly
any aspect of life that is not treated by the emblem-writers; the
hundreds of emblem books produced in Italy, France, Spain, Germany,
England and the Netherlands cover an astonishing range of subjects,
including politics, religion, morals and love (both sacred and profane)
[183]. In spite of their frequently esoteric and precious character,
they left their mark on the art and literature of the Baroque. More
directly concerned with the problem of allegorical imagery is the
Iconologia of Cesare Ripa, first published at Rome in 1593 and re-
printed time and again thereafter. This great illustrated dictionary of
symbols, attributes and personifications, set out in alphabetical
order, was consulted by artists and writers for nearly two hundred
years and obviously satisfied a deeply felt need for an allegorical mode
of communication. Even today it remains 'the key to the painted and
sculptural allegories of the seventeenth and eighteenth centuries'.[4] If
we wish to know, for example, why Bernini represented his statue of
Truth as he did [26], we may find the explanation in Ripa: Truth, he
says, is personified as 'a beautiful nude woman, holding in her right
hand the Sun, at which she gazes, and under her foot is the globe of
the world. She is pictured nude to show that simplicity is natural to
her. She holds the sun to indicate that truth is the friend of light . . .
and the world under her foot denotes that she is above all worldly
things'.[5]

CLASSICAL SUBJECTS

The world of classical antiquity, as reintegrated by the humanistic
learning of the sixteenth century, continued to serve in the Baroque
period as a universal vehicle of allegory, sometimes in a relatively
pure and unadulterated form, but more often with an admixture of
modern motifs and allusions. In *The Four Continents* [90] Rubens

90. *The Four Continents, c.* 1615. Rubens

adheres in the main to the iconography of the ancient past: both the female figures (personifying the continents of Europe, Asia, Africa and America) and their male companions (the river gods Danube, Ganges, Nile and Rio de la Plata) are obviously derived from the figurative repertory of Graeco-Roman art. But the allegory is brought sharply to life through the sensuous vitality and tensed energy of these heroic forms. Rubens's feeling for reality extends even to the animals, which, though their role as 'attributes' of Nile and Ganges is primarily symbolic, are given a prominent place in the foreground of the scene, where three fearless *putti* seek to reconcile the monstrous crocodile to the snarling tigress with her cubs. Despite its many 'Antique' features, the work clearly belongs to an age of exploration and discovery. America, it will be noticed, occupies a dim and shadowy place in the background: even after a century of Spanish colonization the New World remains a largely unknown region. Sir Thomas Browne, writing in 1646, can still speak metaphorically of 'the America and untravelled parts of truth'.[6]

The classical style of Poussin may delude us into believing that this artist was wholly submissive to the authority of the Antique, whereas

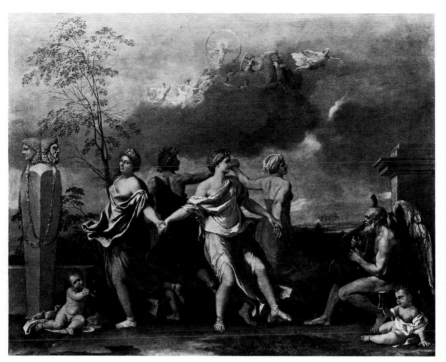

91. *The Dance of Human Life*, c. 1638–40. Poussin

he was in fact always ready to use the vocabulary of pagan mythology to give expression to ideas current in his own time, especially those having to do with human transience. After the exuberant sensuousness of Rubens's allegory, Poussin's *Dance of Human Life* [91] looks rather frigid and severe. But there is feeling in Poussin too, though it often lies concealed beneath a surface of deliberate philosophical calm. The theme of this work is the impermanence and instability not of man alone but of civilizations. Four maidens, whose dress and attributes identify them as personifications of Poverty, Labour, Wealth and Luxury, dance in an unending cycle (like that of the seasons) to the music of Time, the inexorable rhythmic movement of which is also symbolized by the course of the Sun in his chariot across the sky. The children with hour-glass and soap-bubbles signify the brevity and fragility of mortal life.

In *The Fable of Arachne* [92] Velazquez, making one of his few incursions into the realm of pagan mythology, produced an intricate and enigmatic allegory, the full meaning of which is still not perfectly apprehended. Reality and myth are so interfused in this work that we can easily understand why it was long believed to be a genre picture

showing the visit of three ladies to the tapestry workshop of Santa Isabel in Madrid and hence came to be called *The Weavers* ('Las Hilanderas'). Only within recent years has the subject been correctly interpreted as mythological. Arachne, having dared to compete in a weaving contest with Pallas Athene, recklessly chose to represent the scandalous loves of Jupiter and was at length punished for her temerity in challenging the goddess by being turned into a spider. In the brightly lit alcove at the rear (Fig. 8, p. 328), Pallas angrily

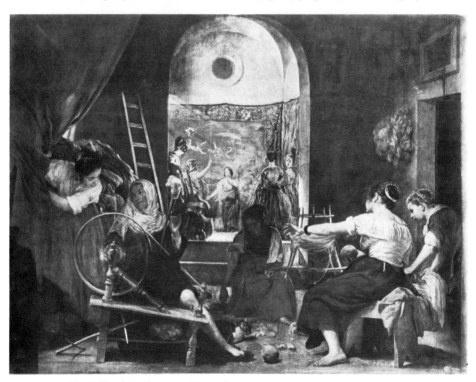

92. *The Fable of Arachne, c.* 1657. Velazquez

confronts Arachne, who stands before a tapestry on which she has woven 'The Rape of Europa' – a copy, in fact, of Titian's painting of this subject, made for Philip II of Spain and now in the Gardner Museum in Boston. For Velazquez, master of the ambivalent, the fable is only the central element in a complex allegory of the divine power of the artist and the punishment of human pride. This higher plane of abstract meaning is characteristically approached through the intensely realistic treatment of the shadowed foreground where women are seen carding and spinning wool – an allusion perhaps to the humbler, mechanical side of artistic performance as distinct from its inspired or godlike aspect.

Allegory also finds a place in biblical illustration, particularly in subjects from the Old Testament. It would be naïve to pretend that Baroque artists were drawn to the Old Testament solely for reasons of piety, or that their choice of subject was always dictated by theological considerations. We have only to think of the many representations of Susanna and the Elders, or of the Betrayal of Samson, to realize that the Bible was often looked on as a source for lively narrative scenes, especially those having to do with lust and violence. It remains true, nevertheless, that most of the Old Testament subjects illustrated by seventeenth-century artists are precisely those which in the late Middle Ages (in such books as the *Biblia Pauperum* and the *Speculum Humanae Salvationis*) were interpreted as prefigurations of the mysteries of salvation. Emile Mâle found it surprising that an artist such as Rubens should adopt this kind of 'medieval symbolism' by showing Job beaten by demons, Jonah cast into the sea, and Abigail kneeling before David, and therefore conjectured that these quaint subjects were commissioned by 'pious donors conversant with these books'.[7] In fact, the typological interpretation of Scripture, far from being regarded with indulgence as a curious relic of superstition, was expounded by some of the keenest minds of the seventeenth century. In the *Pensées*, Pascal adduces various proofs 'to show that the Old Testament is only figurative, and that the prophets understood by temporal blessings other blessings'. 'God has shown,' he writes, 'by the deliverance from Egypt, and from the sea, by the defeat of kings, by the manna, by the whole genealogy of Abraham, that he was able to save, to send down bread from heaven, etc. . . . He has then taught us at last that these things were only types.'[8]

If, with Pascal's words in mind, we turn to Poussin's paintings of Old Testament subjects, we discover a fundamental similarity of approach. Now it is undeniable that in *The Israelites Gathering the Manna* [60] the artist was concerned with several problems of a non-religious character, notably that of the expression of the passions. Yet it cannot be doubted that Poussin was also aware, on a metaphysical plane, that the miracle of the manna in the desert was understood to foreshadow the Eucharist and to be a sign of God's grace. It is for this reason that he has pictured two different responses to the miracle on the part of the Jewish people. The actions of the figures in the foreground are entirely 'carnal': some show charity by aiding the weak and helpless; others are gluttonous and think of nothing but themselves; but all look upon the manna as a blessing that is only of the flesh. Those, on the other hand, who comprehend the spiritual significance of the miracle are to be seen in the middle distance, in the company of devout and thankful Israelites gathered round Moses and

Aaron. In the same way, Poussin's *Rebecca and Eliezer at the Well* [93] is to be interpreted in both a literal and a figurative sense, or (to use Pascal's term) as a 'cipher'. For the story of Eliezer, the servant of Abraham, who chose Rebecca to be the wife of Abraham's son Isaac, is explained in the *Speculum* as presaging Gabriel's Annunciation to the Virgin Mary.[9] Poussin alludes to this mystical meaning in the solemn encounter of the two principal figures — Eliezer pressing forward and proffering a marriage ring, and Rebecca placing her hand on her breast and seeming to withdraw slightly — and in the group of watching girls whose expressions of envy and admiration show that they regard Rebecca as the chosen one who is, like Mary, 'blessed among women'.

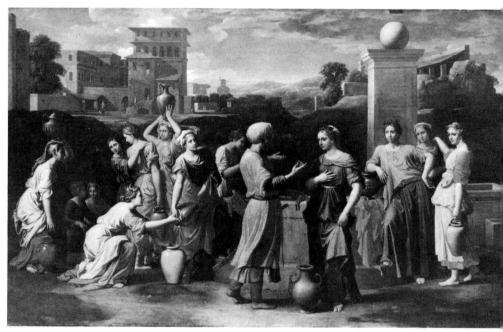

93. *Rebecca and Eliezer at the Well*, 1648. Poussin

The language of symbolism and allegory is very often employed in scenes of the Infancy of Christ, in order to allude proleptically to the Passion. Poussin, in *The Return of the Holy Family from Egypt* (Dulwich), makes this allusion quite unmistakably by showing the Christ Child, who is about to board a boat, looking up at the sky where angels display the Cross. Georges de La Tour makes a more cryptic reference to the Passion when he represents *St Joseph the Carpenter* working by the light of a candle held by the boy Jesus [94]. At first

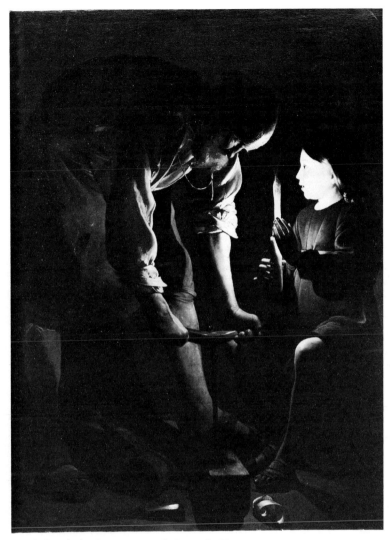

94. *St Joseph the Carpenter, c.* 1638–40. La Tour

glance this might be taken simply as a genre painting of an artisan in
his shop, until we realize that the wood which he is shaping is a pre-
figuration of the Cross, and that the patient attitude of the child
denotes filial obedience and acceptance of his destiny as martyr. The
same theme is treated, in expanded form, by Murillo in his painting of
The Holy Family with the Infant St John the Baptist [95]. While Joseph
works at his carpenter's bench, the Christ Child and St John are play-
fully tying two reeds together to form a cross; Mary pauses in her

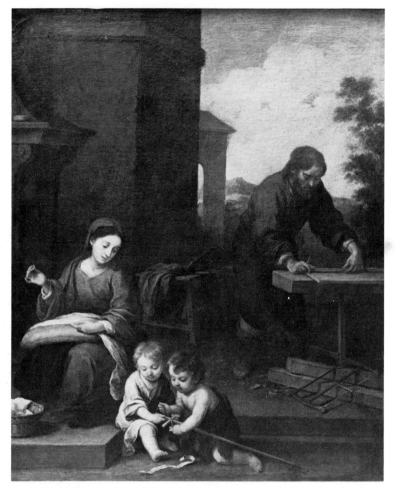

95. *The Holy Family with the Infant St John the Baptist, c.* 1660–70. Murillo

sewing to look down at them, the needle in her upraised hand fore-telling (as D. Fitz Darby has observed of a similar picture) 'the sword that will pierce the heart of the Dolorosa'.[10]

GENRE

The day is past when Dutch genre painting could be accepted merely as a realistic portrayal of everyday life, devoid of any allegorical or emblematic content. Recent studies of the relation between imagery and thought in seventeenth-century Holland have revealed the inadequacy of this long-cherished notion. Yet many problems of interpretation still remain to be solved, for the borderline between

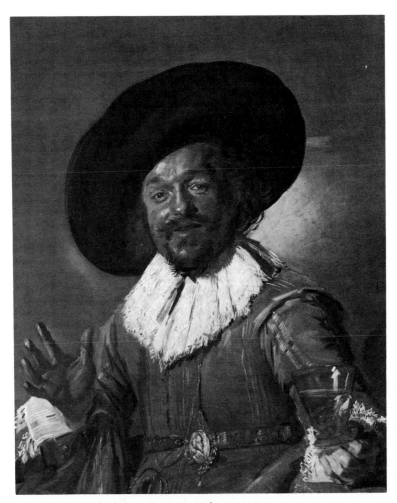

96. *The Merry Drinker, c.* 1628–30. Hals

genre and allegory is tenuous and often difficult to define. In a realistic iconography such as that developed by Dutch artists, symbols are frequently concealed in the form of familiar household objects, and emblematic allusions may be easily overlooked or misunderstood.

In the half-length genre figures of Frans Hals, Gerrit van Honthorst and Hendrick Terbrugghen, the life of the senses is illustrated in the most vivid way imaginable [96]. They laugh, sing or talk; they drink wine or play musical instruments; their hands are lifted in lively gestures; their mouths are open and their animated faces express uninhibited merriment and *joie de vivre*. Yet such paintings – though they may strike us, because of their seeming spontaneity and their unrehearsed appearance, as direct transcriptions of reality – are in

fact descended from traditional sets of allegorical pictures of the Five Senses, in which taste is suggested by the wine-drinker, hearing by the musician, and so forth; and something of that original emblematic flavour can still be detected through the vigorous and particularized realism in which the subjects are clothed.[11] In the same way, the pictures of riotous living which pass under the name of 'Merry Companies' in the work of Willem Buytewech and Honthorst [40] are derived from the biblical story of the Prodigal Son, the moralizing meaning of which they still retain, though in somewhat diluted form.

Rembrandt's *Money-Changer* [13], greedily counting his coins by candlelight, is a 'modernized' version (with up-to-date lighting à la Honthorst) of those Netherlandish genre pieces of the sixteenth century which were meant to inveigh against usury in the persons of money-lenders and excisemen. A work that is in some respects comparable is the *Old Man Sharpening a Pen*, now in a private collection in Hanover, by Rembrandt's pupil Gerrit Dou. This has been shown by J. A. Emmens to be an allegory of 'Practice in the Arts'. The operative

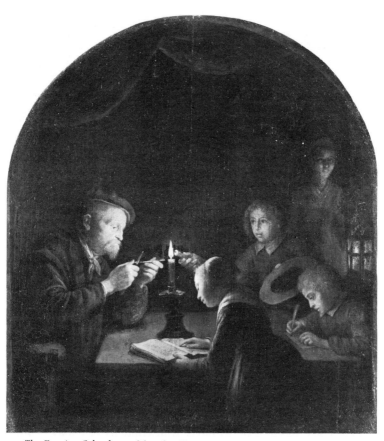

97. *The Evening School, c.* 1660–65. Dou

symbol is the pen, an instrument which must be guided by the hand but which is of no use if it is not, like reason, kept in a state of sharpness. Since the work was painted while Dou was still an apprentice in Rembrandt's studio, Emmens has argued that the subject was proposed by the master as a means of impressing on the pupil 'that art must be learned not on the basis of natural talent alone but above all by continuous practice'.[12] The same theme was treated by Dou in his painting of *The Evening School* [97], in which a teacher sharpens his pen while his pupils work at their lessons by candlelight. Here the candle-flame plainly signifies the enlightenment of young minds.

The richly comic art of Jan Steen rests on a solidly emblematic foundation. Many of his wittiest and most appealing works are illustrations of aphorisms concerning the foibles of mankind masquerading as episodes from daily life. The doctor and the ailing girl whom Steen paints so often and so sympathetically are only enacting a humble proverb — 'Love is a sickness that no medicine can cure.' In the example illustrated here [98], the furnishings of the room include

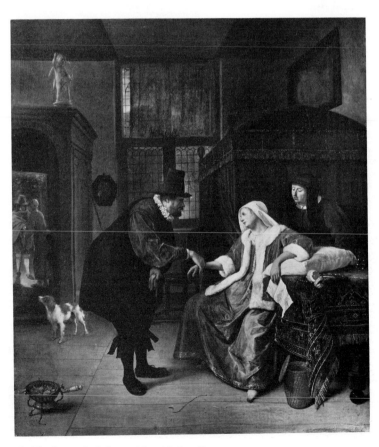

98. *The Lovesick Girl, c.* 1660–68. Jan Steen

a statuette of Cupid who takes aim at the young woman with his arrow. To call such works 'literary', or to suggest that their moralizing content is somehow indicative of a flaw in the painter's genius, is to miss the point. Steen's purpose – and it is a fundamental one in Baroque art – is to give new force and meaning to received truths by transplanting them from the realm of the general and abstract into that of immediate, sensuous and concrete experience.

Even the serene and beautifully ordered world of Jan Vermeer proves – once we have penetrated its crystalline outer surface – to contain veiled emblematic meanings. The *Woman Weighing Pearls* [99] would seem to conform in every respect to the requirements of ordinary

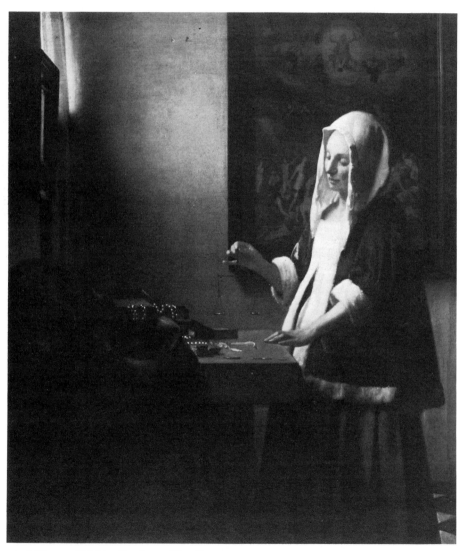

99. *A Woman Weighing Pearls, c.* 1665. Vermeer

domestic genre. But this is in fact a case of 'disguised symbolism'. For the action of the girl with the balance is to be read as alluding to the picture of the Last Judgement that hangs on the wall beyond her; and the painting as a whole is to be construed as a cryptic allegory of *Vanitas*, with particular reference to the futility of earthly possessions.

In the early genre pictures of Velazquez there is a conspicuous emphasis on those humble persons whose lot it is to wait upon others. Paintings such as *The Water-Carrier of Seville* (London, Apsley House) and *The Old Woman Cooking Eggs* (Edinburgh, National Gallery) tell of the artist's respect for the individual, no matter how lowly his station in life. Yet for all his humanity and his feeling of compassion for the

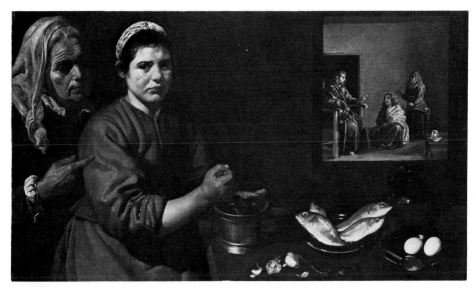

100. *Christ in the House of Mary and Martha, c.* 1618. Velazquez

poor and unfortunate, it would be totally wrong to believe that Velazquez chose such subjects as a form of social comment or as a protest against injustice. The fundamentally moral orientation of these sober *bodegones* is made unequivocally clear by the painting of *Christ in the House of Mary and Martha* [100]. An unhappy kitchen-maid, resentful at having to prepare a meal, is admonished by an old woman who reminds her of Christ's rebuke to Martha. The biblical example is illustrated by what appears to be either a painting or a mirror in the background; it shows Mary seated at Christ's feet while her sister Martha complains that she has been left to do the serving duties alone. (The device of 'the picture within the picture', which derives from Flemish Mannerist prototypes, also appears in Vermeer's *Woman Weighing Pearls* [99].) It is noteworthy that the imagery of the servant recurs in *El arte de la pintura* (1649) by Velazquez's former

master Pacheco, who maintains that 'the aim of painting is the service of God' and who quotes St Paul (Colossians iii, 23–4) in likening the artist to the servant who performs his task cheerfully, because he knows that he is serving not men alone but God.[13]

It has often been remarked that there is some affinity between Velazquez and the French master Louis Le Nain, whose peasant pictures have about them a quasi-religious tone that transpires even through their earthy naturalism. A recurrent theme in the work of Le Nain is the peasant family gathered round a table with bread and wine [31]. For these devout and humble country-folk the meal is a sacred ritual, a meaning reinforced by the prominence given to the bread and wine as eucharistic symbols.

STILL LIFE

The Baroque still life, whether it represents flowers, food and drink, or things of everyday use, makes a direct and powerful appeal to the senses. It is significant that on occasion the objects selected by the painter are to be understood precisely as attributes of the Five Senses. In the beautiful panel by the French master Baugin [101], hearing is symbolized by the lute and the book of music, taste by the glass of wine and the piece of bread, smell by the flowers in the vase, touch by the chess-board and coin-purse, and sight by the mirror on the wall, as well as by the picture as a whole. All these things are brought together in a harmonious grouping of related and contrasting shapes.

In an age so attuned to emblematic allusions, it was only to be expected that the painting of inanimate objects should be made the vehicle of various kinds of symbolic meaning. The secret of many a seventeenth-century still life painting lay in the fact that it offered to the observer a stimulating and life-enriching illusion of reality, while at the same time inviting him – paradoxically – to reflect on the brevity of man's existence and the insubstantiality of all worldly things. This dual meaning is given its most outspoken expression in the Dutch *Vanitas* still life,[14] of which the panel by Harmen Steenwyck in London may stand as a characteristic example [102]. A shaft of cold grey light throws into relief a mysterious collection of objects which have been heaped on a table in a triangular configuration. There are books representing learning, a precious shell and a sword as symbols of wealth and power, and musical instruments to denote sensual pleasures. In the midst of these things, a skull, a timepiece and an oil lamp from which there issues only a faint wisp of smoke are a melancholy reminder of the fleeting nature of all human pursuits.

There is a curious but undeniable connection between the *Vanitas* pictures of Calvinist Holland and those of Roman Catholic Spain. We

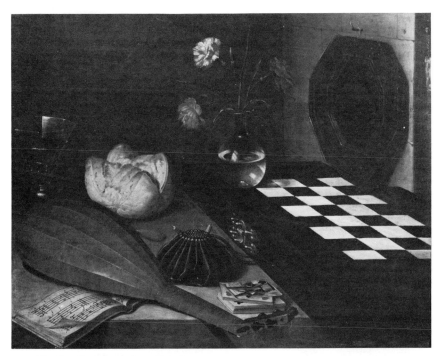

101. *The Five Senses, c.* 1630. Baugin

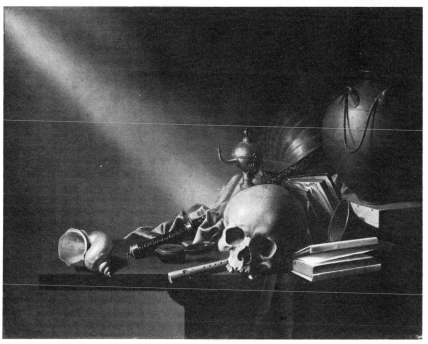

102. *Vanitas,* 1660. Steenwyck

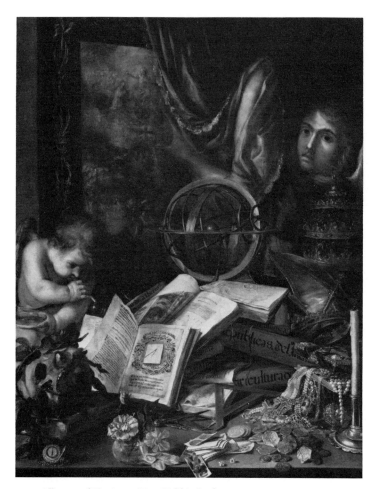

103. *Allegory of Vanity*, 1660. Valdés Leal

recognize at once the meaning of the precious objects piled up like so much rubbish in the *Vanitas* by Juan de Valdés Leal [103]: they are part of the international language of symbolism by which the beholder is enabled to pass from familiar, visible things to the contemplation of invisible ones. The books (some lying open as if death had overtaken the reader), the armillary sphere and the instruments such as the compasses and triangle clearly signify the futility of science and learning; the crowns and sceptre are the vain trappings of worldly rank and power; and the jewels, coins, dice and playing cards stand for the illusory pleasures of this life. The skull wreathed with laurel, the watch, the extinguished candle and the flowers from which the petals have begun to fall denote the inexorable passage of time and the fugacity of human existence. To this still life Valdés Leal adds two

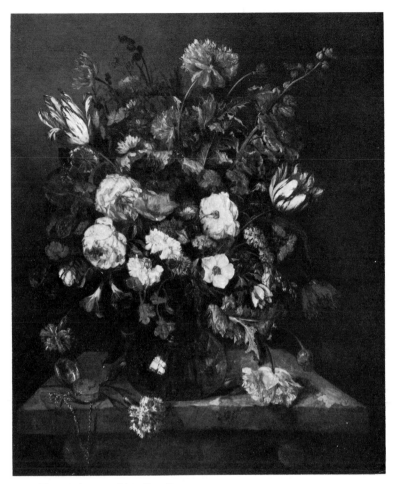

104. *Flower-piece, c.* 1665. Van Beyeren

figures: directly above the death's head is a *putto* blowing soap bubbles, like the child in Poussin's *Dance of Human Life* [91], and in the background an angel draws aside a curtain to disclose a painting of the Last Judgement – a 'picture within the picture' that recalls Vermeer's *Woman Weighing Pearls* [99].

The hundreds of Dutch and Flemish flower-pieces, with their masses of brilliant and colourful blooms, do not instil thoughts of mortality in the modern viewer. But in the seventeenth century such works were likely to bring to mind the words of the Psalmist: 'As for man, his days are as grass: as a flower of the field, so he flourisheth. For the wind passeth over it, and it is gone; and the place thereof shall know it no more.' Arnold Houbraken, in his biography of the Flemish painter and architect Jacob Francart, tells how in his last years he

gave up the practice of his art in order to cultivate flowers, 'in which he saw an emblem of his fleeting life'.[15] Flowers in paintings may of course symbolize many things, according to the iconographical context in which they appear. In seventeenth-century still life subjects they are, more often than not, understood to be hieroglyphs of transience. The artist might, if he liked, underline this meaning by including a skull or other emblems of mortality. Abraham van Beyeren's flower-piece [104] features a luxurious bouquet of tulips, carnations, roses and other blooms set in a glass vase on a marble-topped table. The pocket-watch lying inconspicuously at one side seems, when at last it catches our attention, to be ticking away the brief span of time allotted to flowers and to man.

LANDSCAPE

It is not uncommon to find in Baroque history paintings what Panofsky has called the *paysage moralisé*,[16] that is to say the old-fashioned practice of manipulating the landscape background in such a way as to reinforce the moral of the subject represented. Annibale Carracci adopts this method in his *Choice of Hercules* [206], where the hero must decide between Pleasure and Virtue, the choice that lies before him being symbolized by the contrasting scenery in each half of the picture – a seductive, leafy glade on one side and a steep and rocky path leading to a mountain-top on the other.

The development of the classical landscape, in which the figure subject is sharply scaled down in relation to the outdoor setting, opened the way to new possibilities in the rendering of a 'moralized' nature. This was the problem to which Poussin, near the close of his life, addressed himself in the great set of canvases called *The Four Seasons*. Each season is represented by an appropriate episode from the Old Testament: Spring by *The Earthly Paradise* [184]; Summer by *Ruth and Boaz*; Autumn by *The Grapes from the Promised Land*; and Winter by *The Deluge* [105]. But it is not only the cycle of the seasons that is illustrated in these paintings; for they also contain allusions to related quartets involving the passage of time, namely the four times of day, from sunrise to nightfall, and the four stages of human life, from childhood to old age. What is more, the series takes on even wider significance because, as Sauerländer has shown, the seasons also symbolize different eras in the universal history of mankind.[17] Spring thus corresponds to the world *ante legem*, before the Ten Commandments; Autumn denotes the state of humanity *sub lege*, under the Mosaic law of the Old Testament; Summer typifies the world *sub gratia*, under the grace of Christ, because the marriage of Ruth and Boaz was interpreted as foreshadowing the mystic marriage of Christ and the Church; Winter, finally, signifies the Last Judgement, aptly

105. *Winter: The Deluge*, 1660–64. Poussin

represented by the world-engulfing Flood [105]. The concluding scene
requires no learned exegesis to make its meaning clear: the grim
rocky setting, the menacing darkness and the severity of the com-
position itself convey unmistakably the hopelessness of those con-
demned to perish in the waters. From its beginning in the shining
promise of Spring to its gloomy conclusion in the catastrophe of
Winter, Poussin makes use of this epic cycle to unfold his vision of
the grandeur of nature and time.

Allegories of the Four Seasons, though frequent in prints and
drawings, are virtually absent from Dutch landscape painting of the
seventeenth century. Almost the only relic of this tradition is the
recurrent theme of skaters on a frozen river, which, as Stechow has
pointed out,[18] clearly derives from the picture of Winter in a set of the
Seasons – just as many Dutch genre subjects may be said to trace
their descent from images of the Five Senses. But landscape painting,
as it developed in Holland in the seventeenth century, seems to have
largely shaken itself free of religious, mythological and symbolic
overtones.

To this rule there are of course exceptions. Indeed, one of the excep-
tions comes from the hand of the greatest of all Dutch landscapists –

the *Jewish Cemetery* by Jacob van Ruisdael [106]. The ostensible subject is the Jewish graveyard at Ouderkerk near Amsterdam; but the painting is in fact an allegory of the futility and transience of human life, in which the tombs carry a symbolic meaning comparable to that of the skull in a *Vanitas* still life [102]. Man and his works perish and crumble into dust; nature alone reveals the promise of renewal and salvation, through the rainbow and through the trees that rise to replace those that have died. This moralizing meaning is made even more pointed by the storm clouds massed above the scene, by the ruined building in the background and by the ghostly tree at the right that seems to gesture towards the gravestones scattered throughout this desolate burial-ground (Fig. 9, p. 331).

106. *The Jewish Cemetery, c.* 1660. Ruisdael

THE EARTHLY APOTHEOSIS

Of all the uses of allegory, the most spectacular was the glorification of the earthly ruler. If the Baroque was the age in which divinity was brought down to earth, it was also a time when men sought to become divine. The fiction, already accepted without qualm in the sixteenth century, that the virtues, wisdom and valour of the prince were worthy to be compared with those of the gods, acquired new meaning in the seventeenth century through the doctrine of Divine Hereditary Right.

No artist represented the apotheosis of the monarch with greater con-
fidence and address than Rubens. On the Whitehall Ceiling in London,
painted for Charles I, one may see the King's father, James I, carried
bodily to heaven by allegorical personages under the supervision of
Mercury. Some years earlier, in the Medici Cycle, that extraordinary
mélange of history and fable, Rubens had treated this theme on an
even more epic scale. That King Henry IV of France and his queen
Maria de' Medici should be elevated to a place among the gods of
Olympus was only to be expected. But Rubens carries the divine right
of kings to still greater lengths. In the *Entry into Lyons*, for example
[107], the royal pair are even permitted to usurp the celestial thrones
of Jupiter and Juno. Henry, holding the thunderbolt, sits with one leg

107. *The Entry into Lyons*, 1621–5. Rubens

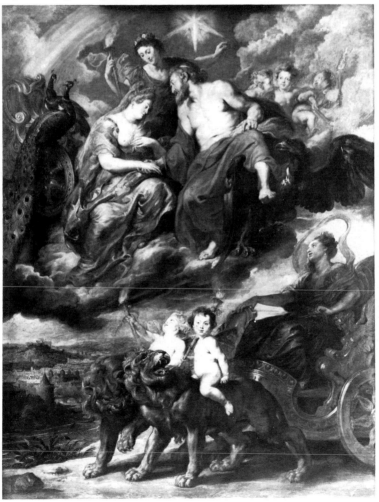

resting upon the wing of Jove's eagle, while Maria, who has taken possession of the goddess's chariot and peacocks, plays the part of a rather ample Juno. Hymenaeus, god of marriage, waits upon the divine couple, over whom shine the rainbow and the morning star as promises of the bright days to come, and on the earth below the personification of Lyons rides in a car drawn by lions, the emblems of the city.

The supreme Baroque image of princely apotheosis is Bernini's bust of *Louis XIV* [108]. Considered simply as a portrait of the king, the work is hardly adequate. Bernini did not choose to be limited by the

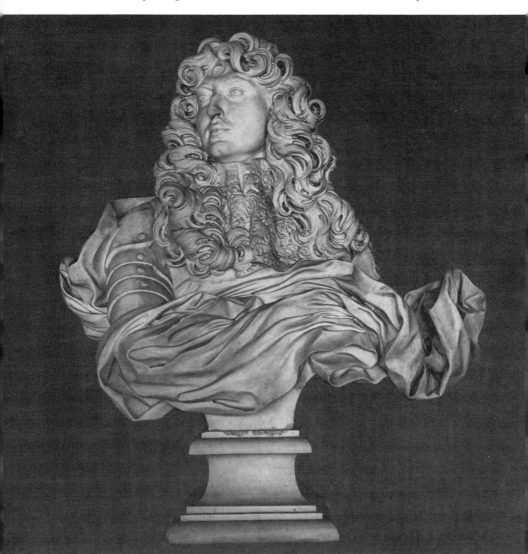

108. *Louis XIV*, 1665. Bernini

merely mortal aspect of his subject: it was his intention to create the
likeness of a divinely ordained ruler, through whose features there
should shine a godlike virtue and majesty. The imperious turn of the
head, the noble brow and the upward glance of the eyes evoke memories
of the deified Alexander the Great. To reinforce this meaning, the
bust was to have been mounted on a gilt globe of the world bearing
the inscription '*Picciola basa*' – too small a base for so grand a monarch.

From this sublime portrait of the king we descend to a lower plane
of inspiration with Jean Nocret's allegorical painting of 1670, in which
the members of the royal family are represented in the guise of

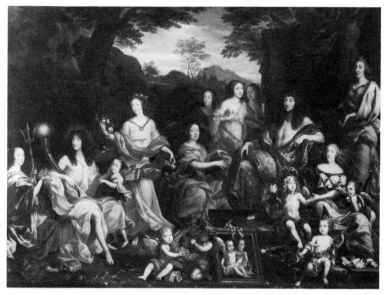

109. *The Family of Louis XIV*, 1670. Nocret

divinities [109]. The company is presided over by Louis XIV en-
throned as Apollo; seated beside him, at the lower right, is the queen
in the role of Juno; she is accompanied by their son, the Dauphin, as
Eros. The king's brother, Monsieur, appears at the left in the character
of Lucifer, the morning star who heralds the advent of the sun.
Madame, the queen mother and the other ladies of the royal house-
hold are assigned roles as deities more or less appropriate to their
station.

The princely apotheosis made its appearance in Holland only about
the middle of the century, when Dutch art became increasingly sus-
ceptible to Flemish influences. For it was at this time that normal
relations were restored between the United Provinces and the Southern
Netherlands, after long years of war, as a result of the Peace of
Münster (1648). Prince Frederick Henry, Stadholder of the Nether-

lands, had ordered a country house, the Huis ten Bosch, to be built near The Hague. When he died in 1647, his widow decided that the great hall, known as the Oranjezaal, should be decorated with paintings in his memory. Since the allegorical programme invented for the hall was distinctly Rubenesque in character, it seemed fitting that the principal painting should be entrusted to the Flemish artist Jacob Jordaens, who had succeeded Rubens as the leading master of the Antwerp School. In the great canvas in the Oranjezaal which represents *The Triumph of Prince Frederick Henry* [110], Jordaens has attempted to outdo Rubens in magnificent pageantry and in profusion

110. *The Triumph of Prince Frederick Henry.* 1652. Jordaens

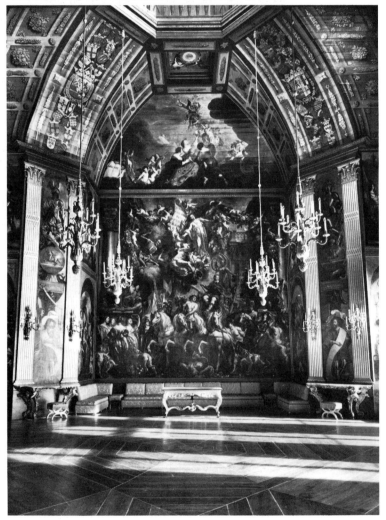

of personifications. It is a conventional, though excessively crowded, triumphal procession, in which the hero, as commander of the Dutch forces in the war against Spain, rides in a chariot drawn by four high-stepping white horses (said by the artist himself to represent 'the innocence and purity of heart' of the Stadholder). The meaning conveyed by the airborne figures in the upper centre of the composition is that the Peace of Münster is the last and greatest of the blessings bestowed upon his people by Frederick Henry. As white-robed Peace descends upon the scene amidst a cloud of *putti* signifying the arts and sciences, Fame leaps forward to put Death to flight, so that the glorious memory of the Prince of Orange shall not be swallowed up in oblivion.

The achievements of the popes were celebrated, it goes without saying, in allegorical programmes no less grandiose than those conceived for secular rulers. To this category of papal exaltation belongs one of the most brilliant creations of Roman Baroque art – the Barberini Ceiling painted by Pietro da Cortona in the great hall of the Barberini Palace in Rome as a glorification of Pope Urban VIII and the Barberini family [111]. Along the four sides of the frescoed vault are mythological subjects which are to be read, in the manner of the day, as allegorical references to the virtuous deeds of the pope, his fight against heresy being figured, for example, by the scene of *Pallas Overcoming the Giants*. But these episodes are in every sense subordinate to the dazzling vision that fills the principal field. Directly above the observer is the Barberini coat of arms, provocatively pictured not as a solid heraldic shield but as a trio of giant bees (a Barberini emblem) framed by laurel branches. This extraordinary device, which seems to have been assembled impromptu, is borne by Faith, Hope and Charity (respectively dressed in white, green and red as prescribed by Ripa's *Iconologia*) and surmounted by the figures of Religion with the keys and Rome with the papal tiara. Almost unnoticed in the upper corner of the composition is a child who holds a laurel wreath over the coat of arms by way of allusion to Urban's accomplishments as a poet. The chief figure on the ceiling is that of Divine Providence, who sits resplendent on a cloud with a sceptre in her hand. Beneath her are stationed Time, in the form of Saturn devouring his children, and the three Fates with the thread of life, to show that Divine Providence holds sway over present and future. At her command Immortality soars upwards to place a crown of stars upon the Barberini arms. The central conceit of this involved allegory, as Vitzthum has neatly phrased it, is that 'Urban VIII receives thus a new triple crown: the papal tiara and the poet's crown for his activities in life, and the crown of Immortality which Divine Providence prepares to be added to his name at the moment of his death.'[19]

111 (*overleaf*). *The Glorification of the Reign of Urban VIII*, 1633–9. Cortona

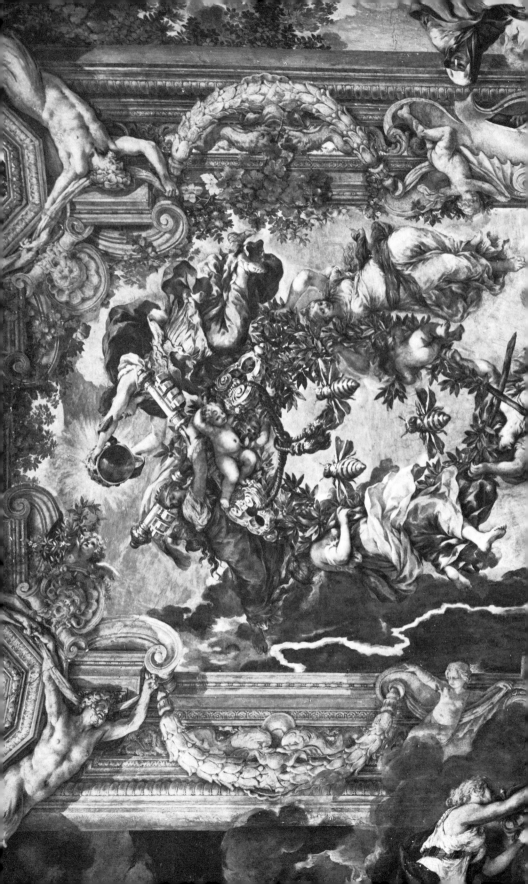

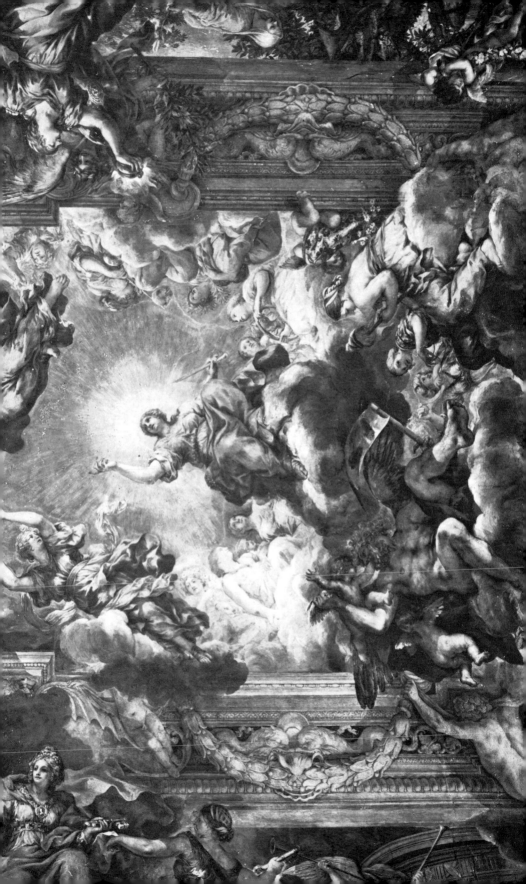

The ingenious emblematic conceits devised for the glorification of Louis XIV at Versailles formed one of the most complicated and far-reaching iconographical programmes of the seventeenth century [112]. 'It must first be pointed out,' wrote André Félibien in 1674, 'that, since the Sun is the emblem of the King and since the poets con-

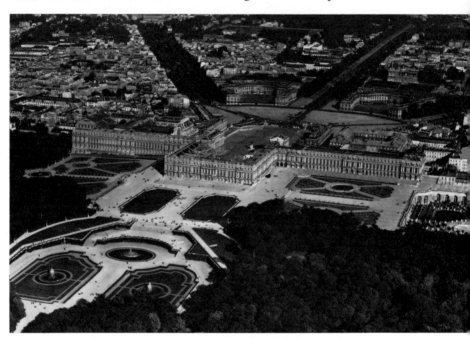

112. The Palace of Versailles, begun 1669. Le Vau and Hardouin Mansart

113. The Parterre d'Eau, Versailles, *c.* 1683. Le Nôtre and Hardouin Mansart

found the Sun and Apollo, there is nothing in this superb residence that is not related to this divinity.'[20] The image of the sun in splendour governed the design of the entire complex, in which the great avenues and *allées* appear to radiate from the palace, the dwelling-place of the *Roi Soleil* [113]. In the Apartment of the King, a suite of seven rooms corresponding to the seven planets culminated in the Salon d'Apollon, which also served, appropriately, as the Throne Room. The ceilings

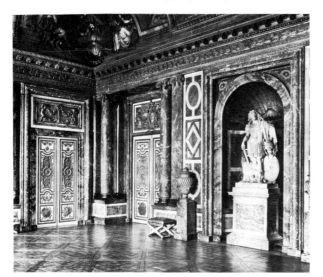

114. The Salle de Vénus, Versailles, 1671–81.
Le Brun, Houasse and Rousseau

115 (*right*). Detail of a door of the Salle de Vénus, 1679–81. Caffiéri

of these rooms, painted under the direction of Charles Le Brun, represent 'the deeds of the heroes of antiquity in relation to each of the planets and to the deeds of His Majesty'. The theme of the Salle de Vénus [114, 115] is the submission of gods and heroes to the power of the goddess of love; one of the pictures in the coving of the vault represents *The Wedding of Alexander and Roxana*, which is to be understood as an allusion to the marriage of Louis XIV and Maria Theresa. The laborious ritual that accompanied the daily *lever* and *coucher* of the monarch in the royal bedchamber constituted yet another allusion to Louis XIV as the 'light of the world'.

In the vast gardens laid out by Le Nôtre and embellished with fountains and sculptures, the same theme was elaborated on an even grander and more universal scale. The principal episodes of the fable of Apollo were illustrated in three widely spaced works. The birth of the god and his sister Diana was represented in the Pond of Latona; and there also were the Lycian peasants who, because they had persecuted Latona, were changed into frogs to denote the punishment

meted out for *lèse-majesté*. At the *Bassin d'Apollon*, at the farther end of the *Tapis Vert*, the chariot of the Sun was seen rising from the waters as Apollo began his daily course across the sky [116]. The grand allegorical sequence was completed in the Grotto of Thetis, where Apollo, in a symbolic rendering of the setting of the Sun, ended his arduous journey by sinking into the sea. The sculptural groups of the interior [117], executed by Girardon and others from drawings by Le Brun, showed, in the central niche, Apollo waited upon by Thetis and her nymphs [211], while at the sides the horses of the Sun were groomed by Tritons. The Grotto (later demolished) was erected close to the palace so as to signify (in the words of Charles Perrault) 'that the King retires at Versailles after having worked for the good of the whole world'.[21]

116. *The Chariot of Apollo*, Versailles, 1668–71. Tuby

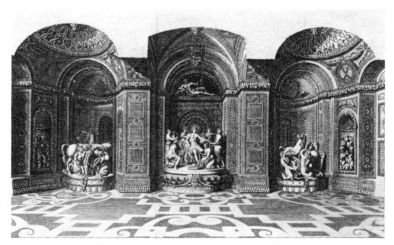

117. *The Grotto of Thetis at Versailles*, 1676. Engraving by J. Le Pautre

The monumental complexes that are generally thought of as typical expressions of the Baroque era have a good deal more in common than their imposing scale. For in these huge projects, as in individual works of painting and sculpture, the same habit of mind prevailed: the master architects and designers conceived of their

works – whether ecclesiastical or secular – as embodying certain abstract ideas. In this sense at least, Versailles is not unique.

Bernini's Piazza of St Peter's [118] was designed to accommodate the throngs of people who gathered at Easter and on other occasions to receive the blessing pronounced by the pope from the Benediction Loggia above the entrance to the Vatican basilica. The mighty colonnade, with its curving wings sweeping round the vast oval of the piazza, was compared by Bernini himself to the maternal arms of the Church, 'which embraces Catholics so as to confirm them in their faith; heretics, to re-unite them to the Church; and infidels, to enlighten them in the true faith'.[22] Bernini's *concetto* thus effectively symbolizes the universal significance of the papal blessing, which is given *urbi et orbi* – to the city and to the world.

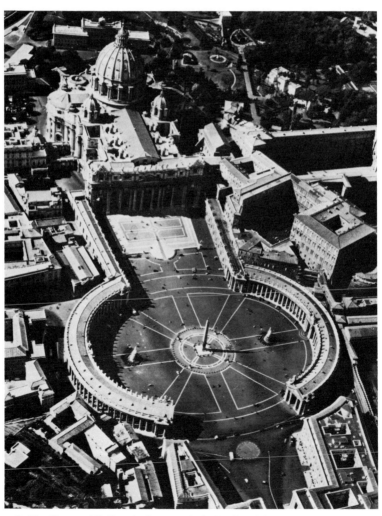

118. The Piazza of St Peter's, Rome, 1656–67. Bernini

119. The Burgerzaal, Amsterdam Town Hall, begun 1648. Van Campen

The iconography of civic buildings provides another insight into the Baroque mind. The great Town Hall of Amsterdam, now the Royal Palace, was built in a classicizing style by Jacob van Campen to replace a medieval building which could no longer meet the needs of a prosperous and rapidly growing citizenry. The new structure, begun in 1648, was intended to serve not only a utilitarian function by providing adequate space for the various municipal departments, but a complex symbolic purpose as well. It was conceived both as a memorial to the Peace of Münster, which for Holland signified formal recognition of the independence of the Dutch Republic, and as a monument to Amsterdam itself. For the poet Joost van den Vondel,

the Town Hall, standing upon the Forum of the city, was nothing less than Amsterdam's Capitol.[23]

In the sculptured pediment of the façade, beneath the crowning statue of Peace, the personification of Amsterdam is shown receiving tribute from the sea. For this republican edifice van Campen provided no grand princely entrance but a series of seven equal doorways through which people could pass to make their way to the municipal offices and the spacious Burgerzaal (the Citizens' Hall) on the first floor [119]. The lunettes of the galleries are filled with paintings illustrating the history of the ancient Batavians, who under their leader Claudius Civilis had risen in rebellion against the Romans, the reference, clearly, being to the successful revolt of the Dutch against Spain conducted by William the Silent.

The sculptural decorations of the interior have as their main theme the authority of the magistrature and the might of the law. 'Human weakness,' wrote Vondel in his poem on the dedication of the Town Hall, 'needs to be strengthened by reward and punishment. This demands authority and lawful order.'[24] The grim meaning of the judicial power was impressed upon the visitor from the moment that he set foot in the building: for in the very entrance lay the Vierschaar (the Hall of Judgement), which was used only for pronouncing the death sentence. On the walls of this room were placed reliefs of judgement scenes from the Bible and Antiquity, and four caryatid figures standing with heads bowed and faces hidden in grief and shame.[25]

5

When I consider the short duration of my life,
swallowed up in the eternity before and after,
the little space which I fill . . .
engulfed in the infinite immensity of spaces of which
I am ignorant and which know me not, I am frightened,
and am astonished at being here rather than there.

Pascal, *Pensées* (1670)

Space

The seventeenth century was the age in which science, setting out from the Copernican hypothesis that the earth is only one of the planets of the solar system, revealed the homogeneous structure of the whole physical universe. The ancient distinction between the celestial and terrestrial spheres had now to be abandoned: for the heavenly bodies were shown to be subject to the same law of gravitation and the same laws of motion as the earth itself. The cosmos was henceforth to be thought of as a vast, uniform system of inter-connected parts. The far-reaching mind of Giordano Bruno had already imagined in 1584 a plurality of solar systems – 'innumerable suns, with countless planets likewise circling about these suns'.[1] It is not too much to say that the sense of the infinite pervaded the entire Baroque age and coloured all its products.

The awareness of the physical unity of the universe is reflected in the new attitude adopted by many Baroque artists towards the problem of space. Their *aim*, as one might put it, is to break down the barrier between the work of art and the real world; their *method* is to conceive of the subject represented as existing in a space coextensive with that of the observer. Implicit in this unification of space, in which everything forms part of a continuous and unbroken totality, is a concept of infinity analogous to that framed by some of the greatest thinkers of the period.

120. *The Immaculate Conception, c.* 1678. Murillo

In the paintings of the Immaculate Conception by Murillo we may catch an echo of the 'infinite immensity of spaces' which evoked such feelings of awe in Pascal. The Soult *Conception* [120] is one of Murillo's most captivating images of the *Purísima*. The Virgin, a radiant figure of childlike innocence and grace, floats in a sea of golden light, her hair and mantle waving gently in the breeze of heaven, while infant angels roll amidst the fluffy clouds. Yet these very qualities of sweetness and delicate charm are deceptive, for they may cause us to overlook the imaginative power and depth of feeling of the artist and to see in him nothing but a kind of sentimental prettiness. Such a reading of Murillo's *Conception* is very far from the

truth. Here he transcends the standard iconographical recipe for the
Immaculata[2] to bring before our eyes a vision of a celestial being, existing from all eternity, suspended in an immeasurable abyss of time and space.

THE INTEGRATION OF REAL AND FICTIVE SPACE

The rational perspective system devised by Renaissance artists had the effect, since it was based on the assumption of a fixed distance between the observer and the subject represented, of setting up a 'window into space'. The Baroque artist seeks to avoid this impression by suggesting that the frame through which we look is merely adventitious – not something that defines an impenetrable picture plane. The principle of coextensive space manifests itself in a variety of forms, amongst which are the *trompe-l'oeil* devices employed by artists to establish an interconnection between the real space of the spectator and the fictive space of the painting. Caravaggio, in his *Supper at Emmaus* [121], relies on emphatic gestures which appear to thrust through the picture plane in order to persuade us that we are actually present at this unexpected intervention of divinity into the everyday world; even the basket of fruit is so placed at the very edge of the table that it seems in danger of falling at our feet (Fig. 12, p. 335).

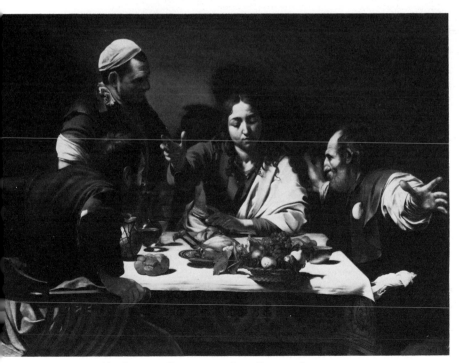

121. *The Supper at Emmaus, c.* 1600. Caravaggio

The gesture that makes contact with our world is also brought into play by Rembrandt in the great painting of 1642 known as *The Night Watch* [122]. The impression of a company of militiamen noisily

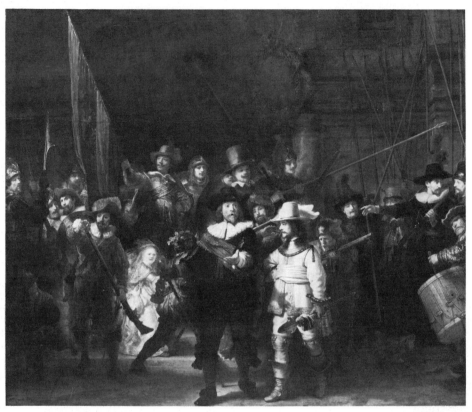

122. *The Night Watch*, 1642. Rembrandt

advancing upon the beholder is reinforced by the fact that the out-stretched hand of Captain Frans Banning Cocq, which casts its shadow upon the lieutenant at his side, protrudes illusionistically beyond the surface of the canvas [123]. The hand extends into our space; but its shadow falls within the pictorial space.

The sculptural equivalent of the painted figure that transgresses the nearer limits of the fictive space is the statue that refuses to be confined within its niche. Bernini, whose restless imagination constantly impels him to transcend accepted boundaries, places his *Habakkuk and the Angel* [128B] in a narrow recess in such a way as to annihilate the plane that lies across the face of the niche. The two figures show an astonishing freedom of movement, leaning this way and that, and thrusting arms and legs beyond the shallow confines of their setting. The explicit denial of restraint and enclosure intensifies

123. Detail of 122

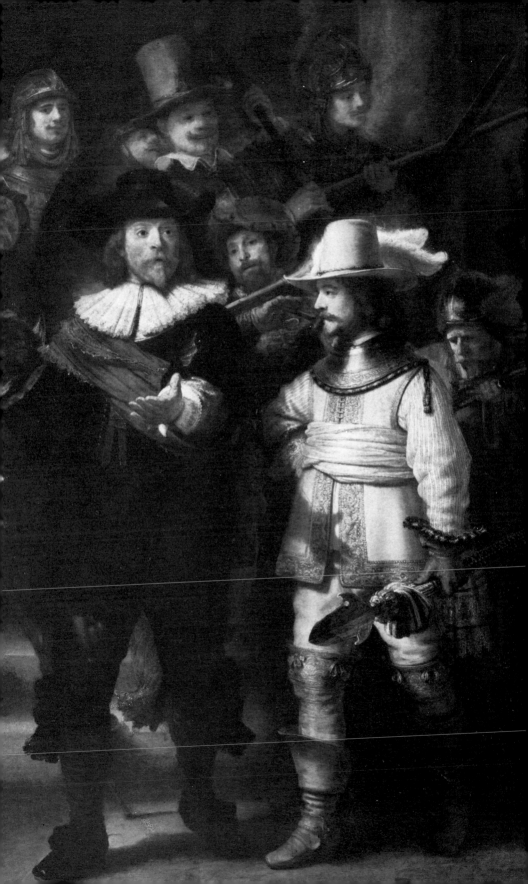

124. *The Meeting of Pope Leo I and Attila*, 1646–53, Algardi

the illusion that they belong as much to the external world of reality
as to the created world of art.

The pictorial relief may be made to conform, perhaps even more readily than painting or sculpture in the round, to the Baroque will to demolish the boundary separating the work of art from real life. A striking example is furnished by Algardi's huge relief of the *Meeting of Pope Leo I and Attila* [124]. The event depicted here took place in the year 452, when Pope Leo persuaded the king of the Huns, whose barbarian hordes were ravaging northern Italy, to withdraw beyond the Alps. As the legend relates, Leo was aided by the intervention of the Apostles Peter and Paul who, swooping down from the sky with swords in their hands, struck terror into the heart of Attila. In order to divest the event of its mythic associations and to bring it to life in a believable spatial milieu, Algardi makes the nearer figures protrude conspicuously from the relief surface. The Apostles, whose presence is perceived only by Attila and the pope, emerge with dramatic suddenness into the space directly above the principal actors. At the base, the conventions of relief sculpture are virtually abandoned: the ground plane advances beyond the limits of the frame, and the three foremost figures standing on it have assumed an almost three-dimensional existence; Attila, looking up in fear at the threatening apparition in the sky, turns abruptly and rushes away in a movement that will carry him into the zone of the observer.

The impulsion to establish a spatial continuum also accounts for the tendency (defined by Wölfflin as a cardinal principle of Baroque painting)[3] to dissolve the surface plane by means of emphatic recessional movements. It is a method repeatedly employed by Rubens, as may be seen in the *Miracles of St Francis Xavier* [59], where the viewer's eye is carried into depth along a diagonal path that begins with the figures in the lower left corner and connects with other receding movements to form a zig-zag sequence. The architectural setting also contributes to the illusion of expansiveness. The pagan temple in the background – and this is characteristic of Rubens – defies rational analysis; but the observer, perceiving a flight of steps, two imposing columns and some monumental sculpture, accepts these things as belonging to a coherent structure of huge proportions.

Another device, employed with great effectiveness by Pieter de Hooch, is the representation of successive spatial compartments which allow the viewer to imagine an unending continuity. The empty foreground which confronts us in De Hooch's *Courtyard* [125] is about to be entered by the maid and child approaching from the darkened area on the right. Opposed to this advancing movement, however, is the implication of a reverse direction through the narrow passage on the left, the magnetic pull of which is activated by the

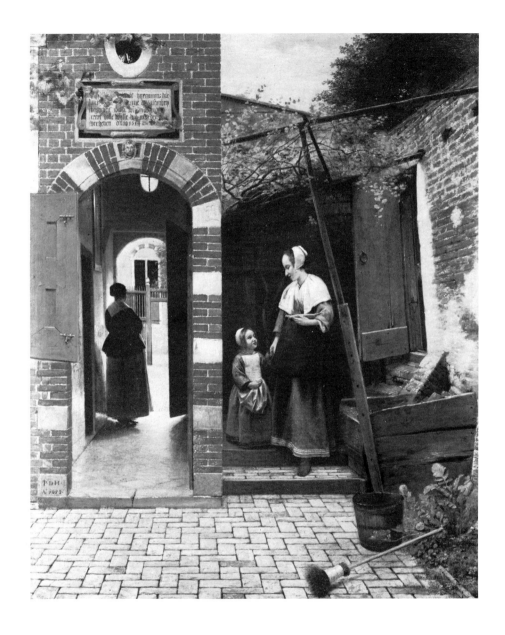

125. *The Courtyard of a House in Delft*, 1658. De Hooch

woman standing at the farther end and looking out into the bright daylight of the open street. An analogous organization of space can be observed in the church interiors of Emanuel de Witte [126], where alternating bands of sunlight and shadow recede from the eye at measurable intervals and numerous openings provide glimpses of other parts of the church and of the outdoors. The picture space, instead of being thought of as a closed, self-contained unit, is treated as a fragment of an infinitely larger totality.

126. *The Interior of a Church*, 1668. De Witte

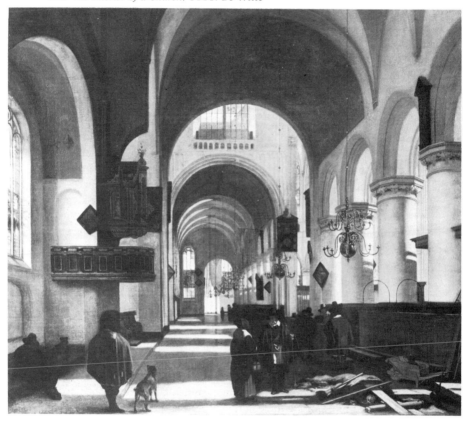

It was one of the advantages of Baroque 'painterliness'[4] that it enabled the artist to suggest effects of atmosphere, mobility and change, and thus to avoid the impression of an airless and immutable setting for human actions. One thinks, for example, of Rembrandt, in whose works the very air becomes tangible [14]. But Rembrandt is not alone in this materialization of space. In Rubens's *Venus and Adonis* [9] the space seems to flow round the figures, creating a

unified and far-reaching field in which they can move freely. The convincing illusion of 'real' space that Velazquez achieves in *The Fable of Arachne* [92] results not so much from the perspective rendering of the room as from the veil of atmosphere and light that plays over the figures and magically gives them existence in surroundings that are in constant flux. Given this conception of space and time, it is only to be expected that the spinning wheel in swift motion should be shown without spokes.

The Baroque preoccupation with the continuum of space found a characteristic outlet in illusionistic ceiling paintings. The frescoed figures on the vault of Carracci's Farnese Gallery [20] do not inhabit an ideal or discrete realm but seem rather to participate in our space and time. The seated youths at the level of the cornice turn their heads to gaze at the mythological paintings displayed on the ceiling above them.

The Barberini ceiling by Pietro da Cortona offers what is perhaps the most brilliant application of illusionistic methods in Italian Baroque art [111]. In order to satisfy the requirements of the complicated literary programme drawn up for this project, Cortona invented a feigned architectural framework which subdivides the vault into five separate areas – a central field devoted to an allegorico-emblematic glorification of Pope Urban VIII, and, in the coving, four accessory mythological subjects. These richly diversified frescoes, embodying a highly sophisticated iconography, have been marshalled into a single, all-embracing composition of immense power and sweep. Through the skilful use of light, colour and atmosphere, Cortona creates the illusion of a vast and airy space in which weighty forms wheel and float above our heads in seeming defiance of gravity.

The possibility of linking images across an intervening space, hinted at by Carracci in the Farnese ceiling [20], was realized with astonishing effect by Pietro da Cortona in the fresco decoration of S. Maria in Vallicella [127]. In the half-dome of the apse is seen the *Assumption of the Virgin*, and in the cupola the *Holy Trinity in Glory*. Though these subjects are painted in separate architectural fields, firmly marked off by heavy and ornate frames, they are grasped by the beholder standing in the nave of the church as related parts of a single whole. Mary, borne up on clouds within the lower zone formed by the vaulting of the apse, has already begun the miraculous ascent that will carry her on a diagonal course through the space of the crossing into the celestial realm of the dome, where she will be received by Christ and God the Father. Because the Assumption is understood to traverse his own space, the spectator feels himself a participant in the sacred mystery.

One of the most imaginative of the many solutions devised by Bernini for the energizing of an interior space may be seen in the

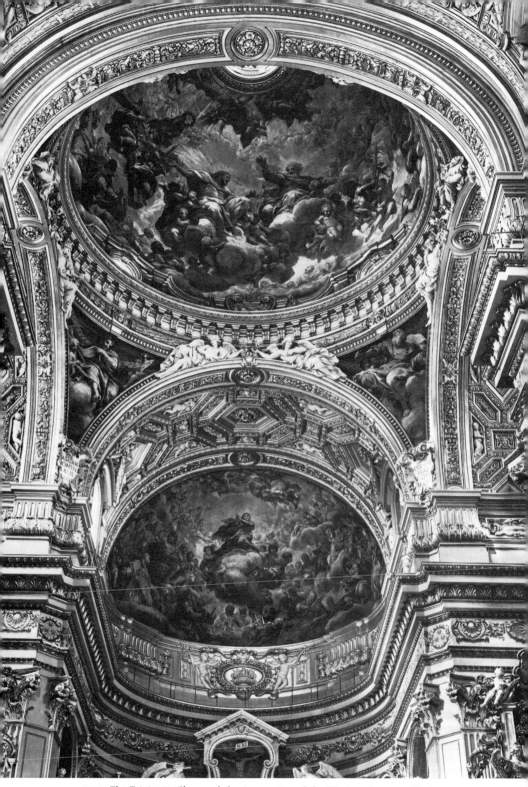

127. *The Trinity in Glory and the Assumption of the Virgin*, 1647–51. Cortona

Chigi Chapel in S. Maria del Popolo, for which the artist made two sculptures. In one of the narrow niches of the chapel appears the figure of Daniel praying in the lions' den. Diagonally opposite him is the prophet *Habakkuk* [128A, B] who, against his will, is to be borne

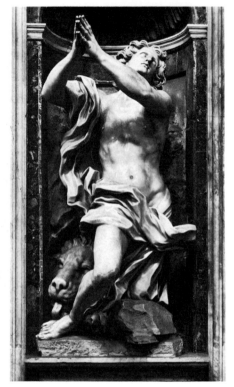 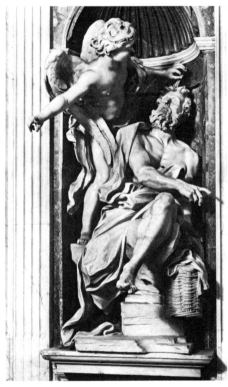

128A. *Daniel,* 1655–61. Bernini

128B. *Habakkuk and the Angel,* 1655–61. Bernini

by an angel to Daniel's den. The seated prophet points questioningly to the unseen reapers to whom he had intended to carry food; but the angel of God, seizing him by the hair, points with an even more emphatic gesture towards Daniel, thus setting up a line of force between the two that runs across the intermediate space in which the beholder stands.

The practice of making companion portraits of man and wife likewise afforded a means of establishing communication between separate pictures. In the pair of canvases representing Stephanus Geraerdts and Isabella Coymans (now unhappily divided, the former being in the Antwerp Museum and the latter in a private collection in Paris), Frans Hals wittily unites the two sitters in a reciprocal action

that gives positive value to what would otherwise be an empty and meaningless void between them [129, 130]: the gentleman, seated casually at the left, holds out his hand to take the rose proffered by his wife, who turns her head to look at him with a smile as she does so.

129. *Stephanus Geraerdts*, *c.* 1650–52. Hals

130. *Isabella Coymans*, *c.* 1650–52. Hals

THE OBSERVER AND THE WORK OF ART

The *Christ of Clemency* by Martínez Montañés [32] does not present itself as an independent, self-sufficient piece of sculpture, but fulfils its purpose only when the beholder willingly takes his place within the prepared space lying immediately in front of it. In a similar way Bernini's *David* [49] is completed by the observer's awareness of an unseen Goliath in the very space that he himself occupies. Duquesnoy's serene *St Susanna* [209], though she may at first glance appear to be a 'classical' statue, impersonal and detached, can in fact only be understood as belonging to a specific spatial setting in the church of S. Maria di Loreto where, gazing directly at the worshipper, she transfers his attention to the altar.

The painter, though he works on a two-dimensional surface, may nevertheless exert some measure of control over three-dimensional space. In *Las Meninas* [131], a work aptly described by Luca Giordano as 'the theology of painting',[5] Velazquez puts himself in the company

of the Infanta Margarita and her attendants, as if to offer visible proof of the nobility of art. Standing before a large canvas with palette and brushes in hand, the artist looks at the figures of King Philip IV and his queen, Mariana of Austria, who, since we see them reflected

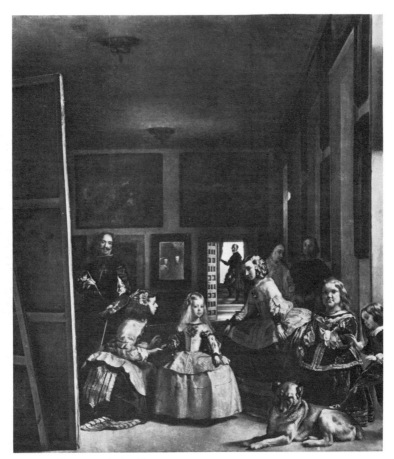

131. *Las Meninas*, 1656. Velazquez

in the mirror on the rear wall, must be assumed to be standing in front of the picture. By thus conjuring up presences both within and outside the painting, Velazquez creates a psychological as well as a spatial tension between the work of art and the beholder.

Rembrandt – even the later, 'withdrawn', Rembrandt – can show comparable instances of the direct involvement of the observer in the spatial-psychological sphere created by the work of art. In the last of his great corporation portraits, the so-called *Syndics* [132], he represents the five sampling officials of the Amsterdam Cloth Guild seated at a table with a servant in attendance – a traditional grouping not

unlike that adopted by Hals in his *Women Regents of the Old Men's* *Home* [67]. H. van de Waal has rightly objected to the anecdotal interpretation of the *Syndics*, which would make of this scene a public meeting at which the officials, seated on a platform, have been interrupted by someone in the audience as they present an account of their stewardship to the members of the guild, supposedly gathered in the hall before them.[6] There is in fact no justification for such a novelistic reading of this corporation portrait, which belongs to an established tradition in Dutch painting. The actions and gestures of the Syndics are to be understood as representative of their office and not as indignant responses to an objector. On the other hand, it may seem that too much has been made, in recent Rembrandt literature, of the

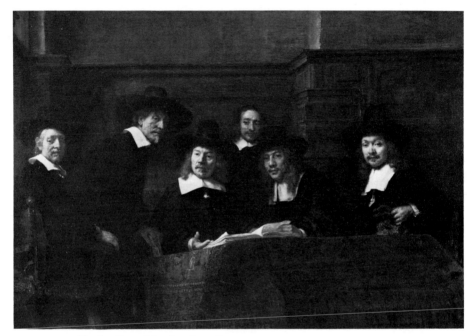

132. *The Syndics*, 1662. Rembrandt

classical serenity and composure of the Syndics: it has become virtually obligatory, for example, to cite the influence of Leonardo's *Last Supper* (which was undeniably known to Rembrandt through various copies). Yet the table at which the *Staalmeesters* are seated is not really analogous to Leonardo's: not only is it seen from below in a provocative and quite unclassical manner but it is placed obliquely so that its long side lies at an angle of something like 60 degrees to the picture plane. In spite of the tranquillity and ordered quality of its surface composition, the work thrusts itself upon the observer in an active and forcible way. It is not necessary to invent an elaborate scenario

to explain the rapport between the Syndics and the spectator: as he looks up to them, so do they stare back sharply at him. The two worlds interlock, physically and psychically.

THE PROGRESSION FROM THE SENSIBLE PHENOMENON TO THE SUPERSENSIBLE REALITY

The notion that Baroque artists, by creating illusory appearances, were simply indulging in a form of theatrical trickery is too absurd to be taken seriously. The purpose of illusionism was not merely to astonish but to persuade, and, especially in the case of devotional subjects, to assist the viewer to lift his mind from the transitory things of this world to the eternal things of the spirit.

In the Salviati Chapel in S. Gregorio al Celio in Rome there is a venerated image of the Madonna which was believed to have spoken to Pope Gregory the Great. For this chapel Annibale Carracci was commissioned to paint an altarpiece representing *St Gregory Praying for the Souls in Purgatory* (Fig. 13, p. 338). The painting is now lost, but an early idea for the work is to be seen in a preparatory study at Chatsworth [133]. The saint, who is attended by two angels, kneels on a cushion in the foreground and directs his prayer to the holy icon which is mounted on the wall to his left. While one of the accompanying angels points to the image of the Madonna with a vigorous gesture that violates the picture plane, the other indicates the heavenward flight of a human soul released from Purgatory. The artist's intention,

133. *St Gregory praying for the Souls in Purgatory.* c. 1600–1601. Annibale Carracci

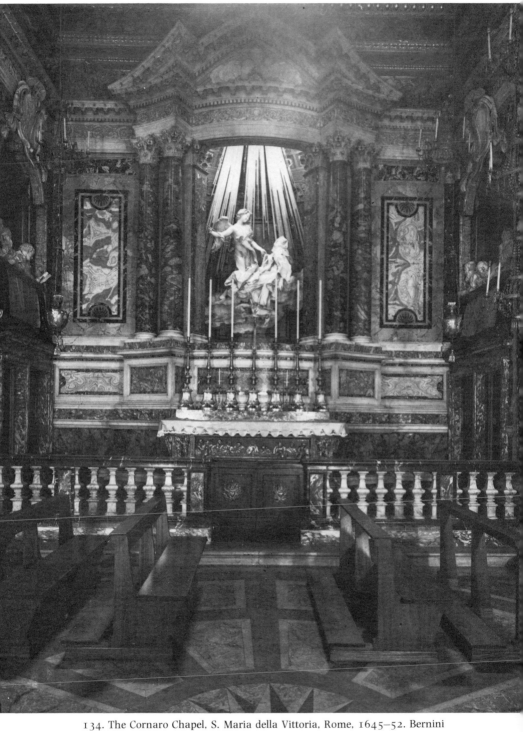

134. The Cornaro Chapel, S. Maria della Vittoria, Rome, 1645–52. Bernini

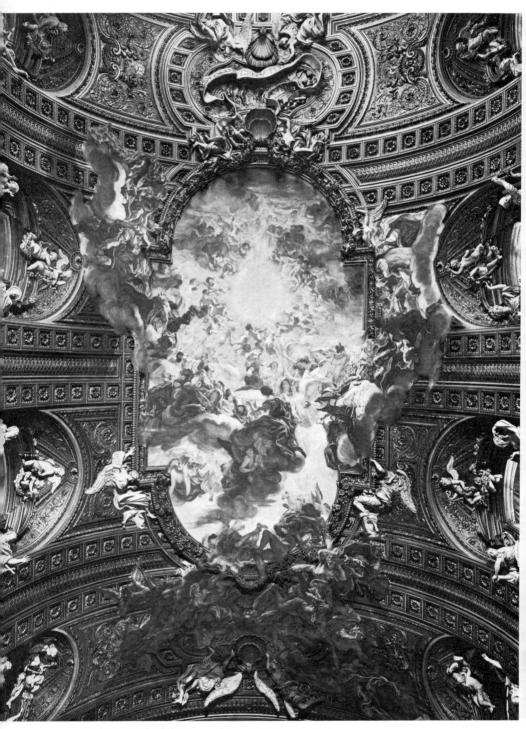

135. *The Triumph of the Name of Jesus*, 1676–9. Baciccio

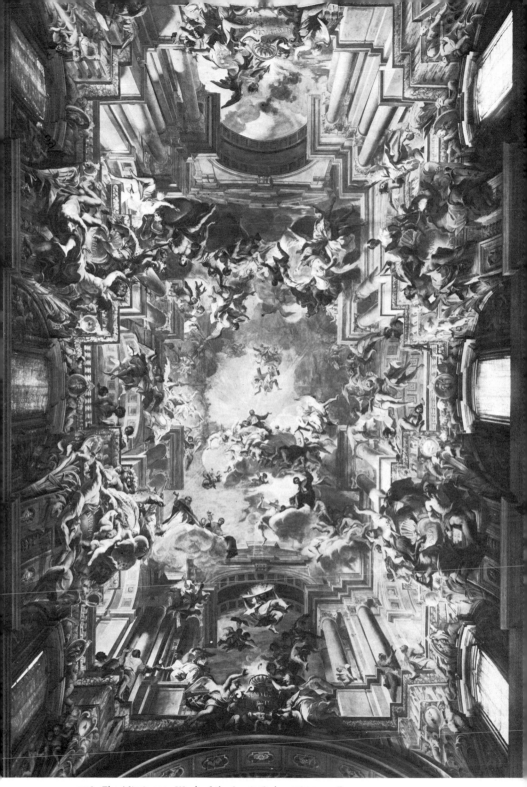

136. *The Missionary Work of the Jesuit Order*, 1691–4. Pozzo

stated more emphatically in the preparatory drawing than in the finished painting, is very clear: the observer standing before the picture is to be made to feel that, instead of occupying a neutral void, he has entered a magnetic field in which his thoughts will be turned to a higher reality.

The theme of the figure in prayer whose gaze is ardently fastened upon an external object was also treated by Bernini in the impassioned portrait of *Gabriele Fonseca* [71]. Looking out from a window-like niche in the chapel, the subject raises his eyes to a painting of the Annunciation above the altar to his left. With one hand pressed to his heart and the other grasping a rosary, Fonseca leans forward with a look of intense longing on his face, so that his whole being appears to be drawn from the narrow limits of this life to the eternal world of the spirit.

The *Fonseca* is one of Bernini's last works. It was in the decoration of the Cornaro Chapel, many years earlier, that the great sculptor had already developed the possibilities of a charged interior space [134]. Above the altar is a convex architectural canopy which appears to expand and burst open, as if in response to a potent spiritual force from within, to disclose the Ecstasy of St Teresa, illumined by rays of supernatural light [76]. The source of that light is explained by the frescoes on the vault, where angels part the clouds to allow the celestial radiance to stream down upon Teresa and the angel. Placed in openings along the sides of the chapel are sculptured figures representing members of the Cornaro family, who contemplate and discuss amongst themselves the mystery here made visible. Dwelling in a space that is both of this world and of the mind, they share with the beholder – and thereby redouble for him – the experience of supernatural revelation.

That an illusion of infinite space can evoke feelings of spiritual exaltation was obviously understood by the painters who decorated the ceilings of the two great Jesuit churches in Rome. Baciccio, in his ceiling of the Gesù [135], and Andrea Pozzo, in his ceiling of S. Ignazio [136], utilized illusionistic devices such as those perfected by Bernini and Cortona in order to make of the vision of Ignatius of Loyola a scene of apocalyptic splendour. In both of these extraordinary works, the heavens are opened to admit streams of light, in which the saint may be seen floating on a cloud in ecstatic contemplation of the divine mystery; and the observer, by identifying himself with Ignatius thus giddily suspended in mid air, is enabled to taste of the saint's mystical rapture and release from earthly bonds. In his treatise on perspective, written for the guidance of painters and architects, Pozzo takes it for granted that spatial illusionism may carry spiritual meaning when he says, 'Therefore, Reader, my Advice is, that you cheerfully begin your Work, with a Resolution to draw all the lines thereof to that true Point, the Glory of GOD.'[7]

The Baroque sense of the totality and continuity of space – of plurality in unity – was perhaps more fully realized in landscape than in any other subject. The interest in landscape, significantly, is widespread in the seventeenth century. It is an interest that brings together such diverse personalities as Carracci, Rubens, Poussin and Rembrandt, to name only a few of those who, without being specialists in the subject, turned their attention to landscape at some point in their career.

It is certainly not true to say that every Baroque landscape offers a prospect of immense, far-reaching space; for the visual realism of the seventeenth century effectively excluded the fantastic mountain scenery and the vast world-panoramas beloved by Mannerist artists. Although the use of perspective to achieve an illusion of great depth is not uncommon (Hobbema's *Avenue at Middelharnis* is a familiar example), the spaciousness of many seventeenth-century landscapes is implied rather than represented: the viewer is made to feel that the scene that is opened before him is accessible, but that it is at the same time only part of an immeasurably larger expanse.

For the Baroque artist, moreover, nature is to be understood in the light of human experience. It is for this reason that landscapes without figures are very rare – even in Holland, where painters commonly dispense altogether with narrative subject-matter and are content to represent nature for its own sake.

The continuity of space may be suggested by travellers making their way through the countryside. In Hobbema's *Village Road* [137], figures stroll along a path that winds through open fields, past farm-houses and beneath great trees, where patches of sunlight and shade

137. *The Village Road*, 1665. Hobbema

produce an effect comparable to the alternating bands of light and dark in De Witte's *Church Interior* [126].

Carracci's *Landscape with the Flight into Egypt* [36] invites the beholder to share the experience of the weary refugees who, having crossed a river by boat, are now trudging up the bank. The theme of passage and the change of scene is reinforced by other moving forms — the flock of sheep trooping down the farther bank, the birds skimming over the water or sailing through the sky, the herdsman with his cows, a solitary horseman and (because Egypt is the destination of the wayfarers) the camels on the distant hillside at the left. Very different is Elsheimer's charming nocturne [44], which represents the Holy Family journeying through a darkened moonlit world where men and animals are at rest. An effect of infinite extension is provided by the firmament with its panoply of stars; prominent amongst these, as we have seen, is the constellation of the Great Bear, which serves as a guide to travellers because it never sets and because it points to the pole star.

Claude Lorrain introduces another form of the journey through the landscape in the biblical story of *The Expulsion of Hagar* [138]. At the insistence of his wife Sarah, the patriarch Abraham dismisses the bondwoman Hagar and her son Ishmael from his house. The pair are seen standing before a palatial doorway, while Abraham points to the awesome landscape vista that fills so much of the background as to become what is almost an independent picture. The contrast between the ordered security of their life in Abraham's household and

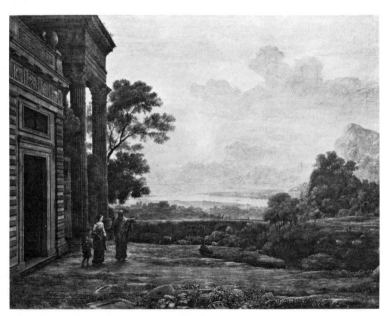

138. *The Expulsion of Hagar*, 1668. Claude

the uncertain fate that awaits the defenceless mother and child in an inhospitable world could not be more poetically expressed.

In the famous seaport pictures Claude treats the theme of travel into the unknown even more explicitly. *The Embarkation of the Queen of Sheba* [139] represents the preparations for the departure of the queen to visit King Solomon (although in fact the biblical account

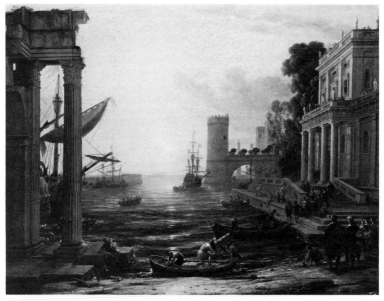

139. *The Embarkation of the Queen of Sheba*, 1648. Claude

says nothing of a voyage by ship). Sheba and her retinue, descending the steps of the stately building in the middle distance, are about to enter a barge that will convey them to the ship lying at anchor behind the ruined structure on the left, while trunks and bales are being loaded into the small boat pulled up on the foreground shore. The time is early morning, and the harbour is filled with sunlight. The air of gentle nostalgia that envelops the scene is made more piquant by the expectation of departure. For Sheba and her attendants are on the point of sailing out of the sheltered haven into the immense and sunlit ocean that lies beyond. The resemblance to the title-page of Bacon's *Novum Organum* [41] is not entirely fortuitous: both employ the imagery of the sailing vessel and the voyage through uncharted seas to evoke the idea of the illimitable.

In all landscape painting of the seventeenth century there is nothing to equal the Dutch panoramic view. As has already been noted, the type is anticipated very early in the century in drawings by Goltzius [37] and reaches its full development after several generations in the work of such masters as Philips Koninck and Jacob van Ruisdael. The

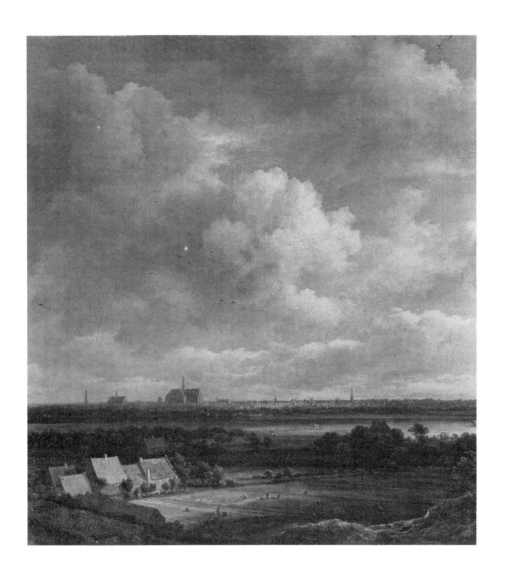

140. *View of Haarlem, c.* 1670. Ruisdael

latter's *View of Haarlem* [140], one of several paintings of this subject, is breathtaking in its subjugation of multifarious detail — houses and trees and workers in the bleaching-fields — to a single unified vision of heroic scale and grandeur. The eye moves rapidly across the level ground and its shifting patterns of light and dark to the distant horizon, where it is momentarily arrested by the commanding shape of the Grote Kerk. Rising dramatically over the land is the immense vault of heaven which, with its great clouds rolling upward and forward in majestic progression, has the effect of lifting the whole scene from the plane of the local and particular to the realm of the infinite and spiritual. The spatial illusionism of Roman Baroque ceiling paintings finds its northern counterpart in the skies of Ruisdael.

One of the most conspicuous differences between the landscapes of the Dutch school and those of Rubens is that the Flemish master gives comparatively little attention to the sky, even when, as in *The Castle*

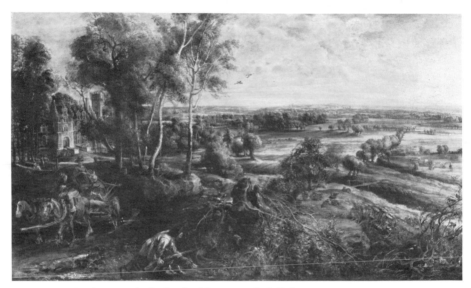

141. *Landscape with the Castle of Steen, c.* 1636. Rubens

of Steen [141], he paints a similarly flat terrain. The picture represents the artist's own country house near Antwerp and the surrounding woodland and pasture. It is characteristic of Rubens — the painter of material abundance and sensuous vitality — that the task of space-creation is chiefly entrusted to the fertile land, which occupies fully two thirds of the surface of the panel and is traversed by long sweeping diagonals formed by lines of trees and other natural features. The work is full of the quiver and murmur of life, the rustle of wind in the leaves and the warm and shimmering light on the trees and fields. The activities of man in this rustic world are not overlooked: the

142. Detail of 141

farmer and his wife fording a stream in their wagon, the hunter and his dog stalking partridges, the dairy-maids on their way to milk the cows and, deep within the grove at the left, the members of Rubens's family taking their ease in the garden before the castle [142]. All this busy life and movement acquires greater universality by being set against a vista of seemingly endless space, in which we may imagine innumerable repetitions of such incidents (like Bruno's plurality of worlds), extending far beyond the reach of sight.

The landscapes of Poussin offer no such sensuous and exhilarating panoramas, but are constructed according to the method of a still life, in which the formal and spatial relationships of objects are thought out with deliberation and care. In the *Landscape with St John on Patmos* [143] the whole world of nature — from the nearest trees and slopes to the configuration of the distant mountain — seems to have been shaped in harmony with the human form of the Evangelist; and the severe geometry of the architectural fragments in the foreground is

echoed in the temple and other buildings behind the grove of trees.
Yet it is not true that Poussin conceives of nature only as a painted
backdrop for man. The heroic scale, the depth and amplitude of the
scene, and the unification both of the space and its diverse forms give
to this landscape its all-encompassing quality.

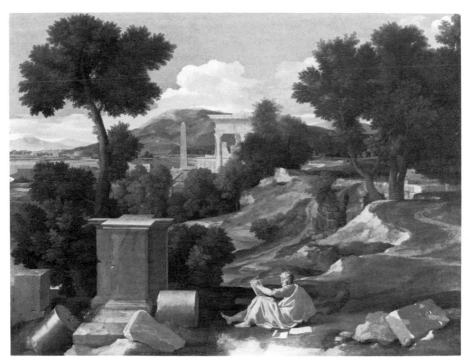

143. *Landscape with St John on Patmos, c.* 1644–5. Poussin

THE EXPANDING WORLD AND THE TASTE FOR THE EXOTIC

Allegories such as Rubens's *Four Continents* [90] and Bernini's
Fountain of the Four Rivers in Piazza Navona [3] testify to the Baroque
consciousness of distant lands and peoples. The revolution in geo-
graphy, which had begun long before with the exploits of the first
Portuguese navigators, was still in progress. In the opinion of Francis
Bacon, the great voyages of discovery of the sixteenth and seventeenth
centuries gave proof of the general increase of knowledge; this, as we
have already seen, is the theme of the engraved title-page of the
Novum Organum of 1620 [41]. But Bacon may have overestimated the
rapidity with which the new geographical knowledge had penetrated
the common understanding. The circumnavigation of the globe had
been accomplished by Magellan fully a hundred years before; yet even
after a century of colonization and trade, of missionary activity and
ruthless exploitation, during which time European art became in-

creasingly receptive to the exotic and the foreign, the knowledge of geography and of alien cultures was often remarkably vague and confused.

Baroque exoticism generally took the form of views of strange and remote regions, both real and imaginary, and of motifs borrowed from various non-European sources, the latter sometimes combined in such a way as to indicate that the difference between the East and West Indies was not always perfectly understood. As a rule, exotic details were simply applied as superficial enrichments; the basic fabric of Baroque art remained unchanged. It was left to the eighteenth century to invent, in the shape of Rococo *chinoiserie*, a whole decorative system inspired by the art of the Far East.

Rubens's painting of *The Miracles of St Francis Xavier* [59], though the scene is laid in the Orient, is uncompromisingly occidental in all but a very few details. The columns of the pagan temple belong to the Corinthian Order, and the balusters, mouldings and other architectural elements are likewise all of classical design. To lend local colour to his subject the artist has inserted a few persons in oriental dress: the tall transparent head-gear worn by one of the spectators in the middle distance, for example, is of a distinct Korean type. Authentic details of this sort were probably picked up by Rubens from Jesuit missionaries in Antwerp who had served in the Indies.[8] The monstrous heathen idols, however, may be regarded as figments of the artist's imagination.

In Holland, it was chiefly through overseas trade that artists acquired their knowledge of the Far East. By the mid seventeenth century immense quantities of oriental articles were being brought to the United Provinces by the ships of the Dutch East India Company. It was at this time that the Delft potteries began to produce their famous blue-and-white ware in imitation of Chinese and Japanese porcelain. Some of these objects made no pretence of copying an oriental model, but were merely decorated with exotic 'Chinese' ornament. A particularly amusing specimen of this kind is the wig-stand manufactured at Delft about 1675, now in the Victoria and Albert Museum [144], which has pseudo-Chinese figures in a fantastic landscape setting. Whether the decoration of this piece bears any relation to its homely function it is perhaps useless to speculate.

The taste for oriental lacquered furniture was already widespread in the early seventeenth century. In England of the Restoration period, when the demand for lacquer could no longer be satisfied by the importation of articles from the Far East, local craftsmen were inspired to develop a simplified method of 'japanning' in imitation of Eastern works. The technical procedures are fully described in the *Treatise of Japaning and Varnishing* (1688) by John Stalker and George Parker, who begin by observing that 'that Island [Japan] not being

able to furnish these parts with work of this kind, the English and Frenchmen have endeavoured to imitate them; that by these means the Nobility and Gentry might be completely furnisht with whole Setts of Japan-work'. The volume is illustrated with a number of quaint designs [145], in which the authors modestly claim to have 'exactly imitated their Buildings, Towers and Steeples, Figures, Rocks

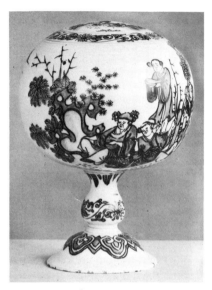

144. Wig-stand,
c. 1675–80. Van Eenhorn

145. Designs for cabinet drawers,
1688. Stalker and Parker

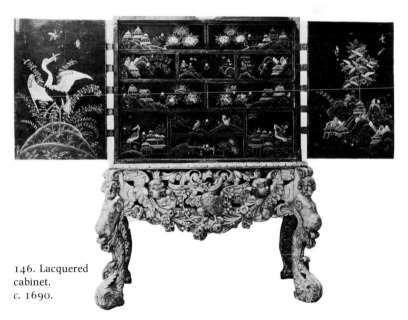

146. Lacquered
cabinet,
c. 1690.

and the like, according to the Patterns which the best workmen amongst them have afforded us on their Cabinets, Screens, Boxes, &c.' It is of course impossible to form an adequate idea of lacquered work from these crude engravings. How exotic patterns of this kind were put to use by professional decorators may be seen in an English japanned cabinet of about 1690 [146], the drawers of which are covered with oriental scenes which, though certainly superior in quality, closely resemble those in Stalker and Parker.

It is sometimes forgotten that there were many channels of communication, both diplomatic and commercial, between Europe and the Near East in the later sixteenth and early seventeenth century. These contacts gave rise, among other things, to the western vogue of oriental dress. One of the first to adopt this exotic fashion was Sir Robert Sherley, an Englishman who served as envoy for the Shah of Persia and who was painted in colourful Persian dress by Van Dyck in 1622 [147]; a companion portrait represents Sherley's Circassian wife. A year or two later Rubens painted the Flemish merchant Nicolas de Respaigne in Turkish costume (Cassel), and this same portly oriental personage also appears in Rubens's paintings of *Queen Tomyris with the Head of Cyrus* (Boston) and *The Adoration of the Magi* of 1624 (Antwerp, Royal Museum).

The interaction of East and West was especially fruitful in the seventeenth century, when on the one hand Islamic art came under European influence, and on the other the importation of oriental miniatures brought before the eyes of western artists some of the most elegant and sophisticated products of Islamic design. It has been shown, for example, that Rubens's Costume Book in the British Museum contains several drawings after contemporary Persian miniature paintings of courtly personages.[9] Rembrandt also found a source of inspiration in Islamic painting. In the 1650s he made a number of fairly faithful copies after a group of Mughal miniatures. One of these copies [148], executed on Japanese paper, represents two Indian princes, one with a falcon and the other with bow and arrow. The figures are set down with a delicacy of draughtsmanship that preserves the archaic simplicity and dignity of the original. The value of the Mughal miniatures, in Rembrandt's eyes, was that they furnished reliable images of the people of the exotic East, a region which he naïvely thought of as including the Holy Land of biblical times.

The lingering confusion between the 'Indian' peoples of the Americas and those of the Orient doubtless contributed to the spirit of exotic fantasy that characterizes so many images of the New World in the seventeenth century. But it is also evident that artists often chose to disregard well-known facts in order to conjure up a purely imaginary America: geographical discoveries were not allowed to dissipate the aura of mystery that still enshrouded the lands beyond the seas.

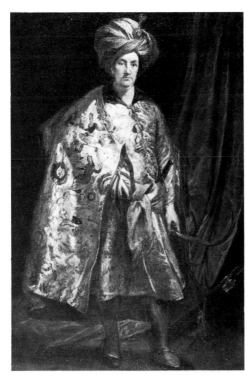

147. *Sir Robert Sherley,* 1622. Van Dyck

148. *Two Indian Noblemen, c.* 1654–6. Rembrandt

This fanciful conception of the New World was one that lent itself particularly to theatrical representation. In 1608, as part of the festivities held in Florence to celebrate the wedding of Prince Cosimo de' Medici, Giulio Parigi designed a stage setting for an intermezzo showing the ship of Amerigo Vespucci in the West Indies [149]. The scene opened to disclose a rocky coastline of fantastic crags and palm trees, amongst which could be seen a native hut and several wild beasts, one of them a rhinoceros. Sailing across the waters of the cove was the ship of the Florentine navigator who gave his name to America. (The engraving of the intermezzo also includes the two machines which appeared after the vessel had passed from view – a

NAVE DI AMERIGO VESPVCCI INTERMEDIO QVARTO

149. *The Ship of Amerigo Vespucci*, 1608. Cantagallina after Parigi

rocky reef rising from the sea and a heavenly apparition in the sky.) The scenery may be described as conventional exotic.

Fantastic settings of this kind might be made still more awesome by invoking the fury of the elements. In his *Shipwreck off the American Coast* [150] the Flemish marine painter Bonaventura Peeters imagines a wild and rugged shore, a violent storm and a great ship being dashed to pieces on the rocks, while Indians watch the luckless sailors from a ledge that conveniently overlooks the scene.

The first European artist to paint American landscapes was Frans Post, who accompanied Count Johan Maurits of Nassau on his expedition to Brazil in 1637 and remained there until 1644. Post's view of the São Francisco River [151], painted in Brazil in 1638, is recognizably the work of a Dutch artist; the composition, with its low horizon, its broad expanse of sky enlivened by clouds, and its wedge of bank serving as a *repoussoir*, is a familiar one in Dutch river

views from Esajas van de Velde to Jan Vermeer. As a sober topo- graphical record of a particular American site it presents a striking contrast to Peeters's fanciful *Shipwreck*. Yet there is undeniably an exotic quality about this Brazilian scene that does not result solely from the presence of such strange and unfamiliar features as the cactus tree and the amiable little beast munching leaves in the foreground. By adopting a naïve manner of representation, by isolating the forms of branches, plants and grasses so as to emphasize their two-dimensional silhouettes, Post suggests an appropriately non-European or 'primitive' milieu, not unlike that created two centuries later by the Douanier Rousseau.

150. *A Shipwreck off the American coast, c.* 1648. Peeters

151. *The São Francisco River and Fort Maurice,* 1638. Post

The most distinctive feature of Baroque architecture is its mastery of space. And it is just to this controlled movement of space, both interior and exterior, that we must look to find the closest affinity with the representational arts. The forecourt principle employed by many architects bears an evident relation to the development of a field of force in front of the work of painting or sculpture. On the façade of the Barberini Palace in Rome, Carlo Maderno, and after him Bernini, did away with the traditional fortress-like wall of the urban palazzo and threw open the whole central mass of the building in three tiers of loggias, as if the enclosed courtyard of a 'normal' palace had been unexpectedly revealed to public view [152, 152A]. The resulting flow of space from the forecourt into the very heart of the palace corresponds to the illusion of coextensive space in the figurative arts.

The methods adopted by Italian architects of the seventeenth century to effect this kind of spatial interpenetration are wonderfully varied and imaginative. Pietro da Cortona, remodelling the front of S. Maria della Pace [153, 153A], dramatizes the entrance by setting before it a semicircular portico, the expansive rotundity of which is countered by the concave arc of the wings that enframe the upper storey of the façade, while the columns of the porch seem to group themselves in such a way as to give free access to the interior. A similar interplay of convexity and concavity – of spatial advance and retreat – may be observed in Bernini's church of S. Andrea al

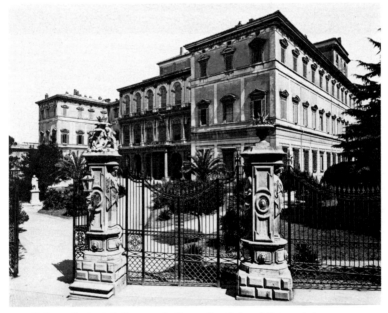

152. Palazzo Barberini, Rome, 1628–33. Bernini and Borromini.
The neo-Baroque gateway, *c*. 1880, by Azzurri

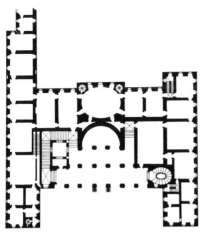

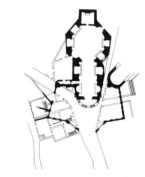

152A. Palazzo Barberini, Rome,
plan

153A. S. Maria della Pace, Rome,
plan of church and piazza

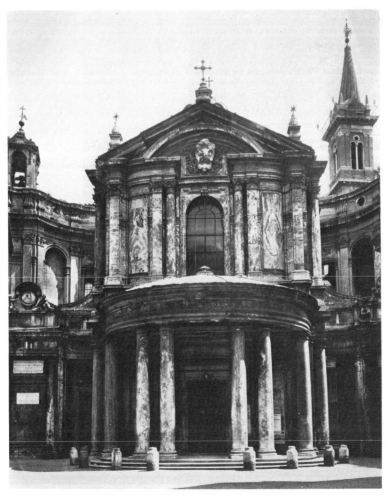

153. S. Maria della Pace, Rome, 1656–7. Cortona

Quirinale [6]. The visitor approaching the building at once feels himself engaged by the bold thrust of the columned porch, the semicircular steps and the curving walls at the sides. Entering the church [154], he

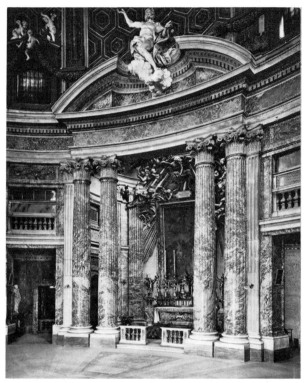

154. S. Andrea al Quirinale, Rome, interior, 1658–70. Bernini

finds himself in a space of provocative mobility – a dome-capped oval, the longer axis of which lies at right angles to the façade. Of the various forces generated by this extraordinary interior, the most potent is that which presses forward and upward from the sanctuary: through an opening in the curved pediment the figure (or better, the soul) of St Andrew appears to be borne aloft towards the celestial light that issues from the lantern of the dome.[10]

Borromini is no less inventive in creating an architecture that appears to respond organically to the flow of space from within and without. The most brilliant and original of Borromini's achievements is perhaps the façade of S. Carlo alle Quattro Fontane [155], the wall of which undulates in a sinuous curve, advancing in the centre as if to obtrude upon the observer's attention. The concave-convex-concave rhythm of the lower storey is altered at the upper level, where all three bays are concave; but the presence of a cylindrical aedicule in the central bay restores the illusion of forward thrust at that point.

155. S. Carlo alle Quattro Fontane, Rome, 1665–7. Borromini

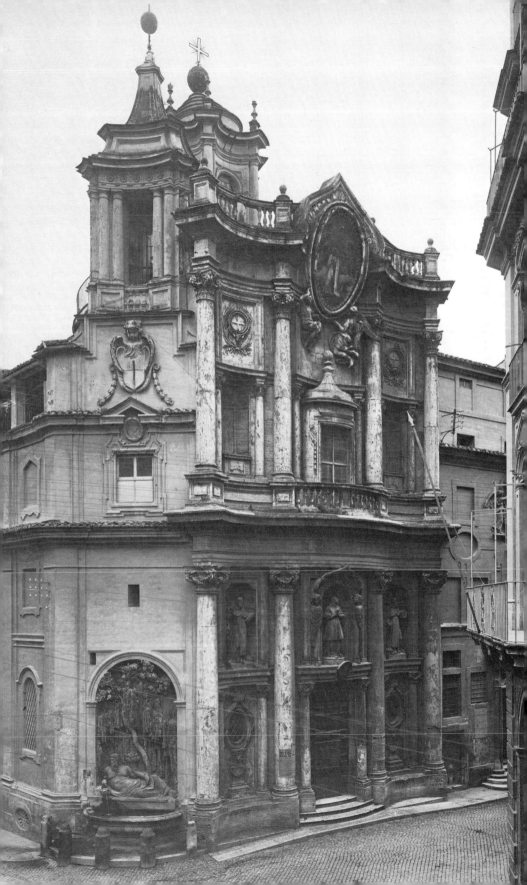

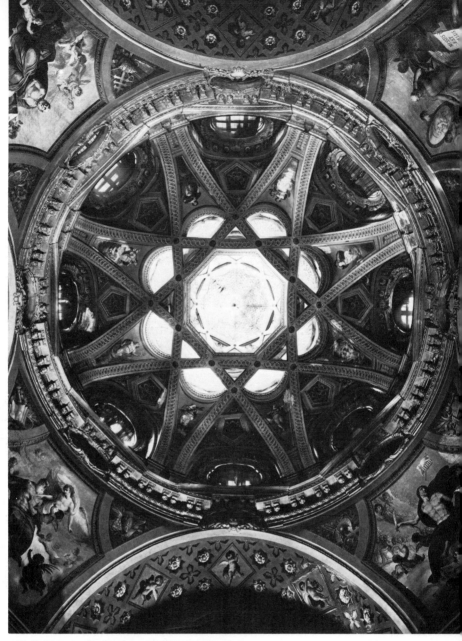

156. S. Lorenzo, Turin, dome, 1668–87. Guarini

In the churches of Guarino Guarini the dome is the *primum mobile* of space. Instead of presenting to the view a structure of solid enclosing surfaces, the dome, as Guarini conceives it, is a crowning feature to be dissolved into fragile reticulations suspended in the air without apparent means of support. The observer, looking up at the dome of S. Lorenzo in Turin [156, 156A], sees an astonishing complex of intersecting ribs forming an intricate starlike pattern; and over this is

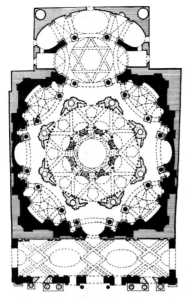

156A. S. Lorenzo, Turin, plan

poised a second dome which seems to be all but dematerialized by light. The contradictions and anomalies of Guarini's architecture have the effect, through their denial of architectural logic, of shifting the emphasis from the material to the ethereal. Painters such as Pozzo [136] are able to bring the experience of infinite space into church interiors by means of cunning perspective illusionism; Guarini's achievement is to produce a comparable result through a purely abstract geometry of architectural forms.

The diminutive scale of Bernini's S. Andrea al Quirinale and Borromini's S. Carlo illustrates the fallacy of the notion that massive size is the leading characteristic of seventeenth-century architecture. Vast complexes such as the sixteenth-century palace of the Escorial and the eighteenth-century palace at Caserta are a reminder that grandiose scale was not a monopoly of the Baroque. Yet it is undeniable that the taste for the very large is everywhere in evidence at this period, and that Baroque architects, like Baroque painters, had the capacity to think in monumental terms.

Some of the largest and most magnificent structures of the seventeenth century reflect a desire not only to achieve sheer bigness but also to command imposing tracts of space. Bernini made use of the restless and space-evoking properties of the oval in laying out the noble colonnades which shape but do not rigidly enclose the Piazza of St Peter's [118]. As in S. Andrea al Quirinale, an element of surprise is provided by the fact that the longer axis of the oval lies at right angles to the principal direction followed by the visitor.

The overwhelming impression made by the palace of Versailles would be notably diminished if it were not for the immense gardens designed by André Le Nôtre [113]. There is something about the breathtaking prospect from the terrace of the palace that conveys, as no words can do, the grandeur, the pride and the aspirations of the age of Louis XIV. A seemingly limitless expanse has been regulated and brought under control by a rational geometric plan which spreads before the eyes of the observer a variegated pattern of avenues, parterres, bodies of water and groves of trees, adorned at selected points with elaborate sculptures and fountains. The majesty of this landscape vista was not lost upon Mansart and Le Brun, who succeeded in making it part of their design for the Galerie des Glaces [157, 158]. The tall windows overlooking the gardens on one side and the matching mirrors reflecting the same view on the other fill the huge room with space and light and thus make it seem even larger than it is.

157. The Galerie des Glaces, Versailles, 1678–84, Hardouin Mansart and Le Brun

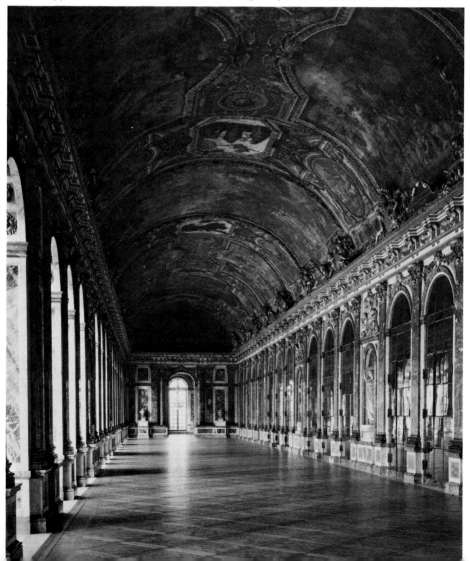

158. *The Galerie des Glaces, Versailles*, 1680. Engraving by Le Clerc

In the Town Hall of Amsterdam, Jacob van Campen prepared a dramatic and unexpected climax in the central block of the building. As the visitor reaches the top of the narrow staircase leading from the entrance to the main floor, he finds himself in the huge Burgerzaal [119]. Here the space seems to expand abruptly and with intoxicating effect, soaring through two full storeys and finding release through the windows and the passageways at the sides and ends. The universal significance of this great hall was to have been set forth by an extensive programme of decorations covering both floor and ceiling.

STAGE DESIGN

No discussion of space in Baroque art would be complete without at least a passing reference to stage design. It may be well to emphasize that we are not concerned here with the scenography of the eighteenth century. The *scena per angolo*, for example, invented about 1700 by Ferdinando Bibiena, is commonly spoken of as 'Baroque' because of its obliquely placed architecture and its exhilarating vistas leading away at angles. Yet this solution does not, strictly speaking, belong to our period. The true Baroque stage setting is symmetrical [149]. The reason is that in seventeenth-century scenic design the space of the stage (the world of art) is regarded as coextensive with that of the auditorium (the real world). It therefore follows that the perspective of the stage scenery must be coordinated with the axis and scale of the theatre as a whole.

Bernini thought in terms of coextensive space when he devised the stage machinery for his theatrical spectacles. We are told of a performance of Bernini's comedy, *The Inundation of the Tiber*, in which the illusion of water breaking through the dikes and flowing across

the stage was managed so skilfully that the spectators rose to their feet in fear of being engulfed by the flood.[11]

Ludovico Burnacini, who was born in Vienna and worked there for the Austrian court, produced some of the most grandiose theatrical spectacles of the seventeenth century, now known to us only through engravings. For the opera *Il Fuoco Eterno*, performed at Vienna in 1674, Burnacini designed twelve stage settings. One of these shows *The Atrium of the Temple of the Vestals* [159]. The scene is framed on either side by rows of paired columns to give the impression of long walls receding in exaggerated perspective towards a central vanish-

159. *The Atrium of the Temple of the Vestals*, 1674. Küsel after Burnacini

ing-point. The niche that closes the space in the distance is largely hidden by the statue of Vesta set on a high pedestal in the middle of the stage. The sky is left open (and this is usually true even of interior settings) so as to allow heavenly figures on clouds to be lowered into view by means of elaborate machinery. There are many parallels in religious art to the *deus ex machina* of the Baroque theatre, one of which is Algardi's relief of *Pope Leo I and Attila*, with its dramatic interposition of the Apostles Peter and Paul [124].

The appearance of the *scena per angolo* in the early eighteenth century is an indication that by this time the symmetrical scenic design, having lost its *raison d'être*, had become boring. For Bibiena and his followers the stage setting no longer represented an extension of the space of the auditorium but was a spectacle to be looked at, as it were, from outside. And this, as we have already noted, is a post-Baroque development.

6

Time's glory is to calm contending kings,
To unmask falsehood and bring truth to light,
To stamp the seal of time in aged things,
To wake the morn and sentinel the night,
To wrong the wronger till he render right,
 To ruinate proud buildings with thy
 hours,
 And smear with dust their glittering
 golden towers.

Shakespeare, *The Rape of Lucrece* (1594)

Time

'No period', wrote Erwin Panofsky, 'has been so obsessed with the depth and width, the horror and the sublimity of the concept of time as the Baroque, the period in which man found himself confronted with the infinite as a quality of the universe instead of as a prerogative of God.'[1] At the root of this obsession lay the findings of the new science. One may well imagine the disturbing implications of Galileo's theory of motion, which entails a view of the universe as a world of bodies moving in space and time without regard to theological notions of man and his salvation. It rests with man, according to Hobbes, to find the fulfilment of his desires and aspirations in this fleeting world. 'For there is no such thing as perpetual tranquillity of mind, while we live here; because life itself is but motion, and can never be without desire, nor without fear, no more than without sense.'[2] In such a climate, when 'new Philosophy calls all in doubt', the well-worn theme of the transience of human life begins to take on more pointed meaning, and art itself seems actuated by the restless flow of time.

The advances in science and in astronomical observation brought about in the seventeenth century a new concern with accuracy in the

measurement of time. In this development Holland took the lead. The pendulum clock was invented in 1656 by Christiaen Huygens, who also devised the spiral balance spring for watches. The 'democratization' of timepieces in this period is reflected in the increasing numbers of clocks and watches that make their appearance in Dutch genre and still life paintings [102, 104].

Much more imposing than these domestic instruments is the ornate Dutch silver clock made by H. C. Breghtel about 1660 [160]. For the decoration of this elaborate mechanical work the silversmith felt it necessary to employ the traditional imagery of time. The base is

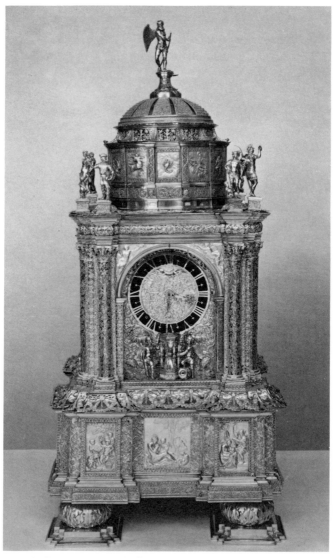

160. Clock, *c.* 1660. Breghtel

decorated with panels representing the Months; on each of the four
sides, the spandrels of the central arch contain figures personifying the
Four Elements; and the drum of the dome bears a series of panels with
the Signs of the Zodiac. That the clock should be crowned with the
figure of winged Time carrying his scythe may seem appropriate
enough; but it is a little surprising to find directly beneath the dial-
plate two *putti* with an hour-glass.

In painting, the impression of transitoriness and mutability is
perhaps most marked in the work of the Dutch masters. The river
views of Jan van Goyen [161] depict a world of sky and water in which

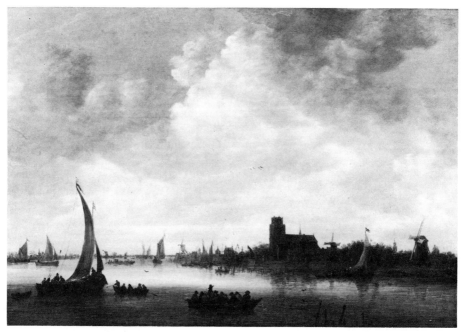

161. *View of Dordrecht*, 1653. Van Goyen

nothing is fixed or static; the shifting clouds will dissolve, only to
assume new and ever-changing shapes; the sailing-vessels are in
motion on the river; the passengers in the little ferry-boat will soon
be put ashore. The very brushwork, by its lightness of touch and lack
of precise definition, is suggestive of inconstancy and change. In the
same way, Hals's *Merry Drinker* is glimpsed in a provocatively fleeting
pose – one hand gesturing, the other holding a glass, the eyes twink-
ling and the lips parted in speech; and here too the whole is set down
with a kind of vivid impressionism that contributes to an effect of
continuous and unarrested movement.

The illusion of temporality and the passing moment is also of
fundamental importance in the art of Bernini, the magician in whose

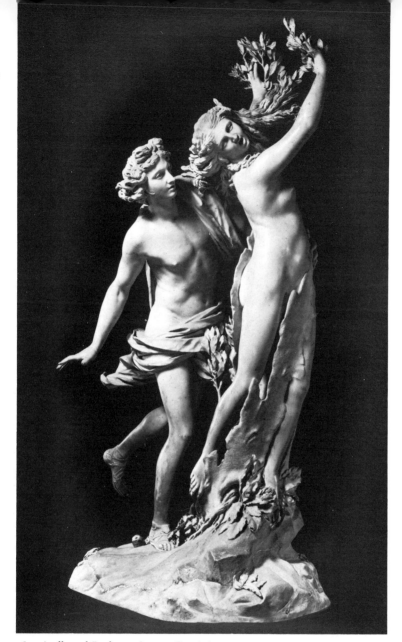

162. *Apollo and Daphne*, 1622–5. Bernini

hands marble becomes pliant and variable in form. Apollo and Daphne [162] are represented at the instant – or is it a succession of instants? – when the god, having overtaken the fleeing nymph, reaches out to embrace her, only to see his beloved being transformed into a laurel tree before his eyes, while she, imagining herself to be still in flight, seems unaware that her prayer has been answered, that roots have sprung from her toes, that her fingers have put out leafy branches and that a hard case of bark has begun to envelop her body.

The visitor to the church of S. Maria in Vallicella, as he looks in the direction of the altar, sees a complex scheme of ceiling decoration comprising the *Assumption of the Virgin* in the apse and (only partly visible) the *Holy Trinity in Glory* in the dome [127]. From the nave (as was pointed out in an earlier chapter) the two frescoes appear to form a single composition spanning the entire zone of the sanctuary and crossing. But as the observer moves closer to the altar, the scene changes: the painted dome, when seen from a point directly below, presents a different appearance and becomes in fact an independent picture [163]. The dominant feature is no longer the figures of God

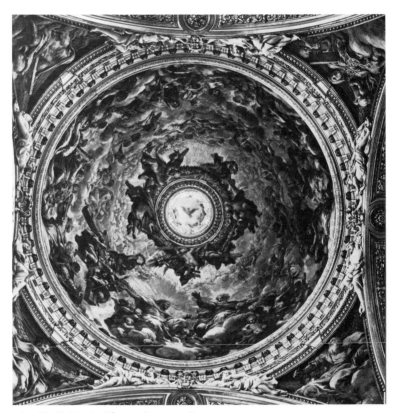

163. *The Trinity in Glory*, 1647–51. Cortona

the Father and Christ waiting to receive the Virgin Mary in her ascent to heaven, but the Dove of the Holy Spirit in the brightly lit circle at the apex, which moreover seems by a perspective illusion to have descended from above into the wide space at the bottom of the dome. The fresco decoration thus embodies two distinct aspects, which are designed to be seen in succession from predetermined points of view; it is the movement of the observer in space and time that brings the second and climactic image into focus.

When Time must be personified, he invariably appears as an old man whose attributes — his wings, a scythe and a serpent biting its tail — denote the swiftness of his flight, his destructive power and his quality of the eternal. It is that frightening swiftness that the young Milton alludes to when he writes,

> How soon hath Time, the subtle thief of youth,
> Stolen on his wing my three and twentieth year!

His all-consuming nature may be emphasized by picturing Time in the guise of Saturn devouring one of his children, as Pietro da Cortona does on the Barberini ceiling [111]; but even here the wings and the great scythe remain conspicuous.

The Flemish sculptor Lucas Faydherbe adheres to the usual type of Time the Destroyer in his tomb of Archbishop Andreas Cruesen [164]. The grim tyrant, his scythe held ready in his hands, advances menacingly upon the kneeling prelate, disregarding the efforts of an infant angel to drive him away. But Cruesen, for whom death holds no terror because of his confident hope in the resurrection, turns his back on Time to fix his eyes upon the risen Christ.

164. The Tomb of Archbishop Cruesen, begun 1660. Faydherbe

165. *Time the Destroyer*, 1638.
Perrier

166. Title-page, 1632.
Galle after Rubens

Time's malevolence is also revealed in the mouldering away of proud monuments of marble. On the Barberini ceiling, that portion of the architectural framework that is adjacent to the figure of Saturn can be seen to be crumbling into ruin as a result of the erosion of Time [111]. The fate that must befall even the noblest works of antiquity is graphically illustrated by François Perrier's engraving of Father Time gnawing at the Belvedere Torso [165], which forms an apt frontispiece to his book on 'Roman statues which have escaped the envious tooth of Time'. A more thoughtful and provocative view of this subject is to be found in a title-page designed by Rubens for a book on Greek and Roman coins [166]. At the upper right Time, aided by Death, hurls into the pit of oblivion four persons representing the great kingdoms of antiquity — Media, Persia, Macedonia and Rome. On the opposite side is illustrated the revival of antiquity in modern times. Mercury unearths with his shovel statues and busts of ancient rulers, while Hercules lifts up from the pit a vase full of coins. The lighted torch held by Minerva, goddess of the arts, signifies the illumination that is shed upon the monuments of antiquity by the study of numismatics. It is typical of Rubens, and his sophisticated understanding of the classical tradition, that he should introduce the concept of history in conjunction with that of time.

Poets and painters occasionally amused themselves with the fanciful notion that the tables might be turned and Time's swift progress

checked by Love. The frivolous spirit of such conceits is nicely exemplified by Simon Vouet's painting of *Time Vanquished by Hope, Love and Beauty* [167]. Beset by these two merry maidens, Time is literally brought to a halt: his deadly scythe slips from his hand and he falls to the ground, still clutching his hour-glass as he attempts to

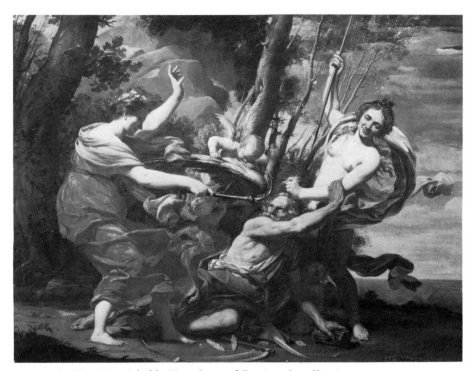

167. *Time Vanquished by Hope, Love and Beauty*, 1627. Vouet

defend himself against his attackers. Beauty, who playfully threatens him with a spear, has seized Time by the forelock, while Hope uses her anchor as a weapon to clip his wings and Cupid busily plucks out his feathers – a clever inversion of the theme of Time clipping Cupid's wings.[3]

Yet Time himself is only rarely present in works of art that treat of the fugacity of mortal things. The *Vanitas* still life, for example [102], with its death's head, its pocket watch and its emblems of human futility, makes its meaning perfectly clear without the intervention of the grim reaper. And the tooth of Time has plainly left its mark on the ruined buildings that overlook the forsaken graves in Ruisdael's *Jewish Cemetery* [106].

This kind of melancholic reflection on the brevity of human life was especially congenial to the romantic soul of Salvator Rosa, who gave full expression to it in his painting of *Democritus in Meditation*

[168]. The setting, which is even more forbidding than Ruisdael's
desolate burial-ground, could not be more conducive to gloomy
thoughts: broken ruins pushed aside by stark trees, a tomb, toppled
obelisks and a figure of Terminus, the Roman god of boundaries who
later came to signify death. Seated here amidst the grisly remains of

168. *Democritus in Meditation*, 1651. Salvator Rosa

human and animal life, the philosopher of whom it was said that he laughed at the follies of this world is at last reduced to utter despair as he contemplates the futility of existence.

The destruction wrought by time and the decay of beauty are themes that continually recur in the sonnets of Shakespeare, as when he writes,

> Thy glass will show thee how thy beauties wear,
> Thy dial how thy precious minutes waste.

Bernini adopts a similar conceit in his design for a mirror for Queen Christina of Sweden. Time (in this instance it is Time the Revealer as well as Time the Destroyer) lifts the curtain from the glass to unveil the image of mortality and decline [169]. The macabre idea of turning the mirror (normally the attribute of vanity and pride) into a kind of *memento mori* was presumably suggested by Christina herself. Rembrandt would have understood this symbolism. In the moving self-portraits of the artist's last years we may imagine him looking

169. Design for a mirror, *c.* 1670. Bernini

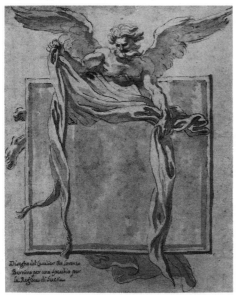

into the glass to see himself 'with Time's injurious hand crush'd and o'erworn'. The most remarkable, and the most enigmatic, of these works is the laughing self-portrait in Cologne [170]. Białostocki has convincingly shown that the artist, weighed down by age and decrepitude, here confronts a sculptured herm representing Terminus, the god of the boundary and of death (seen also in Rosa's painting), whose ominous motto is *Concedo nulli* – I yield to none.[4]

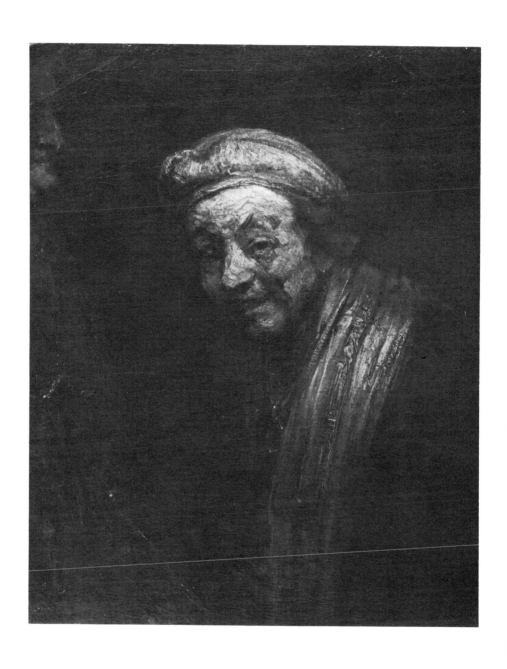

170. *Self-Portrait*, c. 1667–9. Rembrandt

It is not by chance that Death himself sometimes appropriates Time's wings and carries his scythe or hour-glass. For as regards man's brief existence, Time the Destroyer and Death are one. In 1672 Valdés Leal painted for the Church of the Brotherhood of Charity in Seville two 'Hieroglyphs of the Four Last Things'. The first of these grim and forbidding pictures, which bears the title *In Ictu Oculi*, shows a marble tomb surrounded by the customary emblematic objects of the *Vanitas* theme [171]. Death enters in the form of a

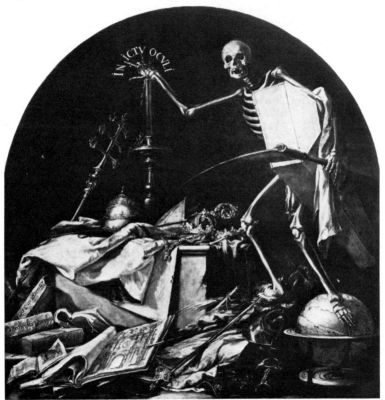

171. *In Ictu Oculi*, 1672. Valdés Leal

skeleton, carrying a coffin, shroud and scythe. Striding across the scene, with one foot standing on the globe of the world, he reaches out to quench the flame of a candle – a reminder that human life may be snuffed out 'in the twinkling of an eye'.

Death is also present as an active participant in Bernini's Tomb of Pope Alexander VII [172]. The pontiff kneels in prayer on a high pedestal, around which are the personifications of the virtues which he displayed in life – Charity at the left side, Prudence and Justice at the back; the remaining figure at the right, instead of representing the fourth of the Cardinal Virtues, Temperance, is identified as Truth by

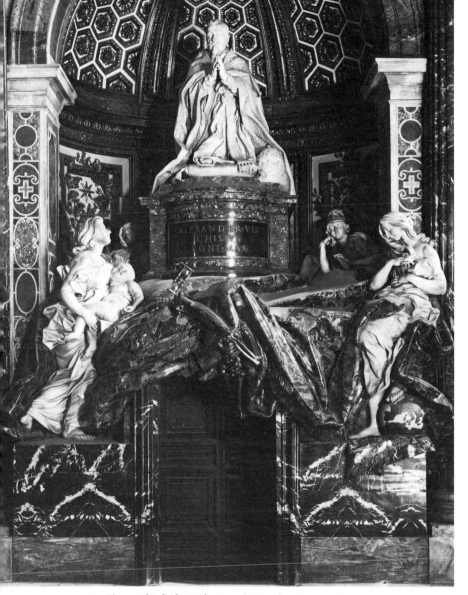

172. The tomb of Alexander VII, St Peter's, 1671–8. Bernini

the disk of the sun which she carries as her attribute and by the fact
that she rests her foot on the world. Death, a winged skeleton half
hidden in the shadows, eerily lifts the massive jasper pall that covers
the lower part of the monument to reveal a door which the artist
imagines as leading to a tomb chamber; one bony arm holds up the
hour-glass, the sands of which have run out. Yet it is noteworthy that
Bernini sets a limit to Death's triumph. For although Alexander's
mortal life is terminated by the tomb, Death is overshadowed in his
moment of victory by the light of Truth, whose presence ensures that
the virtues of the deceased will live on in the memory of men. Jacob

Jordaens devised a similar allegory for his *Triumph of Prince Frederick Henry* [110], in which Fame engages in an open struggle with Death.

It is not surprising that the gruesome skeletons and death's heads which are the common currency of so many Baroque allegories of time and human mortality should have been distasteful to Poussin. In the *Arcadian Shepherds* [11] he dealt with this theme in a characteristically calm and reflective manner. Three shepherds, accompanied by a girl, have come upon a tomb and stop to decipher the inscription carved in its surface: *Et in Arcadia Ego.* Slowly the realization dawns upon them that death is present even in Arcadia, that someone who once enjoyed the carefree life that they now lead is dead and buried in the tomb.

TIME THE REVEALER

That same winged Time, whose scythe mows all men down, has another, more benign duty, which is 'to unmask falsehood and bring truth to light'.

The theme of Truth rescued from concealment by her father Time was obviously one that could be adapted to a variety of metaphorical uses. Sir Thomas Browne speaks of 'that obscured Virgin half out of the Pit' to describe the achievements of the new science, which he characterizes as 'this noble Eluctation of Truth, wherein, against the tenacity of Prejudice and Prescription, this Century now prevaileth'.[5] But the allegory was more often employed for religious ends. During the sixteenth century the motto 'Truth revealed by Time' had been adopted by both Protestants and Catholics to justify the rightness of their cause. For the former it signified the belief that Christian Truth would in the fullness of time be freed from her imprisonment by the Papacy; by the latter it was taken to foretell the liberation of the true faith from the clutches of heresy. Only in the seventeenth century, when the heat of the controversy had somewhat diminished, was it possible for a master such as Rubens to translate this polemic imagery into a great work of art. Time plays an active and vigorous role in Rubens's *Triumph of Eucharistic Truth over Heresy* [173], where the enemies of the sacrament (amongst whom Calvin and Luther are especially prominent) have fallen victim to his scythe. Having vanquished these heretics, Time bodily lifts Truth into the sky. Since she is not Truth in general, but religious Truth, she wears shining white raiment and points upward to a scroll inscribed with the words *Hoc est corpus meum.*

But, as the art of Rubens also reminds us, 'Truth brought to light' could be used for personal as well as for religious vindication. Thus it was that for the concluding episode of the cycle glorifying Maria de'

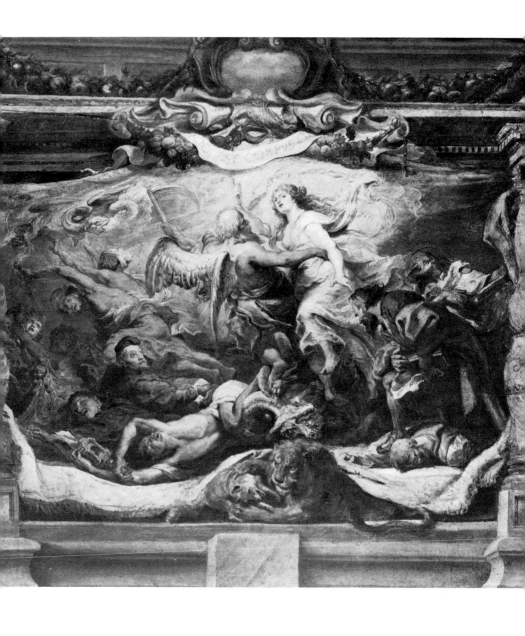

173. *The Triumph of Eucharistic Truth over Heresy, c.* 1625–6. Rubens

Medici Rubens painted *The Triumph of Truth* [174]. The picture pur-
ports to represent the reconciliation of the Queen Mother and her son
Louis XIII, who offers her a wreath containing a flaming heart and
clasped hands, as emblems of love and concord. Beneath the royal
pair, who have taken their place in heaven like gods, Father Time flies
upward carrying his daughter Truth in order to affirm the veracity of
the entire history of Maria and of its happy ending in particular.
Since it was well known that the Queen and her son remained bitterly
hostile to each other, the figure of Truth in this scene must be under-

174. *The Triumph of Truth*, 1621–5. Rubens

stood not in an absolute but in a relative sense. (Rubens himself wrote
that when Louis XIII visited the Medici Gallery the paintings were
interpreted for him by the Abbé de St Ambroise, who showed great
skill in 'changing or concealing the true meaning'.)[6]

Cardinal Richelieu, the adviser and subsequently the enemy of
Maria de' Medici, was not slow in applying the Triumph of Truth to
his own situation when he in turn became the object of hostile
criticism. The ceiling painting which he commissioned from Poussin
shows *Time Rescuing Truth from Envy and Discord* [175] and was

175. *Time Rescuing Truth from Envy and Discord*, 1641. Poussin

intended as an allegorical statement of the cardinal's victory over his
detractors. Time's heavenward flight is made more dramatic by the
foreshortened view from below and by the attitude of Truth, who
spreads her arms and turns her face ecstatically up to the light.

It was not only princes who sought to defend their reputation by
appealing to Truth as the daughter of Time. The sculptor Bernini,
when he found himself in disgrace over the failure of his plans for the
façade of St Peter's, likewise turned to this subject as a means of

alleviating injured pride. Believing himself to be the victim of ignorance and envy, Bernini set about designing a monumental sculptural group of Truth revealed by Time. As he himself explained, the winged figure of Time was to have been supported by columns, obelisks and mausolea overturned and destroyed by him.[7] In the end, the statue of Truth alone was completed [26]; but in this extraordinary fragment, which we have already discussed in previous chapters, the sculptor far surpassed his original narrow aim of mere self-justification.

Bernini's intention was to unite Time the Destroyer and Time the Revealer in a single personification. Jordaens made use of a similar combination of ideas in one of his pictures for the Orange Hall of the Huis ten Bosch. Beside his huge *Triumph of Prince Frederick Henry* [110] he placed a smaller canvas representing Time, portly and elderly, but

176. *Time Mowing Down Slander and Vice and Death Strangling Envy*, 1650. Jordaens

still a formidable figure, striding over fallen buildings and wielding his scythe with furious energy to mow down Slander, Deceit and those other vices who would malign the good name of the prince [176]. Even Death, though he lends a helping hand by strangling Envy, is himself overcome by Time, who bears two little children on his wings to signify 'the transformation of old into new'. Time the annihilator is thus fused with Time the regenerator.

THE REVOLUTIONS OF TIME

In the recurrent cycle of night and day the Baroque artist saw an illustration of Time as a cosmic principle governing the very rhythm of human existence. The classic statement of the theme is Guido

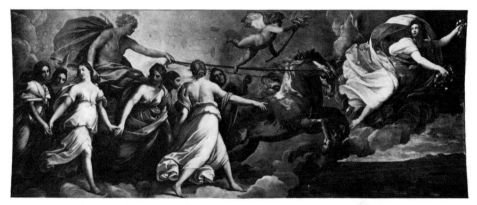

177. *Aurora*, 1613–14. Guido Reni

Reni's incomparably graceful fresco, always known, if not quite correctly, as *Aurora* [177]. The radiant sun-god Apollo, accompanied by dancing maidens representing the Hours, rides in a chariot drawn through the sky by dappled horses. At the head of the procession is Aurora, goddess of the dawn, who strews over the darkened earth the flowers that mark the first rays of daylight. As she floats along with her draperies fluttering in the breeze, she turns her head to see behind her the full glory of the rising sun. Some years later Guercino produced a ceiling painting [178] that goes far beyond Reni's conception in its imaginative reach and in its expansion of the pictorial field. Guercino's fresco presents a total illusion, embracing walls as well as ceiling. The spectator, looking upwards, sees Aurora, seated in her own horse-drawn chariot, being rapidly conveyed across the open sky. At the left end of the vault, that is to say behind Aurora, the personification of Day appears to float into the room, and at the opposite end Night lurks in shadow with her children Sleep and Death (Fig. 19, p. 348).

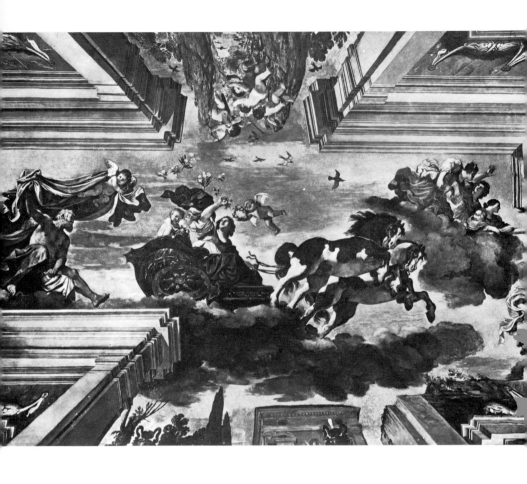

178. *Aurora*, 1621. Guercino

The daring foreshortening, the spirited execution and the effect of light spreading over the world evoke in a most telling way the endless turning of time.

The motif of Aurora and the rising sun carries the same meaning in the art of Poussin. In *The Dance of Human Life* [91] the passage of these

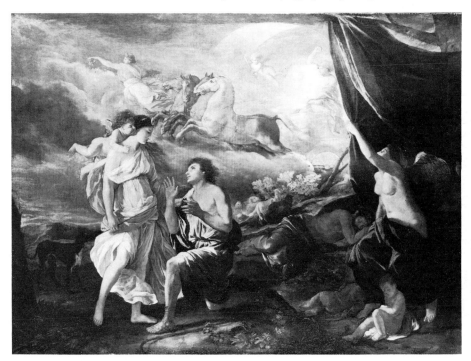

179. *Diana and Endymion, c.* 1631–3. Poussin

luminaries across the heavens forms an obbligato to the principal theme of the picture – the dance to the music of Time. Aurora and the chariot of the sun are even more prominent in the painting of *Diana and Endymion* [179], which tells of the love of the moon-goddess for the shepherd Endymion, whom she can visit only by night. It is the moment of dawn, and Endymion is shown kneeling in adoration before the lovely goddess as both realize that she must leave him. For winged Night, at whose feet lie Sleep and Death, is already drawing back the curtain of darkness which has concealed the lovers to disclose the brightening sky, where Aurora springs upwards to announce the ascent of Apollo in his chariot.

Sunrise and sunset remind us, as do no other hours of the day, of the relentless advance of Time, whose duty is 'to wake the morn and sentinel the night'. It is not by chance that so many of the paintings of Claude Lorrain are devoted to the poetry of these fleeting moments. Scenes of embarkation generally take place in the light of early

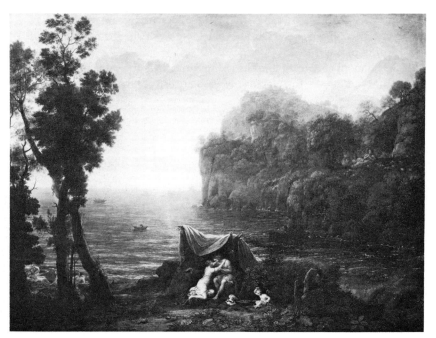

180. *Landscape with Acis and Galatea*, 1657. Claude

morning [139], whereas sunset is made to cast an aura of nostalgia over the ruins of ancient Rome [202]. The setting sun also contributes to the mood and meaning of the *Landscape with Acis and Galatea* [180], a work in which everything seems to suggest the uninterrupted flow of time. The sea-nymph Galatea and her lover Acis are seen embracing under a shelter on the foreground shore, oblivious of the Cyclops Polyphemus who plays his pipes on a distant promontory. On the surface the scene is one of idyllic calm and peacefulness. But there is a threat of the danger to come in the erupting volcano and the heavy clouds hanging in the sky; for Polyphemus, maddened by Galatea's indifference to his amorous serenade, will rise and destroy his rival Acis by hurling a boulder at him. The fragility of human happiness is aptly symbolized by the failing light of the setting sun, soon to give way to darkness and death; and the rippled surface of the water might almost be taken as an illustration of Shakespeare's lines,

> Like as the waves make towards the pebbled shore,
> So do our minutes hasten to their end.

Rubens's great landscape known as *The Mired Cart* [181] actually shows in one picture the transition from day to night. Though the sun still shines over the upland countryside on the right side, the low terrain at the left already presents a nocturnal aspect: the moon has

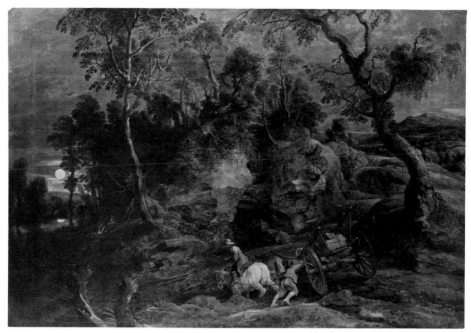

181. *The Mired Cart, c.* 1615–17. Rubens

risen, and bats fly through the darkened air. The sense of time elapsed between daylight and nightfall is reinforced by the fact that the eye, passing from one area to the other, is momentarily arrested by the massive rocky outcropping in the middle of the picture and by the episode of the heavily loaded wagon which threatens to overturn.

It is not only by the regular succession of day and night that the endless rotations of time may be allegorized. Poussin's *Dance of Human Life* [91] represents, as we have seen, the recurrent cycle in which civilizations rise from rude Poverty by means of Labour to a state of Wealth and thence to one of Luxury, reverting at last to their original lowly condition. This 'giddy round of Fortune's wheel' is governed by the incessant rhythm of Time's lyre.

The ballet performed to the music of Time recurs in an etching by Claude Lorrain [182]. In a pastoral landscape made more charming by picturesque ruins, Father Time sits strumming his harp. The sun god Apollo personally conducts four lightly tripping maidens into the presence of the ancient tyrant who sets the tempo for heaven and earth alike. Led by Spring, they come forward hand in hand to begin the dance which denotes the perpetual round of the seasons.

Otto van Veen, the master of Rubens, treated the cycle of the year in one of the emblems of his *Emblemata Horatiana* of 1607 [183]. Beneath a sundial held by a winged *putto*, the four seasons are pictured

182. *Time, Apollo and the Seasons,* 1662. Claude

marching in single file. Spring is an eager child; Summer a dancing young woman with spikes of grain; Autumn, laden with fruits, represents maturity; and Winter, wrapped in a mantle and carrying a brazier against the cold, walks with a stick to signify old age. The

183. *The Four Seasons,* 1607. Van Veen

crescent moon, continually waxing and waning, and the serpent biting its tail denote the eternal cycles of time, in contrast to man's brief existence. The emblem was inspired by these lines from an ode by Horace (IV, 7):

The year and the hour that snatches the kindly day from us warn thee not to hope for immortality. The frosts soften under the zephyrs. Summer tramples spring underfoot, but must herself perish as soon as fruit-bearing autumn pours forth its harvest; and inert winter soon returns. Yet the quickly-changing moons make good these heavenly losses; but we, when we have gone down to where Aeneas, wealthy Tullus, and Ancus have gone, are but dust and shadow.[8]

The representation of the times of the year in the form of landscape views, which in the sixteenth century had been raised to a sublime level by the genius of Pieter Bruegel the Elder, was kept alive by Netherlandish draughtsmen and engravers of the succeeding century. But of the leading masters of the Baroque the only one to produce a series of landscapes dealing with this traditional subject was Nicolas Poussin, whose canvases of *The Four Seasons* have always been recognized as an artistic and intellectual achievement of the highest order. The complex allusiveness of this great cycle has been indicated in an earlier chapter; the seasons are figured by Old Testament stories

184. *Spring: The Earthly Paradise*, 1660–64. Poussin

which may also be read as referring to the times of day and (like the personifications in Van Veen's emblem) to the stages of human life. *Spring*, which is represented by the Earthly Paradise [184], is full of bright beginnings – of flowers and verdant foliage, of the human race, of childhood, and of daybreak and the early morning hours. Behind the screen of rocks and trees at the left the rays of the rising sun have already filled the land with light. In *Summer*, Ruth has sheaves of wheat, and the spies in *Autumn* carry grapes. At each stage in this grand cycle of the Seasons we are conscious of the endless revolutions of time and the eternal processes of life, death and the renewal of life.

7

Just as in this corporeal world there is a light
by means of which whatever things exist continue to be preserved,
so also in the archetype, that invisible
 and super-celestial world, there is a light from which,
as from an abundant source, all things proceed . . .
and of which this material light is, so to speak, but a symbol.

Athanasius Kircher, *Ars magna lucis et umbrae* (1646)

Light

When writers of an earlier day spoke of Caravaggio's 'tenebrism' they were acknowledging that that artist's effects of light depend principally on contrast: in Caravaggio's universe there can be no light without darkness. The formula is in fact a rather artificial one [8]; a beam of strongly polarized light, slanting from the upper left, is trained upon a group of figures assembled in a darkened space so as to throw significant features into vivid relief, while leaving the rest in impenetrable shadow. Though the source and nature of the light are not specified, the manner in which it falls upon bodies is so carefully observed that it appears to be extremely realistic. The impact of Caravaggio's chiaroscuro manner, and the meaning that it held for his younger contemporaries, may be gauged from the great wave of Caravaggism that swept over western Europe in the first decades of the seventeenth century.

In the hands of his followers, Caravaggio's system of lighting from an unspecified external source underwent certain modifications, the most important of which was the development of the true nocturne. The Dutch painter Gerrit van Honthorst, for example, introduced a form of candlelight illumination [40] which was widely imitated, even by so great an artist as Georges de La Tour [56]. Yet in the works of these masters, as in those of Caravaggio himself, it is still the circumambient darkness that gives to the light its force and meaning.

Few artists went as far as Elsheimer in the multiplicity of sources of light in night scenes. His *Flight into Egypt* [44] includes, in addition to a star-filled sky and a full moon (which is also reflected in the water), the lantern carried by Joseph and the campfire that the shepherds have lit to keep themselves warm.

LIGHT AS NATURAL PHENOMENON

We have already taken note in a previous chapter of the function of light in defining space. The ordered vistas which Pieter de Hooch unrolls in his paintings of serene Dutch interiors owe much of their charm to the softly changing effects of light and shadow as the observer moves, in imagination, from one room to the next. De Witte adopts a similar method for his beautiful *Interior of a Church* of 1668 [126], where the space is articulated and made more resonant by the broad shafts of sunlight that pass between the columns to create striking patterns on the floor and vaulting. Vermeer can suggest a whole outdoor world by placing a figure near a window, through which he tantalizingly allows us to see nothing. Only the light that floods into the room creates an irresistible sense of the continuum of space.

The painters of landscape, notwithstanding their diversity of style, were united in recognizing that light is the animating principle of naturalism. The lyrical quality of the landscapes of Claude Lorrain, and the extraordinary sense of freshness and immediacy that they communicate to the observer, are mainly to be attributed to the shimmering light that permeates the pictorial space, softening the contours of trees and buildings and glistening on the surface of water [202]. With Poussin, the sensuous feeling for the light of nature, though it is less conspicuous in his painted landscapes, emerges with extraordinary power in drawings made by the artist on the spot, such as that of the Aventine Hill [185]. We look directly into the brilliant morning sunshine that spills down the hillside; the areas of shadow are handled with such sensitivity that the white of the paper seems to vibrate with the movement of the light as it dances and sparkles on the leaves. In the work of a master such as Ruisdael space is energized through the action of light. In *The Mill at Wijk bij Duurstede* [186] it is as if chance beams of sunlight were breaking through the moving cloud masses and falling in unexpected patches on the water and on the side of the mill. These lighted areas, suggestive of the swiftly changing moods of nature, are distributed in such a way as to carry the eye through the entire field of depth.

It was perhaps only to be expected of Bernini, whose mastery of theatrical illusion we have already mentioned, that he should have invented a stage device to represent the rising of the sun. Living as we do in interiors illumined by electricity, it is difficult for us to imagine that

185. *The Aventine Hill, c.* 1645. Poussin

186. *The Mill at Wijk bij Duurstede, c.* 1670. Ruisdael

our ancestors were capable of subtle effects of lighting. Yet Bernini's machine was so successful and the effect of sunrise so much admired that King Louis XIII of France was said to have asked for a model of it.[1]

In spite of the fact that his usual subject is the prosaic domestic interior and (what is even more disconcerting) that he probably made use of a mechanical aid in the form of a camera obscura, Vermeer of Delft is one of the supreme poets of light in Baroque art. The limpid daylight that streams through the window in *A Maidservant Pouring Milk* [45], while it astonishes us by its verisimilitude, seems at the same time to metamorphose everything that it touches into a jewel-like state transcending mere realism. It is possible that the peculiar phenomena of light revealed by the imperfect lens of the camera obscura (notably the so-called 'circles of confusion') took on in the artist's mind a quasi-mystical import precisely because they were things that could not be seen with the unaided eye.

DIVINE LIGHT

One of the consequences of the Baroque predilection for representing even symbols in explicitly naturalistic terms was that the uses of light as the visible manifestation of the supernatural were vastly expanded. Some of the possibilities thus opened up to artists were demonstrated by Caravaggio in the grand series of devotional pictures painted in Rome during the first years of the seventeenth century. *The Madonna of Loreto* [187] shows two poor and ill-dressed pilgrims, kneeling in prayer at the shrine of the Virgin, who are granted the privilege of seeing the Madonna and Child appear before them in the flesh and of receiving Christ's blessing. The miracle is manifested through the agency of the heavenly light that penetrates the oppressive darkness, illumining the holy Mother and Child and opening the eyes of the pilgrims to their presence. This dualistic conception of light, which even when it carries a spiritual meaning, as it unmistakably does here, must conform to the material laws of sense, is one of Caravaggio's most inspired inventions.

Lanfranco employs a similar diagonal composition and a similar fall of light in his *Ecstasy of St Margaret* [75]. The rapt emotion of the saint, overpowered by the sudden appearance of the Crucified, is intensified by the explosive burst of light that invades the shadowy mortal world.

A supernatural presence may be intimated by light, even when no divine being is visible. When he represents the *Conversion of St Paul on the Road to Damascus* [188], Caravaggio ignores the conventional iconography of the scene and boldly omits the customary apparition of Christ in the sky. The harrowing visionary experience undergone

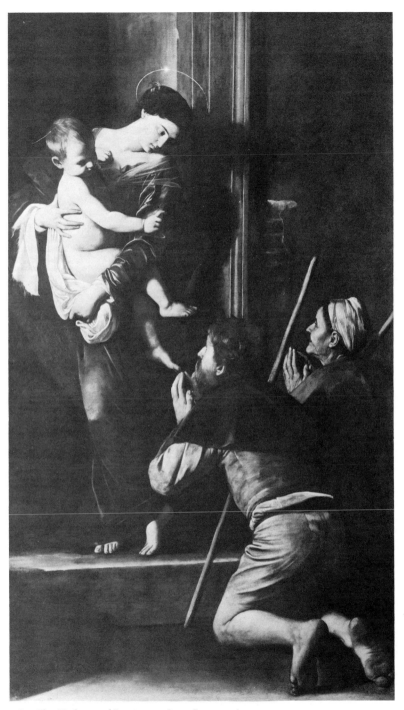

187. *The Madonna of Loreto, c.* 1604. Caravaggio

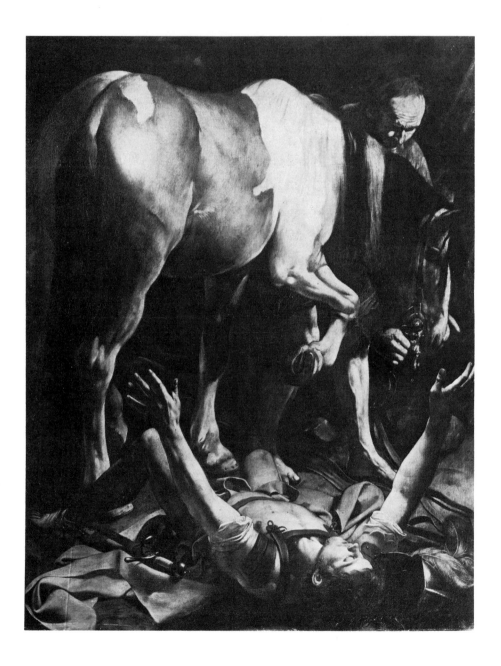

by Paul is thus reduced to the beam of heavenly light which both blinds the outward eye and brings inner illumination. Even the austere Philippe de Champaigne resorts to this device in the votive picture known as *The Two Nuns of Port Royal* [189]. The work illustrates the miraculous cure of the artist's daughter, who was a nun at the Jansenist convent of Port Royal and who had been left helpless by an attack of paralysis. It is the very moment of the miracle, when the

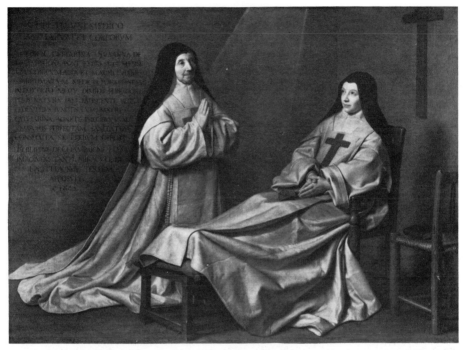

189. *Two Nuns of Port Royal*, 1662. Philippe de Champaigne

young woman is restored to health. Yet there are no excited movements or gestures, nor any sign of divine intervention, except for the single ray of light that shines into the bare cell between the seated nun and the kneeling abbess.

The writings of the German mystic Jakob Boehme (1575–1624) offer certain striking analogies to the work of Baroque painters, above all Caravaggio and Rembrandt, in the symbolic interpretation of light and dark as fundamental contrasts. Boehme published an account of his visions in his first book, the *Aurora* of 1612. There is of course no reason to think that Rembrandt, or any other artist, might have known or been directly influenced by the abstruse speculations of this 'Teutonic theosopher'.[2]

The light from above which announces to a mortal the presence of divinity is a distinctive feature of Rembrandt's great mythological

190. *Danaë*, 1636. Rembrandt

narrative, the *Danaë* in Leningrad [190]. Jupiter's appearance to Danaë in the form of a 'golden shower' had traditionally been interpreted (by Titian, for example) as a rain of coins falling upon the girl. Rembrandt gives a wholly new meaning to the fable by showing Danaë's servant in the act of pulling aside a curtain to admit a flood of golden light. The nude heroine, awaiting the advent of the god with joyous expectation, raises her hand as if to shield her eyes from the splendour of the celestial illumination and at the same time to welcome her lover, whose radiance already envelops her body in its caress.

Biblical subjects may also be made to yield fresh meanings through the action of light. When Ribera represents *The Dream of Jacob* [191],

191. *The Dream of Jacob*, 1639. Ribera

the ladder reaching from heaven to earth, with 'the angels of God ascending and descending on it', becomes a broad stream of light which falls upon the sleeping figure and which signifies both the presence of God and his promise to be with Jacob and watch over him. Jacob's dream might thus be said to be assimilated to the mystical vision of Baroque devotional art.

In the monumental decorative projects of the Roman Baroque, light frequently connotes limitless space. The elaborate spectacle unfolded by Baciccio on the ceiling of the Gesù [135] achieves its effect through the illusion of celestial light, emanating from the monogram of Jesus at an infinite distance in the heavens and continuing with undiminished force into the actual space of the church.

The introduction of real light as part of the formal vocabulary of the work of art is a dramatic, but not wholly unexpected, innovation of the Baroque age. The celestial symbolism of the dome plays an important part in this development. Beneath the dome of St Peter's, Bernini's figure of *St Longinus* spreads his arms and looks up at the cross crowning the Baldacchino as the heavenly light falls upon him from the great cupola [192]. Puget's *Blessed Alessandro Sauli* [80] is similarly placed beneath the dome of the Genoese church of S. Maria di Carignano so as to receive the divine illumination which alone explains his ecstatic state.

In the frescoed dome of S. Andrea della Valle, which represents the *Assumption of the Virgin*, Lanfranco daringly made use of the daylight admitted by the lantern at the top to create a circle of brilliant illumination in the midst of this vision of heavenly glory.[3] Lanfranco's solution was revived and perfected some twenty years later when Pietro da Cortona painted the frescoes of the dome and apse of S. Maria in Vallicella [127]. As the observer stands directly beneath the great cupola [163], he looks up to behold God the Father, Christ and a host of angels airily suspended in the empyrean. The central feature of the composition is a wreath supported by infant angels, in which appears the Dove of the Holy Spirit. Though the dove is painted on the ceiling of the lantern, the illusion produced is that the wreath, suspended in space with its blazing circle of light, has descended through the hemisphere of the cupola to the level of God the Father and the Son, so as to complete the group of the Holy Trinity awaiting the advent of the Virgin in heaven.

In the imaginative use of directed light to signify the miracle of divine illumination there is no one to equal Bernini: whether he represents St Teresa's voluptuous rapture [76], the death of the Blessed Ludovica Albertoni [78], or the ascension of St Andrew [154], the meaning is in each case conveyed through the transfiguring power of light.

Near the foot of the Scala Regia in the Vatican Bernini placed a monumental equestrian statue of the Emperor Constantine [193]. With the memory of Caravaggio's *Conversion of Paul* [188] still fresh in his mind, the sculptor has represented Constantine's vision of the cross and his conversion to Christianity. The great curtain behind the group is blown by a wind that is not of this world; the horse rears in fright; and Constantine raises his eyes to gaze in wonder at the heavenly light that envelops him in its rays.

The climax of the rich decorations devised by Bernini for the Vatican basilica is the Throne of St Peter [194], in which sculpture, architecture, painting and real light are fused in a dazzling pictorial unity. The work may be read as a progression from the immaterial – the glowing light in which the dove is suspended – to the material – the gilt-

WATERSTONES WEST END

23/08/93 10:37 D 0 13005

1 @	6.99	0140510559 £	6.99*
		WHO'S WHO IN THE	
1 @	7.99	0006862519 £	7.99*
		DEMOCRACY AND CL	
1 @	6.99	ACAD £	6.99*
1 @	9.99	0140137580 £	9.99*
		HIGH RENAISSANCE	
1 @	7.99	0140137599 £	7.99*
		MANNERISM	
1 @	7.99	0140137602 £	7.99*
		NEOCLASSICISM	
1 @	6.95	0500201862 £	6.95*
		CONCEPTS OF MODE	
1 @	14.99	0140146660 £	14.99*
		ROMANTICISM	
1 @	14.99	0140153632 £	14.99*
		BAROQUE	

SUBTOTAL	£	84.87
SALES TAX @ 0.00%	£	0.00
TOTAL	£	84.87
TENDER CHQ	£	84.87

WATERSTONE'S BOOKSELLERS LTD.128 PRINCES
ST.EDINBURGH.031 22626666.VAT 238554836

WATERSTONES WEST END

23/08/93 10:37 0 0 1300S

1 @ 6.99 01040510659	£	6.99*	
WHO'S WHO IN THE			
1 @ 7.99 00068625I9	£	7.99*	
DEMOCRACY AND CL			
1 @ 6.99 AGAD	£	6.99*	
1 @ 9.99 01040317580	£	9.99*	
HIGH RENAISSANCE			
1 @ 7.99 01040317599	£	7.99*	
MANNERISM			
1 @ 7.99 01040317602	£	7.99*	
NEOCLASSICISM			
1 @ 6.95 05020201862	£	6.95*	
CONCEPTS OF MODE			
1 @ 14.99 01040146660	£	14.99*	
ROMANTICISM			
1 @ 14.99 01040153632	£	14.99*	
BAROQUE			

SUBTOTAL	£	84.87
SALES TAX @ 0.00%	£	0.00
TOTAL	£	84.87
TENDER CHQ	£	84.87

WATERSTONE'S BOOKSELLERS LTD.128 PRINCES
ST.EDINBURGH.031 2265266.VAT 298545636

192. *St Longinus*, 1629–38. Bernini

bronze figures of the four Church Fathers (Fig. 20, p. 351) and the mighty throne hovering in their midst. Yet these monumental and imposing forms, which thrust themselves so emphatically upon our senses, are understood to owe their existence to the spiritual light, of which they are, so to speak, mere concretions.

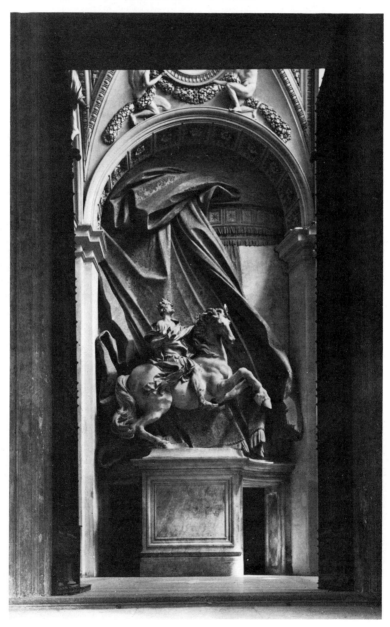

193. *Constantine the Great*, 1654–70. Bernini

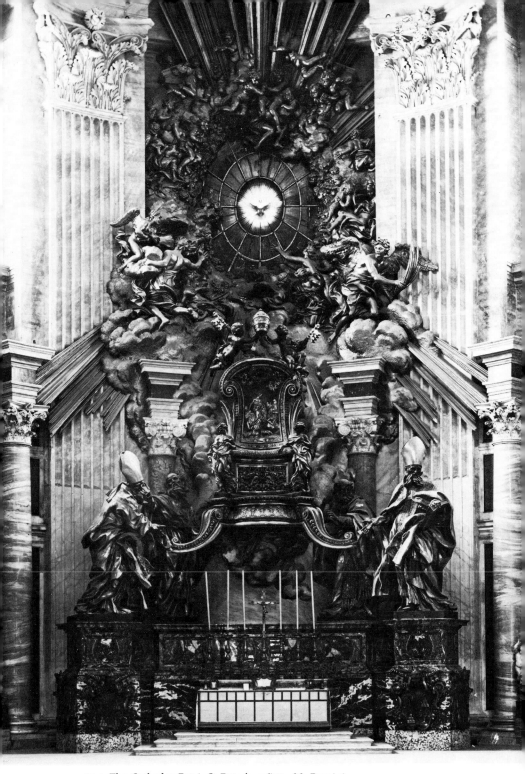

194. The Cathedra Petri, St Peter's, 1657–66. Bernini

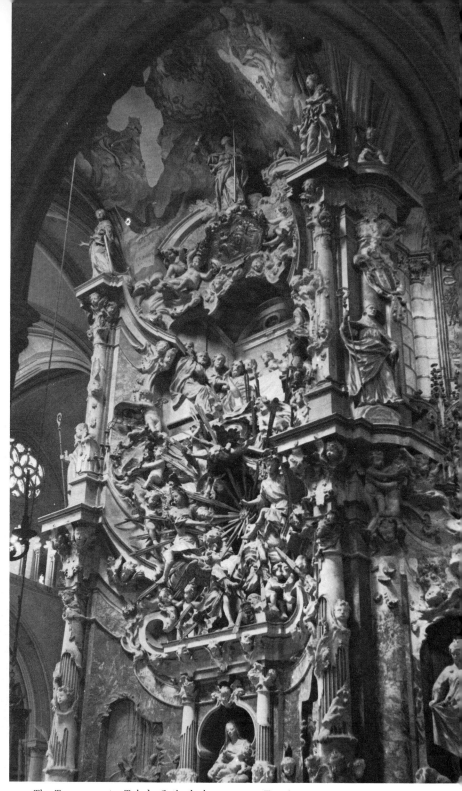

195. The Transparente, Toledo Cathedral, 1721–32. Tomé

Of the many Baroque monuments in which real, directed light forms an integral part of a spatial composition, the most sensational is to be found in Spain. The Transparente by Narciso Tomé in the Cathedral of Toledo [195] was completed in 1732. As we pass through the shadowy ambulatory of the cathedral, we suddenly come upon an ornate and towering altarpiece, the face of which is brilliantly illumined by the light from an unseen window high above the vaulting. The architectural forms of this astounding invention are foreshortened in such a way as to give the illusion of a deep apse-like recess. Starting with the statues of the Madonna and Child in the niche above the altar, the eye of the observer moves swiftly upwards to a crowd of angels surrounding a sunburst, then to an elevated room with Christ and his disciples at the Last Supper, and finally to the Virgin at the very top.

LIGHT AS SYMBOL

Blindness, which has always held a dread fascination for artists, becomes a frequent subject in seventeenth-century painting. The meaning of Rembrandt's *Blinding of Samson* [196] is enlarged by the symbolic opposition of light and dark. The bright light that shines into the room through the parted curtains at the left seems to offer a way of

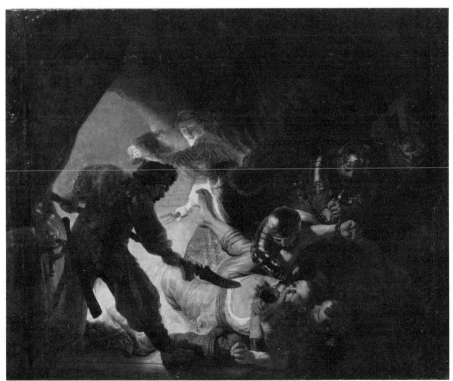

196. *The Blinding of Samson*, 1636. Rembrandt

escape; but Samson, overpowered and rendered helpless by his enemies, is pinned down in the shadows – the region of danger and blindness – where a soldier savagely drives a dagger into his eye. The traitress Delilah, clutching in her hands the shears and the hair clipped from the hero's head, runs towards the light, now to be denied to Samson for ever.

Caravaggio takes up the theme of blindness as a way of intensifying the significance of light. The tax-gatherers in the scene of the *Calling of St Matthew* [34] who are farthest from Christ are incapable of experiencing the light of grace that falls upon their companion: the boy with head bowed has eyes only for the money that he is counting, and the spectacles through which the old man peers at the coins denote his spiritual sightlessness. *The Conversion of St Paul* [188] embodies a similar idea. The saint, lying on his back with arms waving in the air, is blinded by the light of heaven which, even while it physically deprives him of sight, inwardly opens his eyes to the faith. But to the groom standing beside the great horse no light is visible; being thus excluded from the sacred mystery, he can only stare in wonderment at his fallen master.

The theme of blindness also attracted the attention of Poussin, though it goes without saying that he treated it very differently from Caravaggio. Poussin's *Christ Healing the Blind Men* of 1650 [197], with its air of classic restraint, its studied poses and gestures, and its careful

197. *Christ Healing the Blind Men*, 1650. Poussin

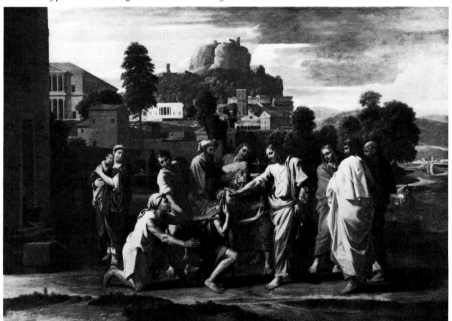

integration of figures and setting, is cast in the grand manner of *Rebecca and Eliezer* [93] and other history paintings of this period. But in the *Blind Men* there is, in addition, a strong element of suspense. It may be felt in the tense attitudes of the bystanders who watch breathlessly as Christ lays his hand on the blind man's brow and touches the unseeing eyes with his fingers. It is typical of Poussin, too, that he has chosen the most appropriate hour for the miracle. The long shadows cast by the buildings and by the actors in the scene, and the unusual brightness and freshness of the colours show that the miracle takes place in the light of early morning, as if to symbolize the dramatic change from darkness to the brightness of day.

Rembrandt's great etching of *Christ Healing the Sick*, the so-called *Hundred-Guilder Print* [198], illustrates yet another kind of symbolic meaning in the dialogue of light and dark. The aureole that surrounds Christ's head is the visible sign of his supernatural power. Yet on this luminous figure, rising so serenely above the sick and infirm who have come to be healed, there falls the shadow of an old woman kneeling in supplication before him (Fig. 21, p. 352). By means of that dramatic patch of darkness, which is nothing less than the shadow of death, the artist alludes to the mortal nature of Christ.

The candle-flame that is a routine feature of so many seventeenth-century nocturnes is often used metaphorically to signify enlighten-

198. *Christ Healing the Sick (The Hundred-Guilder Print)*, 1649. Rembrandt

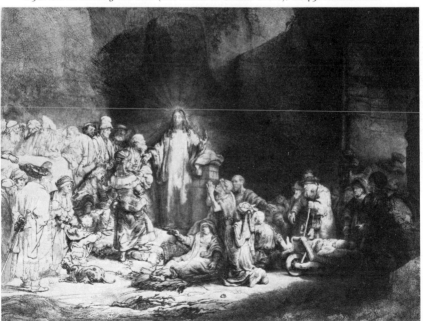

ment, as in Dou's *Evening School* [97], where it has reference to education and the dispelling of ignorance. In Rembrandt's painting of *Peter Denying Christ* [199] this banal motif is raised to a quite unexpected level of psychological revelation. Asked by the maid if he is not a follower of Jesus, the frightened apostle disavows his master; at this moment Christ, standing amidst his accusers in the background, turns to look at the man who has proved false to him. The light that floods over the disciple from the candle held up to his face by the suspicious girl aptly symbolizes Peter's sudden recognition of his own weakness

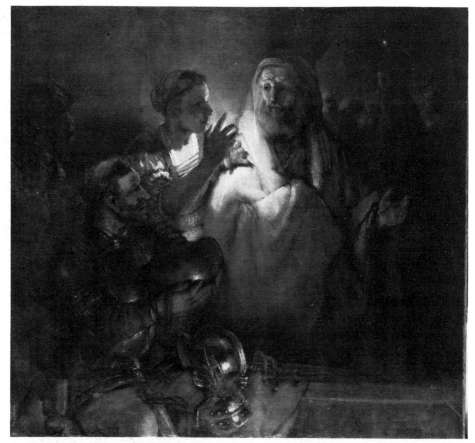

199. *Peter Denying Christ*, 1660. Rembrandt

and failure. In much the same way, the flame at which Mary Magdalene gazes in La Tour's painting [56] denotes the inward illumination that has brought the sinner to a state of penitence and meditation.

It can hardly surprise us that the magic light of Vermeer is sometimes made the bearer of symbolic meaning. *The Art of Painting* [200] represents a painter and his model in what is evidently Vermeer's own

studio. Yet this work, though it might appear at first glance to be simply a genre picture of a painter's atelier, has been shown to be an allegorical statement of art as the union of craftsmanship and inspiration. The young woman whose form the nameless artist seeks to record on his canvas may be identified by her attributes (the book and the trumpet) as Clio, Muse of History; the reference, clearly, is to the immortal fame of painting. It is significant too that the source of light, which we know from other interiors by Vermeer to be the tall windows along the left wall of the room, is here concealed by a curtain. The

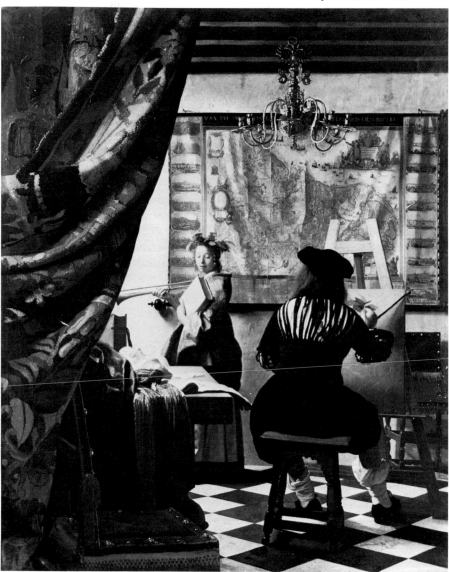

200. *The Art of Painting, c.* 1666–70. Vermeer

figure of the girl is thus set off by a brightness which (since its origin is hidden from us) is surely intended to denote an illumination of the mind. Here we may be reminded of the solution adopted by Velazquez in the *Fable of Arachne* [92]: the darkened foreground, where women work in silence and obscurity, and the bright alcove beyond, where the apparition of the goddess Pallas to the mortal Arachne is accompanied by rays of supernatural light.

The opposition of light and dark, though it is generally achieved through the pictorial means of chiaroscuro, may be reinforced by the device of personification. In the great *Council of the Gods* that forms part of the History of Maria de' Medici [214], Rubens shows the shining figure of Apollo, god of Reason and Light, expelling the sinister creatures of evil who lurk under the shadow of Night.

The theme of light triumphant over darkness is also implicit in the recurrent Baroque allegory of Truth unveiled by Time. Bernini's statue of *Truth* [26] was to have been completed by the form of Time who reveals his daughter Truth by sweeping aside the drapery that has obscured her. This extraordinary figure, whose very nudity has emblematic significance, looks up with a smile of rapture while holding in her hand the radiant face of the sun, to show that 'Truth is the friend of Light'.

The imagery of the sun was well adapted to the doctrine of Divine Hereditary Right. Hobbes, the champion of absolute monarchy, makes use of such a simile to illustrate how the power of the subjects vanishes before that of the sovereign: 'though they shine some more, some less, when they are out of his sight; yet in his presence, they shine no more than the stars in the presence of the sun'.[4] At Versailles the symbolism of the sun is all-pervading. To the panegyrists of Louis XIV, the king appeared to be 'the light of the world': he was *le Roi Soleil*, whose matchless splendour was expressed by the motto *Nec Pluribus Impar* — not unequal to many suns. La Fontaine, imagining the king and his retinue gathered on the terrace of Versailles to admire the sunset, compares the light of the two suns in his *Psyché* (1669):

> Là, dans des chars dorés, le Prince avec sa cour
> Va goûter la fraîcheur sur le déclin du jour.
> L'un et l'autre Soleil, unique en son espèce,
> Étale aux regardants sa pompe et sa richesse.
> Phébus brille à l'envi du monarque françois . . .

> There, in golden chariots, the Prince with his court
> Comes to enjoy the freshness at the close of day.
> Each Sun, unique of his kind,
> Sheds over the onlookers his magnificence and splendour.
> Phoebus shines in emulation of the French monarch . . .

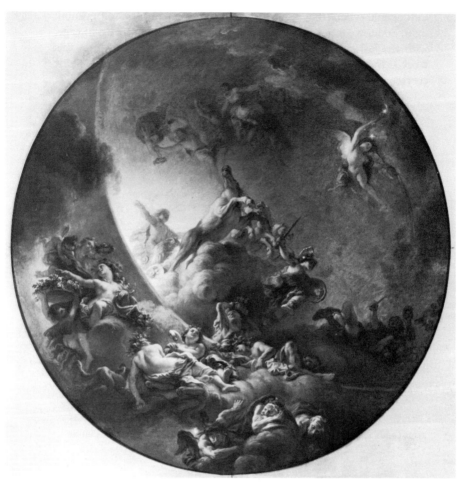

201. *The Rising of the Sun, c.* 1680. La Fosse

Another form of this solar symbolism may be seen in the *Rising of the Sun* by Charles de la Fosse [201]. This spirited work is a design for the ceiling of the Room of Apollo, the final and climactic room in the suite of seven forming the Apartments of the King at Versailles. Phoebus, drawn in his car by the swift horses of the sun, soars through the heavens in a blaze of light to illumine the world and to rout Night and the powers of darkness.

The diurnal motion of the sun was also looked on, as we recall, as an apt symbol of the course of time. In Claude Lorrain's *Landscape with the Arch of Constantine and the Colosseum* [202], the painter's vision is so perfectly realized that we find nothing incongruous in the translation of these urban monuments to a pastoral setting on the Roman

Campagna, where they appear as if half dissolved in the soft evening light. Soon, we feel, the entire scene will fade from view, like a mirage, with the last rays of the setting sun. The title formerly given to this work — *The Decline of the Roman Empire* — is not the correct one; but it corresponds well enough to the meaning of the painting.

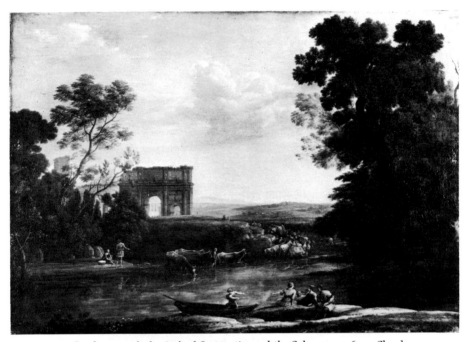

202. *Landscape with the Arch of Constantine and the Colosseum*, 1651. Claude

THE LIGHT OF THE SOUL

In the third book of *Paradise Lost*, which opens with an invocation to celestial light, Milton speaks of his blindness and the inner light that sustains him.

> Thus with the year
> Seasons return, but not to me returns
> Day, or the sweet approach of Even or Morn,
> Or sight of vernal bloom, or Summer's rose,
> Or flocks, or herds, or human face divine;
> But cloud instead, and ever-during dark
> Surrounds me, from the cheerful ways of men
> Cut off, and for the book of knowledge fair
> Presented with a universal blank
> Of Nature's works to me expunged and rased
> And wisdom at one entrance quite shut out.

So much the rather thou, Celestial Light,
Shine inward, and the mind through all her powers
Irradiate, there plant eyes, all mist from thence
Purge and disperse, that I may see and tell
Of things invisible to mortal sight.

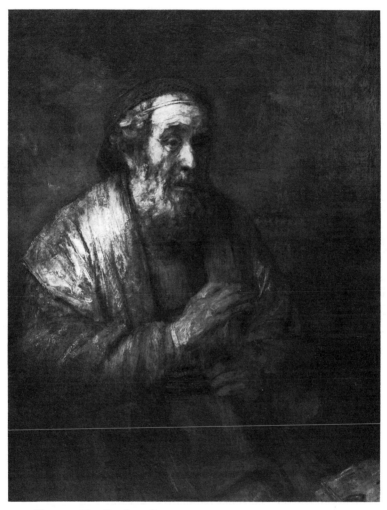

203. *Homer*, 1663. Rembrandt

 Milton's image of the blind poet, with its unspoken but unmistakable allusion to Homer, finds a certain correspondence in Rembrandt's representation of the Greek poet [203]. The painting, which is only a fragment of a somewhat larger canvas, originally showed Homer dictating to one or two pupils. The sightless poet, a worn and aged figure, lifts his hand as if to give emphasis to the words framed by his

lips. The soft glow of golden light playing over his head and shoulders suggests the visionary powers which enable him 'to see and tell of things invisible to mortal sight'.

Yet it was perhaps in portraiture that the conception of the inner light was put to its most expressive use. Rubens, writing in 1630 to the French scholar Peiresc, who had just sent him a portrait of himself, remarked:

> Your portrait has given very great pleasure to me and to those who have seen it. They are entirely satisfied with the resemblance. I confess, however, that I do not see shining in this face that animation and vigour of expression which seem to me to belong to your genius, but which it is not easy for anyone to capture in a painting.[5]

What Rubens meant by these words may be deduced from the portrait that he painted of his friend, the Antwerp humanist Caspar Gevartius [204]. The subject is represented at his desk, where he is writing his commentary on the works of Marcus Aurelius (as the bust of the philosopher-emperor serves to indicate); with the pen still held in his right hand, Gevartius momentarily lifts his eyes from the page to look directly at us. It is a face in which we may see glowing that light of intellectual and spiritual force that Rubens found to be lacking in the portrait of Peiresc.

This sensitivity to the inner light of man is shared by all the great portraitists of the Baroque; Velazquez makes use of it to vitalize and give animation to the likeness of *Juan de Pareja* [66]. But the master who surpasses all others in rendering the light of the soul is Rembrandt. It is true that the artist's youthful works give hardly any hint of this extraordinary power, which is only brought to its full realization in the paintings (and above all in the portraits) of the mature and late periods. The soft luminosity of the *Jan Six* of 1654, for example [70], by permeating and unifying the pictorial space, generates what might be called an atmosphere of consciousness. Similarly, the patches of light that flicker over the face of Titus while he sits in his chair reading (Vienna, Kunsthistorisches Museum) do not have a merely representational function, but somehow suggest the lively activity of the boy's mind as his face lights up with interest and pleasure.

Rembrandt's very personal handling of light and shade provoked some unfavourable comment, especially from artists of a younger generation who were offended by his disregard for the conventions of classicism. In 1670, the Flemish painter and art-dealer Abraham Brueghel spoke with contempt of Rembrandt's preference for the 'trifling clothed half-figure, where there is only a little light on the tip of the nose, and one doesn't know where it comes from, because all the rest is in darkness'.[6] Brueghel's amusing description, travesty though it is, nevertheless contains a grain of truth: for in certain paintings of

204. *Caspar Gevartius, c.* 1628. Rubens

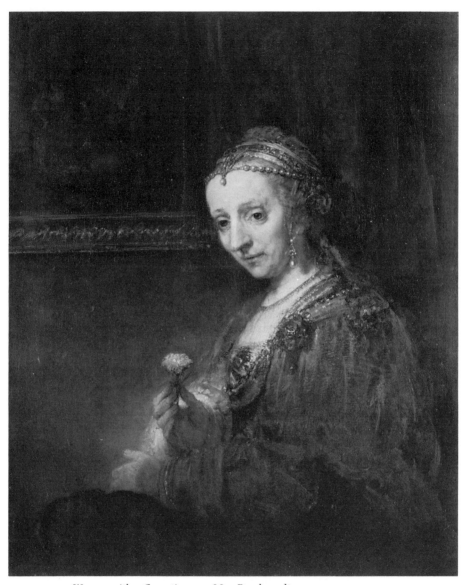

205. *Woman with a Carnation, c.* 1665. Rembrandt

Rembrandt's late period the light does not so much seem to fall upon the form from an identifiable outward source as to emanate from the figure itself. The *Woman with a Carnation* [205], who looks out abstractedly with an air of ineffable sadness, is one of the richest and most subtle portraits of the last years. But it is chiefly the mysterious glow from within that creates the illusion (familiar even to the most casual observer) of corporeal and spiritual presence. The light of Rembrandt illuminates in an uncanny way the tragic experience of all mankind.

8

I am convinced that in order to achieve the highest perfection
one needs a full understanding of [ancient] statues,
even a complete absorption in them:

but one must make judicious use of them
and above all avoid the effect of stone.

Rubens, *De Imitatione Statuarum*

Attitudes to Antiquity

The world of antiquity was rarely absent from the seventeenth-century mind. As a result of systematic study by classical scholars and the formation of great collections by noblemen and connoisseurs, the knowledge of ancient art and architecture was now more wide-spread than ever before.

Yet all this expanded knowledge of antiquity did not succeed in bringing the past closer. The ancient world appeared to the Baroque, even more than to the Renaissance, as an age irrevocably cut off from the present by history and time. The atmosphere of nostalgia that lies like an almost palpable veil over the landscapes of Claude Lorrain [202] is only one manifestation of a pervasive sentiment of regret for the lost world of antiquity. Even the most ardent students of the classical past did not deceive themselves into thinking that the spirit of that past could be wholly recovered. Rubens, who was persuaded that he was living in a weak and degenerate age, spoke with envious tones of that ancient era of heroic strength and virtue, now gone beyond recall.[1] Poussin's view of the unbridgeable distance separating the Rome of his day from that of antiquity is summed up in a story told by Bellori. The artist, he relates, was visiting ancient ruins in the company of a foreigner who wished to take home with him some precious relic of antiquity. Gathering up a handful of earth and gravel mixed with fragments of porphyry and marble, he gave it to the visitor, saying to him, 'Here, put this in your museum, and say: This is ancient Rome.'[2]

One cannot speak of a single Baroque conception of antiquity. The widely differing attitudes adopted by artists towards the ancient past might rather be viewed as paralleling, or even as reflecting, the rich stylistic diversity of the period. The classical heritage did not appear in the same light to Bernini [162] and Salvator Rosa [168], and it obviously had quite different meanings for Rembrandt [203] and Velazquez [219]. Poussin, through his association with the antiquarian Cassiano dal Pozzo, and Rubens, who maintained a learned correspondence with the French scholar Peiresc, both displayed an archaeological interest in the remains of ancient Rome that was shared by few other artists.

In the visual arts, the legacy of Rome far outweighed that of Greece. Rome was more accessible, and its wealth of sculptural and architectural remains had long been a subject of study by artists and antiquarians. Greece, on the other hand, was not only farther from western Europe but also lay under Turkish domination. Yet Greek sculpture of the classical period, though it can have made little impression on Baroque artists, was not wholly unknown in the seventeenth century. Thomas Howard, Earl of Arundel, employed agents to gather antiquities from sites in Greece, Asia Minor and elsewhere.[3] Rubens was privileged to see the Arundel Marbles, undoubtedly the greatest collection of antiquities in England of the seventeenth century, when he visited that country on a diplomatic mission in 1629.[4] Arundel, moreover, was not alone in his enthusiasm for Greek sculptures. Among the papers of John Milton at Columbia University there is an anonymous manuscript 'Of Statues and Antiquities', which describes where the visitor to Greece might find the best ancient works and how he might bribe the Turkish officials into allowing him to export them. 'The things to be sought for,' the writer begins, 'are these following: Statues clothed and naked, but the naked ones are of greatest value . . . The most ancient are to be desired, for as for those done in latter times, of the Easterne Emperors they are of small value.' Among the many sites recommended to the traveller are the ruins of the Temple of Zeus at Olympia and the Temple of Apollo at Delphi. The Parthenon is particularly mentioned as a monument still virtually intact (it was not seriously damaged until 1687): at Athens, we read, there 'yet remaineth standing a great part of the Temple of Pallas, in which are manie excellent Sculptures of Basso Relevo'.[5]

THE MASTERS OF THE CLASSICAL IDEAL

The establishment of classicism in early Baroque art was the work of a number of Bolognese painters who appeared in Rome in the years just before and just after 1600. Annibale Carracci, the guiding spirit

of the group, came to Rome in 1595 and was followed by Guido Reni,
Domenichino and other artists. What they accomplished in this
crucial period may be regarded as a prelude to the full triumph of
classicism in the art of Nicolas Poussin.

The imaginative richness and power of Annibale's art are fully
exhibited in the great fresco cycle of the Farnese Gallery. But it is
perhaps through such works as *The Choice of Hercules* [206] that his
role as the founder of Baroque classicism may best be understood.

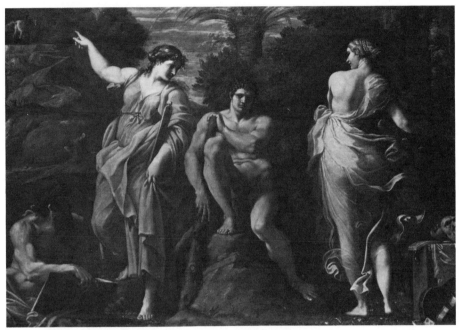

206. *The Choice of Hercules, c.* 1596. Annibale Carracci

The edifying subject, the austere, relief-like composition, and the cal-
culated placing of the three principal figures, expressing unequivocally
the meaning of the choice confronting the hero, might almost be
taken as a paradigm of the classical method. Carracci's sources are of
course not to be looked for in ancient art alone. No less important is
the example of the great masters of the sixteenth century, particularly
Raphael and Michelangelo. This fusion of Graeco-Roman antiquity
and Roman High Renaissance is characteristic of Baroque classicism.

Domenichino's frescoes of the life of St Cecilia belong to the most
classic moment of that artist's career. The scene in which Cecilia is
condemned by the judge for refusing to sacrifice to the pagan gods
[207] is at once a masterpiece of dramatic narrative and an exercise
in archaeological correctness; attitudes, costumes and furnishings
have been carefully studied from the Antique, and the painting as a

207. *St Cecilia before the Judge*, 1615–17. Domenichino

whole is organized after the manner of a Roman bas-relief, like that on
the pedestal beneath the judge's throne. Paintings such as this made
a deep impression on Poussin when he arrived in Rome in 1624.

In his *Inspiration of the Epic Poet* [208] Poussin adopted an appro-
priately lofty mode of expression. As in Carracci's *Choice of Hercules*, the
very composition awakens echoes of Roman figural reliefs. Apollo,
seated before a tree, dictates to a poet who, holding a pen and writing

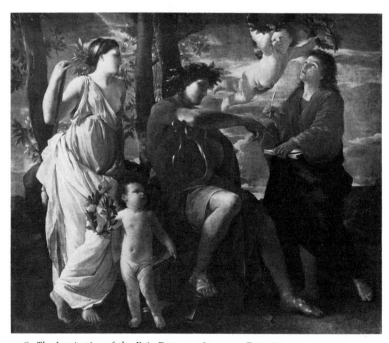

208. *The Inspiration of the Epic Poet*, c. 1630–33. Poussin

tablet, listens with rapt attention to the divine words. The graceful
goddess at the left is Calliope, muse of epic poetry, whose attitude and
drapery show that she has been modelled after antique statuary. The
constraint born of idealization seems only to enhance the sensuous
beauty of this figure.

Among Poussin's contemporaries in Rome, the painter Andrea
Sacchi and the sculptors Alessandro Algardi and François Duquesnoy
were animated by the same desire to give to their art the semblance of
the antique ideal. Duquesnoy's attitude to antiquity seems in fact to
have been a remarkably sophisticated one. According to the seven-
teenth-century biographer Passeri, Duquesnoy and Poussin not only
distinguished between Greek and Roman art but even rated Greek
style higher than the Roman — another reminder that the Hellenic
world was not unknown in the early seventeenth century.[6] Duques-
noy's celebrated *St Susanna* [209] might be described as a sacred
counterpart of the muse in Poussin's *Inspiration*. Bellori says that the
artist perfected his *Susanna* only after careful study of the living model
and prolonged contemplation of the antique statue on the Capitol
known as *Urania*.[7] Yet in spite of the undeniably classical quality of
Duquesnoy's statue it remains true, as Wittkower has observed, that
'nobody with any knowledge of the history of sculpture would fail to
date the *Susanna* in the seventeenth century'.[8] It is not only that the
figure surpasses the ancient prototype in sensuous warmth and

209. *St Susanna*,
1629–33. Duquesnoy

emotional power but also that the work was manifestly designed to occupy a particular site in the church of S. Maria di Loreto. Though Susanna's demeanour is subdued, as befits the chaste modesty of this virgin martyr, her posture and gestures are motivated by her role as mediator between the worshipper and the altar, to which she points while turning her head to look down upon the people.

Algardi's *Decapitation of St Paul* [210], the violence of the subject notwithstanding, is composed as harmoniously as Poussin's *Inspiration of the Epic Poet*. The two figures – the one standing in an active, rotating pose, the other kneeling in passive anticipation of the mortal

210. *The Decapitation of St Paul*, 1641–7. Algardi

blow – are contained within a simple quadrilateral, the vertical sides of which are emphasized by the draperies that fall from their shoulders. Executioner and victim are held in counterbalance by secret affinities of posture, their heads being inclined at a similar angle and the diagonal of the upraised sword being continued along the shoulders of the kneeling saint. Algardi has followed the example of antiquity in the

compact and simple outlines of the figures and in the powerful build of the swordsman, whose back and shoulders are reminiscent of the *Belvedere Torso*.

One of the greatest achievements of French classical sculpture is the group of *Apollo Tended by the Nymphs* by François Girardon [211]. In the conception of the individual figures, the sculptor has not sought to conceal his indebtedness to the Antique. For the attitude of the seated Apollo, who extends his left hand so that a nymph may pour water over it, he has taken as his model the *Apollo Belvedere* [212]; and the girls who wait upon the god are likewise fashioned

211. *Apollo Tended by the Nymphs*, 1666–72. Girardon and Regnaudin

212. *The Apollo Belvedere*

after Hellenistic statues. But the serene and measured harmony of the group as a whole points to another source of inspiration – the paintings of Poussin [cf. 208].

THE USE OF ANCIENT MODELS

Bellori relates that in their early days in Rome Poussin and Duquesnoy 'applied themselves intently' to the study of the Antique and that together they made measurements of the statue known as *Antinoüs*, of which Bellori duly published an engraving [213].[9] That artists such as

213. 'Antinoüs',
from Bellori;
Le vite . . ., 1672.

these, whose devotion to the classical ideal was so openly professed, should have found models amongst the works of ancient sculpture to be seen in Rome may seem only logical and consistent on their part. It would nevertheless be a mistake to believe that these 'classic' masters were the only ones to make a close study of antique marbles. Virtually all artists working in Rome in the seventeenth century looked to the ancient past for inspiration and employed classical prototypes in their works in greater or less degree.

No doubt artists of different temperaments were drawn to different models: if Poussin preferred the restraint and composure of statues such as the *Antinoüs*, Bernini and Rubens found inspiration in more vigorous and animated works such as the *Borghese Warrior* and the *Laocoön*. But this generalization is not wholly satisfactory, for it can be shown that the same classical sculptures were sometimes consulted by both Poussin and Rubens, and by Poussin and Bernini.

The task of finding suitable models was made easier by the fact that there was a generally recognized 'canon of antiques' with which artists quickly became familiar.[10] This established repertory was well known to Rubens, who, during his Italian sojourn, immersed himself in the art of the past by systematically making drawings of the princi-

pal antique sculptures. A list of such copies made by the Flemish artist would read, as Julius Held has observed, 'like a roll-call of all the celebrated marbles known in his time'.[11] These drawings he took back with him to Antwerp, where they served as a storehouse from which he selected appropriate models for his paintings. It may therefore seem paradoxical (and this has already been remarked on in an earlier chapter) that Rubens's painted figures, for all his studious attention to the great works of ancient sculpture, do not much resemble classical marbles. If he venerated ancient statues, it was not only for their grace and beauty but also because he saw them as embodiments of the humanistic values of antiquity. And these values, if they were to have meaning for his own age, must be clothed in new and more sensuous forms. The metamorphosis undergone by ancient imagery in Rubens's hands may be illustrated by the figure of Apollo in *The Council of the Gods*, from the History of Maria de' Medici [214]. Though we recognize at once the derivation from the *Apollo Belvedere* in the Vatican [212], we nevertheless feel, as Max Rooses put it, that this is 'marble made flesh, walking and moving under the creative afflatus of the master'.[12] Amongst the evil beings who recoil before Apollo's attack is a male figure with legs widespread who turns his head to look in terror at the god while flinging his right arm across his face with a furious gesture. The pose is that of the so-called *Ludovisi Gaul* [215]. The contrast between the serene deity, represent-

214. *The Council of the Gods*, 1621–5. Rubens

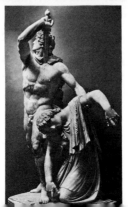

215. *The Ludovisi Gaul*

ing the enlightened spirit of Hellenic civilization, and the 'barbarian' Gaul, symbol of the dark and violent side of human nature, could not be more vividly expressed. The 'borrowings' from antiquity are not selected at random but for reasons of 'decorum': by alluding to certain ancient statues Rubens intends to bring into play the appropriate connotations of the originals.

One of the few Baroque masters who can equal Rubens in the ability to comprehend and at the same time to transform the classical heritage is Bernini, whose imagination was likewise stimulated, especially in the early works, by ancient statuary. 'When I was still very young,' Bernini remarked to the members of the French Academy, 'I often drew from the Antique, and when I was in difficulties with my first statue I turned to the *Antinoüs* as my oracle.'[13] For the *David* [49] he made use of the threatening attitude of the *Borghese Warrior*. Bernini's adaptation of the *Apollo Belvedere* may be seen in the marble group of *Apollo and Daphne* [162], where the illusion of mobility even surpasses that suggested by Rubens in paint. Without sacrificing the essentials of the pose and facial features of the classical statue, the sculptor brings into being a swiftly running form that seems to have wholly freed itself from the restrictions of a carving in stone.

For Rubens and Bernini, the antique prototype is generally the starting-point from which their artistic conceptions are developed, whereas in Poussin, as Wittkower has shown,[14] the classical model is introduced only at a relatively advanced stage in the creative process. The motif of the *Ludovisi Gaul*, for instance, which Rubens employed in *The Council of the Gods*, likewise appears in Poussin's *Rape of the Sabine Women* in the Metropolitan Museum in New York [216], where it has been adapted, in the reverse sense, for the figure brandishing a dagger in the group of father, daughter and soldier in the right foreground. Though it might seem particularly well suited to a scene of abduction such as that represented here, the motif was in fact not present in Poussin's mind from the start. For there is no sign of the antique model in the preparatory drawing for this work in Windsor [217], which contains an early idea for the trio of old man, girl and abductor and, at the right, a soldier dragging a girl on the ground. In the painting, Poussin combines details from both episodes to form the definitive group of three figures, at the same time assimilating the striding soldier to the pose of the *Ludovisi Gaul*. Poussin's procedure, then, is the reverse of that followed by Rubens and Bernini: instead of elaborating a classical model so as to arrive in the end at a highly individual solution, the French master frequently begins with a spontaneous idea which gradually evolves into a specific classical motif.

Those painters to whom the great works of ancient sculpture were not readily accessible in the original could sometimes find an acceptable substitute in small copies. The practice of making reductions of

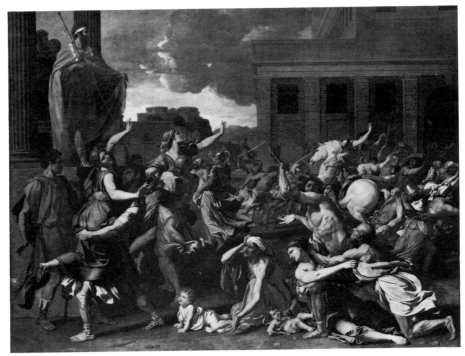

216. *The Rape of the Sabine Women, c.* 1634–7. Poussin

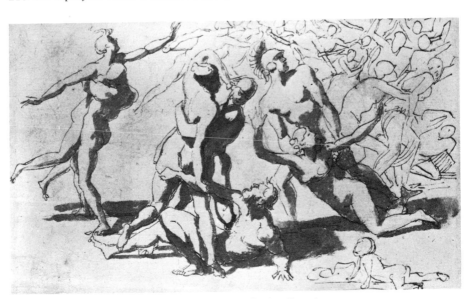

217. Study for *The Rape of the Sabine Women, c.* 1634–7. Poussin

antique statuary probably originated in the sixteenth century (see the statuette held by Jacopo Strada in Titian's portrait in Vienna), but it was only in the Baroque period that accurate reductions began to be produced in quantity by reputable sculptors to satisfy the demands of collectors. In Florence, for example, bronze statuettes after the Antique were made by Antonio and Giovanni Francesco Susini and by Massimiliano Soldani.[15] That artists actually made use of such reduced copies of famous antique marbles is proved by Largillierre's portrait of Charles Le Brun [218]. Seated before his easel, on which can be seen an oil sketch for one of the ceiling compartments of the Galerie des Glaces at Versailles, Le Brun directs our attention to the two statuettes on the table at the right, one of which is an accurate bronze reduction of the *Borghese Warrior* and the other a small marble copy of the *Antinoüs*, as if to present them as contrasting models of physical force and composure.

218. *Portrait of Le Brun*, 1686. Largillierre

It is a recurrent theme in seventeenth-century criticism that painters such as Caravaggio and Rembrandt were indifferent – if not actually hostile – to the art of antiquity. Bellori says explicitly that Caravaggio 'not only ignored the most excellent marbles of the ancients . . . but despised them . . . When the famous statues of Phidias and Glycon were pointed out to him as models for his painting, he gave no other reply than to extend his hand towards a crowd of men, indicating that nature had provided him sufficiently with teachers'.[16] Like many of Bellori's anecdotes, this must be taken with a grain of salt. For Caravaggio, though admittedly not disposed to paint in a classical manner, was by no means blind to ancient sculptures and more than once made adaptations after them. In the smooth and sensual *Bacchus* (Florence, Uffizi) there is an unmistakable allusion to the Emperor Hadrian's favourite, Antinoüs;[17] and the facial features of the evangelist in the first *St Matthew and the Angel* (formerly in Berlin) are clearly those of Socrates, as we know them from ancient portraits of the philosopher.[18] But if Caravaggio did not wholly neglect the art of antiquity, it cannot be said to have offered to him, as it did to so many other artists, a constant and unfailing source of inspiration. *The Death of the Virgin* [8] does not derive its sombre and mysterious power from the clear light of the classical world.

There were some notable collections of classical sculpture in seventeenth-century Holland, but they seem to have had little effect on Dutch artists. Rembrandt owned a number of antiques, including a cast of the *Laocoön*. That the artist was acquainted, chiefly through prints, with the great works of Graeco-Roman art cannot be doubted. The inventory of his possessions made in 1656 lists several books of drawings by Rembrandt himself after the Antique, as well as an album of engravings of ancient statues.[19] The bust of Homer that appears in the *Aristotle* of 1653 (New York, Metropolitan Museum) was probably copied from a piece in his own collection; and the seated figure of *Bathsheba*, in the great canvas of the following year [54], has been shown to derive from an engraving of an antique relief.[20] The depth of Rembrandt's understanding of the classical tradition is evident in his interpretation of subjects drawn from mythological and ancient history. Yet his paintings in general reflect surprisingly little of the artist's interest in classical sculpture; more often it was the art of the Italian Renaissance that directly nourished his imagination.[21]

And what of Velazquez? We might be tempted to conclude, from his earthy way of interpreting ancient fable, that antiquity appealed to this master even less than to Caravaggio. The popular names given to some of his mythologies – *The Triumph of Bacchus* [28], nicknamed *The Drinkers*, and *The Fable of Arachne* [92], prosaically reduced to

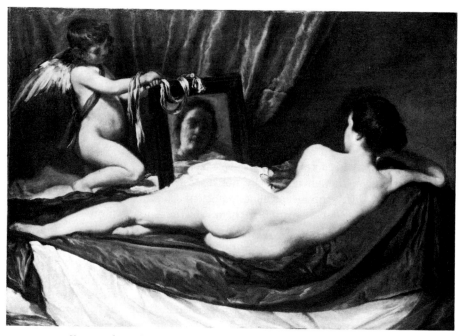

219. *Venus and Cupid* (*The 'Rokeby Venus'*), *c.* 1649–51. Velazquez

The Weavers – seem only to lend support to the notion of Velazquez as an anticlassical artist. What is generally overlooked, however, is that Velazquez recommended to Philip IV that antique statues be purchased for the decoration of a royal gallery, and that on his visit to Italy in 1649–51 he acquired a number of marble originals and selected still others to be cast in plaster and bronze. Amongst the latter was a reproduction of the antique *Hermaphrodite*. He was so taken by the lithe and sinuous pose of this figure seen from the back that he adopted it with variations for his painting of *Venus and Cupid* [219]. Rubens himself could not have made a more successful translation of sculpture into painting.

ARCHITECTURE AND THE DECORATIVE ARTS

Classicism in architecture, like classicism in painting and sculpture, was not invariably nurtured by direct study of the Antique. Inigo Jones's Banqueting House [220], though unquestionably a landmark in the development of an English classical style, is not so much inspired by ancient buildings as by Palladio's treatise on architecture of 1570, of which Jones is known to have been an avid reader. Palladio, fortunately, was a trustworthy guide to antiquity. And this no doubt explains why the Banqueting House, the interior of which consists of

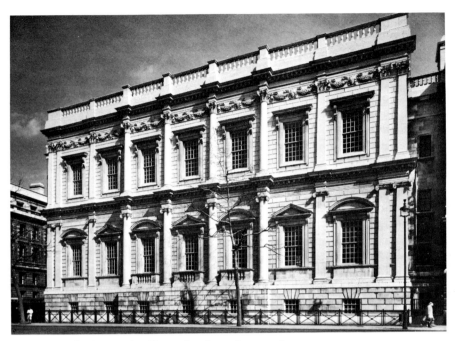

220. The Banqueting House, London, 1619–22. Jones

a single large room, follows the general form of the ancient Roman basilica as described by Vitruvius. Jones, in designing a new hall to serve as a setting for court entertainments for King James I, surely understood that *Basilica* (as Palladio remarks in his treatise) means 'royal house'.[22]

Since the time of Vignola in the sixteenth century the touch-stone of classicism had been the proper use of the Orders. Whereas in France this tradition was kept alive by theoretical writers throughout the seventeenth century, in Italy the great Baroque architects displayed much less interest in the 'correct' application of the Orders. How little these pedantic rules mattered to Borromini, for example, is evident in the arbitrary handling of the columns on the façade of S. Carlo [155]; Bernini likewise had no scruples about placing an Ionic entablature over the Doric columns of the Colonnade of St Peter's [118].

The reason why Bernini could indulge in 'licence' of this sort was that it was not his intention to imitate the particulars of the Orders but to preserve the larger meaning of ancient buildings. The most perfect architectural forms, he once remarked, are circles, squares, hexagons, octagons and the like; and he made it clear that he regarded the Pantheon as the best specimen of ancient architecture precisely because it is composed of simple geometric shapes.[23] A

glance at Bernini's church of S. Maria dell' Assunzione at Ariccia is sufficient to show that the idea of a domed cylinder entered through a pedimented portico was directly inspired by the Pantheon.[24] It is significant too that in the regular spacing of the niches of the interior Bernini followed what he believed to be the original decorative system of the Pantheon. One will not miss here the analogy to Bernini's use of classical models in sculpture, which likewise involves the metamorphosis of ancient forms in order to give them new currency.

It was in France, during the later seventeenth century, that the pure classical doctrine in architecture was brought to its fullest development in treatises by Fréart de Chambray, François Blondel, Antoine Desgodetz and Claude Perrault, all of whom painstakingly derived their theoretical principles from the surviving buildings of antiquity and from *The Ten Books on Architecture* by the Roman writer Vitruvius. The effects of this doctrine on architectural practice may be seen, in their most conspicuous form, in the celebrated Colonnade of the Louvre, erected in 1667–70 by Louis Le Vau, Charles Le Brun and Claude Perrault [221]. Though the work is patently Baroque in the monumental unity of its design and in such features as the paired columns, the chief impression evoked by this noble façade is of antiquity reconstituted. The colonnade has indeed been likened to the peristyle of a Roman temple on its high podium, the sides being opened out, as it were, so as to lie parallel to the pedimental front. The details

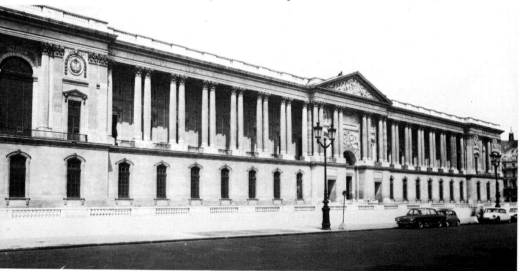

221. The Colonnade of the Louvre, Paris, 1667–70.
Le Vau, Le Brun and Perrault

of the Corinthian Order, moreover, are carried out with a purity and correctness that are comparable to the cold precision of the illustrations in Desgodetz's treatise of 1682 on the ancient edifices in Rome [222].

222. From Desgodetz:
Edifices antiques de Rome, 1682

In the decorative arts of the Louis XIV period a different attitude towards the classical architectural vocabulary may be seen making its appearance under the influence of Italian models. The taste for greater opulence and more lavish ornament that is characteristic of the late Baroque was fostered by the craftsmen of the Gobelins factory in Paris. Of the furniture made for Versailles at this period little survives: the sumptuous silver furnishings of the Galerie des Glaces, for example [158], were melted down in 1689 to finance the wars. All the more precious, therefore, is the cabinet at Alnwick [223], one of a pair made for Louis XIV by the Italian furniture-maker Domenico Cucci, a work that is remarkable both for its technical perfection and for the ostentation and costliness of its materials. Classical usage prevails in the decoration of the cabinet itself, which, being fundamentally architectural in form, is articulated by proper Composite pilasters and caryatid figures. But in the gilt bronze ornamentation of the base the tectonic spirit has given way to an exuberant curvilinear movement. The bold acanthus scrolls, though derived from antique sources [222], are combined with festoons and shells to produce a strikingly rich and luxuriant effect.

223. Cabinet, 1681–3. Cucci

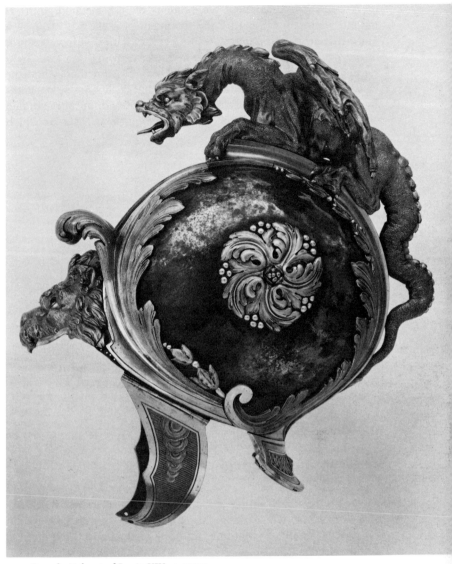

224. Parade Helmet of Louis XIV, c. 1700.

Gilt bronze mounts are also used on the parade helmet of Louis XIV, now in the Metropolitan Museum in New York [224]. The lion mask and dragon crest impart to this pseudo-antique work a certain air of military ferocity, but that effect is counter-balanced by the decorative handling of the acanthus scrolls which enframe the globe-like body of the helmet in a way that emphasizes its purely ceremonial function. In any case, since the helmet weighs thirteen pounds, it can only have been worn for very brief periods, if at all.

We may conclude these observations on the metamorphosis of antique forms by comparing the treatment of a classical vase by a Mannerist artist of the mid sixteenth century with that by a sculptor of the late Baroque period. In the beautiful drawing of a ewer by a German or Flemish goldsmith [225] it can be seen that, while the conventional shape of the antique pitcher has been more or less faithfully preserved,[25] the entire surface is covered with an intricate and closely-woven ornamentation of an utterly non-classical sort, in which

225. Design for a decorative ewer, mid sixteenth century

satyrs are confined within the curving bands of sixteenth-century strapwork. The whole design is emphatically two-dimensional in character, so much so that one can hardly imagine its being adapted to the rounded form of a vase.

Very different in conception from the tightly constricted and spatially inhibited design of the Mannerist work is the great bronze ewer of the late seventeenth century by Massimiliano Soldani [226], which however is so ebullient and so openly expansive that the characteristic slender form of the ancient prototype is almost totally forgotten. Here we cannot really speak of relief decoration on the body of the vase, for the very shape of the ewer is determined by the rhythmic flow of the ornament and the boldly modelled figures of Neptune and his attendants. Through an astonishing *tour de force* Soldani is able to realize in the design of a water-jug something of the space-evoking properties

and sheer sculptural energy of Bernini's *Fountain of the Four Rivers* [3].
Yet in spite of the obvious derivation of Soldani's sculptural style from
the Berninesque idiom, it can be seen that certain elements in the
work, particularly the curvilinear ornamentation of the neck, are
more suggestive of the decorative vocabulary of the eighteenth
century than the seventeenth. The process of transition from late
Baroque to early Rococo is in fact already perceptible in this extra-
ordinary piece.

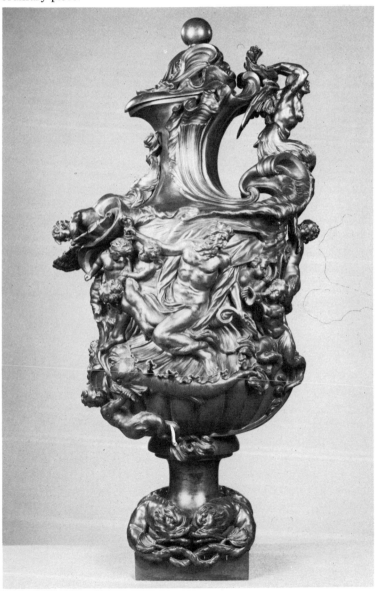

226. Ewer, *c.* 1695. Soldani Benzi

Appendix A:

Peter Paul Rubens, On the Imitation of Statues

[The manuscript of Rubens's essay *De Imitatione Statuarum* was owned by Roger de Piles, who first published it in his book, *Cours de peinture par principes*, Paris, 1708, pp. 139–47. The translation given here is that of the English edition, *The Principles of Painting*, London, 1743, pp. 86–92. Punctuation has been modernized.]

To some painters the imitation of the antique statues has been extremely useful, and to others pernicious, even to the ruin of their art. I conclude, however, that in order to attain the highest perfection in painting it is necessary to understand the antiques, nay, to be so thoroughly possessed of this knowledge that it may diffuse itself everywhere. Yet it must be judiciously applied, and so that it may not in the least smell of the stone. For several ignorant painters, and even some who are skilful, make no distinction between the matter and the form, the stone and the figure, the necessity of using the block, and the art of forming it.

It is certain, however, that as the finest statues are extremely beneficial, so the bad are not only useless but even pernicious. For beginners learn from them I know not what that is crude, liny, stiff, and of harsh anatomy; and while they take themselves to be good proficients do but disgrace nature; since instead of imitating flesh they only represent marble tinged with various colours. For there are many things to be taken notice of and avoided which happen even in the best statues, without the workman's fault: especially with regard to the difference of shades; where the flesh, skin, and cartilages, by

their diaphanous nature, soften, as it were, the harshness of a great many outlines, and wear off those rugged breaks which in statues, by the force and depth of their shade, make the stone, tho' very opaque, appear still more opaque and impenetrable to light than it really is. There are, besides, certain places in the *natural* which change their figure according to the various motions of the body and, by reason of the flexibility of the skin, are sometimes dilated and at other times contracted. These are avoided by the generality of sculptors; yet are sometimes admitted into use by the most excellent, and are certainly necessary to painting; but must be used with moderation. To this we must add that not only the shade but also the lights of statues are extremely different from the *natural*; for the gloss of the stone and sharpness of the light that strikes it raise the surface above its proper pitch or at least fascinate the eye.

He who has, with discernment, made the proper distinctions in these cases cannot consider the antique statues too attentively nor study them too carefully; for we of this erroneous age are so far degenerate that we can produce nothing like them: Whether it is that our grovelling genius will not permit us to soar to those heights which the antients attained by their heroick sense and superior parts; or that we are wrapt up in the darkness that overclouded our fathers; or that it is the will of God, because we have neglected to amend our former errors, that we should fall from them into worse; or that the world growing old, our minds grow with it irrecoverably weak; or, in fine, that nature herself furnished the human body, in those early ages, when it was nearer its origin and perfection, with everything that could make it a perfect model; but now being decay'd and corcupted by a succession of so many ages, vices and accidents has lost its efficacy, and only scatters those perfections among many, which it used formerly to bestow upon one. In this manner, the human stature may be proved from many authors to have gradually decreased: For both sacred and profane writers have related many things concerning the age of heroes, giants and *Cyclopes*, in which accounts, if there are many things that are fabulous, there is certainly some truth.

The chief reason why men of our age are different from the antients is sloth and want of exercise; for most men give no other exercise to their body but eating and drinking. No wonder therefore if we see so many paunch-bellies, weak and pitiful legs and arms, that seem to reproach themselves with their idleness: Whereas the antients exercised their bodies every day in the academies and other places for that purpose, and exercised them so violently as to sweat and fatigue them, perhaps, too much. See in *Mercurialis de arte gymnasticâ* how many various exercises they took, how difficult, and what vigour of constitution they required. Thus all those parts of the body which are fed by idleness were worn away; the belly was kept within its bounds,

and what would have otherwise swelled it was converted into flesh
and muscles: For the arms, legs, neck, shoulders, and whatever works
in the body, are assisted by exercise and nourish'd with juice drawn
into them by heat, and thus increase exceedingly both in strength and
size; as appears from the backs of porters, the arms of prize fighters, the
legs of dancers, and almost the whole body of watermen.

Appendix B:

Paul Fréart de Chantelou, Bernini in France

[Paul Fréart, Sieur de Chantelou, was appointed by Louis XIV to wait upon Bernini during the Italian master's sojourn in France in 1665. Artistically speaking, Bernini's visit was an almost unrelieved failure, for, with the exception of the bust of the king [108], the projects on which he worked came to nothing. What compensates in some degree for these disappointments is Chantelou's copious and very readable diary, in which he faithfully recorded everything that the 'Cavalier Bernini' had said in Paris. The following selections are translated from the edition by L. Lalanne, *Journal du voyage du Cavalier Bernin en France par M. de Chantelou*, Paris, 1885.]

ON PORTRAITURE IN SCULPTURE[1]

Speaking of sculpture and the difficulty of achieving a successful result, and in particular of capturing a likeness in marble portraits, Bernini told me something remarkable that he has since repeated on several occasions: that is, that if someone were to whiten his hair, beard, eyebrows and, if possible, the pupils of his eyes and his lips, and then showed himself in that state, even those who saw him every day would have difficulty in recognizing him. And as proof of this he added: when a person falls into a faint the pallor that spreads over his face is alone sufficient to make him almost unrecognizable, so that we often say, 'He no longer looks himself.' For this reason it is very difficult to obtain a likeness in a marble portrait, which is all of one colour. He told me something else that is even more remarkable: that in a marble portrait it is sometimes necessary, in order to imitate

nature well, to do what is not in nature. Though this may seem to be a paradox, he explained it in this way: in order to represent the bluish patch that some people have around the eyes, it is necessary to hollow out the marble at the place where this bluish colour is, so as to create the effect of the colour and by this artifice to make up, as it were, for the defect in the art of sculpture, which cannot give colour to things. Thus it is, he said, that nature and imitation are not the same thing.

His Majesty told Bernini that he would not see him for three days but that in his absence he would be able to work on the hair of the bust portrait [108]. Bernini replied that he would indeed work on it; he ventured to say to His Majesty that it was not an easy thing, because he wanted to give to this hair the lightness that it has in nature; that to do so it was necessary to combat the material, which is of a contrary nature, but that if His Majesty had seen his *Daphne* [162] he would know that in that work he had found a satisfactory solution for the same kind of problem.

M. de Créqui then spoke of the statue of *Truth* [26], which is in Bernini's place in Rome, as a work of perfect beauty. The Cavalier Bernini said that he made it in order to keep it in his house; that the figure of *Time*, who carries and reveals *Truth*, is not finished, and that it is his intention to represent him carrying her through the air and by the same means to show the effects of time, which finally destroys and consumes all things. He said that in his model he made columns, obelisks and mausolea, and that these things, which are shown as overthrown and destroyed by Time, are the very ones that support him in the air, for without them he couldn't be there, 'although he has wings', he said laughing. He added that at the Roman court there was currently a popular saying, 'Truth is only to be found at the Cavalier Bernini's.' He then related to His Majesty an episode from one of his comedies, where someone describes the misfortunes and unjust persecutions that he is suffering, and another person, to console him, tells him to take courage, that calumny will not last forever, for time at last uncovers and reveals the truth; to which this unhappy person replies, 'It is true that Time reveals her, but he often doesn't reveal her in time.'

ON ARCHITECTURE[2]

The Nuncio remarked that when the Louvre was finished, buildings would be made in the same style. I replied that this could easily be believed, because the Louvre would then become the fashion. I said that all that was needed in France was one good example, and that even in Rome it was the remains of antiquity that served for both sculpture and architecture and continued to provide guidance and assistance in good practice through many beautiful and great ex-

amples. He would not agree with this, saying that the ancients had never done anything to equal St Peter's. 'If you mean mere grandeur of size and quantity of masonry,' I replied, 'I will not dispute this. But in grandeur of *style* St Peter's is smaller than the Rotonda [the Pantheon] and inferior in nobility of workmanship, exactitude and diligence. In any event, monsieur, do you believe that there were no ancient temples in Greece and Italy that equalled St Peter's in size and quantity of material?' The Nuncio still maintained that there were none and then called the Cavalier Bernini to ask him if it were not true that St Peter's was built in a more noble and more excellent style than the Pantheon. Bernini candidly replied no, that the most perfect forms are circles, squares, hexagons, octagons and the like, that the dome of St Peter's is in truth beautiful and without parallel among antique works, but that there are a hundred faults in St Peter's and none in the Pantheon. Michelangelo, he said, had not wanted a nave for St Peter's, and there was a drawing of St Peter's by Baldassare Peruzzi, which is to be seen in Serlio's book on architecture, which is much more beautiful than what was actually built.

ON THE STUDY OF ANCIENT SCULPTURE[3]

On September fifth, the Cavalier Bernini worked as usual and in the evening was at the Academy. MM. du Metz, Nocret and de Sève came to receive him at the street door as deputies of that body. The Cavalier went first to the place where they draw from the models, who, when they saw him, at once assumed the attitudes that had been given them. After staying there for some time he went on to the room where the academic lectures are held. He was offered the first place but did not wish to sit down . . . The Cavalier cast his eye over the paintings in the room, which happened not to be by the most talented artists, and looked also at some bas-reliefs by sculptors of the Academy. Later, while remaining standing in the middle of the room, surrounded by all the members of the Academy, he said that it was his opinion that they should have in the Academy casts of all the best ancient statues, bas-reliefs and busts for the instruction of young people, making them draw after these ancient models in order to instil in them at the outset that idea of beauty which would afterwards be useful to them for their whole life. It is dangerous, he said, to set them to draw from nature at the very beginning, because nature is almost always weak and paltry and because, if their imagination is filled only with that, they will never be able to produce anything beautiful and great which is not to be found in nature. Those who draw from nature must already have considerable skill in order to be able to recognize faults and to correct them, which young people who have no experience are incapable of doing . . . He went on to say that when he was still very young he

often drew from the Antique, and when he found himself in difficulty with his first figure he turned to the *Antinoüs* as his oracle, adding that from day to day he then observed in that statue beauties that he had not previously seen and would never have seen, if he had not taken up the chisel to work in stone. For this reason he always advised his pupils, and everyone else, not to give themselves over to drawing and modelling so much that they could not also manage at the same time to work, whether in sculpture or in painting, by mixing production and imitation, the one with the other, and (so to speak) by combining action and contemplation, from which results a great and marvellous progress.

ON THE PAINTINGS OF POUSSIN[4]

The Cavalier Bernini . . . had planned to spend the morning looking at Jabach's collection of drawings, but since these arrangements had fallen through he asked if he might come to my house. It was half past eight. His son [Paolo] and Mattia [his pupil, Mattia de' Rossi] were with him . . . Bernini spent a long time considering the portrait of M. Poussin,[5] and later asked me who had painted it. I asked him if he recognized the face and he replied that it was Signor Nicolo Pussino. I then told him that it was a self portrait, though Poussin was not in the habit of making them. Bernini said that he thought it was the only one he had done. They all admired it and then went into the little room, where, as I told him, there were some copies after Poussin, the originals of which were at the Château de Richelieu. He considered for at least a quarter of an hour the first *Bacchanal* with the masks lying on the ground and found the composition admirable.[6] He then said, 'Truly, this man was a great history painter and a great painter of fable.' Next he looked for a long time at *Hercules carrying off Deianira*,[7] saying, 'This is beautiful.' Then, having begun to consider it again, he added, 'He has made the Hercules very slender, as well as those *putti* carrying his club and lion's skin.' Of the bacchanal in the *Triumph of Bacchus*[8] he said that he would not have taken it for a Poussin. In the third picture,[9] which he examined for a long period, he praised the terraces, the trees and the whole composition, repeating once again, 'Oh, this great painter of fable!'

Bernini then entered the room with the *Seven Sacraments*,[10] where the only painting uncovered was the *Confirmation*. He looked at it very closely and then remarked, 'He has imitated the colour of Raphael in this picture; it is a beautiful history painting. What devotion! What silence! What beauty in that girl!' His son and Mattia admired the young Levite, then the woman dressed in yellow, and finally all the figures, one after another. I next had the *Marriage* uncovered, which he studied as he had the first, without saying a

word, arranging the curtain which partly covered a figure who stands behind a column. At length he said, 'It is St Joseph and the Virgin. But the priest is not dressed as a priest.' I replied that this was before the establishment of our religion. He answered that there were nevertheless high priests in Judaism. They all expressed admiration for the grandeur and majesty of the work and considered the whole composition with great attention; then, turning to particulars, they admired the nobility and the attentiveness of the girls and women whom he introduced into the ceremony, especially the one who is half concealed by a column. They looked next at the *Penance* [35], which they also studied and admired for a long time. In the meantime I had the *Extreme Unction* taken down and placed near a window so that the Cavalier could see it better. He looked at it standing for some time and then knelt down so as to see it more clearly, changing his glasses from time to time and showing his astonishment without saying anything. Finally he got up and said that the picture could be compared to a beautiful sermon to which one listens with very close attention and from which one departs without uttering a word, because the effect is felt inwardly.

I also had the *Baptism* brought close to the window, and I said to the Cavalier that the scene took place at daybreak. He sat looking at it for some time, then got down on his knees again, changing position from time to time in order to see it better, now at one end and now at the other, and at last said, 'I like this quite as well as the others.' He asked me if I had all seven, and I replied yes. He did not tire of looking for an entire hour. Then, rising, he said, 'You have given me very great displeasure by showing me the merit of a man who makes me realize that I know nothing.' I replied that it must be a great satisfaction to him to have reached the summit of perfection in his art and to know that his works would be on a par with those of the ancients. I then brought to him the little painting by Raphael,[11] which he considered at length, turning from time to time to look at the *Extreme Unction*. Finally he said, 'I value these pictures as highly as those by any painter in the world.' . . . Later he saw the two other *Sacraments* and examined them as carefully as he had the previous ones. There is in the *Ordination* a kind of tower. Pointing to this Bernini said laughingly that it must please me very much because it resembled the French way of building a roof. As for the *Last Supper*, the Cavalier liked it very much and pointed out to Paolo and Mattia the beauty of the heads, one after another, and the harmony of the lighting. He went back now to one, now to the other, and then said, 'If I had to choose one of these pictures I should be very puzzled', and he included the Raphael with the others. 'I should not know,' he went on, 'which to choose. I have always thought highly of the seigneur Poussin, and I remember that Guido Reni was angry at me for the way I spoke of

his [Poussin's] *Martyrdom of St Erasmus* in St Peter's, because in his
opinion I greatly exaggerated its beauty when I told Pope Urban VIII
that if I were a painter that picture would give me great mortification.
This is a great genius, and with all that he has made the Antique his
chief study.' Then, turning to me, he said, 'You must realize that in
these pictures you have a treasure that you must on no account ever
relinquish.'

Appendix C:

Arnold Houbraken,
Life of Rembrandt

[Arnold Houbraken's biography of Rembrandt was published in 1718 in the first volume of his *Groote Schouburgh*, and for more than a century was regarded as the most authoritative source of information on the artist. Though he understood Rembrandt's genius as a history-painter and his skill as an etcher, Houbraken was puzzled by the master's indifference to the 'rules of art' and seems to have believed that the late style was the result of careless technique. The translation, which omits some passages of the original, is by T. Borenius (*Rembrandt, Selected Paintings*, London, Phaidon Press, 1942, pp. 23–8); the notes have been revised.]

The year 1606, so prolific in producing good artists, caused also, on July 15th, Rembrandt to be born on the Rhine near Leiden. His father was called Herman Gerritzen van Ryn and was a miller at the corn-mill between Leydendorp and Koukerk, on the Rhine. His mother's name was Neeltje Willems van Zuitbroek, and both parents earned their livelihood honestly through their work.

Our Rembrandt was an only son, and his parents were anxious that he should learn Latin and become a learned man, so they sent him to school at Leiden. But his particular inclination towards drawing caused them to alter their decision; and as a result they sent him, in order to acquire the elements of art, to Jakob Izakzen van Zwanenborg, with whom he spent some three years, in which time he made such progress that everyone was amazed and thought that something important could be expected from him. For this reason his father, in

order that he should lack no opportunity of laying a firm basis for his art, decided to bring him to P. Lastman at Amsterdam. He stayed with the latter six months, after which he spent some months with Jacob Pynas. Thereupon he determined to continue on his own, and from the very beginning he was marvellously successful in this. Others maintain that Pynas was his first teacher, and Simon van Leeuwen says in his *Short Description of Leiden* that Joris van Schoten was the teacher of Rembrandt and Jan Lievens.[1]

While he thereupon eagerly and with great enthusiasm daily went on with his art by himself in the house of his parents, he was occasionally visited by lovers of art, who eventually indicated to him a gentleman in The Hague to whom he should show and offer a picture which he had just finished. Rembrandt went with it on foot to The Hague and sold it for 100 florins. He, tremendously pleased and not used to having so much money in his purse, wanted to get home as quickly as possible so that his parents should share in the pleasure it brought to himself. To go on foot was too undignified, to travel by barge too common, therefore he boarded the open cart which travelled to Leiden. When they changed horses at the Huis den Deil and every traveller left the cart to take refreshment, only Rembrandt stayed on in the cart with his spoil, not trusting it left alone. What happens? The nose-bag just removed, while the waggoner and his man in readiness came along, the horses bolted and ran on with him, without taking notice of the reins, until within the gates of Leiden, and stopped with the cart in front of their usual inn, at which everyone wondered, asking him how it happened. To which he gave little answer, but disappeared from the cart, with his spoil, to his parents, well pleased that he thus, gratis and for nothing, speedier than in any other fashion, should have been brought to Leiden.

This brilliant beginning showed him the possibility of earning money, and his enthusiasm was spurred on in consequence, so that he gained the satisfaction of all connoisseurs. Thus he got (as the proverb says) the hands full of work. And as he later frequently was obliged to go to Amsterdam, in order to paint both portraits and other pictures, he found it advisable – since this city seemed to him particularly favourable to him and presaged his success – to settle there. This was about the year 1630.

There commissions flowed to him from all quarters, as also a crowd of pupils, for whom he rented a warehouse on the Bloemgracht, in which he gave each a room for himself, often divided from that of others only by paper or canvas, so that everyone, without disturbing anyone else, could draw from life. Since young people, especially if there are many of them together, will sometimes get into mischief, so it happened also here. As one of them needed a female model, he took her into his room. This aroused the curiosity of the others, who, in

order not to be heard, in their socks, one after the other, looked on through a chink in the wall made on purpose. Now it happened, on a warm summer's day, that both the painter and the model stripped so as to be stark naked. The merry jokes and words which passed between the two could easily be retold by the spectators of this comedy. About the same time there arrived Rembrandt to see what his pupils were doing and, as was his custom, to teach one after the other; and so he came to the room where the two naked ones were sitting next to one another. He found the doors closed, but, told about the thing, he watched for a while their pranks through the chink that had been made, until among other words he also heard, 'Now we are exactly as Adam and Eve in Paradise, for we are also naked.' On this he knocked at the door with his mahlstick and called out, to the terror of both, 'But because you are naked you must get out of Paradise.' Having forced his pupil by threats to open the door, he entered, spoilt the Adam and Eve play, transformed comedy into tragedy, and drove away with blows the pretended Adam with his Eve, so that they were only just able, when running down the stairs, to put on part of their clothes, in order not to arrive naked in the street.

As an artist he was prolific in ideas, and that is why one often sees by him a large number of different sketches of one and the same subject; and he was also inexhaustible, be it in regard to facial features and attitudes or in regard to costume. In this respect he may be praised above all others, but especially with regard to those who always introduce into their pictures the same faces and costumes, as if all men were twins. Indeed in this respect he surpassed all others, and I know nobody who has varied his sketches of one and the same subject in so manifold a fashion. This is a result of close observation of the various emotions, which were the cause of a definite event, and may be recognized in the facial features of people, notably through a particular expression or through the most varied movements of the body. For instance, lovers of drawings are acquainted with several different sketches (apart from the two prints) of the scene when Christ through breaking the bread makes Himself known to the two disciples who had gone with Him to Emmaus. No smaller is the number which exists of sketches of the two disciples amazed and astounded as Christ has vanished before their eyes. We have ourselves, as a guidance for still unexperienced young painters, engraved and shown herewith one such sketch which pleased us most by reason of the excellent expression of astonishment and the speechless staring at the empty chair on which Christ still was sitting a moment before He disappeared . . .[2]

But it is to be regretted that, with such a bent towards alterations or easily driven towards something else, he should have but half carried out many of his pictures, and even more of his etchings, so

that only the completed ones can give us an idea of all the beauty that 283
we would possess from his hand if he had finished everything the way
he had begun it. This is in particular to be seen from the *Hundred
Guilder Print* [198], whose treatment we can only wonder at, because
we fail to understand how he was able to carry this out on the basis of
a first rough sketch. Nevertheless, this method of his may be seen
from the *Portrait of Lutma*, which exists in print first as a rough sketch,
then with a background, and finally quite completed.[3] In an exactly
similar fashion he treated his pictures, of which I have seen some in
which some details are executed with the utmost care while the rest
was daubed over as with a rough house-painter's brush, without any
regard to the drawing. But he was not to be kept back from doing this,
and said in his justification that a picture is completed when the
master has achieved his intention by it; nay, he went so far in this
respect that he, in order to give full effect to one single pearl, daubed
over a beautiful Cleopatra. I remember in this connection an example
of his whimsicalness. One day he was working on a great portrait
group, in which man and wife and children were to be seen. When he
had half completed it, his monkey happened to die. As he had no
other canvas available at the moment, he portrayed the dead ape in
the aforesaid picture. Naturally the people concerned would not
tolerate that the disgusting dead ape appeared alongside of them in the
picture. But no: he so adored the model offered by the dead ape that he
would rather keep the unfinished picture than obliterate the ape in
order to please the people portrayed by him. The picture in question
subsequently for a long time served as a dividing wall for his pupils.

Nevertheless there are many pictures from his hand which, care-
fully carried out and completed, may be seen in the principal cabinets,
though some years ago many of them, bought up at large prices,
were exported to Italy and France.

And I have noticed that in his youth he had much more patience
to execute his pictures carefully than later. This is particularly notice-
able in a picture which is known under the name of *St Peter's Boat*,
which long hung in the cabinet of the late Alderman and Burgomaster
Jan Jakobzen Hinloopen at Amsterdam.[4] The attitudes of the figures
and their features are expressed as much in conformity with the event
as can be imagined, and at the same time the whole is executed much
more carefully than one is accustomed to see anything done by him.
In the same collection is yet another picture by Rembrandt, *Haman,
Esther and Ahasuerus at Table*,[5] which the poet Jan Vos, an intelligent
connoisseur, has described — together with the strength of the
emotions expressed in it — as follows:

Here one sees Haman eating with Ahasuerus and Esther,
But it is in vain, his breast is full of grief and pain.

He bites at Esther's food: but deeper into her heart.
The King is possessed by revenge and rage,
The wrath of a king is shocking as it raves.
Threatening all men, it is nullified by a woman.
So falls one from the summit into the chasm of adversity.
The vengeance which comes slow has the strongest rods.

Similarly treated is also the picture called *The Woman taken in Adultery*, belonging to Master Willem Six, senior Alderman of the City of Amsterdam;[6] as also the picture of the *Sermon of St John the Baptist*, a *grisaille*, amazing in the natural rendering of the faces of the listeners and the various costumes: it belongs to the Postmaster Johan Six in Amsterdam.[7] I must also for this reason assume with certainty that he attached importance to these circumstances and did not trouble much about the rest. I am all the more sure of this as many of his pupils told me that he at times sketched a face in ten different ways before he brought it on the canvas, or else might spend a whole day or two in placing a turban according to his taste. With the nude model he did not make so many preparations, but treated it for the most part only hastily. A good hand by him one sees but seldom, because he hid the hands, notably in his portraits, in the shadow; or he painted simply the hand of any old wrinkled woman.

His nude women, however, the most wonderful subject of the brush, upon which all celebrated masters from time immemorial spent all their industry, are (as the saying goes) too pitiful for one to make a song about. For these are invariably figures before which one feels repugnance, so that one can only wonder that a man of such talent and spirit was so self-willed in the choice of his models . . .

Karel van Mander[8] tells that Michelangelo da Caravaggio used to say that every picture, whatever it was, and by whom, was only a childish and trifling affair if everything was not painted from Nature: there was nothing that could be preferred to following Nature. Hence he never did a single stroke without having the living model before him. Of the same opinion was our great master Rembrandt, who laid down the principle that one should only follow Nature and that everything else was worthless to him . . .

Rembrandt would not be bound by any rules made by others and not even follow the exalted examples of those who through their rendering of beauty had prepared for themselves eternal fame: he contented himself with imitating Nature, as it appeared to him, without being fastidious. Hence the good poet Andries Pels very perspicaciously remarks on him in his poem *Use and Misuse of the Theatre* that,

If he painted, as sometimes would happen, a nude woman,
He chose no Greek Venus as his model,
But rather a washerwoman or a treader of peat from a barn,
And called his whim 'imitation of nature'.

Everything else was to him idle ornament. Flabby breasts,
Ill-shaped hands, nay, the traces of the lacings
Of the corselets on the stomach, of the garters on the legs,
Must be visible, if Nature was to get her due:
That is *his* Nature, which would stand no rules,
No principles of proportion in the human body.

I praise this candour in Pels and ask the reader also to put the best possible interpretation on my frank judgement, since it is not expressed from any hatred of the man's works, but in order to compare with one another the different opinions and the varying artistic points of view and to spur the aspiring artist to imitation of that which is most worthy of fame. For apart from this, I must say with the poet mentioned before:

What a loss it was for art that such a master hand
Did not use its native strength to better purpose.
Who surpassed him in the matter of painting?
But oh! the greater the talent, the more
 numerous the aberrations
When it attaches itself to no principles, no rules,
But imagines it knows everything of itself.

For the rest, his works were at the time so highly valued and so much sought after that, as the saying goes, you had to beg of him as well as pay him. For years he was so overwhelmed with orders that people had to wait long for their pictures, although, especially in the last years of his life, he worked so fast that his pictures, when examined from close by, looked like having been daubed with a bricklayer's trowel. For that reason visitors to his studio who wanted to look at his works closely were frightened away by his saying, 'The smell of the colours will bother you.' It is said that he once painted a picture in which the colours were so heavily loaded that you could lift it from the floor by the nose. You see also stones and pearls, in necklaces and turbans, painted with an impasto so thick as if they were chiselled; and through this manner of painting his pictures have a powerful effect even when seen from a long distance.

Of the great number of excellent portraits, there was his self-portrait belonging to M. Jan van Beuningen, carried out so artistically and vigorously that the most brilliant pictures by Van Dyck or Rubens could not rival it. Indeed, the head seemed to issue forth from the picture and address the spectator. No less praise is given on account of its strength, to the self-portrait in the gallery of the Grand Duke in Florence . . .[9]

Of his paintings we think, however, that we have said enough. We want (although his biography has already been inordinately lengthened) yet to speak of his naturalistic and inimitable etchings,

which by themselves would have sufficed to preserve his fame. Amateurs of engraving know some hundreds of them, as also a not inferior number of pen-drawings on paper, in which the emotions called forth by various events have been expressed by him so skilfully and clearly in the features that it is amazing. Anger, hatred, sorrow, joy and so on are represented so naturally that one can read from the strokes of the pen what each signifies. Among many, one of the most excellent is the rendering of the *Last Supper of Christ*,[10] which I have seen in the possession of the lover of art Van der Schelling, and which now belongs to M. Willem Six, frequently mentioned by us, and is valued at more than 20 ducats, though it is but a mere pen-and-paper sketch. You may see from it that in observing the most various emotions, he was able to absorb a permanent conception of them.

Many witty subjects, figures, portraits and a great number of male and female heads have been etched by him on copper merely with the needle – some of them very carefully – and diffused in print to the delectation of amateurs.

He had also a method all his own of gradually treating and finishing his etched plates, a method which he did not communicate to his pupils; and it is not to be ascertained how they were done. Thus the invention . . . has been buried with the inventor.

To give an instance: of the *Portrait of Lutma* three different impressions are known – one roughly sketched, another somewhat more finished, in which the window-frame is visible, and finally one which is completed with great care and vigour. One discovers also, as regards the *Portrait of Sylvius*, that, similarly, it is first roughly etched, and that the tender sparkling shadows and vigorous touches are then brought in, and so well and delicately treated as may be achieved in mezzotint.[11] These works brought him great fame and no small advantage, and in particular through the device of slight changes of small and unimportant additions, which he made on his prints, thanks to which these could be sold again as fresh ones. Nay, the demand was at that time so great that people were not considered as true amateurs who did not possess the Juno with and without the crown, the Joseph with the light and the dark head and so on. Indeed, everyone wanted to have *The Woman by the Stove* – for that matter one of his least important etchings – both with and without the stove-key, in spite of the fact that he sold the etching through his son Titus, as if it were too unimportant for himself.[12]

Besides, he had so great a number of pupils, of whom each brought him annually 100 florins, that Sandrart, who used to have personal contact with him, says that he could calculate that Rembrandt from his pupils had an annual income of more than 2,500 florins. Yet such was his love of money (I will not say craving for money) that his pupils who noticed this, often for fun would paint on the floor or else-

where, where he was bound to pass, pennies, twopenny pieces and shillings, and so on, after which he frequently stretched out his hand in vain, without letting anything be noticed as he was embarrassed through his mistake. 'Money stops no desire.' Add to this what he gained with his brush, because he made people pay well for his painting. He must thus necessarily have earned large sums of money, all the more so as he spent little at taverns or parties and still less at home, where he lived but simply, often content with some bread and cheese or a pickled herring as his whole meal. Nevertheless, one heard nothing trumpeted about a large estate at the time of his death . . .

His wife was a peasant woman from Raarep, or Ransdorp, in the district of Waterland, small in figure, but well shaped of face and plump of body. Her portrait may be seen next to his in one of his prints . . .

In the autumn of his life he kept company mostly with common people and such as practised art. Perhaps he knew the laws of the art of living as set out by Gracián, who says, 'It is a good thing to frequent distinguished persons in order to become one yourself; but once that is achieved you should mix with ordinary people.' And he gave this reason for it: 'If I want to give my mind diversion, then it is not honour I seek, but freedom.'

Appendix D:

Francisco Pacheco,
On the Aim of Painting

[In the following passage Pacheco offers what is perhaps the clearest definition that we possess of the transcendental significance of Baroque naturalism. Francisco Pacheco's *El arte de la pintura* was published at Seville in 1649. The authoritative modern edition is by F. J. Sánchez Cantón, Madrid, 1956. The translation used here is that of Jonathan Brown; see R. Enggass and J. Brown, *Italy and Spain 1600–1750* (Sources and Documents in the History of Art Series), Englewood Cliffs, N.J., Prentice-Hall, Inc., 1970, pp. 162–3.]

When dealing with the aim of painting (as we have proposed to do), it is necessary to borrow a distinction used by the doctors of the Church, which serves to clarify our purpose. They distinguish between the aim of the work and the aim of the worker. Following this doctrine, I would like to distinguish between the aim of the painting and the aim of the painter. The aim of the painter, in his capacity as an artisan, will be by means of his art to earn a living, achieve fame or renown, to afford pleasure or service to another or to work for his own enjoyment. The end of painting (in general) will be, by means of imitation, to represent a given subject with all the power and propriety possible. Some people call this the soul of painting, because it makes it seem alive, so that the beauty and variety of colours and other embellishments become of secondary importance. Hence Aristotle said that, of two paintings, one inaccurate but displaying beautiful colour and the other true to life but simply drawn, the former will be inferior and the latter superior, because the former contains the incidental and the latter incorporates the fundamental and substantial, which consists

of reproducing perfectly, by means of good drawing, that which one
wishes to imitate.

But considering the aim of the painter as a Christian artisan (which
is our present task), he may have two goals or ends: one primary, the
other secondary. The latter, and less important, will be to exercise his
art for gain or renown or for other reasons (as I have said above), but
controlled by factors of time, place and circumstance, so that no one
may accuse him of abusing this art or of working against the highest
good. The principal goal will be to achieve a state of grace through
the study and practice of this profession; because the Christian, born
to achieve high things, is not content to restrict his activities to lower
things, attending only to human rewards and earthly comfort. Rather,
raising his eyes heavenward, he dedicates himself to a greater and
more excellent goal that is found in things eternal. And this is why
St Paul often cautioned the serfs and all other men that, when
ministering unto others, they should remember that they did so
chiefly for the sake of God, saying: 'Servants, be obedient to them that
are your masters in the flesh, not with eyeservice, as men pleasers;
but as servants of Christ, knowing that whatsoever good any man
doeth, the same shall he receive of the Lord [Ephesians, vi, 5–8].' And
elsewhere: 'Whatsoever ye do, do it heartily, as to the Lord, and not
unto men; knowing that of the Lord ye shall receive the reward of the
inheritance [Colossians, iii, 23–4].'

And if the aim of painting (speaking of it now as an art), is, as we
have said, to approximate what it intends to imitate, let us now add
that when it is practised as a Christian work, it acquires another more
noble form and by this means advances to the highest order of virtue.
This privilege is born of the greatness of God's law, by means of which
all actions (which otherwise would be considered vile), committed
with thoughtfulness and directed to the final goal, become greater and
are adorned with the rewards of virtue. But do not think that art is
destroyed or denied by this; rather it is elevated and ennobled and
receives new perfection. Thus, speaking of our problem, we can say
that painting, which before had imitation as its sole aim, now, as an
act of virtue, takes on new and rich trappings; and, in addition to
imitation, elevates itself to a supreme end — the contemplation of
eternal glory. And as it keeps men from vice, so does it lead them to
the true devotion of God our Lord.

Thus we see that Christian images are directed not only towards
God, but also towards ourselves and our fellow man. For there is no
doubt that all virtuous works may serve simultaneously the glory of
God, our own education and the edification of our fellow man. And
the more these three elements are present, the more will the work be
esteemed, for in these elements exists the totality of Christian per-
fection.

Appendix E:

Philippe de Champaigne, On Poussin's Rebecca and Eliezer

[Poussin's painting of *Rebecca and Eliezer at the Well* [93] was the subject of a lecture delivered by Philippe de Champaigne before the Royal Academy of Painting and Sculpture on 7 January 1668. Though the text of the lecture is lost, the substance of Champaigne's remarks is preserved in the résumé made by Guillet de Saint-Georges, historiographer of the Academy. Guillet's report of the lecture was read at several meetings of the Academy, the most important being that of 10 October 1682, which was presided over by the great Colbert himself. This version was published in *Mémoires inédits sur la vie et les ouvrages des membres de l'Académie Royale de Peinture et de Sculpture*, 1854, I, pp. 245–58, and in H. Jouin, *Conférences de l'Académie Royale de Peinture et de Sculpture*, 1883, pp. 86–99. The translation is that of E. G. Holt, *Literary Sources of Art History*, Princeton, N.J., Princeton University Press, 1947, pp. 388–94.]

The subject of the lecture and of the picture was taken from the twenty-fourth chapter of Genesis. It related how one of Abraham's serving-men, making a trip in search of the girl Isaac was to marry and finding himself suffering from thirst, encountered Rebecca, who had just drawn water from the well, and who in an obliging way gave some to the traveller and to the camels of his caravan. By this he recognized her as the girl he sought and presented her with two earrings and two gold bracelets.

M. de Champaigne's lecture began by praising Poussin, and he pointed out with justice that this excellent painter had been through his art the honour of France and [had had] the admiration of the foreigners. He added that this picture of Rebecca had greatly contributed to Poussin's having acquired so well founded a reputation. He maintained, moreover, that the excellence of the painting depended less on rules of art than on great genius [*beau génie*], but that both are found in this picture, and he noted in the picture the compliance with three or four general and important rules.

He stated the first of these rules to be that of representing the principal action in the situation depicted with so much art that it might be easily distinguished from the secondary elements. In this picture by Poussin, he demonstrated that the eye of the spectator looks first at the principal figures of the narrative and that they are easily distinguished from the less important figures by their posture; that the servant of Abraham helps to express the main subject by his gesture, namely, in presenting the gifts to Rebecca he shows that he is convinced that it is she for whom he is seeking, and by observing the modest air of Rebecca and her apparent hesitancy in accepting the presents just given her, we find in her the trait of chastity and nobility belonging to great souls and above all to her sex. This greatly helps in distinguishing this figure from the others less important to the subject.

M. de Champaigne gave as the second general rule, the disposition by groups in the painting and showed that it is admirably observed in this picture since in it many figures can be seen which form separate companies or groups such as ordinarily occur in large assemblies. For it is natural for persons to separate into different groups, each seeking to withdraw from the crowd and to join people who have the same interests or inclinations. Therefore a painter who treats large subjects should carefully observe the judicious distribution of figures by groups.

He said, moreover, that expression is the third feature of the painting and that it is observed exactly in each figure in this painting. He pointed out the figure of a girl who is leaning on a vase near the well. To the observer, it would seem that she blames Rebecca for having accepted the gift from an unknown man. But M. de Champaigne wished to point out that M. Poussin had imitated in this figure the proportions and draperies of the ancients of whom he had always made a servile and careful study. He expressed himself in a way that would seem to blame Poussin slightly for a certain amount of sterility and for having leaned over-much on the ancients to the point of stealing from them. But while M. de Champaigne was thus speaking, M. Le Brun interrupted him and taking the part of M. Poussin said that learned men who work toward the same discoveries and toward the same end can be found to chance upon the same solutions without

deserving the title of imitators or plagiarists. Therefore, we must recognize the difference between competitors and copyists and not confuse the things which are stolen or counterfeited with those which by their very nature must be in conformity with each other. All historians who have written independently on the same subject have not been able to prevent a similarity, although they have never consulted with each other. Following their example, M. Poussin when studying and discovering the true phenomena of nature equalled the able men of antiquity. He, like them, made a good choice and a good use of these phenomena of nature and could not help approximating their ideas. If one doesn't make these distinctions, one would accuse unjustly all the great craftsmen of antiquity of having copied each other, since having taken nature and the true for models, they were bound to keep in their figures the same proportions and to follow the same principles. In truth, the Greeks had a great advantage over us because their country produced naturally better formed persons than ours and furnished them with more beautiful models, for they wore clothes which did not hinder the body and did not spoil the form of the parts exposed, and even these clothes only half covered the body, making it easier for their painters and sculptors to observe their beauty. To make it even easier, they had constantly before their eyes nearly nude young slaves as well as the frequent performances of well-formed athletes which gave these excellent craftsmen ample material for study and for perfecting [their works].

M. Le Brun thus ended his remarks. M. de Champaigne resumed the discussion and came back to the figure of the girl leaning on the vase. He said that the other figures of the girls with her in the group show on their faces a smile mixed with pride and censure as though they were jealous to see that anyone would prefer Rebecca to them. There is one dressed in red and green whose embarrassment is considerable. She observes what is happening between Rebecca and Abraham's servant without being aware that she is pouring water for one of her companions, while the latter, whose pitcher is already full, seems to reproach this careless person for paying no attention to what she is doing. The charm and force of expression appears also in three or four figures of girls who are more in the background. One of them holds her pitcher on her head with her two hands and looks at Rebecca with all the attention of a curious person. Another, leaning on the shoulder of one of her companions – seen only from the back – seems to call a third, whose attitude is worthy of admiration for in spite of already having one of her vases on her head, she is very attentive to what is happening and bends over, stretching out her hand to pick up the other vase that is on the ground in a gesture so natural, so effortless and so well delineated, that one is made to see that her figure appears to have summoned all the skill possible for the brush

of the painter. This troop of girls withdraws or prepares to withdraw either because their disapproval drives them away or because their duty at home is calling them.

M. de Champaigne added that the distribution of light, shade and colour is judiciously handled in this picture, above all in the gentle and imperceptible unification of the landscape and the figures. Although the landscape is gay and even very much varied, it seems a unified background for it in no way detracts from the force and plastic quality of the figures.

After some praise of M. Poussin which he so well deserved, M. de Champaigne, while calling attention to an element of this picture which he did not approve, claimed that he did not make his criticism in a quarrelsome and disparaging spirit and that he only wanted to clarify for himself a doubt and to examine all that may serve to the advantage of art in keeping with the freedom given him by the illustrious protector of the Academy who wishes that the truth be pursued by means of criticisms and wise discussion to its source. He then said that it seemed to him that M. Poussin had not handled the subject of the picture with complete truth to history, for he had omitted the camels which the Scripture mentions when it says that Abraham's servant recognized Rebecca by the considerate care she gave his camels when she offered drink to them as well as to him. The Scripture specifies that these animals actually drank the water she gave them and that at the same moment she received the present of the bracelets and earrings. In a painting true to history this might have been shown to demonstrate the exactitude and fidelity of the painter. He added that perhaps one might excuse M. Poussin by saying that he wished to paint only agreeable objects in his work and the ugliness of the camels would have been a deformity in his work. M. de Champaigne maintained this would have been a frivolous excuse and, on the contrary, the ugliness of these animals would have enhanced the brilliance of so many beautiful figures. According to him nothing in the world ever appears so well as when it is contrasted with its opposite. Virtue seems less charming and desirable unless compared to vice. Even M. Poussin himself would never have been able to distribute so agreeably the light in his picture if he had not also put in some shadows.

M. Le Brun took up the discussion and asked M. de Champaigne if he believed that M. Poussin could have been ignorant of the story of Rebecca. Whereupon M. de Champaigne agreed with the entire assembly that M. Poussin was much too enlightened and too learned to have not known this point of sacred history. This prompted M. Le Brun to say that the camels had not been omitted from this picture without serious thought. M. Poussin, seeking always to purify and unencumber the subject of his works and to make the principal action which he handles appear agreeable, had rejected the bizarre elements

which could distract the eye of the spectator and detain him by minute details. The field of the picture is destined only for the figures necessary to the subject and for those that can be depicted in an ingenious and agreeable manner. Therefore, he did not need to concern himself with a caravan of camels, as thankless of treatment as they are embarrassing by their number. The book of Genesis mentions ten camels and if it had been necessary to handle the subject with the faithfulness and exactitude the critics maintain, one would have to put in ten and make a complete caravan. M. Poussin often reflected on such an arrangement incompatible with painting and said as a maxim that painting as well as music has its own modes. In the harmonious proportion of the ancients, the Phrygian mode designed for military airs never mingles with the Dorian which was reserved for the divine cult. The Ionian mode broken up by trills never mixed with the Aeolian which was simple and natural. Each mode, having its own rules, could never be confused with any other. In keeping with this, M. Poussin, when he considered the particular kind of any subject he treated, suppressed the objects which, as they were disparate, would have been discordant. He considered them minor details and that their being withdrawn did no harm to the story. He said that poetry proceeds in the same way and does not permit the easy and familiar expression of a comic poem to be mixed with the pomp and gravity of the heroic in the same work of art. M. Le Brun further added to the remarks of M. Poussin that even poetry avoids the narration of bizarre actions in a serious work. An excellent poet of our time describing the battle between Alexander and Porus has withdrawn from his narrative that Porus was at the time mounted on an elephant. He feared that by mentioning a kind of mount not in use by our army, he would offend the ears of his listeners and the principal theme would be disturbed by this petty detail which is contrary to our methods of combat. Could one say with justice that sacred and profane history have been harmed when here the mention of the elephant and there the pictorial representation of camels has been omitted? To emphasize this opinion, M. Le Brun added yet another example worthy of respect and said that ordinarily in representing Jesus Christ dying on Calvary, one has only five figures appear there and more often, three, although it is well known that there came then an unusually large crowd from Jerusalem, for the celebration of the feast of the Passover had attracted nearly all the people of Judea.

On this occasion the painters cannot suppose with any truth to reality that the multitude watched the spectacle from afar, for who would have kept them from approaching, and is it not apparent that the crowd of Jews, already familiar with the extraordinary life of Jesus Christ and curious to see its end, would have surrounded the foot of the cross? But the painters have wisely realized that by assuming such

a great embarrassment, they would not satisfy well the piety of contemplative persons because so many different objects would interrupt their meditations and their fervour.

Although these reasons satisfied a large part of the assembly, there were still several partisans of M. de Champaigne who persisted in maintaining that the story of Rebecca would have been more intelligible if at least three or four camels had been represented there. As M. Poussin had not provided this detail, one would take Abraham's servant for a merchant seeking to show and to sell his jewels. But M. Le Brun turned the weapons of his censurers against themselves and made them realize that camels are used for the ordinary wagon of the Levantine merchant. He told them that, quite contrary to their opinion, if several camels were represented near the servant of Abraham, it would be an indication that he actually was a merchant from afar, who pauses with these girls on his way to pursue his trade. By suppressing this detail the painter avoided the error into which he might have fallen had he painted what these critics desired. He added that whatever character a painter employs to explain the subject of his picture, he always encounters gross or malicious interpreters who will endeavour to alter or obscure the truth of everything. The painter who would satisfy the ignorance of some or anticipate the malice of others would in the end be obliged to write in his picture the names of the objects he wished to represent.

Regarding what M. de Champaigne had said, it was also observed that the ugliness of the camels would serve to heighten the brilliant effect of so many beautiful figures, and that nothing in the world seems so beautiful as when it is contrasted with its opposite. This objection was met by saying that, while it was true that things thus contrasted seem heightened, it is not true that as a result they seem more suitable or symmetrical. In fact, if in order to portray virtue more agreeably and brilliantly it were necessary to contrast or to compare it with vice, it would follow that honest men would never be able to appear truly splendid unless they were confronted with scoundrels. Thus it would seem that good cannot act without evil and that virtue would be indebted to vice for all its splendour. When M. de Champaigne said, in order to maintain the same contention, that M. Poussin would not have been able to create the beauties of the picture of Rebecca without the aid of shadows, he spoke the truth; but he proved nothing in favour of Poussin, for shadows and lights are relative and reciprocal. Both are essential in the picture of an artist who in that and in all other things wishes to imitate the effects of nature, and if, according to the maxim that has just been affirmed, one wished to paint a picture where shadows do not accompany light, it would be necessary to reverse the order of nature which has made these two conditions inseparable. Thus the shadows ought not be considered as the orna-

ment of a picture, but as the absolute necessity — although it is true that judicious economy in their use is one of art's greatest secrets.

But finally, to settle the question to the advantage of M. Poussin, it was observed that, as a learned man, Poussin had looked for support for his painting of Rebecca in the text of the Holy Scripture; in Genesis it is expressly stated that Rebecca, after having given a drink to the servant of Abraham, ran to the well a second time to draw water for his camels. This indicates that there was some distance between the camels and the well. Therefore, M. Poussin had a sound basis for assuming that these animals had been drawn aside as though convention demanded they be separated from the crowd of attractive girls, above all at a time when a marriage was about to be contracted with one of them — an occasion which demanded all the circumspection and propriety of a gallant interview.

Notes

INTRODUCTION (*pages 11–17*)

1. By Jacob Burckhardt in the *Cicerone* and by Wilhelm Luebke in his *Geschichte der Architektur*, both published in 1855.

2. See O. Kurz, 'Barocco, storia di una parola', *Lettere Italiane*, XII, 1960, pp. 414–44.

3. This is the view of G. Briganti; see his article 'Baroque Art', *Encyclopedia of World Art*, 1960, II, especially cols. 263–7.

4. W. Stechow, 'Definitions of the Baroque in the Visual Arts', *Journal of Aesthetics and Art Criticism*, v, 1946–7, p. 114.

5. Cited by W. Friedlaender, *Caravaggio Studies*, 1955, p. 276.

I. THE QUESTION OF STYLE (*pages 19–38*)

1. Roger de Piles, *Conversations sur la connoissance de la peinture*, 1677, p. 135.

2. In his book *Versions of Baroque: European Literature of the Seventeenth Century* (1972, p. 1), F. J. Warnke uses the word 'Baroque' 'to denote not a precisely definable style but a period complex made up of a whole cluster of more or less related styles'.

3. J. Rosenberg, *Rembrandt, Life and Work*, rev. ed. 1964, p. 293.

4. The chief sources on the controversy are M. Missirini, *Memorie per servire alla storia della romana Accademia di San Luca*, 1823, and G. D. Ottonelli and P. Berrettini (Pietro da Cortona), *Trattato della pittura e scultura, uso, et abuso loro*, 1652. The best summary is given by R. Wittkower, *Art and Architecture in Italy, 1600–1750*, rev. ed. 1973, pp. 263–6. The point is perhaps worth emphasizing that this famous controversy was not really concerned with matters of style, much less with what we think of as 'Baroque and Classic', but rather with problems of art theory and the relation of painting to poetry. In the course of an academic lecture the theoretical question was raised whether large paintings with numerous figures were not preferable to small paintings

containing only a few. In the discussion that followed the lecture, Pietro da Cortona spoke enthusiastically in favour of *grandi opere*. Others, adhering to the doctrine *ut pictura poesis*, observed that in classical tragedy the greatest effect was achieved by the least number of actors and therefore argued that the same principle ought to be imitated in painting. Most of the academicians, however, appeared to be persuaded that vast subjects required vast compositions in which, as in epic poetry, there must be a main theme accompanied by many subordinate episodes. A careful reading of the evidence does not support the idea of a formal debate between Sacchi and Cortona, nor is there any clear proof that Sacchi himself took part in the discussion. I am indebted, for much of the material in this note, to a study made at Princeton University several years ago by Mr David Wright.

5. A. Fontaine, *Les doctrines d'art en France*, 1909.

6. P. Fréart de Chantelou, *Journal du voyage du Cavalier Bernin en France*, ed. L. Lalanne, 1885, pp. 64–5. See Appendix B, p. 274.

7. C. Hofstede de Groot, *Die Urkunden über Rembrandt*, 1906, pp. 190–210.

8. C. White, *Rembrandt as an Etcher*, 1969, I, p. 154.

9. De Piles, *Conversations*, pp. 220–21.

2. NATURALISM (*pages 39–72*)

1. The surviving fragment of Agucchi's *Trattato della Pittura*, originally published in *Diverse figure da Annibale Carracci intagliate in rame da Simone Guilino . . .*, 1646, is reprinted with annotations in Denis Mahon, *Studies in Seicento Art and Theory*, 1947, pp. 241–58; for the passages quoted above see pp. 247–9.

2. G. P. Bellori, *Le vite de' pittori, scultori et architetti moderni*, 1672, p. 212. For an English translation of Bellori's Life of Caravaggio see W. Friedlaender, *Caravaggio Studies*, 1955, pp. 245–54.

3. Bredero's statement, from the introduction to his *Boertig Liedboek*, is quoted by G. Knuttel, *De Nederlandsche Schilderkunst*, 1938, pp. 204–5.

4. K. van Mander, *Het Schilder-Boeck*, 1604, fol. 191. Friedlaender gives an English translation of Van Mander's Life of Caravaggio in his *Caravaggio Studies*, p. 260.

5. Agucchi, *Trattato*, reprinted in Mahon, *Studies in Siecento Art and Theory*, p. 257.

6. Bellori, *Le vite*, pp. 201, 212–13.

7. R. de Piles, *Conversations sur la connoissance de la peinture*, 1677, pp. 228, 257.

8. Bellori, *Le vite*, p. 248.

9. Rubens's essay *De Imitatione Statuarum* was printed by Roger de Piles, *Cours de peinture par principes*, 1708, pp. 139–47. See Appendix A, p. 271.

10. *Correspondance de Rubens*, ed. M. Rooses and C. Ruelens, 1887–1909, III, pp. 85ff.

11. F. Baldinucci, *Vita di Bernini* (1682), ed. S. Samek Ludovici, 1948, p. 141. Compare the famous remark by the sculptor Pierre Puget in a letter of 1683: 'Je me suis nourri aux grands ouvrages, je nage quand j'y travaille; et le marbre tremble devant moi, pour grosse que soit la pièce.' (L. Lagrange, 'Pierre Puget', *Gazette des Beaux-Arts*, XIX, 1865, p. 426.)

12. N. Pevsner, *An Outline of European Architecture*, Jubilee Edition, 1960, p. 397.

13. Rubens, *De Imitatione Statuarum* in de Piles, *Cours de peinture*, p. 141.

14. A. Palomino, *El museo pictórico y escala óptica* (1724), ed. M. Aguilar, 1947, pp. 913, 921.

15. The lines on Rembrandt in Andries Pels's *Gebruik en misbruik des toneels*, 1681, are reprinted in S. Slive, *Rembrandt and his Critics, 1630–1730*, 1953, pp. 210–11. See also Appendix C, pp. 284–5.

16. Arnold Houbraken's biography of Rembrandt is contained in his book *De Groote Schouburgh der Nederlantsche Konstschilders en Schilderessen*, 1718. See Appendix C, p. 280.

17. A. Félibien, *Entretiens sur les vies et sur les ouvrages des plus excellents peintres anciens et modernes*, 1725, III, p. 194.

18. Félibien, *Entretiens*, IV, p. 14.

19. *The Spiritual Exercises of Saint Ignatius of Loyola*, transl. W. H. Longridge, 1919, p. 53 (First Exercise).

20. W. Friedlaender, *Mannerism and Anti-Mannerism in Italian Painting*, 1957, p. 77.

21. B. G. Proske, *Juan Martínez Montañés*, 1967, p. 40.

22. *Spiritual Exercises*, transl. Longridge, pp. 57–8 (First Exercise, Colloquy).

23. E. H. Gombrich, 'Renaissance Artistic Theory and the Development of Landscape Painting', *Gazette des Beaux-Arts*, XLI, 1953, pp. 335–60, reprinted in the same author's *Norm and Form, Studies in the Art of the Renaissance*, 1966, pp. 107–21.

24. J. von Sandrart, *Deutsche Akademie der Bau- Bild- und Mahlerey-Künste* (1675), ed. A. R. Peltzer, 1925, p. 209.

25. C. Sterling, *Still Life Painting from Antiquity to the Present Time*, transl. J. Emmons, 1959, p. 45.

26. Caravaggio's remark is quoted in a letter by Vincenzo Giustiniani. (G. Bottari, *Raccolta di lettere sulla pittura, scultura ed architettura*, 1768, IV, pp. 247–53.)

27. E. Fromentin, *Les maîtres d'autrefois* (1876), transl. M. C. Robbins, *The Old Masters of Belgium and Holland*, 1963, p. 146.

28. Francis Bacon, *Instauratio magna, id est, Novum Organum*, 1620, p. 23 (Distributio operis).

29. W. M. Ivins, *Prints and Visual Communication*, 1953, pp. 43–6, 163; A. Chastel, 'Le baroque et la mort', *Atti del III Congresso Internazionale di Studi Umanistici*, 1955, p. 39.

30. E. Panofsky, *Galileo as a Critic of the Arts*, 1954, p. 5, figs. 2, 3.

31. W. Prinz, 'The Four Philosophers of Rubens and the Pseudo-Seneca in Seventeenth-Century Painting', *Art Bulletin*, LV, 1973, pp. 410–28.

32. A. Blunt, *Nicolas Poussin*, 1967, I, p. 285.

3. THE PASSIONS OF THE SOUL (*pages 73–118*)

1. R. W. Lee, *Ut pictura poesis: The Humanistic Theory of Painting*, 1967, pp. 23–32.

2. T. Hobbes, *Leviathan*, 1651, Part I, chaps. 13, 11 and 6 respectively.

3. See D. Posner, 'Caravaggio's Homoerotic Early Works', *Art Quarterly*, XXXIV, 1971, pp. 304–5.

4. Huygens's fragmentary autobiography of about 1630, in which he praises Rembrandt's *Judas*, was published by J. A. Worp in *Bijdragen en Mededeelingen van het historisch Genootschap*, XVIII, 1897.

5. R. Burton, *Anatomy of Melancholy*, 1621, Part III. Sect. II. Mem. III. Subs. I.

6. Bellori, *Le vite*, p. 29.

7. De Piles, *Conversations*, pp. 219–20. On Rubens's sketch-book, see M. Jaffé, *Van Dyck's Antwerp Sketchbook*, 1966, I, pp. 301–2.

8. Y. Delaporte, 'André Félibien en Italie (1647–1649)', *Gazette des Beaux-*

Arts, LI, 1958, p. 202.

9. Bellori, *Le vite*, pp. 460–61. See also A. Blunt, *Nicolas Poussin*, 1967, pp. 362–3.

10. Poussin's letter to Stella is quoted by Félibien, *Entretiens*, 1725, IV, p. 26.

11. A. Félibien, *Les reines de Perse aux pieds d'Alexandre, peinture du Cabinet du Roy*, 1663, reprinted in his *Description de divers ouvrages de peinture faits pour le Roy*, 1671.

12. R. Descartes, *Traité des passions de l'âme*, 1649, 3e partie, art. 165.

13. *Conférence de M. Le Brun sur l'expression générale et particulière*, 1698. I quote from the English edition of 1701, *Conference of Monsieur Le Brun . . . upon Expression, General and Particular*, pp. 17–18.

14. On Vondel's poem see J. A. Emmens, 'Ay Rembrandt maal Cornelis stem', *Nederlands Kunsthistorisch Jaarboek*, VII, 1956, pp. 133–65.

15. See on this question G. C. Argan, 'La "Rettorica" e l'arte barocca', *Atti del III Congresso Internazionale di Studi Umanistici*, 1955, pp. 9–14.

16. *La vida de Santa Teresa de Jesus escrita por ella misma*, cap. 29.

17. G. Glück, *Rubens, Van Dyck und ihr Kreis*, 1933, pp. 276–81.

18. Joannes Molanus, *De historia SS. imaginum et picturarum*, 1594, bk. II, chap. 40.

4. THE TRANSCENDENTAL VIEW OF REALITY (*pages 119–53*)

1. Johannes Kepler, *Gesammelte Werke*, ed. M. Caspar, I, 1938, p. 9 (*Mysterium Cosmographicum*); VII, 1953, p. 258 (*Epitome Astronomiae Copernicae*).

2. G. Milhaud, *Descartes savant*, 1921, pp. 47–63.

3. Sir Thomas Browne, *Religio Medici*, i. 14. Browne refers here to the treatise *On the Use of the Parts of the Body of Man* by the ancient Greek physician Galen and to the *Metaphysics* of the Spanish theologian Francisco Suarez (1548–1617).

4. E. Mâle, 'La clef des allégories peintes and sculptées au 17e et au 18e siècles', *Revue des Deux Mondes*, XXXIX, 1927, pp. 106ff., 375 ff.

5. C. Ripa, *Iconologia*, 1613, *sub voce* 'Verità'.

6. Sir Thomas Browne, *Pseudodoxia Epidemica*, 1646, 'To the Reader'.

7. E. Mâle, *L'art religieux après le Concile de Trente*, 1932, p. 343.

8. Pascal, *Pensées*, transl. W. F. Trotter, 1948, p. 190 (No. 674).

9. *Speculum Humanae Salvationis*, cap. VII, ed. J. Lutz and P. Perdrizet, 1907, p. 19.

10. *Art Bulletin*, LIII, 1971, p. 418.

11. H. Kauffmann, 'Die Fünfsinne in der niederländischen Malerei des 17. Jahrhunderts', in *Kunstgeschichtliche Studien*, ed. H. Tintelnot, Breslau, 1943, pp. 133–57.

12. J. A. Emmens, 'Natuur, Onderwijzing en Oefening bij een drieluik van Gerrit Dou', *Album Discipulorum J. G. van Gelder*, 1963, pp. 125–36.

13. F. Pacheco, *El arte de la pintura* (1649), ed. F. J. Sánchez Cantón, 1956, I, pp. 212–15. See Appendix D, p. 288.

14. On the *Vanitas* theme, see J. Białostocki, *Stil und Ikonographie*, 1966, pp. 187–230.

15. A. Houbraken, *De Groote Schouburgh*, ed. of 1753, I, p. 163; cited by I. Bergström, *Dutch Still Life Painting*, 1956, p. 214.

16. E. Panofsky, *Studies in Iconology*, 1939, p. 64.

17. W. Sauerländer, 'Die Jahreszeiten. Ein Beitrag zur allegorischen Landschaft beim späten Poussin', *Münchner Jahrbuch der bildenden Kunst*, VII, 1956, pp. 160–84.

18. W. Stechow, *Dutch Landscape Painting of the Seventeenth Century*, 1966, pp. 82–100.

19. W. Vitzthum, 'A Comment on the Iconography of Pietro da Cortona's Barberini Ceiling', *Burlington Magazine*, CIII, 1961, pp. 427–33.

20. A. Félibien, *Description sommaire du chasteau de Versailles*, 1674, pp. 13–14, 31.

21. Charles Perrault, *Mémoires de ma vie*, ed. P. Bonnefon, 1909, pp. 108–10.

22. Bernini's memorandum on the Colonnade is cited by R. Wittkower, 'A Counter-Project to Bernini's "Piazza di S. Pietro"', *Journal of the Warburg and Courtauld Institutes*, III, 1939–40, p. 103.

23. K. Fremantle, *The Baroque Town Hall of Amsterdam*, 1959, p. 30.

24. Fremantle, p. 60.

25. Fremantle, pp. 78–86, pls. 84–97.

5. SPACE (*pages 155–96*)

1. *De l'infinito, universo e mondi*, Dial. III.

2. The 'orthodox' directions for representing the Virgin of the Immaculate Conception are given by Francisco Pacheco in *El arte de la pintura*, 1649. There is an English translation in R. Enggass and J. M. Brown, *Italy and Spain 1600–1750* (Sources and Documents in the History of Art), 1970, pp. 165–7.

3. Wölfflin, *Principles of Art History*, pp. 73–106.

4. The word 'painterly' (*malerisch*) was used by Wölfflin to characterize the art of the seventeenth century in contrast to the 'linear' style of the sixteenth. See *Principles of Art History*, pp. 18–53.

5. Palomino, *El museo pictórico*, ed. M. Aguilar, p. 922.

6. H. van de Waal, 'De Staalmeesters en hun legende', *Oud Holland*, LXXI, 1956, pp. 61–107.

7. *Perspectiva pictorum et architectorum*, 1693 ('Al Lettore'). I quote from the English edition of 1707, *Rules and Examples of Perspective proper for Painters and Architects*.

8. See on this question C. S. Wortley, 'Rubens' Drawings of Chinese Costume', *Old Master Drawings*, IX, 1934–5, pp. 40–47.

9. R. A. Ingrams, 'Rubens and Persia', *Burlington Magazine*, CXVI, 1974, pp. 190–97. See also H. and O. Kurz, 'The Turkish Dresses in the Costume Book of Rubens', *Nederlands Kunsthistorisch Jaarboek*, XXIII, 1972, pp. 275–90.

10. The *Racconto della fabrica* of 1672 says that the statue 'rappresenta l'anima di S. Andrea, che va in cielo' (cited by G. Giachi and G. Matthiae, *S. Andrea al Quirinale*, 1969, pp. 49, 88.

11. Baldinucci, *Vita di Bernini*, ed. S. Samek Ludovici, p. 150.

6. TIME (*pages 197–222*)

1. E. Panofsky, *Studies in Iconology*, 1939, p. 92.

2. T. Hobbes, *Leviathan*, Part I, chap. 6.

3. This epigram is illustrated in an emblem-book by Otto van Veen, *Amorum Emblemata*, 1608 (repr. in Panofsky, *Studies in Iconology*, fig. 57).

4. J. Białostocki, 'Rembrandt's Terminus', *Wallraf-Richartz Jahrbuch*, XXVIII, 1966, pp. 49–60.

5. Sir Thomas Browne, *Christian Morals*, II, sect. v.

6. R. S. Magurn (ed.), *The Letters of Peter Paul Rubens*, 1955, p. 109.

7. P. Fréart de Chantelou, *Journal du voyage du Cavalier Bernin en France*, ed. L. Lalanne, 1885, p. 116. See Appendix B, 274.

8. F. Brittain (ed.), *The Penguin Book of Latin Verse*, 1962, pp. 29–30.

1. Baldinucci, *Vita di Bernini*, ed. S. Samek Ludovici, p. 151.
2. See Rosenberg, *Rembrandt, Life and Work*, rev. ed. 1964, p. 184.
3. Reproduced in E. Waterhouse, *Italian Baroque Painting*, 1962, fig. 36.
 T. Hobbes, *Leviathan*, Part II, chap. 18.
5. *Correspondance de Rubens*, ed. M. Rooses and C. Ruelens, 1887–1909, V, p. 312.
6. Brueghel's criticism of Rembrandt is contained in a letter to Don Antonio Ruffo, who owned Rembrandt's *Homer* [203]. See V. Ruffo, 'Galleria Ruffo nel secolo XVII in Messina', *Bollettino d'arte*, X, 1916.

8. ATTITUDES TO ANTIQUITY (*pages 249–69*)

1. Rubens, *De Imitatione Statuarum*, in de Piles, *Cours de peinture*, pp. 139–48. See Appendix A.
2. Bellori, *Le vite*, p. 441.
3. A. Michaelis, *Ancient Marbles in Great Britain*, 1882, pp. 6–27.
4. *The Letters of Peter Paul Rubens*, ed. R. S. Magurn, pp. 320–21.
5. *The Works of John Milton*, ed. F. A. Patterson et al. (Columbia Edition), XVIII, pp. 258–61, 519–20. Professor Roland Frye, who kindly brought this memorandum to my attention, has suggested to me that Milton might have acquired it from a knowledgeable collector when it was his intention, never to be realized, to tour the ancient Greek world.
6. G. B. Passeri, *Die Künstlerbiographien*, ed. J. Hess, 1934, p. 112. Cf. A. Blunt, *Nicolas Poussin*, 1967, p. 232.
7. Bellori, *Le vite*, p. 273. For the *Urania* see N. Huse, 'Zur "S. Susanna" des Duquesnoy', *Argo. Festschrift für Kurt Badt*, 1970, pp. 324–35, fig. 109.
8. R. Wittkower, *Art and Architecture in Italy 1600–1750*, rev. ed. 1973, p. 274.
9. Bellori, *Le vite*, pp. 411–12, 456–9. For the statue see Blunt, *Poussin*, p. 233, fig. 183.
10. J. G. van Gelder, 'Jan de Bisschop's Drawings after Antique Sculpture', *Studies in Western Art* (Acts of the Twentieth International Congress of the History of Art), 1963, III, pp. 51–8.
11. J. S. Held, *Rubens, Selected Drawings*, 1959, I, p. 51.
12. M. Rooses, *L'oeuvre de P. P. Rubens*, 1886–92, II, p. 240.
13. Chantelou, *Journal du voyage du Cavalier Bernin en France*, ed. L. Lalanne, p. 134. The *Antinoüs* is the work measured by Poussin and Duquesnoy [213].
14. R. Wittkower, 'The Role of Classical Models in Bernini's and Poussin's Preparatory Work', *Studies in Western Art* (Acts of the Twentieth International Congress of the History of Art), 1963, III, pp. 41–50.
15. H. R. Weihrauch, *Europäische Bronzestatuetten, 15.–18. Jahrhundert*, 1967, pp. 225–9; 242–7; K. Lankheit, *Florentinische Barockplastik, Die Kunst am Hofe der letzten Medici, 1670–1743*, 1962, pp. 139–43.
16. Bellori, *Le vite*, pp. 202–3.
17. Not to be confused with the full-length statue admired by Poussin and Duquesnoy. The type may be illustrated by the celebrated relief of Antinoüs in the Villa Albani, though Caravaggio could not have known this very piece. See D. Posner, 'Caravaggio's Homoerotic Early Works', *Art Quarterly*, XXXIV, 1971, p. 313.
18. I. Lavin, 'Divine Inspiration in Caravaggio's two *St. Matthews*', *Art Bulletin*, LVI, 1974, pp. 59–81.

19. C. Hofstede de Groot, *Die Urkunden über Rembrandt*, 1906, pp. 190–210.

20. H. Bramsen, 'The Classicism of Rembrandt's *Bathsheba*', *Burlington Magazine*, XCII, 1950, pp. 128–31.

21. K. Clark, *Rembrandt and the Italian Renaissance*, 1966.

22. Another testimony to the development of classical taste in English architecture of the early seventeenth century is Sir Henry Wotton's book, *The Elements of Architecture* (1624). Wotton, like Inigo Jones, was well grounded in Vitruvius and Palladio.

23. Chantelou, *Journal du voyage Cavalier Bernin*, p. 167.

24. R. Wittkower, *Art and Architecture in Italy 1600–175*, rev. ed. 1973, pp. 178–81.

25. For the classical type see the silver ewers found at Bernay in France (K. Lehmann-Hartleben, 'Two Roman Silver Jugs', *American Journal of Archaeology*, XLII, 1938, pp. 82–105, pls. XIII–IV). The ewer held by the kneeling girl in Girardon's *Apollo Tended by the Nymphs* [211] is of the 'correct' Roman pattern.

APPENDIX B. CHANTELOU (*pages 274–9*)

1. Chantelou (ed. Lalanne), pp. 18, 116.

2. Chantelou (ed. Lalanne), p. 167.

3. Chantelou (ed. Lalanne), pp. 134–5.

4. Chantelou (ed. Lalanne), pp. 63–7.

5. Poussin's self-portrait of 1650 is now in the Louvre.

6. The original *Triumph of Pan* from the Château de Richelieu is now in the collection of Simon Morrison, Sudeley Castle, England.

7. The painting is now lost.

8. The original *Triumph of Bacchus* from the Richelieu Bacchanals is now lost.

9. The original *Triumph of Silenus* is lost.

10. Chantelou's paintings of the *Seven Sacraments* now belong to the Duke of Sutherland (on loan to the National Gallery of Scotland, Edinburgh).

11. Chantelou owned a copy (which he believed to be original) of Raphael's *Ecstasy of Ezekiel*, now in the Pitti Gallery in Florence.

APPENDIX C. HOUBRAKEN (*pages 280–7*)

1. Houbraken was not particularly well informed about the early years. Rembrandt was born in (not near) Leiden and was one of seven children. He spent three years as a pupil of the Leiden painter Jacob van Swanenburgh and six months with Pieter Lastman in Amsterdam. Whether he studied with Jacob Pynas is not certain, but he seems to have been influenced by the work of the latter's brother Jan.

2. Houbraken's etching was probably made after the drawing now in the Fitzwilliam Museum at Cambridge (repr. in S. Slive, *Rembrandt and his Critics 1630–1730*, 1953, fig. 43).

3. For the three states of the *Jan Lutma* of 1656 see C. White and K. G. Boon, *Rembrandt's Etchings*, 1969, B 276.

4. *Christ in the Storm on the Sea of Galilee*, 1633. Boston, Isabella Stewart Gardner Museum.

5. *Haman and Ahasuerus at the Feast of Esther*, 1660. Moscow, Pushkin Museum.

6. *Christ and the Woman taken in Adultery*, 1644. London, National Gallery.

7. *St John the Baptist Preaching*. Berlin-Dahlem, Gemäldegalerie.

8. K. van Mander, *Het Schilder-Boeck*, 1604, fol. 191.

9. Probably the self-portrait of about 1664 in the Pitti Gallery in Florence.

10. Perhaps the drawing of 1635 in the Berlin Print Room (O. Benesch, *The Drawings of Rembrandt*, 1954–57, ii, pp. 101–2, No. 445).

11. Rembrandt's portrait of the preacher Jan Cornelisz Sylvius is dated 1646 (White and Boon, *Rembrandt's Etchings*, B 280).

12. Houbraken refers here to the following etchings: *The Marriage of Jason and Creusa* (with a statue of Juno) (White and Boon, B 112); *Joseph telling his Dreams* (B 37); *Woman sitting half-dressed beside a Stove* (B 197).

Books for Further Reading

HISTORICAL BACKGROUND. *The New Cambridge Modern History* offers an authoritative introduction to the period: vol. IV, *The Decline of Spain and the Thirty Years War 1609–1659* (1970); vol. v, *The Ascendancy of France 1648–88* (1961), with a chapter on art and architecture by Rudolf Wittkower; and vol. VI, *The Rise of Great Britain and Russia 1688–1715/25* (1970). There are excellent surveys in the series *Peuples et civilisations*; see especially H. Hauser, *La prépondérance espagnole 1559–1660* (1933) and A. R. de Saint-Léger and P. Sagnac, *La prépondérance française 1661–1715* (1935). Equally valuable are the volumes devoted to the seventeenth century in the series *The Rise of Modern Europe*: Carl J. Friedrich, *The Age of the Baroque 1610–1660* (1952); Frederick L. Nussbaum, *The Triumph of Science and Reason 1660–1685* (1953); and J. B. Wolf, *The Emergence of the Great Powers 1685–1715* (1951). Two deservedly popular books are David Ogg, *Europe in the Seventeenth Century* (8th ed. 1960) and G. N. Clark, *The Seventeenth Century* (1929). Theodore K. Rabb, *The Struggle for Stability in Early Modern Europe* (1975), offers a reinterpretation of what has come to be known as the 'crisis of the seventeenth century'.

For the Low Countries there are Pieter Geyl, *The Netherlands in the Seventeenth Century* (1961; translated from the Dutch) and the classic essay by Johan Huizinga, *Dutch Civilization in the Seventeenth Century* (1968; originally published in German in 1932). A good recent survey, with well-chosen illustrations, is K. H. D. Haley, *The Dutch in the Seventeenth Century* (1972). On France the volume by Robert Mandrou, *La France aux XVIIe et XVIIIe siècles* (1967), in the series *Nouvelle Clio: l'histoire et ses problèmes*, is particularly recommended. Another volume in this series is Pierre Jeannin, *L'Europe du nordouest et du nord aux XVIIe and XVIIIe siècles* (1969), which has brilliant chapters on economic and religious life in the British Isles, the Netherlands and the Scandinavian countries. Ludwig von Pastor's *History of the Popes* is still indispensable on all matters relating to the papacy, including that of artistic patronage; in the English edition the pertinent volumes are XXIII–XXXII (1933–40).

Three works of unusual interest are Basil Willey, *The Seventeenth Century Background* (1934), which discusses (as the subtitle indicates) 'the thought of the age in relation to poetry and religion'; E. A. Burtt, *The Metaphysical Foundations of Modern Science* (rev. ed., 1932); and Marjorie H. Nicolson, *The Breaking of the Circle, Studies in the Effect of the 'New Science' upon Seventeenth Century Poetry* (rev. ed., 1960). The influence of the scientific revolution on literature, music and the visual arts is the subject of *Seventeenth Century Science and the Arts*, ed. by Hedley H. Rhys (1961), with contributions by Stephen Toulmin, Douglas Bush, James S. Ackerman and Claude V. Palisca.

ETYMOLOGY. On the history and meaning of the word 'Baroque' see O. Kurz, 'Barocco, storia di una parola', *Lettere Italiane*, XII, 1960, pp. 414–44, and B. Migliorini, 'Etimologia e storia del termine "barocco"', in *Manierismo, Barocco, Rococò. Convegno Internazionale*, Rome, 1960 (1962), pp. 39–49.

THE CONCEPT OF THE BAROQUE. The word Baroque was first applied, in the modern critical sense, to architecture, as when C. Gurlitt published his *Geschichte des Barockstils in Italien* in 1887. Italian architecture is also the subject of the pioneering book by Heinrich Wölfflin, *Renaissance und Barock* (1888; English translation 1965, with an introduction by Peter Murray). Wölfflin subsequently enlarged his exposition of the Baroque so as to include painting and sculpture as well as architecture in his best-known work, *Kunstgeschichtliche Grundbegriffe* (1915; translated as *Principles of Art History*, 1932), which I have mentioned in the Introduction of this book. Though the weaknesses of Wölfflin's exclusively formalistic approach are now fully apparent, the book marks an important stage in the development of the idea of Baroque and, within the limits set for himself by the author, is a model of methodological precision.

Mannerism had no place in Wölfflin's scheme, founded as it was on the notion of an antithesis between Renaissance and Baroque. The recognition of Mannerism as a stylistic phase preceding the Baroque owes much to two articles by Walter Friedlaender in *Repertorium für Kunstwissenschaft* (1925) and *Vorträge der Bibliothek Warburg* (1928–9), which have been translated in his book *Mannerism and Anti-Mannerism in Italian Painting* (1957). The intermediate role of Mannerism in Italian art of the sixteenth century is also emphasized by H. Hoffmann, *Hochrenaissance, Manierismus, Frühbarock* (1938).

No attempt can be made here to list the many books that have been written on the concept of the Baroque. They include the purely negative and curiously old-fashioned interpretation of Benedetto Croce, who argued that 'art is never Baroque and Baroque is never art' (*Der Begriff des Barock*, 1925, and *La storia dell' età barocca in Italia*, 1929), as well as the view taken by Eugenio d'Ors and others that Baroque is a recurrent anti-classical phenomenon that may appear at any time and place (*Du Baroque*, 1935). The attempt by Werner Weisbach (*Der Barock als Kunst der Gegenreformation*, 1921) to equate Baroque art with the spirit of the Catholic Counter-Reformation was effectively refuted by Nikolaus Pevsner in two important articles in *Repertorium für Kunstwissenschaft* (1925 and 1928; now available in English translation in his *Studies in Art, Architecture and Design*, 1968). A retrogressive step was taken by Gustav Schnürer in a book which, though long outdated, is still occasionally cited as authoritative by reputable historians – *Katholische Kirche und Kultur in der Barockzeit* (1937); it is Schnürer's contention that Baroque art originated even before the Counter-Reformation, in 'the renewed religiosity in Rome in the second quarter of the sixteenth century'. Sir Anthony Blunt takes an unexpectedly narrow view of the Baroque (and the Rococo) in a published lecture

originally delivered at the British Academy (*Some Uses and Misuses of the* *Terms Baroque and Rococo as applied to Architecture*, 1973). The author argues that 'Baroque' ought to be restricted to certain forms of Roman architecture of the Seicento (Bernini, Borromini, Pietro da Cortona) and to those works which are plainly derived from the 'High Roman Baroque' (Guarini, Fischer von Erlach, the brothers Asam).

Most writers today would probably apply the term Baroque to the art of Europe and Latin America during the period that extends from the final decades of the sixteenth century to the close of the seventeenth, or even beyond. Wolfgang Stechow, 'Definitions of the Baroque in the Visual Arts', *Journal of Aesthetics and Art Criticism* (1946–7) gives a concise summary. A more recent and more detailed survey will be found in Giuliano Briganti's article on Baroque art in *Encyclopedia of World Art* (1960). The best and most comprehensive treatment of the subject is the article by Jan Białostocki, 'Barock: Stil, Epoche, Haltung', originally published in Polish in 1958 and reprinted in German in his book *Stil und Ikonographie, Studien zur Kunstwissenschaft* (1966). The essay includes the following topics: the history of the concept of the Baroque; Wölfflin's *Principles* and the Renaissance–Baroque dialogue; the Baroque in relation to Mannerism and the Rococo; the problem of Baroque and Classicism; interpretations of the Baroque; the importance of rhetoric and the power of persuasion in Baroque art.

The word Baroque has acquired wholly new meanings in contemporary art criticism. For an analysis of such meanings, with particular reference to film and the novel, see Pierre Charpentras, 'De quelques acceptions du mot "Baroque"', *Critique*, xx, 1964, pp. 651–66.

ART AND ARCHITECTURE. Books and articles on individual artists and works of art are cited in the Catalogue of Illustrations.

Erich Hubala, *Die Kunst des 17. Jahrhunderts* (1970), in the series *Propyläen-Kunstgeschichte*, is an unusually thorough and well-ordered survey, with over 400 illustrations and extensive commentaries by various scholars. In English, the best and most complete review of the subject is that by Julius S. Held and Donald Posner, *17th and 18th Century Art. Baroque Painting, Sculpture, Architecture* (1972).

The vexed question of the influence of the Jesuits on religious art of the seventeenth century is examined in a balanced and thorough fashion in *Baroque Art: The Jesuit Contribution*, ed. by Rudolf Wittkower and Irma B. Jaffe (1972) (papers by Wittkower, Howard Hibbard, James Ackerman, Francis Haskell and others).

For Italy there is Rudolf Wittkower's solid and authoritative *Art and Architecture in Italy, 1600–1750* (rev. ed., 1973) and, on painting alone, Ellis K. Waterhouse, *Italian Baroque Painting* (rev. ed., 1969). Still useful for painting in Rome is Hermann Voss, *Die Malerei des Barock in Rom* (1924). Francis Haskell, *Patrons and Painters. A Study in the Relations between Italian Art and Society in the Age of the Baroque* (1963) is an admirable and illuminating work of scholarship.

A convenient survey of Flemish Baroque art will be found in Horst Gerson and E. H. ter Kuile, *Art and Architecture in Belgium 1600–1800* (1960). On the various specialities in Flemish painting the following books should be consulted: Y. Thiéry, *Le paysage flamand au XVIIe siècle* (1953); E. Greindl, *Les peintres flamands de nature morte au XVIIe siècle* (1956); S. Speth-Holterhoff, *Les peintres flamands de cabinets d'amateurs* (1957); F. C. Legrand, *Les peintres flamands de genre au XVIIe siècle* (1963); M. L. Hairs, *Les peintres flamands de fleurs au XVIIe siècle* (2nd ed., 1965).

On the art of the Northern Netherlands there is no better introduction than Jacob Rosenberg, Seymour Slive and E. H. ter Kuile, *Dutch Art and Architecture 1600–1800* (rev. ed., 1972). Wolfgang Stechow's *Dutch Landscape Painting of the Seventeenth Century* (1966) is the definitive work on the subject. Ingvar Bergström, *Dutch Still Life Painting in the Seventeenth Century* (1956) gives an excellent account of all the principal branches of still life in Holland. Dutch history painting is treated in a remarkable study by H. van de Waal, *Drie eeuwen vaderlandsche geschied-uitbeelding 1500–1800, een iconologische studie* (2 vols., 1952, with an English summary). The fundamental work on Dutch group portraits is still A. Riegl, *Das holländische Gruppenporträt* (2 vols., 1931).

The best general account of the French Baroque is Anthony Blunt, *Art and Architecture in France 1500–1700* (rev. ed., 1973). On painting see the brilliant essay by Charles Sterling, 'La pittura francese del XVII secolo', in the exhibition catalogue *Il Seicento Europeo* (1956).

The literature on Spanish Baroque art is still inadequate. There is a good introduction in George Kubler and Martin Soria, *Art and Architecture in Spain and Portugal and their American Dominions 1500–1800* (1959), but the volume covers so broad a field that the great Spanish masters of painting and sculpture are somewhat slighted.

The seventeenth century in England is well represented in John Summerson, *Architecture in Britain 1530–1830* (rev. ed., 1963) and Ellis K. Waterhouse, *Painting in Britain 1530–1830* (2nd ed., 1962). For Germany and Austria there is E. Hempel, *Baroque Art and Architecture in Central Europe* (1965); see also the important book by H. Tintelnot, *Die Barocke Freskomalerei in Deutschland* (1952).

On the theatre and stage design, see C. Ricci, *La scenografia italiana* (1930), H. Tintelnot, *Barocktheater und Barocke Kunst* (1939) and *Baroque and Romantic Stage Design*, ed. by János Scholz with an introduction by A. Hyatt Mayor (1955).

THEORY. For artistic theory in the seventeenth century the following are indispensable: Erwin Panofsky, *Idea. Ein Beitrag zur Begriffsgeschichte der älteren Kunsttheorie* (1924; English translation by J. J. S. Peake, *Idea, A Concept in Art Theory*, 1968); Rensselaer W. Lee, *Ut Pictura Poesis; The Humanistic Theory of Painting* (1967; originally published in *Art Bulletin*, 1940); Denis Mahon, *Studies in Seicento Art and Theory* (1947). To these might be added Erwin Panofsky's brilliant little book, *Galileo as a Critic of the Arts* (1954).

On academic theory there is Nikolaus Pevsner, *Academies of Art, Past and Present* (1940); for France, A. Fontaine, *Les doctrines d'art en France* (1909), gives the best summary. G. C. Argan, 'La "Rettorica" e l'arte barocca', *Atti del III Congresso Internazionale di Studi Umanistici* (1955), discusses the importance of rhetoric for seventeenth-century art in a paper that is stimulating but perhaps a little overdrawn.

ICONOGRAPHY. There is still much work to be done in the field of Baroque iconography. The principal subjects of the period are conveniently listed in A. Pigler, *Barockthemen* (2 vols., 1956). For the iconological method the student must consult E. Panofsky, particularly his *Studies in Iconology* (1939; reprinted 1962). Mario Praz, *Studies in Seventeenth-Century Imagery* (1939–47) offers the best introduction to the emblem-books; see also the important article by W. S. Heckscher and K. A. Wirth, 'Emblem, Emblembuch', *Reallexikon zur deutschen Kunstgeschichte*, V (1959). A valuable addition to the literature on emblems is the comprehensive reference book by Arthur Henkel and Albrecht Schöne, *Emblemata. Handbuch zur Sinnbildkunst des 16. und 17. Jahrhunderts* (1967).

On Christian iconography Emile Mâle, *L'Art religieux après le Concile de Trente* (2nd ed., 1951), is essential; see also B. Knipping, *De iconografie van de Contra-Reformatie in de Nederlanden* (1939–40; English translation 1974). Some of the iconographical problems in Dutch painting are touched on by H. Kauffmann, 'Die Fünfsinne in der niederländischen Malerei des 17. Jahrhunderts', in *Kunstgeschichtliche Studien*, ed. H. Tintelnot (1943), and by Seymour Slive, 'Realism and Symbolism in Seventeenth Century Dutch Painting', *Daedalus* (Summer, 1962). A useful contribution to the literature on this subject is the provocative study by E. de Jongh, *Zinne- en minnebeelden in de schilderkunst van de zeventiende eeuw* (1967). The importance of symbol and allegory in Spanish painting is discussed by Julián Gállego, *Vision et symboles dans la peinture espagnole du siècle d'or* (1968).

LITERATURE AND MUSIC. The problems of interpretation that confront the historian of Baroque art are also present in the fields of literature and musicology. The situation in literature has been ably analysed by René Wellek in his paper, 'The Concept of Baroque in Literary Scholarship', *Journal of Aesthetics and Art Criticism*, v (1946–7); reprinted with a 'Postscript 1962' in the same author's *Concepts of Criticism* (1963). Wylie Sypher, *Four Stages of Renaissance Style* (1955), attempts to discover correspondences, or 'analogies of form', in art and literature of the Renaissance, Mannerist and Baroque periods. One difficulty is that the literary historian's terminology still appears to be in an unsettled state. It is thus possible for E. R. Curtius, in his important book *Europäische Literatur und lateinische Mittelalter* (1948; English translation 1953) to propose that the term 'Baroque' should be replaced by 'Mannerism'. The student of art history will find much of value in the recent book by Frank J. Warnke, *Versions of Baroque, European Literature in the Seventeenth Century* (1972); but he may well be perplexed by the use of the word 'Mannerism' to denote 'one tendency found recurrently throughout the Baroque'.

For the musicologist's view of the Baroque see Manfred F. Bukofzer, *Music in the Baroque Era* (1947), and Friedrich Blume, *Renaissance and Baroque Music* (1967; originally published in *Die Musik in Geschichte und Gegenwart*, 1963).

Catalogue of Illustrations

Abbreviations:

Blunt, *Poussin*, 1966: Anthony Blunt, *The Paintings of Nicolas Poussin, A Critical Catalogue* (London, 1966)
Blunt, *Poussin*, 1967: Anthony Blunt, *Nicolas Poussin* (New York, 1967)
Bredius/Gerson: A. Bredius, *Rembrandt, The Complete Edition of the Paintings*, revised edition by H. Gerson (London and New York, 1969)
Hibbard, *Bernini*: H. Hibbard, *Bernini* (London and Baltimore, 1965)
Rosenberg, *Rembrandt*: Jakob Rosenberg, *Rembrandt, Life and Work*, rev. ed. (London, 1964)
Wittkower, *Bernini*: Rudolf Wittkower, *Gian Lorenzo Bernini, The Sculptor of the Roman Baroque*, rev. ed. (London, 1966)

1. THE DESCENT FROM THE CROSS. By Peter Paul Rubens, 1611–12. Oil on panel, 420 × 310 cm. (central panel of triptych). *Antwerp, Cathedral.* (Photograph: A.C.L.-Bruxelles).

 The triptych was commissioned by the Guild of Harquebusiers for their altar in the Cathedral. An oil sketch for the central panel is in the Courtauld Institute Galleries in London. The wings were not delivered until 1614.

 Lit: J. R. Martin: *Rubens: The Antwerp Altarpieces, The Raising of the Cross, The Descent from the Cross*, 1969; F. Baudouin, in *Rubens before 1620*, ed. J. R. Martin, 1972. 59–62.

2. THE DEPOSITION. By Francesco Salviati, *c.* 1547. Oil on panel, 430 × 260 cm. *Florence, Museo di S. Croce.* (Photograph: Alinari)

 Painted for the Dini chapel in S. Croce. The frame is original.

 Lit: J. Shearman: *Mannerism*, 1967. 101; S. J. Freedberg: *Painting in Italy 1500–1600*, 1970. 303–4.

3. THE FOUNTAIN OF THE FOUR RIVERS. By Gian Lorenzo Bernini, 1648–51. Travertine and marble. *Rome, Piazza Navona.* (Photograph: Alinari)

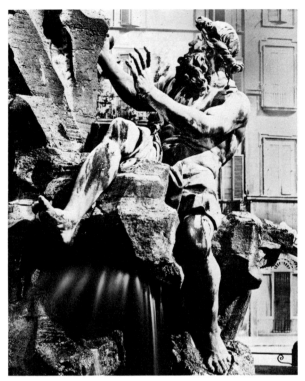

Figure 1. *Danube*, 1648–51. Raggi

Commissioned by Pope Innocent X Pamphili. The giant marble figures of the four rivers were executed by assistants from Bernini's design; *Danube* [Fig. 1] is the work of Antonio Raggi.

Lit: Wittkower, *Bernini*. 30–31, 219–20; Hibbard, *Bernini*. 118–23.

4. NEPTUNE FOUNTAIN. By Bartolomeo Ammanati and assistants, 1560–75. Bronze and marble. *Florence, Piazza Signoria.* (Photograph: Alinari)

The great block of marble had already been defaced by Ammanati's rival Bandinelli, so that it was impossible for the sculptor to represent Neptune with his arm raised in a commanding gesture as ruler of the sea. Illustration 5 shows one of the groups of bronze figures at the corners of the basin.

Lit: B. H. Wiles: *The Fountains of Florentine Sculptors and their Followers from Donatello to Bernini*, 1933. 50–4, 117–19; J. Pope-Hennessy: *Italian High Renaissance and Baroque Sculpture*, 2nd ed. 1970. 74–6.

5. Detail of 4. (Photograph: Alinari)

6. S. ANDREA AL QUIRINALE. By Gian Lorenzo Bernini, 1658–70. *Rome.* (Photograph: Anderson)

Commissioned by Cardinal Camillo Pamphili, nephew of Pope Innocent X, for the Jesuit novices on the Quirinal. The façade exhibits some similarities to that designed by Pietro da Cortona for S. Maria della Pace [153], especially in the semicircular portico on free-standing columns and in the interplay of concave and convex forms. The oval plan is unusual in that the long axis lies parallel to the façade. For the interior see No. 154.

181–4; Hibbard, *Bernini*. 144–8.
6A. S. ANDREA AL QUIRINALE. PLAN (From *Insignium Romae Templorum Prospectus*, 1684).
7. S. ANDREA IN VIA FLAMINIA. By Vignola, 1550–53. *Rome*. (Photograph: Courtesy Ilse Mayer)
 Built for Pope Julius III as part of the complex of the Villa Giulia.
 Lit: M. Walcher Casotti: *Il Vignola*, 1960. i, 64–6, 150–51; H. L. Heydenreich and W. Lotz: *Architecture in Italy 1400–1600*, 1974. 276–7.
7A. S. ANDREA IN VIA FLAMINA. PLAN (Penguin Books).
8. THE DEATH OF THE VIRGIN. By Caravaggio, 1605–6. Oil on canvas, 369 × 245 cm. *Paris, Louvre*. (Photograph: Réunion des Musées Nationaux)
 Painted for a chapel in the Roman church of S. Maria della Scala but rejected by the fathers as being too vulgar. Despite this clerical disapproval, Caravaggio's altarpiece was greatly admired by the painters in Rome and in 1607 was purchased by the Duke of Mantua, on the recommendation of no less an artist than Rubens.
 Lit: W. Friedlaender: *Caravaggio Studies*, 1955. 126–7, 195–8.
9. VENUS AND ADONIS. By Peter Paul Rubens, *c.* 1635. Oil on canvas, 197.2 × 241.6 cm. *New York, Metropolitan Museum of Art* (*Gift of Harry Payne Bingham, 1937*). (Photograph: Museum)
 The painting depends, as Panofsky has shown (*Problems in Titian*, 1969. 154n.), on Titian's *Leave-taking of Adonis* in the Prado, of which Rubens had made a copy.
 Lit: J.-A. Goris and J. S. Held: *Rubens in America*, 1947. 38.
10. SALT-CELLAR. By Georg Petel, *c.* 1627–8. Ivory, with silver-gilt base and salt receptacle, 44 cm. high. *Stockholm, Royal Palace*. (Photograph: Sven Nilsson)
 The cylindrical ivory carving represents the triumph of the sea-born Venus, who is accompanied by a Triton and three nymphs. The salt-cellar, which was executed by Petel from a design by Rubens, is mentioned in the inventory of Rubens's estate drawn up in 1640. Lit: K. Feuchtmayr, A. Schädler, N. Lieb and T. Müller: *Georg Petel 1601/2–1634*. 1973. 98–102.
11. THE ARCADIAN SHEPHERDS. By Nicolas Poussin, *c.* 1640. Oil on canvas, 85 × 121 cm. *Paris, Louvre*. (Photograph: Réunion des Musées Nationaux)
 The best exposition of the subject is by E. Panofsky, in *Philosophy and History. Essays presented to Ernst Cassirer*, 1936. 223–54 (see also his *Meaning in the Visual Arts*, 1955. 295–320). Panofsky points out that the painting presents a more classical and more 'philosophical' interpretation of the theme of *Et in Arcadia Ego* than that seen in Poussin's earlier version of the subject now at Chatsworth. Whereas in the Chatsworth picture there is an element of surprise as the shepherds come unexpectedly upon the tomb, the Louvre canvas shows them absorbed in calm discussion and meditation on the idea of mortality. The dating of the picture is a matter of dispute: the arguments are summarized by Blunt (*Poussin*, 1966. 80–81), who would himself prefer to place it as late as the 1650s.
12. CARDINAL DE BOUILLON. By Hyacinthe Rigaud, 1708. Oil on canvas, 274 × 217 cm. *Perpignan, Musée Rigaud*. (Photograph: Lauros-Giraudon)
 The Baroque state portrait in its ultimate and most opulent form. Cardinal de Bouillon (1644–1715), Dean of the Sacred College, is represented at the opening of the Porta Santa of St Peter's in Rome in the year 1700. The children posing as infant angels are portraits of members of the Cardinal's family, La Tour d'Auvergne.

Lit: A. J. Dézallier d'Argenville: *Abrégé de la vie des plus fameux peintres*, 1745–52. ii, 408.

13. THE MONEY-CHANGER. By Rembrandt, 1627. Oil on panel, 32 × 42 cm. *Berlin-Dahlem, Gemäldegalerie*. (Photograph: Walter Steinkopf)

Clearly inspired by the candlelight pictures of Honthorst (see No. 40 below). K. Bauch interprets the picture as a representation of Avarice (*Der junge Rembrandt und seine Zeit*, 1960. 139).

Lit: Rosenberg, *Rembrandt*. 308, 321; Bredius/Gerson. 587.

14. THE SUPPER AT EMMAUS. By Rembrandt, 1648. Oil on panel, 68 × 65 cm. *Paris, Louvre*. (Photograph: Réunion des Musées Nationaux)

The subject was treated by Rembrandt in four paintings and two etchings. On the iconography see W. Stechow, in *Zeitschrift für Kunstgeschichte*, 1934. 329–41.

Lit: Rosenberg, *Rembrandt*. 215–16; Bredius/Gerson. 609.

15. THE MARTYRDOM OF ST BARTHOLOMEW. By Guercino, *c.* 1636. Pen and brown wash, 20.3 × 25.4 cm. *Princeton University Art Museum*. (Photograph: Museum)

Denis Mahon connects the drawing with the *Martyrdom of St Bartholomew* commissioned in 1636 for the church of S. Martino in Siena.

Lit: J. Bean: *Italian Drawings in the Art Museum, Princeton University*, 1966. 33; D. De Grazia: *Guercino Drawings in the Art Museum, Princeton University*, 1969. No. 14.

16. THE RETURN OF THE PRODIGAL SON. By Rembrandt, *c.* 1642. Pen and brown wash, with corrections in white body-colour, 19 × 22.7 cm. *Haarlem, Teyler Foundation*. (Photograph: Museum)

Rembrandt also treated this subject in an etching of 1636 and in a painting of the late period in Leningrad.

Lit: O. Benesch: *The Drawings of Rembrandt*, 1954–57. iii, 150.

17. STUDIES OF HEADS, WITH SASKIA ILL IN BED. By Rembrandt, *c.* 1641–2. Etching, 15.1 × 13.6 cm. *New York, Pierpont Morgan Library*. (Photograph: Library)

C. White, *Rembrandt as an Etcher*, 1969. i, 158–9, has an excellent discussion of the print and the drawings related to it.

18. THE VOYAGE OF PRINCE FERDINAND FROM BARCELONA TO GENOA. By Peter Paul Rubens, 1634–5. Oil on panel, 49 × 64 cm. *Cambridge, Mass., Fogg Art Museum, Harvard University, purchase – Alpheus Hyatt Fund*. (Photograph: Museum)

Sometimes called *The Wrath of Neptune*. Oil sketch for the left wing of the Stage of Welcome erected for the Entry of the Cardinal-Infante Ferdinand into Antwerp in 1635. The full-size painting is in the Gemäldegalerie in Dresden.

Lit: J. R. Martin: *The Decorations for the Pompa Introitus Ferdinandi* (Corpus Rubenianum Ludwig Burchard, XVI), 1972. 49–56.

19. THE FALL OF TANTALUS. By Hendrick Goltzius after Cornelis van Haarlem. 1588. Engraving, 31 cm. diameter. *Princeton University Art Museum*. (Photograph: Museum)

From *The Disgracers*, a set of four plates representing mythological figures (Tantalus, Ixion, Icarus and Phaethon) who came to grief for their presumptuousness. The violent contortions and exaggerated musculature are typical of Dutch Mannerism of the 1580s.

Lit: O. Hirschmann: *Hendrick Goltzius*, 1919. 52–3.

20. THE FARNESE GALLERY. By Annibale Carracci and assistants, *c.* 1597–1604. *Rome, Palazzo Farnese*. (Photograph: Alinari)

The fresco decoration of the vault was completed in the year 1600.

Lit: J. R. Martin: *The Farnese Gallery*, 1965; D. Posner: *Annibale Carracci*, 1971. i, 93–108.

21. JUPITER AND JUNO. By Annibale Carracci, 1597–1600. Fresco. *Rome,*
Palazzo Farnese, Galleria. (Photograph: Gabinetto Fotografico Nazionale)

Part of the frieze that fills the coving of the frescoed vault of the Farnese Gallery. The mythological subject is treated as a framed picture flanked by decorative figures simulating statuary and by Michelangelesque *ignudi* in imitation of living persons. For these figures Annibale made a number of splendid chalk drawings from the life.

Lit: J. R. Martin: *The Farnese Gallery,* 1965. 69–80, 89–90, 190–230; D. Posner: *Annibale Carracci,* 1971. i, 93–108.

22. STUDY FOR THE FARNESE CEILING. By Annibale Carracci, *c.* 1598. Black chalk heightened with white on grey-blue paper, 41.3 × 41 cm. *Paris, Louvre.* (Photograph: Museum)

Study from the model for one of the seated *ignudi* in the coving of the vault.

Lit: J. R. Martin: *The Farnese Gallery,* 1965. 221–2, 264.

23. DOMESTIC SCENE. By Annibale Carracci, *c.* 1585. Pen and black ink, grey wash, 32.6 × 23.1 cm. *New York, Metropolitan Museum* (Dick Fund and Rogers Fund, 1972). (Photograph: Villani)

Formerly in the Ellesmere Collection. The woman is warming her child's night-dress before a fire.

Lit: D. Mahon in exh. cat. *Mostra dei Carracci. Disegni,* 1963. 152–3; D. Posner, *Annibale Carracci,* 1971. i, 18–19.

24. ANDROMEDA. By Peter Paul Rubens, *c.* 1638–40. Oil on panel, 188 × 94 cm. *Berlin-Dahlem, Gemäldegalerie.* (Photograph: Walter Steinkopf)

According to Ovid's *Metamorphoses* (IV, 665–7), Perseus flew through the air with wings on his feet. Rubens (as Professor Rensselaer Lee informs me) follows the version of the fable told in the *Moralized Ovid* of Pierre Bersuire in representing Perseus riding on Pegasus.

Lit: M. Rooses: *L'Oeuvre de P. P. Rubens,* 1886–92. iii, 145.

25. THE ALLOCUTION OF CONSTANTINE. By Peter Paul Rubens, 1622. Oil on panel, 46.4 × 56.5 cm. *Philadelphia, John G. Johnson Collection.* (Photograph: Museum)

An oil sketch for one of the Constantine tapestries designed by Rubens for Louis XIII of France. The artist seems to have sent to Paris the full-size cartoons rather than the original oil sketches. In any event, the *Allocution* was one of the first subjects to be submitted for approval, and Peiresc's frank report on it is contained in a letter to Rubens dated 1 December 1622 (see p. 47). The tapestry woven from this design is in the Mobilier National in Paris. Rubens follows the formula for the Allocation seen in the relief of Marcus Aurelius on the Arch of Constantine in Rome.

Lit: J.-A. Goris and J. S. Held: *Rubens in America,* 1947. 38; D. Dubon: *Tapestries from the Samuel H. Kress Collection at the Philadelphia Museum of Art. The History of Constantine the Great Designed by Peter Paul Rubens and Pietro da Cortona,* 1964. 3–10.

26. TRUTH UNVEILED. By Gian Lorenzo Bernini, 1646–52. Marble, 280 cm. high. *Rome, Galleria Borghese.* (Photograph: Alinari)

Bernini's original intention was to carve a large marble group of *Time unveiling Truth.* By 1652, when the *Truth* was already completed, the figure of *Time* had not even been begun, and the marble block lay still untouched in the master's house at the time of his death.

Lit: F. Saxl in *Philosophy and History. Essays presented to Ernst Cassirer,* 1936. 215–18; Wittkower, *Bernini.* 33, 218–19.

27. BALDACCHINO. By Gian Lorenzo Bernini, 1624–33. Mainly bronze, partly gilt, 28.5 m. high. *Rome, St Peter's.* (Photograph: Alinari)

There are good accounts of the Baldacchino in Wittkower, *Bernini*, 189–90 and Hibbard, *Bernini*, 75–80. For a fuller documentary and iconographical analysis, see I. Lavin: *Bernini and the Crossing of St Peter's*, 1968.

28. THE DRINKERS (THE TRIUMPH OF BACCHUS). By Diego Velazquez, 1628–9. Oil on canvas, 165 × 225 cm. *Madrid, Prado*. (Photograph: Anderson)

The peasants in this early mythological subject would not be out of place in a genre painting.

Lit: J. López-Rey: *Velazquez. A Catalogue Raisonné of his Oeuvre*, 1963. 43–5, 141.

29. Detail of 28.

30. A NAKED WOMAN SEATED ON A MOUND. By Rembrandt, *c.* 1631. Etching, 2nd state, 17.7 × 16 cm. *London, British Museum*. (Photograph: Museum)

It was for works of this kind that Rembrandt was criticized by Andries Pels in his poem *Gebruik en misbruik des toneels* (1681).

Lit: C. White: *Rembrandt as an Etcher*, 1969. i, 173; C. White and K. G. Boon: *Rembrandt's Etchings*, 1969. i, 96.

31. THE PEASANTS' MEAL. By Louis Le Nain, 1642. Oil on canvas, 97 × 122 cm. *Paris, Louvre*. (Photograph: Réunion des Musées Nationaux)

The innate classicism of Louis Le Nain reveals itself both in the composition and in the figure attitudes of this otherwise unidealized subject.

Lit: P. Fierens: *Les Le Nain*, 1933. 34.

32. CHRIST OF CLEMENCY. By Juan Martínez Montañés, 1603–6. Polychrome wood, 190 cm. high. *Seville, Cathedral*. (Photograph: Mas)

Commissioned on 5 April 1603 by Mateo Vázquez de Leca, archdeacon of Carmona. The final payment to Montañés was made on 9 April 1606. In addition to showing the Saviour alive, and with eyes open [33], the Crucifix is unusual in having four nails instead of three. Although each foot is attached to the wood by a single nail, the legs are not parallel but are crossed one over the other. Montañés explained to Francisco Pacheco that he took this detail from the *Revelations* of St Bridget, who describes precisely how the Saviour was nailed to the cross.

Lit: B. G. Proske: *Juan Martínez Montañés*, 1967. 39–43; José Hernández Díaz in exh. cat. *Martínez Montañés (1568–1649) y la escultura andaluza de su tiempo*, 1969. 40.

33. Detail of 32.

34. THE CALLING OF ST MATTHEW. By Caravaggio, *c.* 1598–1600. Oil on canvas, 338 × 348 cm. *Rome, S. Luigi dei Francesi, Contarelli Chapel*. (Photograph: Alinari)

The decoration of the Contarelli chapel was Caravaggio's first monumental commission. He was to furnish three paintings – an altarpiece showing *St Matthew and the Angel*, and two large laterals representing the *Calling of St Matthew* and his *Martyrdom*. The first altarpiece was found unsatisfactory, and a second version (still *in situ*) was accordingly painted by the artist. That the action of the *Calling* takes place out of doors and not, as has been suggested, in 'a downstairs room in the Palazzo del Monte', was established by W. Schöne: *Über das Licht in der Malerei*, 1954. 137–8. The contemporary dress worn by Matthew and the tax-gatherers [Fig. 2] denotes their worldliness and greed of gain.

Lit: W. Friedlaender: *Caravaggio Studies*, 1955. 106–10, 178–9; G. A. Dell'Acqua and M. Cinotti: *Il Caravaggio e le sue grandi opere da San Luigi dei Francesi*, 1971.

35. PENANCE. By Nicolas Poussin, 1647. Oil on canvas, 178 × 117 cm. *Edinburgh, National Gallery of Scotland* (on loan from the Duke of Sutherland). (Photograph: Annan)

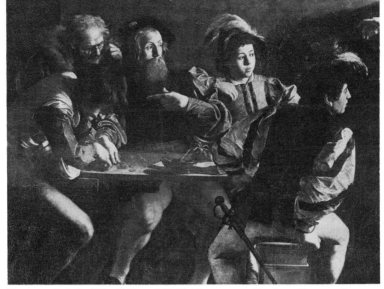

Figure 2. Detail of *The Calling of St Matthew, c.* 1598–1600. Caravaggio

One of the series of the Seven Sacraments painted between 1644 and 1648 for Paul Fréart de Chantelou. Poussin had earlier painted a set of the Sacraments for his Roman patron Cassiano dal Pozzo and had been asked by Chantelou to have copies made of them. In the end the artist decided to paint an entirely new series for Chantelou. Writing about this picture in a letter of 30 May 1644 to Chantelou, Poussin specifically mentions the Roman triclinium at which the apostles will be shown reclining.

 Lit: C. Jouanny: *Correspondance de Nicolas Poussin,* 1911. 272; Blunt, *Poussin,* 1966. 78–9; Blunt, *Poussin,* 1967. 187–8.

36. LANDSCAPE WITH THE FLIGHT INTO EGYPT. By Annibale Carracci, *c.* 1604. Oil on canvas, 122 × 230 cm. *Rome, Galleria Doria-Pamphili.* (Photograph: Villani)

 One of a set of six lunettes painted for the chapel of the Palazzo Aldobrandini in Rome, only two of which, the *Flight into Egypt* and the *Entombment,* are by Annibale himself. The landscape in the former canvas is dominated by the great citadel on the background hill [Fig. 3].

 Lit: D. Posner: *Annibale Carracci,* 1971. i, 121–2; ii, 67.

Figure 3. Detail of *The Flight into Egypt, c.* 1604. Annibale Carracci

37. LANDSCAPE WITH DUNES NEAR HAARLEM. By Hendrick Goltzius, 1603. Pen and brown ink, 8.7 × 15.3 cm. *Rotterdam, Museum Boymans-van Beuningen*. (Photograph: Museum)

One of the incunabula of Dutch seventeenth-century landscape art.

Lit: E. K. J. Reznicek: *Die Zeichnungen von Hendrick Goltzius*, 1961. i, 404; ii, 381; W. Stechow: *Dutch Landscape Painting of the Seventeenth Century*, 1966. 17, 34–5.

38. BASKET OF FRUIT. By Caravaggio, *c.* 1596. Oil on canvas, 46 × 59 cm. *Milan, Pinacoteca Ambrosiana*. (Photograph: Anderson)

Presented to the Accademia Ambrosiana by Cardinal Federico Borromeo, to whom it may have been given by Cardinal Francesco del Monte, one of the artist's Roman patrons. This work, if it is not a fragment of a larger picture, is Caravaggio's only independent still life.

Lit: W. Friedlaender: *Caravaggio Studies*, 1955. 142–4.

39. PEASANTS FIGHTING OVER CARDS. By Adriaen Brouwer, *c.* 1632. Oil on panel, 33 × 49 cm. *Munich, Alte Pinakothek*. (Photograph: Museum)

Brouwer's paintings of low-life genre scenes had a decisive influence on the work of Adriaen van Ostade in Holland and David Teniers in Flanders.

Lit: G. Knuttel: *Adriaen Brouwer, The Master and his Work*, 1962. 107–10.

40. THE MERRY COMPANY. By Gerrit van Honthorst, 1620. Oil on canvas, 142 × 212 cm. *Florence, Uffizi*. (Photograph: Soprintendenza)

A characteristic work of Honthorst's early Caravaggesque phase, painted in Italy for the Grand Duke of Tuscany. The 'Merry Company' is a popular theme in the repertory of Dutch genre painting.

Lit: J. R. Judson: *Gerrit van Honthorst*, 1959. 40–6, 244–6.

41. TITLE-PAGE OF FRANCIS BACON'S INSTAURATIO MAGNA (NOVUM ORGANUM). By Simon de Passe, 1620. Engraving, 24.4 × 15.6 cm. *London, British Library*. (Photograph: Library)

The title-page refers to the following passage in the *Novum Organum*: 'Nor should we neglect the prophecy of Daniel concerning the last days of the world: "Many shall run to and fro, and knowledge shall be increased" [Daniel xii, 4], thus plainly hinting and suggesting that Fate (which is Providence) would cause the circuit of the globe (which by means of so many distant voyages is now accomplished or at least going forward) and the increase of knowledge to happen at the same time' (I, Aphorism 93).

42. DRESSING-CASE. Dutch, 1665–79. Silver, 6.6 cm. high, 25 cm. long. *The Hague, Collection Haags Gemeentemuseum*. (Photograph: Museum)

Part of a silver toilet service, each piece of which bears the monogram ABVE. The designer is unknown, but two pieces are signed by the silversmith Albrecht van Wingaerden, one by Jozef Haverstam and one by Hermanus van Gulick.

Lit: J. W. Frederiks: *Dutch Silver, Embossed Ecclesiastical and Secular Plate from the Renaissance until the End of the Eighteenth Century*, 1961. 79–80.

43. THE COSIMO PANEL. By Grinling Gibbons, 1682. Limewood, about 5 × 3½ feet. *Florence, Museo Nazionale*. (Photograph: Soprintendenza alle Gallerie)

The medallion suspended from a chain bears a portrait of Pietro da Cortona, who had worked in Florence for the Grand Duke Ferdinand II.

Lit: D. Green: *Grinling Gibbons, His Work as Carver and Statuary, 1648–1721*, 1964. 51–2.

44. THE FLIGHT INTO EGYPT. By Adam Elsheimer, 1609. Oil on copper, 31 × 41 cm. *Munich, Alte Pinakothek*. (Photograph: Museum)

The engraving made after this work by Hendrick Goudt probably influenced the paintings of the same subject by Rubens (Cassel) and Rembrandt (Dublin). A. Ottani Cavina argues (*Burlington Magazine*, 1976. 139–44) that Elsheimer must have observed the moon through a telescope.

Lit: H. Weizsäcker: *Adam Elsheimer, der Maler von Frankfurt,* 1936 and 1953.
i, 252; ii, 17; E. Hempel, *Baroque Art and Architecture in Central Europe,* 1965.
59; W. Stechow, *Dutch Landscape Painting of the Seventeenth Century,* 1966. 174.

45. A MAIDSERVANT POURING MILK. By Jan Vermeer, *c.* 1660. Oil on canvas,
46 × 42 cm. *Amsterdam, Rijksmuseum.* (Photograph: Museum)
The evidence for Vermeer's use of the camera obscura is examined by
C. Seymour Jr in *Art Bulletin,* 1964. 323–31, and D. A. Fink in *Art Bulletin,*
1971. 493–505.
Lit: L. Gowing: *Vermeer,* 1952. 109–12.

46. TWO PEASANTS AND THEIR DOG. By Jacob van Ruisdael, *c.* 1650–55.
Etching, 2nd state, 19 × 27 cm. *Princeton University Art Museum.* (Photo-
graph: Barbara Glen)
The title given to this work hardly matches the intent of the artist, which is
to portray the struggle for life of a great tree.
Lit: M. E. Dutuit: *Manuel de l'amateur d'estampes,* 1885. vi, 279.

47. LANDSCAPE WITH DIOGENES. By Nicolas Poussin, 1648? Oil on canvas,
160 × 221 cm. *Paris, Louvre.* (Photograph: Réunion des Musées Nationaux)
Blunt believes that this is the picture mentioned by Félibien as having been
painted in 1648 for a certain Lumague, whereas Mahon considers it to belong
to the period about 1658–60.
Lit: D. Mahon in *Art de France,* i, 1961. 129–32; Blunt, *Poussin,* 1966.
108–9; Blunt, *Poussin,* 1967. 165, 285.

48. SELF-PORTRAIT, OPEN-MOUTHED AND STARING. By Rembrandt, 1630.
Etching, 2nd state, 5.1 × 4.6 cm. *New York, Pierpont Morgan Library.*
(Photograph: Library)
One of a number of studies of expression in which Rembrandt used himself
as a model.
Lit: Rosenberg, *Rembrandt.* 38–9; C. White and K. G. Boon: *Rembrandt's
Etchings,* 1969. i, 147.

49. DAVID (detail). By Gian Lorenzo Bernini, 1623–4. Marble, 170 cm. high. *Rome,
Galleria Borghese.* (Photograph: Anderson)
One of the early works made for Cardinal Scipione Borghese. Baldinucci
relates that the sculptor studied the reflection of his own face in a mirror in
order to achieve the appropriate expression.
Lit: Wittkower, *Bernini.* 5–6, 182–3.

50. MILO OF CROTONA. By Pierre Puget, 1671–82. Marble, 270 cm. high. *Paris,
Louvre.* (Photograph: Réunion des Musées Nationaux)
Puget, whose style was considered too Italian and too unclassical by Colbert,
was over fifty years of age before he succeeded in placing any of his works at
Versailles. In 1683 his *Milo* was accepted and given a prominent site in the
garden of the palace.
Lit: K. Herding: *Pierre Puget, das bildnerische Werk,* 1970. 95–109, 167–73;
A. Blunt: *Art and Architecture in France 1500–1700,* rev. ed. 1973. 376–8.

51. MILO OF CROTONA. By Pierre Puget, *c.* 1672. Brush and ink wash,
37 × 28 cm. *Rennes, Musée des Beaux-Arts.* (Photograph: Museum)
Composition study for the marble statue [50].
Lit: K. Herding: *Pierre Puget,* 1970. 98, 170.

52. JUDAS RETURNING THE THIRTY PIECES OF SILVER. By Rembrandt, 1629.
Oil on panel, 76 × 101 cm. *Private Collection.* (Photograph: Royal Academy
of Arts)
The painting illustrates the passage in Matthew xxvii, 3–5.
Lit: S. Slive: *Rembrandt and his Critics,* 1953. 15; Bredius/Gerson. 604.

53. MAN WRINGING HIS HANDS. By Jan Joris van Vliet, 1634. Engraving
22.4 × 18.5 cm. *Princeton University, The Art Museum.* (Photograph:
Museum)

Van Vliet's print reproduces the figure of Judas from Rembrandt's painting [52].

54. BATHSHEBA WITH KING DAVID'S LETTER. By Rembrandt, 1654. Oil on canvas, 142 × 142 cm. *Paris, Louvre.* (Photograph: Réunion des Musées Nationaux)

X-ray photographs disclose that Rembrandt altered the position of Bathsheba's head, which was originally held higher. The final state, with lowered eyes, adds greatly to the pensive quality of the figure. (M. Hours in *Bulletin du Laboratoire du Musée du Louvre*, VI, 1961. 3–43.)

Lit: Rosenberg, *Rembrandt.* 97, 221–2; Bredius/Gerson. 601.

55. THE OYSTER BREAKFAST. By Frans van Mieris the Elder, 1661. Oil on panel, 27 × 30 cm. *The Hague, Mauritshuis.* (Photograph: A. Dingjan)

In seventeenth-century emblematic imagery, the oyster is an explicitly sexual symbol.

56. ST MARY MAGDALENE MEDITATING. By Georges de La Tour, *c.* 1636–8. Oil on canvas, 128 × 94 cm. *Paris, Louvre.* (Photograph: Réunion des Musées Nationaux)

La Tour painted several versions of the repentant Magdalen with a night-light.

Lit: F. G. Pariset: *Georges de La Tour*, 1948. 160–64; J. Thuillier in exh. cat. *Georges de La Tour*, 1972. 183–5; B. Nicolson and C. Wright: *Georges de La Tour*, 1974. 35, 173–4.

57. 'THE PATERNAL ADMONITION'. By Gerard ter Borch, *c.* 1654. Oil on canvas, 71 × 73 cm. *Amsterdam, Rijksmuseum.* (Photograph: Museum)

The title first appeared in 1765 on an engraving of this subject by J. G. Wille; it was adopted by Goethe in his *Wahlverwandtschaften*, who interpreted the scene as a father admonishing his daughter. There is another version at Berlin-Dahlem.

Lit: S. J. Gudlaugsson: *Gerard ter Borch*, 1959–60. i, 96–7; ii, 116–17; S. Slive in *Daedalus*, 1962. 496–500.

58. ST ROCH DISTRIBUTING ALMS. By Annibale Carracci, 1594–5. Oil on canvas, 331 × 447 cm. *Dresden, Gemäldegalerie.* (Photograph: Villani)

The last work painted by Annibale Carracci in Bologna before leaving for Rome. Commissioned by the Confraternity of San Rocco in Reggio Emilia as early as 1587 or 1588, but executed for the most part in 1595. The painting became widely known through the etching made after it by Guido Reni. Fig. 4 shows a detail of the right-hand part of the picture.

Lit: G. C. Cavalli in exh. cat. *Mostra dei Carracci*, 1958. 207–10; D. Posner, *Annibale Carracci*, 1971. ii, 35–7.

59. THE MIRACLES OF ST FRANCIS XAVIER. By Peter Paul Rubens, 1616–17. Oil on canvas, 535 × 395 cm. *Vienna, Kunsthistorisches Museum.* (Photograph: Museum)

Commissioned, together with its companion piece, *The Miracles of St Ignatius of Loyola*, for the high altar of the Jesuits' church in Antwerp. Though Ignatius and Francis Xavier were not canonized until 1622, the altarpieces seem to have been completed no later than 1617. They remained in the church until the suppression of the Jesuit Order in 1773, after which they were removed to Vienna. Also in the Vienna Museum are the oil sketches, or *modelli*, for these compositions. Like the paupers in Carracci's *St Roch*, the afflicted persons crowd round Xavier's pedestal [Fig. 5].

Lit: J. R. Martin: *The Ceiling Paintings for the Jesuit Church in Antwerp* (Corpus Rubenianum Ludwig Burchard I), 1968. 29–31; F. Baudouin in *Miscellanea Josef Duverger*, 1968. i, 301–22; J. G. Smith in *Jahrbuch der Kunsthistorischen*

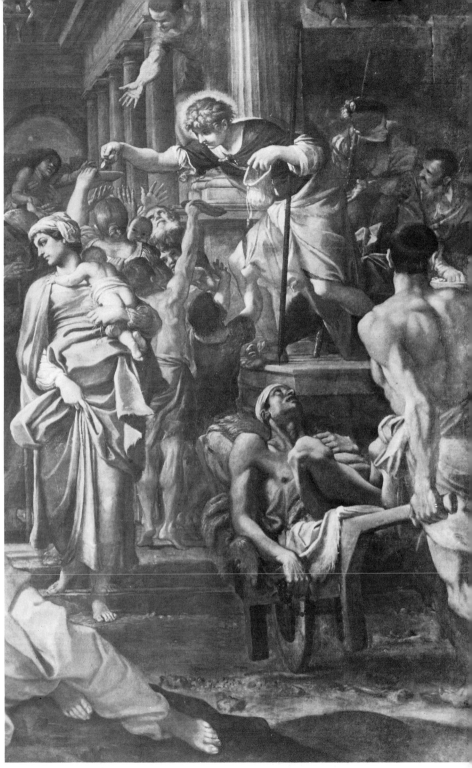

Figure 4. Detail of *St Roch Distributing Alms*, 1594–5. Annibale Carracci

Figure 5. Detail of *The Miracles of St Francis Xavier*, 1616–17. Rubens

Sammlungen in Wien, 1969. 39–60; H. Vlieghe: *Saints* (Corpus Rubenianum Ludwig Burchard VII, ii), 1973. 26–35.
60. THE ISRAELITES GATHERING THE MANNA. By Nicolas Poussin, 1638–9. Oil on canvas, 149 × 200 cm. *Paris, Louvre*. (Photograph: Villani)

Painted for Paul Fréart de Chantelou, to whom Poussin wrote in March 1639 to say that the picture was finished. As the artist indicated in his letter to Stella (see p. 86), the work was the first in which he made use of his method of expressing the passions. In the group at the left [61] Poussin represents 'une action de charité'.

Lit: C. Jouanny: *Correspondance de Nicolas Poussin*, 1911. 19–20; Blunt, *Poussin*, 1966. 18; Blunt, *Poussin*, 1967. 223, 271–3.
61. Detail of 60.
62. THE QUEENS OF PERSIA AT THE FEET OF ALEXANDER. By Charles Le Brun, 1660–61. Oil on canvas, 298 × 435 cm. *Versailles, Château*. (Photograph: Réunion des Musées Nationaux)

The Tent of Darius, as it was also called, was commissioned by Louis XIV, who watched it being painted at Fontainebleau. It was to the success of this

work (now sadly deteriorated) that Le Brun owed his appointment as First
Painter to the King. The painting furnished several models for Le Brun's own
lecture on expression.

Lit: H. Jouin: *Charles Le Brun et les arts sous Louis XIV*, 1889. 133–7,
497–8; J. Thuillier in exh. cat. *Charles Le Brun 1619–1690*, 1963. 71–3.

63A, B. HOPE and FEAR. From Charles Le Brun: *Conférence sur l'expression générale et
particulière* (1698).

64. COSTANZA BUONARELLI. By Gian Lorenzo Bernini, *c.* 1635–6. Marble,
72 cm. high. *Florence, Bargello.* (Photograph: Alinari)

Costanza Buonarelli, with whom Bernini had a passionate love affair, was
the wife of one of his studio assistants. The bust has been in Florence at least
since 1645, when John Evelyn saw it in the Grand-Ducal collection.

Lit: Wittkower, *Bernini*. 13, 203.

65. SUSANNA FOURMENT. By Peter Paul Rubens, *c.* 1620–25. Oil on panel,
79 × 54 cm. London, Trustees of The National Gallery. (Photograph:
Museum)

Susanna Fourment was the older sister of Helena, whom Rubens was to
marry in 1630. The old title, *Le Chapeau de Paille*, though defended by H. G.
Evers, is dismissed by G. Martin as meaningless.

Lit: H. G. Evers: *Rubens und sein Werk: Neue Forschungen*, 1943. 275–88;
G. Martin: *National Gallery Catalogues. The Flemish School*, 1970. 174–82.

66. JUAN DE PAREJA. By Diego Velazquez, 1649–50. Oil on canvas, 82 × 69.8 cm.
New York, Metropolitan Museum of Art (Isaac D. Fletcher Fund, Rogers Fund
and Bequest of Adelaide M. de Groot, Bequest of Joseph M. Durkee, by exchange,
supplemented by gifts from Friends of the Museum, 1971). (Photograph:
Museum)

Juan de Pareja (1610–1670) accompanied Velazquez as an assistant on the
master's second visit to Italy in 1649–51. The portrait was executed in Rome
and shown in the Pantheon in March 1650. The canvas had been folded over
at the top and along the right side. On the restoration of the picture to its
original size see H. von Sonnenburg in *Metropolitan Museum of Art Bulletin*.
n.s. XXIX, 1971. 476–8.

Lit: J. López-Rey: *Velazquez*, 1963. 300.

67. THE WOMEN REGENTS OF THE OLD MEN'S HOME. By Frans Hals, *c.* 1664.
Oil on canvas, 170 × 249 cm. *Haarlem, Frans Hals Museum.* (Photograph:
A. Dingjan)

Painted, like its pendant, *The Regents of the Old Men's Home*, when the artist
was over eighty years of age. The group is composed according to a conven-
tional scheme for 'regent pieces': the four governesses are seated at a table as
if in conference, while a servant enters bearing a message. But in no other
respect does Hals's painting resemble the neatly finished and unimaginative
productions of the fashionable Dutch portraitists of his day.

Lit: S. Slive: *Frans Hals*, 1970–74. i, 210–12; iii, 113.

68. Detail of 67.

69. CORNELIS CLAESZ ANSLO. By Rembrandt, 1641. Etching and dry-point,
18.8 × 15.8 cm. *London, British Museum.* (Photograph: Museum)

Anslo (1592–1646) was a theological scholar and minister of the Waterland
Mennonites. There is a preparatory drawing, dated 1640, in the British
Museum. Vondel's lines are written in an old hand on the back of the mount
of the drawing and on the impression of the print reproduced here. In 1641
Rembrandt painted *Anslo in Conversation with a Woman* (Berlin-Dahlem).

Lit: C. White: *Rembrandt as an Etcher*, 1969. i, 124–5; C. White and K. G.
Boon: *Rembrandt's Etchings*, 1969. i, 124.

70. JAN SIX. By Rembrandt, 1654. Oil on canvas, 112 × 102 cm. *Amsterdam,
Six Foundation.* (Photograph: Six Foundation)

Jan Six (1618–1700) was an Amsterdam merchant and humanist whom Rembrandt had earlier portrayed in an etching of 1647. The date of the painting is supplied by a chronogram composed by Six himself:

AonIDas qVI sVM tenerIs VeneratVs ab annIs
TaLIs ego IanVS SIXIVs ora tVLI.

(Such a face had I, Jan Six,
Who have revered the Aeonian goddesses [the Muses] since my childhood.)

The work has been in the possession of the Six family since the time it was made.

Lit: Rosenberg, *Rembrandt*. 79–81; Bredius/Gerson. 570–71.

71. GABRIELE FONSECA. By Gian Lorenzo Bernini, 1668–*c*. 1675. Marble, over life-size. *Rome, S. Lorenzo in Lucina*. (Photograph: Anderson)

Gabriele Fonseca had been the personal physician of Pope Innocent X. Though Bernini must have begun the portrait before Fonseca's death in 1668, the style of the work shows it to have been executed for the most part in the 1670s. The bust is set in a niche to the left of the altar in the Fonseca Chapel of S. Lorenzo in Lucina, and the subject's gaze is directed to a painting of the Annunciation above the altar.

Lit: Wittkower, *Bernini*. 256–7; Hibbard, *Bernini*. 217–18.

72. CASSIANO DAL POZZO. By Gian Lorenzo Bernini. Pen. *Rotterdam, Museum Boymans-van Beuningen*. (Photograph: A. Frequin)

Cassiano dal Pozzo (1588–1657), antiquarian, collector, and friend and patron of Poussin and other artists in Rome. The drawing was discovered by Sir Anthony Blunt. The inscription describes the caricature as being done 'in imitation of Carracci'.

Lit: F. Haskell and S. Rinehart in *Burlington Magazine*, CII, 1960. 321.

73. THE VISION OF ST FRANCIS. By Annibale Carracci, *c*. 1597–8. Oil on copper, 47 × 36.8 cm. *London, Sir John Pope-Hennessy*. (Photograph: Villani)

The architecture in the background imitates the arcaded court of the Palazzo Farnese in Rome, where Annibale lived while in the service of Cardinal Odoardo Farnese. There are several copies of the picture, one of which (on canvas) is in the Detroit Institute of Arts.

Lit: D. Posner: *Annibale Carracci*, 1971. i, 85–6; ii, 43.

74. THE VISION OF THE BLESSED HERMAN JOSEPH. By Anthony van Dyck, 1630. Oil on canvas, 160 × 128 cm. *Vienna, Kunsthistorisches Museum*. (Photograph: Museum)

Van Dyck became a member of the Sodality of Bachelors directed by the Antwerp Jesuits in 1628, shortly after his return from Italy. The *Blessed Herman Joseph* is one of two works painted by him for the Sodality.

Lit: G. Glück: *Van Dyck* (Klassiker der Kunst), 1931. 243; H. Gerson and E. H. ter Kuile: *Art and Architecture in Belgium 1600–1800*, 1960. 121.

75. THE ECSTASY OF ST MARGARET OF CORTONA. By Giovanni Lanfranco, 1618–20. Oil on canvas, 230 × 285 cm. *Florence, Galleria Pitti*. (Photograph: Villani)

Painted for the church of S. Maria Nuova in Cortona, where it remained until it was purchased in the early eighteenth century by Prince Ferdinando de' Medici and taken to Palazzo Pitti. In its place Ferdinando commissioned a painting of the same subject by Giuseppe Maria Crespi. The little dog seen in Lanfranco's painting is specifically mentioned in the legend of St Margaret. There are two drawings for the work in the Louvre.

Lit: H. Voss: *Die Malerei des Barock in Rom*, 1924. 525; G. C. Cavalli in exh. cat. *Maestri della pittura del seicento emiliano*, 1959. 229–30.

76. THE ECSTASY OF ST TERESA. By Gian Lorenzo Bernini, 1645–52. Marble,
the figures life-size. *Rome, S. Maria della Vittoria.* (Photograph: Alinari)

Commissioned by Cardinal Federigo Cornaro for the Carmelite church of
S. Maria della Vittoria. St Teresa of Avila, who was canonized in 1622, was the
founder of the Barefooted Carmelites. Her Life, with the descriptions of her
religious experiences, was written between 1563 and 1565. Bernini's ability
to penetrate the deeply emotional state of the mystic is evident above all in the
face of Teresa. On the analogy between Bernini and Richard Crashaw's 'Hymn
to the Name and Honour of the Admirable Saint Teresa', see R. T. Petersson:
The Art of Ecstasy, Teresa, Bernini and Crashaw. 1970.

Lit: Wittkower: *Bernini.* 24–8; Hibbard, *Bernini,* 136–41.

77. Detail of 76.

78. THE BLESSED LUDOVICA ALBERTONI. By Gian Lorenzo Bernini, 1674.
Marble, the figure over life-size. *Rome, S. Francesco a Ripa.* (Photograph:
Alinari)

One of Bernini's last and most extraordinary works. The cult of the Blessed
Ludovica Albertoni was sanctioned in 1671.

Lit: Wittkower: *Bernini.* 257–9; Hibbard, *Bernini.* 220–27.

79. Detail of 78. (Photograph: Alinari)

80. THE BLESSED ALESSANDRO SAULI. By Pierre Puget, 1665–8. Marble,
420 cm. high. *Genoa, S. Maria di Carignano.* (Photograph: Direzione Belle
Arti, Genoa)

Puget was commissioned to carve four statues for the crossing piers of
S. Maria di Carignano, but completed only two – a *St Sebastian* and *The
Blessed Alessandro Sauli.* There are *bozzetti* for the *Sauli* in Aix-en-Provence,
Munich and Cleveland [Fig. 6]. *Cleveland, The Cleveland Museum of Art, Andrew
R. and Martha Holden Jennings Fund.* (Photograph: Museum)

Lit: G. Walton in *Art Bulletin,* XLVI, 1964. 89–94; K. Herding: *Pierre Puget,
das bildnerische Werk,* 1970. 71–4, 155–7.

Figure 6. *Bozzetto* for
The Blessed Alessandro Sauli, 1665–8. Puget

Figure 7. Study for *The Raising of the Cross*, 1610–11. Rubens

81. THE RAISING OF THE CROSS. By Peter Paul Rubens, 1610–11. Oil on panel, the centre panel 4.62 × 3.41 m., the wings 4.62 × 1.5 m. *Antwerp, Cathedral.* (Photograph: A.C.L.-Bruxelles)

The triptych was commissioned in 1610 for the high altar of the church of St Walburgis in Antwerp (since destroyed). An oil sketch showing all three panels is in the Louvre, and there are several chalk drawings for the principal subject, including a study for the figure of Christ in the Fogg Art Museum at Harvard [Fig. 7]. *Fogg Art Museum, Gift of Meta and Paul J. Sachs.* (Photograph: Museum)

Lit: J. R. Martin: *Rubens: The Antwerp Altarpieces, The Raising of the Cross, The Descent from the Cross*, 1969; F. Baudouin, in *Rubens before 1620*, ed. J. R. Martin, 1972. 57–9.

82. THE MARTYRDOM OF ST BARTHOLOMEW. By Jusepe de Ribera, *c.* 1638. Oil on canvas, 234 × 234 cm. *Madrid, Prado.* (Photograph: Anderson)

D. Fitz Darby argues in *Art Bulletin* 1953, 74 that the picture cannot represent the Martyrdom of St Bartholomew because the victim does not resemble

other Bartholomews painted by Ribera. The canvas is generally said to be dated 1630, though the last digit is in fact illegible. Professor Jonathan Brown informs me that this date is inadmissible and that the work must be assigned on stylistic grounds to the artist's middle period.

Lit: E. du Gué Trapier: *Ribera*, 1952. 65–71; J. Milicua in *Archivo español de arte*, 1952. 296–9.

83. THE MARTYRDOM OF ST LIEVEN. By Peter Paul Rubens, *c.* 1633. Oil on canvas, 450 × 335 cm. *Brussels, Musées Royaux des Beaux-Arts de Belgique.* (Photograph: A.C.L.-Bruxelles)

Painted for the high altar of the Jesuit Church in Ghent, where it remained until the suppression of the order in 1773. There are oil sketches for the composition in Brussels and Rotterdam.

Lit: M. Rooses: *L'Oeuvre de P. P. Rubens*, 1886–92. ii, 319; H. Vlieghe: *Saints* (Corpus Rubenianum Ludwig Burchard VIII, ii), 1973. 109–16.

84. S. AGNESE IN PIAZZA NAVONA, FACADE. By Francesco Borromini, 1653–5. *Rome.* (Photograph: Alinari)

The church was begun in 1652 by Carlo Rainaldi for Pope Innocent X. Rainaldi's designs were not found acceptable, and in 1653 he was replaced by Borromini, who within the space of a few years transformed the project into something unmistakably his own. The façade is substantially the work of Borromini, though the towers were not built by him.

Lit: R. Wittkower: *Art and Architecture in Italy 1600–1750*, rev. ed. 1973. 213–18; P. Portoghesi: *The Rome of Borromini*, 1968. 167–72; F. Spinosi, ed.: *Piazza Navona isola dei Pamphili*, 1970. 225–38.

85. S. AGNESE IN PIAZZA NAVONA, INTERIOR. By Francesco Borromini, begun 1652. *Rome.* (Photograph: Alinari)

The decoration of the interior was not completed until many years after Borromini's death. The frescoes were executed by Baciccio and Ciro Ferri, and the sculptural reliefs by Ercole Ferrata, Antonio Raggi and others.

85A. S. AGNESE IN PIAZZA NAVONA. PLAN (From *Insignium Romae Templorum prospectus*, 1684)

86. S. MARIA IN CAMPITELLI, FAÇADE. By Carlo Rainaldi, 1663–7. *Rome.* (Photograph: Anderson)

Lit: R. Wittkower in *Art Bulletin*, 1937. 295–9; *idem: Art and Architecture in Italy 1600–1750*, rev. ed. 1973. 279–83; F. Fasolo: *L'opera di Hieronimo e Carlo Rainaldi*, 1961. 147–84.

87. S. MARIA IN CAMPITELLI, INTERIOR. By Carlo Rainaldi, 1663–7. *Rome.* (Photograph: Foto Marburg)

The scenic character of the interior is unique among Roman Baroque churches and suggests North Italian prototypes.

87A. S. MARIA IN CAMPITELLI. PLAN. (From *Insignium Romae Templorum prospectus*, 1684)

88. THE ABBEY CHURCH AT WELTENBURG, INTERIOR. By Cosmas Damian and Egid Quirin Asam, 1717–21. (Photograph: Hirmer Fotoarchiv München)

The sculptured group above the high altar is by Egid Quirin Asam. The glittering silver statue of St George on horseback, seen beside the polychrome figure of the Princess Cleodolinda, suggests a truly miraculous apparition.

Lit: E. Hanfstaengl: *Die Brüder Cosmas Damian und Egid Quirin Asam*, 1955. 16–21.

89. THE ANATOMICAL THEATRE AT LEIDEN. By W. Swanenburgh after J. C. Woudanus, 1610. Engraving. *Leiden, Akademisch Historisch Museum.* (Photograph: Museum)

The anatomical theatre is described by J. J. Orlers in the second edition of his *Beschryvinge der Stadt Leyden*, 1641.

Lit: W. S. Heckscher: *Rembrandt's Anatomy of Dr Nicolaas Tulp*, 1958. 97–8, 184–7; J. S. Held: *Rembrandt's Aristotle and other Rembrandt Studies*, 1969. 73.

90. THE FOUR CONTINENTS. By Peter Paul Rubens, *c.* 1615. Oil on canvas, 209 × 284 cm. *Vienna, Kunsthistorisches Museum*. (Photograph: Museum)

The river-god Nile, with his crocodile and *putti*, is derived from the colossal Hellenistic sculpture in the Vatican.

Lit: M. Rooses: *L'Oeuvre de P. P. Rubens*, 1886–92. iv, 57–8; H. G. Evers: *Peter Paul Rubens*, 1942. 164–5.

91. THE DANCE OF HUMAN LIFE. By Nicolas Poussin, *c.* 1638–40. Oil on canvas, 83 × 105 cm. *London, Trustees of the Wallace Collection*. (Photograph: Museum)

Often called *The Dance to the Music of Time*. Painted for Cardinal Giulio Rospigliosi, later Pope Clement IX, who suggested the subject to the artist. A preparatory drawing is reproduced in the exh. cat. *Nicolas Poussin*, 1960. 158, No. 159.

Lit: E. Panofsky: *Studies in Iconology*, 1939. 92–3; Blunt, *Poussin*, 1966. 81–82; Blunt, *Poussin*, 1967. 153.

92. THE FABLE OF ARACHNE. By Diego Velazquez, *c.* 1657. Oil on canvas, 220 × 289 cm. *Madrid, Prado*. (Photograph: Anderson)

The subject was correctly identified by D. Angulo in *Archivo español de arte*, 1948. 1–19. After the painting was damaged by fire in 1734, a broad strip of canvas was added along the top, and narrower pieces on the other three sides. Without these additions, the picture corresponds in size to a 'Fable of Arachne' described in the inventory of a private collection in Madrid in 1664. The tapestry in the background reproducing Titian's *Rape of Europa* is illustrated in Fig. 8. (Photograph: Mas)

Lit: J. Camón Aznar: *Velazquez*, 1964. ii, 856–70.

Figure 8. Detail of *The Fable of Arachne*, *c.* 1657. Velazquez

93. REBECCA AND ELIEZER AT THE WELL. By Nicolas Poussin, 1648. Oil on
canvas, 118 × 197 cm. *Paris, Louvre.* (Photograph: Réunion des Musées Nationaux)

Painted for the Parisian banker Pointel, who (as Félibien reports) wished the artist to produce a picture that should rival Guido Reni's *Virgin Mary in the Midst of her Companions* (the so-called 'Sewing Circle'). The work differs from Poussin's other versions of this subject (e.g. that in the collection of Sir Anthony Blunt) in that Rebecca does not offer water to Eliezer and that the latter's camels are not shown. The suppression of these episodes in the Louvre canvas serves to make the allusion to the Annunciation more explicit.

Lit: Blunt, *Poussin,* 1966. 10–11; Blunt, *Poussin,* 1967. 179, 234, 258; T. L. Glen in *Art Bulletin,* LVII, 1975. 233–6.

94. ST JOSEPH THE CARPENTER. By Georges de La Tour, *c.* 1638–40. Oil on canvas, 137 × 101 cm. *Paris, Louvre.* (Photograph: Réunion des Musées Nationaux)

Like certain other nocturnes by La Tour, this work might easily be read as a genre piece pure and simple. There is a replica in the Museum of Besançon.

Lit: F. G. Pariset: *Georges de La Tour,* 1948. 241–4; J. Thuillier in exh. cat. *Georges de La Tour,* 1972. 168–71. B. Nicolson and C. Wright: *Georges de La Tour,* 1974. 37, 172–3.

95. THE HOLY FAMILY WITH THE INFANT ST JOHN THE BAPTIST. By Bartolomé Esteban Murillo, *c.* 1660–70. Oil on canvas, 156 × 126 cm. *Budapest, Museum of Fine Arts.* (Photograph: Museum)

On the importance of 'the Carpenter's Shop' in Spanish seventeenth-century painting, see J. Gallego: *Vision et symboles dans la peinture espagnole du siècle d'or,* 1968. 209–10. 245.

96. THE MERRY DRINKER. By Frans Hals, *c.* 1628–30. Oil on canvas, 81 × 66.5 cm. *Amsterdam, Rijksmuseum.* (Photograph: Museum)

The painting may have been intended to represent the Sense of Taste. *The Merry Drinker* was to figure in the nineteenth-century 'rediscovery' of Frans Hals by critics such as Thoré-Bürger and by painters such as Manet.

Lit: S. Slive: *Frans Hals,* 1970–74. i, 110–11; iii, 38–9.

97. THE EVENING SCHOOL. By Gerrit Dou, *c.* 1660–65. Oil on panel, 25.4 × 22.8 cm. *New York, Metropolitan Museum of Art (Bequest of Lillian M. Ellis, 1940).* (Photograph: Museum)

In his later years Dou made a speciality of small candlelight scenes.

Lit: W. Martin: *Gerard Dou, des Meisters Gemälde* (Klassiker der Kunst), 1913. 174.

98. THE LOVESICK GIRL. By Jan Steen, *c.* 1660–68, Oil on canvas, 61 × 52.1 cm. *Munich, Alte Pinakothek.* (Photograph: Museum)

The subject exists in many versions by Steen. The letter held by the young woman bears the artist's signature and the inscription: *Daar baat geen medesyn want het is minepyn* (Medicine is of no avail if the pains are those of love). This theme is reinforced both by the Cupid and by the painting of two lovers over the bed. The doctor's costume shows him to be not a physician from real life but a stock character from the comedy stage; see on this subject S. J. Gudlaugsson, *De Komedianten bij Jan Steen en zijn tijdgenooten,* 1945. 15–23.

99. A WOMAN WEIGHING PEARLS. By Jan Vermeer, *c.* 1665. Oil on canvas, 42.5 × 38 cm. *Washington, National Gallery (Widener Collection, 1942).* (Photograph: Museum)

Also called *A Woman Weighing Gold.* In fact, as A. K. Wheelock Jr has shown, the balance appears to be empty. For the interpretation of the picture as an allegory of *Vanitas,* see H. Rudolph in *Festschrift Wilhelm Pinder,* 1938. 407–11.

Lit: L. Gowing: *Vermeer,* 1952. 135–6.

100. CHRIST IN THE HOUSE OF MARY AND MARTHA. By Diego Velazquez, c. 1618. Oil on canvas, 60 × 103.5 cm. *London, Trustees of The National Gallery.* (Photograph: Museum)

Kitchen-pieces in which a biblical subject is relegated to an obscure place in the background were made popular by sixteenth-century Netherlandish artists such as Pieter Aertsen and Joachim Beuckelaer.

Lit: N. MacLaren: *National Gallery Catalogues, The Spanish School,* 1952. 74–5.

101. THE FIVE SENSES. By Baugin, c. 1630. Oil on panel, 55 × 73 cm. *Paris, Louvre.* (Photograph: Réunion des Musées Nationaux)

Nothing is known of the artist.

Lit: C. Sterling: *Still Life Painting from Antiquity to the Present Time,* 1959. 49–50.

102. VANITAS. By Harmen Steenwyck, 1660. Oil on panel, 39.2 × 50.7 cm. *London, Trustees of The National Gallery.* (Photograph: Museum)

The picture originally showed at the right a sculptured bust, no doubt representing a Roman emperor, but this was painted out by the artist and replaced by the large water-bottle.

Lit: I. Bergström: *Dutch Still-Life Painting in the Seventeenth Century,* 1956. 166–8; N. MacLaren: *National Gallery Catalogues, The Dutch School,* 1960. 406–8.

103. ALLEGORY OF VANITY. By Juan de Valdés Leal, 1660. Oil on canvas, 128.7 × 97.5 cm. *Hartford, Wadsworth Atheneum.* (Photograph: Museum)

The books and other objects in the foreground are identified by Trapier. The painting has a pendant in the so-called *Conversion of Miguel Mañara* (York City Gallery).

Lit: E. du Gué Trapier: *Valdés Leal, Spanish Baroque Painter,* 1960. 30–4.

104. FLOWER-PIECE. By Abraham van Beyeren, c. 1665. Oil on canvas, 80 × 69 cm. *The Hague, Mauritshuis.* (Photograph: A. Dingjan)

One of the few known flower-pieces by this gifted master of still life, who is chiefly remembered for his fish-pieces and sumptuous banquet tables. The fact that the bouquet includes flowers that bloom at different times indicates that Van Beyeren did not paint an actual bunch of flowers in a vase but worked up his composition from studies of individual blooms.

Lit: H. E. van Gelder: *W. C. Heda, A. van Beyeren, W. Kalf,* 1941. 32–3; I. Bergström: *Dutch Still-Life Painting in the Seventeenth Century,* 1956. 244–5.

105. WINTER: THE DELUGE. By Nicolas Poussin, 1660–64. Oil on canvas, 118 × 160 cm. *Paris, Louvre.* (Photograph: Réunion des Musées Nationaux)

Painted for the duc de Richelieu (see also 184 below). During the last years of his life, when he was at work on the *Four Seasons,* Poussin was afflicted by a trembling of the hands which made it increasingly difficult for him to practise his art. 'They exhort me to have patience,' he wrote to Chantelou in 1664, 'which is the remedy for all ills; I take it as a medicine which costs little but which also cures nothing.'

Lit: W. Sauerländer, in *Münchner Jahrbuch der bildenden Kunst,* 1956. 169–84; Blunt, *Poussin,* 1967. 332–6.

106. THE JEWISH CEMETERY. By Jacob van Ruisdael, c. 1660. Oil on canvas, 142 × 189 cm. *Detroit, Institute of Arts.* (Photograph: Museum)

The detail [Fig. 9] shows the dead and living trees at the right side. There is another, smaller version in the Gemäldegalerie at Dresden. This is the work about which Goethe writes in his 'Ruysdael als Dichter' (1816).

Lit: J. Rosenberg in *Art in America,* 1926. 37–44; W. Stechow, *Dutch Landscape Painting of the Seventeenth Century,* 1966. 139–40, 211–12.

Figure 9. Detail of *The Jewish Cemetery*, c. 1660. Ruisdael

107. THE ENTRY INTO LYONS. By Peter Paul Rubens, 1621–5. Oil on canvas, 394 × 295 cm. *Paris, Louvre.* (Photograph: Réunion des Musées Nationaux)

The tenth in the cycle of twenty-one paintings of the Life of Maria de' Medici, commissioned by her for the decoration of a gallery in the Luxembourg Palace in Paris. The scene records, by means of a quite preposterous allegory, the arrival of Henry IV in Lyons to meet his wife Maria, who had come from Italy to join him. There is an oil sketch of the subject, in grisaille, in Leningrad. A second Medici cycle, glorifying the life of Henry IV, was begun by Rubens but never completed.

Lit: J. Thuillier and J. Foucart: *Rubens' Life of Marie de' Medici,* 1967. 79–80.

108. THE BUST OF LOUIS XIV. By Gian Lorenzo Bernini, 1665. Marble, 80 cm. high. *Versailles.* (Photograph: Giraudon)

The only project realized by Bernini during his sojourn in France in 1665. The progress of the work from start to finish is carefully recorded by Chantelou in his diary of Bernini's visit.

Lit: Paul Fréart, Sieur de Chantelou: *Journal du voyage du Cavalier Bernin en France,* ed. L. Lalanne, 1885; R. Wittkower: *Bernini's Bust of Louis XIV,* 1951; Wittkower, *Bernini.* 15–16, 246–7; Hibbard, *Bernini.* 176–8.

109. THE FAMILY OF LOUIS XIV. By Jean Nocret, 1670. Oil on canvas, 298 × 419 cm. *Versailles.* (Photograph: Réunion des Musées Nationaux)

The heads, in keeping with the demands of court portraiture, are all relentlessly shown in three-quarter view.

Lit: E. Soulié: *Notice du Musée Impérial de Versailles,* 1860. ii, 198.

110. THE TRIUMPH OF PRINCE FREDERICK HENRY. By Jacob Jordaens, 1652. Oil on canvas, 730 × 750 cm. *The Hague, Huis ten Bosch.* (Photograph: Rijksdienst v/d Monumentenzorg)

The programme of decoration for the Oranjezaal was worked out in some detail by the architect Jacob van Campen, but Jordaens insisted on being given considerable freedom in devising his enormous *Triumph.* In 1652, when the work was finished, he sent to Amalia van Solms, the widow of Frederick Henry, an 'annotation' in French, explaining the iconography of the painting. There are oil sketches for the composition in Antwerp, Brussels and Warsaw. The best account of the Oranjezaal paintings is by J. G. van Gelder in *Nederlandsch Kunsthistorisch Jaarboek,* 1948/9. 118–64.

Lit: M. Rooses: *Jacob Jordaens, His Life and Work,* 1908. 159–68; K. Fremantle: *The Baroque Town Hall of Amsterdam,* 1959. 139–41.

111. THE GLORIFICATION OF THE REIGN OF URBAN VIII. By Pietro da Cortona, 1633–9. Fresco. *Rome, Palazzo Barberini.* (Photograph: Alinari)

The basic study of the Barberini Ceiling is still that by H. Posse in *Jahrbuch der Preussischen Kunstsammlungen,* 1919. See also W. Vitzthum in *Burlington Magazine,* 1961. 427–33; and G. Briganti: *Pietro da Cortona, o della pittura barocca,* 1962. 196–203.

Fig. 10 gives a closer view of Divine Providence, Saturn and the three Fates. There is a drawing in the Morgan Library [Fig. 11] for the figure of Rome holding the papal tiara. *New York Pierpont Morgan Library.* (Photograph: Museum)

112. THE PALACE OF VERSAILLES. By Louis Le Vau and Jules Hardouin Mansart, begun 1669. (Photograph: Archives Photographiques, Paris)

The transformation of the modest hunting lodge built at Versailles by Louis XIII began in 1669, when Le Vau proceeded to envelop the garden side of the original structure in a new building. In 1678 Mansart filled in the central terrace overlooking the gardens in order to build the Galerie des Glaces and added large wings on either side of the main block.

Figure 10. Detail of *The Glorification of the Reign of Urban VIII*, 1633–9. Cortona

Figure 11. Study for *The Glorification of the Reign of Urban VIII*, 1633–9. Cortona

Lit: P. de Nolhac: *La création de Versailles*, 1901; idem, *Histoire du Château de Versailles, Versailles sous Louis XIV*, 1911; A. Marie: *Naissance de Versailles*, 1968.

113. THE PARTERRE D'EAU AT VERSAILLES. By André Le Nôtre and Jules Hardouin Mansart, *c.* 1683. (Photograph: Archives Photographiques)

The Parterre d'Eau lying before the garden façade of Versailles underwent successive transformations. The fourth, definitive state, with its two large ponds, was begun by Mansart and Le Nôtre in 1683.

Lit: E. de Ganay: *André Le Nostre*, n.d. 23–6.

114. THE SALLE DE VÉNUS. By Charles Le Brun, René-Antoine Houasse and Jacques Rousseau, 1671–81. *Versailles, Château.* (Photograph: Alinari)

The Salle de Vénus was originally the first in the suite of seven planet rooms making up the king's State Apartment. The marble columns and pilasters with their gilt bronze bases and capitals reappear illusionistically in the perspective paintings by Rousseau. The principal painting on the ceiling, by Houasse, represents *Venus bringing the Gods and Heroes under her Sway*. The statue of the young Louis XIV is the work of Jean Warin. The iconography of the room is described in verse by J.-B. Monicart, *Versailles immortalisé par les merveilles parlantes*, 1720, i, 136–48.

Lit: P. Gille: *Versailles et les deux Trianons*, 1899–1900. i, 186–90; P. de Nolhac: *La création de Versailles*, 1901. 104–6.

115. DETAIL OF A DOOR OF THE SALLE DE VÉNUS. By Philippe Caffiéri, 1679–81. *Versailles, Château.* (Photograph: Alinari)

The doors of the Grands Appartements, with the emblem of the sun in splendour, were carved by Philippe Caffiéri and his atelier.

Lit: J. Guiffrey: *Les Caffiéri, sculpteurs et fondeurs-ciseleurs*, 1877. 29–36; P. de Nolhac: *La création de Versailles*, 1901. 104.

116. THE CHARIOT OF APOLLO. By Jean-Baptiste Tuby, 1668–71. Lead. *Versailles, Bassin d'Apollon.* (Photograph: Agraci)

The group was originally gilded. The resemblance of the seated figure of Apollo to the sun-god in Guido Reni's *Aurora* [177] has often been noted.

Lit: P. Francastel: *La sculpture de Versailles*, 1930. 35–40.

117. THE GROTTO OF THETIS AT VERSAILLES. By J. le Pautre, 1676. Engraving. (Photograph: Bibliothèque Nationale)

The central group of Apollo tended by the nymphs by Girardon and Regnaudin, 1666–72 (illustration 211), is flanked by the horses of Guérin and Marsy. The Grotto was demolished in 1684 to make room for Mansart's enlargement of the palace, and the sculptures were set up in the Bosquet de la Renommée. In the late eighteenth century they were moved to a new setting designed by Hubert Robert.

Lit: P. Francastel: *Girardon*, 1927. 69–70; L. Lange in *Art de France*, I, 1961. 133–48.

118. THE PIAZZA OF ST PETER'S. By Gian Lorenzo Bernini, 1656–67. *Rome.* (Photograph: Fototeca Unione)

The best and most recent account of the history of this project is T. K. Kitao: *Circle and Oval in the Square of St Peter's: Design and Meaning in Bernini's Plan*, 1974.

119. THE BURGERZAAL IN THE AMSTERDAM TOWN HALL. By Jacob van Campen, begun 1648. *Amsterdam.* (Photograph: Rijksdienst v/d. Monumentenzorg)

The universal implications of this room are summed up by K. Fremantle: 'As he walked across the Burgerzaal the citizen traversed the terrestial hemispheres, correctly orientated, depicted in two great maps which were drawn in coloured mosaic lines and with brass divisions and lettering in the stones of the floor . . . In the words of a contemporary writer "you can make your way

across the whole world in a moment" in this room. But more than the world was represented, for in the Burgerzaal and the galleries together the spectator was to have been placed in his setting in the universe. Between the maps of the terrestrial hemispheres is depicted the northern hemisphere of the sky, and painted above it in the central compartment of the ceiling . . . the southern celestial hemisphere was to have been represented.' (*The Baroque Town Hall of Amsterdam*, 1959. 42–3.) For the architectural history of the building, see R. van Luttervelt: *Het Raadhuis aan de Dam*, 1950. See also J. Rosenberg, S. Slive and E. H. ter Kuile: *Dutch Art and Architecture 1600–1800*, rev. ed. 1972. 397–9.

120. THE IMMACULATE CONCEPTION. By Bartolomé Esteban Murillo, *c.* 1678. Oil on canvas, 274 × 190 cm. *Madrid, Prado.* (Photograph: Mas)

The so-called 'Soult *Conception*' (after Marshal Soult, who took the work to France) was painted for the Hospital de los Venerables Sacerdotes in Seville. The painting, which had been in the Louvre since 1852, was returned to Spain in 1940 and is now in the Prado. On the iconography of the Immaculate Conception in the sixteenth and seventeenth centuries see E. Mâle: *L'Art religieux après le concile de Trente*, 1932. 40–48.

Lit: A. L. Mayer: *Murillo, Des Meisters Gemälde* (Klassiker der Kunst), 1913. xiv–xxiv, 166; S. Montoto: *Bartolomé Esteban Murillo*, 1923. 113–15.

121. THE SUPPER AT EMMAUS. By Caravaggio, *c.* 1600. Oil on canvas. 139 × 195 cm. *London, Trustees of The National Gallery.* (Photograph: Museum)

Bellori writes of this picture: 'In the *Supper at Emmaus*, besides the rustic forms of the two apostles, and of the Lord figured as young and beardless, the host waits at table with his cap on, and on the table there is a dish of grapes, figs and pomegranates, out of season.' (*Le vite de' pittori, scultori et architetti moderni*, 1672. 213.) The still life passage [Fig. 12] is particularly striking – even if, as Bellori complains, the fruit could not have been ripe so early in the year. The basket of fruit bears a marked resemblance to Caravaggio's painting in the Ambrosiana in Milan [38]. On the symbolism of the fruit in the London picture see D. T. Kinkead in *Palatino*, x, 1966. 114.

Lit: W. Friedlaender: *Caravaggio Studies*, 1955. 164–7.

Figure 12. Detail of *The Supper at Emmaus*, *c.* 1600. Caravaggio

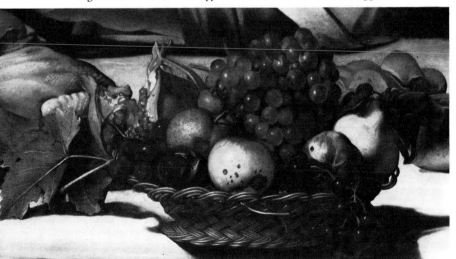

122. THE NIGHT WATCH. By Rembrandt, 1642. Oil on canvas, 359 × 438 cm. *Amsterdam, Rijksmuseum.* (Photograph: Museum)

The Militia Company of Captain Frans Banning Cocq has been known as 'The Night Watch' since the early nineteenth century. Baldinucci, whose *Life of Rembrandt* was published in 1686 and who took his information from a former pupil of Rembrandt, particularly mentions the spatial illusionism in the rendering of the two officers [123]: 'Among the figures [is] one with his foot raised in the act of marching and holding in his hand a halberd so well drawn in perspective that, though upon the picture surface it is no longer than half a yard, it yet appeared to everyone to be seen in its full length.' (*Cominciamento e progresso dell'arte d'intagliare in rame colla vita de' più eccellenti maestri della stessa professione,* 1686). The canvas was cut down in the eighteenth century when it was moved from the hall of the civic-guard companies (the Kloveniersdoelen) to the Town Hall. An early copy of the work, attributed to Gerrit Lundens (London, National Gallery), shows the composition in its original state.

Lit: Rosenberg, *Rembrandt.* 138–43, 350–52; Bredius/Gerson. 584–5.

123. Detail of 122.

124. THE MEETING OF POPE LEO I AND ATTILA. By Alessandro Algardi, 1646–53. Marble relief, 7.15 m. high. *Rome, St Peter's.* (Photograph: Alinari)

A painting of the meeting of Pope Leo and Attila had been proposed for St Peter's some years earlier; but the Cavaliere d'Arpino, who was given the commission for the altarpiece, died before completing it. Algardi was commissioned to execute the marble relief in 1645. The sculptor's full-scale model in stucco is installed on the staircase of the Biblioteca Vallicelliana.

Lit: J. Pope-Hennessy: *Italian High Renaissance and Baroque Sculpture,* 2nd ed. 1970. 448; R. Wittkower: *Art and Architecture in Italy 1600–1750,* rev. ed. 1973. 270–71.

125. THE COURTYARD OF A HOUSE IN DELFT. By Pieter de Hooch, 1658. Oil on canvas, 73.5 × 60 cm. *London, Trustees of The National Gallery.* (Photograph: Museum)

One of the works of De Hooch's Delft period, when he produced his finest paintings. The stone tablet over the passage at the left came from the Hieronymusdale Cloister in Delft.

Lit: W. R. Valentiner: *Pieter de Hooch, Des Meisters Gemälde* (Klassiker der Kunst), 1929. 55. N. MacLaren: *National Gallery Catalogues, The Dutch School,* 1960. 188–90.

126. THE INTERIOR OF A CHURCH. By Emanuel de Witte, 1668. Oil on canvas, 89 × 111.7 cm. *Rotterdam, Museum Boymans-van Beuningen.* (Photograph: A. Frequin)

Despite its appearance of architectural accuracy, this majestic interior does not represent a real church, but is a *capriccio* – a combination of motifs from the Oude Kerk and Nieuwe Kerk in Amsterdam and of purely imaginary ones.

Lit: I. Manke: *Emanuel de Witte,* 1963. 42, 104–5.

127. THE TRINITY IN GLORY AND THE ASSUMPTION OF THE VIRGIN. By Pietro da Cortona, 1647–51 (the dome), 1655–6 (the apse). Fresco. *Rome, S. Maria in Vallicella.* (Photograph: Alinari)

Work on the frescoes began in 1647 but was interrupted for several years during which Cortona painted the Gallery in the Palazzo Pamphili in Piazza Navona. Despite the lapse of time between the decoration of the dome and that of the apse, the interdependence of the two zones proves that the frescoes were conceived as a unified composition from the start. For another view of the dome see illustration 163.

Lit: R. Wittkower: *Art and Architecture in Italy 1600–1750*, rev. ed. 1973. 256–8; G. Briganti: *Pietro da Cortona, o della pittura barocca*, 1962. 248–9, 261.

128A, B. DANIEL and HABAKKUK AND THE ANGEL. By Gian Lorenzo Bernini, 1655–61. Marble, the figures over life-size. *Rome, S. Maria del Popolo, Chigi Chapel.* (Photograph: Alinari)

The chapel, designed by Raphael for Agostino Chigi, already contained two statues of *Jonah* and *Elijah*. Bernini was commissioned by Alexander VII Chigi to add the figures of *Daniel* and *Habakkuk*. They are placed in diagonally opposite niches, so as to establish a relationship across the intervening space. As a result the chapel is charged with an energy that is altogether foreign to Raphael's intention. The story of Daniel and Habakkuk is told in the apocryphal book of Bel and the Dragon.

Lit: Wittkower, *Bernini.* 232–4; Hibbard, *Bernini.* 187–91.

129. STEPHANUS GERAERDTS. By Frans Hals. *c.* 1650–52. Oil on canvas, 115.4 × 87.5 cm. *Antwerp, Koninklijk Museum voor Schone Kunsten.* (Photograph: A.C.L.-Bruxelles)

The mood of this work and its companion piece [130] is unusually playful for Hals of the later period.

Lit: S. Slive: *Frans Hals*, 1970–74. i, 159–60, 184–5; iii, 97–9.

130. ISABELLA COYMANS. By Frans Hals, *c.* 1650–52. Oil on canvas, 116 × 86 cm. *Paris, Collection Baronne de Rothschild.*

131. LAS MENINAS. By Diego Velazquez, 1656. Oil on canvas, 318 × 276 cm. *Madrid, Prado.* (Photograph: Anderson)

Described as *el cuadro de la Familia* in the seventeenth-century inventories of the Royal Palace at Madrid, and not given its popular title 'Las Meninas' until the nineteenth century. Palomino devotes an entire chapter to this work in his Life of Velazquez. (*El museo pictórico y escala óptica.* Part III, 1724, ed. M. Aguilar, 1947.)

Lit: J. López-Rey: *Velazquez. A Catalogue Raisonné of his Oeuvre*, 1963. 109–13, 204–5. G. Kubler in *Art Bulletin*, XLVIII, 1966. 212–14; M. Kahr in *Art Bulletin*, LVII, 1975. 225–46.

132. THE SYNDICS. By Rembrandt, 1662. Oil on canvas, 185 × 274 cm. *Amsterdam, Rijksmuseum.* (Photograph: Museum)

The Sampling Officials of the Drapers' Guild is Rembrandt's only regent piece; it conforms to the usual type in including the servant who stands ready to wait upon the officers of the guild. From x-ray photographs of the composition and from the artist's preparatory drawings it can be seen that the composition assumed its definitive form only after lengthy study and repeated changes.

Lit: H. van de Waal in *Oud Holland*, 1956. 61–105; Rosenberg, *Rembrandt.* 143–8; K. Clark: *Rembrandt and the Italian Renaissance*, 1966. 61–3; Bredius/Gerson. 585–6.

133. ST GREGORY PRAYING FOR THE SOULS IN PURGATORY. By Annibale Carracci, *c.* 1600–1601. Pen, brown and grey wash heightened with white over black chalk. 38.9/39.3 × 25.6/26.3 cm. *Chatsworth, the Trustees of the Chatsworth Settlement.* (Photograph: Courtauld Institute of Art)

The altarpiece was commissioned by Cardinal Antonio Maria Salviati for a chapel in S. Gregorio Magno in Rome and later passed to the Ellesmere Collection at Bridgewater House, London, where it was destroyed by fire during the Second World War [Fig. 13]. There is another composition study in Windsor Castle, and a drawing for the right-hand angel in the Metropolitan Museum, New York.

Lit: D. Mahon in exh. cat. *Mostra dei Carracci. Disegni*, 1963. 92–3, no. 120; D. Posner: *Annibale Carracci*, 1971. ii, 57.

338

Figure 13. *St Gregory praying
for the Souls in Purgatory,*
c. 1600–1601. Annibale Carracci

134. THE CORNARO CHAPEL. By Gian Lorenzo Bernini, 1645–52. *Rome, S. Maria
della Vittoria.* (Photograph: Fototeca Unione)

Bernini transformed the left transept of the church into a sepulchral chapel
for Cardinal Federigo Cornaro and other members of the Cornaro family, who
are represented on either side as if in contemplation of the *Ecstasy of St
Teresa* [76].
Lit: Wittkower: *Bernini.* 24–8; Hibbard: *Bernini.* 136–41.

135. THE TRIUMPH OF THE NAME OF JESUS. By Giovanni Battista Gaulli, called
Baciccio, 1676–9. Fresco. *Rome, Il Gesù, ceiling of the nave.* (Photograph:
Alinari)

In the combination of fresco and stucco and in the extension of parts of the
painting over the architecture, the Gesù ceiling exemplifies the ideas of Bernini
on monumental decoration.
Lit: R. Enggass: *The Painting of Baciccio,* 1964. 43–52.

136. ALLEGORY OF THE MISSIONARY WORK OF THE JESUIT ORDER. By Andrea
Pozzo, 1691–4. Fresco. *Rome, S. Ignazio, ceiling of the nave.* (Photograph:
Alinari)

A late and spectacular application of the methods of architectural illusion-
ism, or *quadratura*. The vanishing point coincides with the group of the Holy
Trinity at the centre of the vault [Fig. 14]. The engraving from Pozzo's
treatise [Fig. 15] shows one quarter of the vault with the light and shade
carefully indicated.
Lit: B. Kerber, *Andrea Pozzo,* 1971. 69–74.

137. THE VILLAGE ROAD. By Meindert Hobbema, 1665. Oil on panel, 76 ×
110 cm. *New York, The Frick Collection.* (Photograph: Museum)

The painting is typical of the expanded space in Hobbema's landscapes of
the middle sixties.

Figure 14. Detail of
The Missionary Work of the Jesuit Order,
1691–4. Pozzo

Figure 15. Engraving from Pozzo:
Perspectivum pictorum et architectorum,
Rome. 1693–1702

Lit: W. Stechow: *Dutch Landscape Painting of the Seventeenth Century*, 1966. 78.

138. THE EXPULSION OF HAGAR. By Claude Lorrain, 1668. Oil on canvas, 106 × 139 cm. *Munich, Alte Pinakothek*. (Photograph: Museum)

Painted, together with its pendant, *The Angel appearing to Hagar in the Wilderness* (also in Munich), for Count Waldstein, a German patron of the artist.

Lit: M. Röthlisberger: *Claude Lorrain, The Paintings*, 1961. i, 406–8.

139. THE EMBARKATION OF THE QUEEN OF SHEBA. By Claude Lorrain, 1648. Oil on canvas, 148.5 × 194 cm. *London, Trustees of The National Gallery*. (Photograph: Museum)

One of a pair of pictures painted for the duc de Bouillon. The other, which is also in London, is the *Landscape with the Marriage of Isaac and Rebecca*.

Lit: M. Davies: *National Gallery Catalogues. The French School*, 1957. 42; M. Röthlisberger: *Claude Lorrain, The Paintings*, 1961. i, 285–7.

140. VIEW OF HAARLEM. By Jacob van Ruisdael, *c.* 1670. Oil on canvas, 33 × 38 cm. *Amsterdam, Rijksmuseum*. (Photograph: Museum)

One of the numerous 'Haarlempjes' of the late period of Ruisdael. The bleaching fields of Haarlem are visible in the lower part of the picture.

Lit: J. Rosenberg: *Jacob van Ruisdael*, 1928. 57; W. Stechow: *Dutch Landscape Painting of the Seventeenth Century*, 1966. 45–7.

141. LANDSCAPE WITH THE CASTLE OF STEEN. By Peter Paul Rubens, *c.* 1636. Oil on panel, 135 × 236 cm. *London, Trustees of The National Gallery*. (Photograph: Museum)

The picture shows the country estate of Steen at Elewijt, not far from Mechlin, which Rubens purchased in 1635 and to which he retired for the summer months during the last years of his life. The castle itself [142] still stands. A probable companion to this painting is the *Landscape with a Rainbow* in the Wallace Collection, London.

Lit: G. Glück: *Die Landschaften von Peter Paul Rubens*, 1940. 65–6; N. Maclaren: *Peter Paul Rubens, The Château de Steen*, 1946; G. Martin: *National Gallery Catalogues, The Flemish School*, 1970. 137–42.

142. Detail of 141.

143. LANDSCAPE WITH ST JOHN ON PATMOS. By Nicolas Poussin, *c.* 1644–5. Oil on canvas, 102 × 136 cm. *Chicago, Art Institute*. (Photograph: Museum)

Plainly related to the *Landscape with St Matthew* in Berlin. Poussin may have intended to paint a series of the four evangelists, but St Mark and St Luke were never executed.

Lit: Blunt, *Poussin*, 1966. 59–60.

144. WIG-STAND. By Samuel van Eenhorn, *c.* 1675–80. Tin-glazed earthenware, 18 cm. high. *London, Victoria and Albert Museum*. (Photograph: Museum)

An early specimen of pure *chinoiserie* from Samuel van Eenhorn's factory in Delft.

Lit: E. Neurdenburg: *Old Dutch Pottery and Tiles*, 1923. 75; H. Honour: *Chinoiserie: The Vision of Cathay*, 1961. 67, 245.

145. DESIGNS FOR CABINET DRAWERS. Engraving from John Stalker and George Parker, *A Treatise of Japaning and Varnishing*, 1688. *New York, Metropolitan Museum* (Harris Brisbane Dick Fund 1932). (Photograph: Museum)

Lit: H. Honour: *Chinoiserie*, 1961. 71–4.

146. LACQUERED CABINET. English, *c.* 1690. Wood, japanned in black with raised decoration in red, green and gold, on a carved and silvered wooden stand, 159 cm. high. *London, Victoria and Albert Museum*. (Photograph: Museum)

The decorations show a marked resemblance to the designs in Stalker and Parker's *Treatise* [145].

147. SIR ROBERT SHERLEY. By Anthony van Dyck, 1622. Oil on canvas, 200.5 ×
133.5 cm. *Petworth, Sussex, Petworth Collection*. By permission of The National
Trust, Petworth House. (Photograph: Courtauld Institute of Art)

Van Dyck's Italian sketchbook contains four preparatory studies for the
portraits of Sherley and his wife. (G. Adriani: *Anton van Dyck. Italienisches
Skizzenbuch*, 1940. 55–6, pls. 60v, 62, 62v, 63.)

Lit: C. H. Collins Baker: *Catalogue of the Petworth Collection*, 1920. 28–9;
G. Glück: *Van Dyck, Des Meisters Gemälde* (Klassiker der Kunst), 1931.
510, 577–8; H. Gerson and E. H. ter Kuile: *Art and Architecture in Belgium
1600–1800*, 1960. 118.

148. TWO INDIAN NOBLEMEN. By Rembrandt, *c.* 1654–6. Pen and brown wash,
with touches of red chalk wash and red and yellow chalk and some white
body-colour on Japanese paper, 19.1 × 23 cm. *New York, Pierpont Morgan
Library*. (Photograph: Library)

The two figures were probably copied from separate Mughal miniatures.
The man on the right with bow and arrow has been identified by Professor
Richard Ettinghausen as Abd al-Rahim Khan, an important personage of the
Mughal Court. Rembrandt's etching of *Abraham Entertaining the Three Angels*
[Fig. 16] was inspired by an Eastern miniature. *Princeton, the Art Museum*.
(Photograph: Museum)

Lit: O. Benesch: *The Drawings of Rembrandt*, 1954–7. v, 335–6.

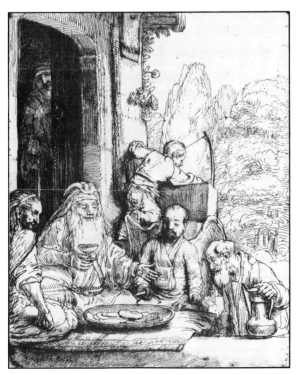

Figure 16. *Abraham Entertaining the Three Angels*,
1656. Rembrandt

149. THE SHIP OF AMERIGO VESPUCCI. Etching by Remigio Cantagallina after Giulio Parigi, 1608. *New York, Metropolitan Museum of Art* (Bequest of Edwin De T. Bechtel 1957). (Photograph: Museum)

The etching reproduces the stage setting for the fourth intermezzo of Giulio Parigi's *Il Giudizio di Paride*, performed at Florence in 1608. The print was copied by Inigo Jones in his drawing of 'An Indian Shore' for William Davenant's masque, *The Temple of Love*, 1635. (S. Orgel and R. Strong: *Inigo Jones. The Theatre of the Stuart Court*, 1973. ii, 605, pl. 295.)

Lit: A. M. Nagler: *Theatre Festivals of the Medici 1539–1637*, 1964. 107–8.

150. A SHIPWRECK OFF THE AMERICAN COAST. By Bonaventura Peeters, *c.* 1648. Oil on panel, 47 × 72.4 cm. *Philadelphia Museum of Art* (New Members Fund 70-2-1). (Photograph: Museum)

To be compared with the same artist's *Stormy Sea and Shipwreck* in Brussels (repr. in R. H. Wilenski: *Flemish Painters 1430–1830*, 1960. ii, pl. 690) and with his *Dutch Men-of-War off a West Indian Coast* of 1648, in the Wadsworth Atheneum, Hartford (repr. in Wilenski, ii, pl. 702).

151. THE SÃO FRANCISCO RIVER AND FORT MAURICE. By Frans Post, 1638. Oil on canvas, 62 × 95 cm. *Paris, Louvre.* (Photograph: Réunion des Musées Nationaux)

The fort erected by the Dutch can be seen on the hill overlooking the river. The picture formed part of the gift of paintings to Louis XIV from Count Johan Maurits.

Lit: E. Larsen: *Frans Post*, 1962. 96–7, 185; J. Rosenberg, S. Slive and E. H. ter Kuile: *Dutch Art and Architecture 1600–1800*, rev. ed. 1972. 260–61; J. de Sousa-Leão: *Frans Post 1612–1680*, 1973. 55.

152. PALAZZO BARBERINI, FAÇADE. By Carlo Maderno, Gian Lorenzo Bernini and Francesco Borromini, 1628–33. *Rome.* (Photograph: Alinari)

The commission to remodel the original palace was given by Pope Urban VIII to Maderno, who was succeeded in 1629 by Bernini. The feigned perspective of the windows of the uppermost storey probably follows Maderno's design. Borromini's contribution to the project is difficult to determine. The neo-Baroque gateway is by Francesco Azzurri (1827–1901), probably *c.* 1880.

Lit: H. Hibbard: *Carlo Maderno and Roman Architecture 1580–1630*, 1971. 80–84; R. Wittkower: *Art and Architecture in Italy 1600–1750*, rev. ed. 1973. 112–15, 198.

152A. PALAZZO BARBERINI. PLAN adapted from a drawing by N. Tessin showing the palace before rebuilding of *c.* 1670. (Courtesy Howard Hibbard)

153. S. MARIA DELLA PACE, FAÇADE. By Pietro da Cortona, 1656–7. *Rome.* (Photograph: Alinari)

The remodelling of the fifteenth-century church of S. Maria della Pace was ordered in 1656 by Pope Alexander VII. Cortona's design of the façade became enormously influential, the portico being imitated by Bernini at S. Andrea al Quirinale [6] and in London by Sir Christopher Wren on the transepts of St Paul's and by James Gibbs on the façade of St Mary-le-Strand.

Lit: P. Portoghesi: *Roma Barocca*, 1970. 242–6; C. Norbert-Schulz: *Baroque Architecture*, 1971. 43–57; R. Wittkower: *Art and Architecture in Italy 1600–1750*, rev. ed. 1973. 241–3.

153A. S. MARIA DELLA PACE. PLAN OF CHURCH AND PIAZZA. (From a drawing in the Vatican Library)

154. S. ANDREA AL QUIRINALE, INTERIOR. By Gian Lorenzo Bernini, 1658–70. *Rome.* (Photograph: Alinari)

The predominance of the altar in this richly decorated interior is assured by the unexpectedly short distance between the entrance and the apsidal chapel and by the light that falls upon it from a concealed source. In addition, the transverse axis terminates in pilasters rather than in open chapels, with the

result that the eye of the spectator, glancing to left and right, is checked at 343 these points and quickly returned to the altar chapel. The sculptured figure of St Andrew (carved by Antonio Raggi) soars upward from the painting of his martyrdom (the work of Guillaume Courtois) to the light of the heavenly dome where the dove of the Holy Spirit appears within the lantern. For the façade see illustration 6.

155. S. CARLO ALLE QUATTRO FONTANE, FAÇADE. By Francesco Borromini, 1665–7. *Rome.* (Photograph: Alinari)

The Spanish Discalced Trinitarians commissioned Borromini to build the monastery of S. Carlo alle Quattro Fontane in 1634. The church itself was constructed in 1638–41. The façade, erected 1665–7, was Borromini's last work. Its fusion of architectural and sculptural elements and its rhythmic manipulation of surface make it one of the most imaginative creations of all Seicento architecture.

Lit: E. Hempel: *Francesco Borromini*, 1924. 32–48, 179–82; P. Portoghesi: *Borromini, Architettura come linguaggio*, 1967. 39–48. R. Wittkower: *Art and Architecture in Italy 1600–1750*, 1973. 197–229.

156. S. LORENZO, DOME. By Guarino Guarini, 1668–87. *Turin.* (Photograph: Alinari)

The structure and spatial relationships of the interior of the church [Fig. 17] (Photograph: Alinari) are no less complex and bewildering than those of the dome.

Figure 17. S. Lorenzo, Turin, 1668–87. Guarini

Lit: P. Portoghesi: *Guarino Guarini 1624–1683*, 1956; G. M. Crepaldi: *La Real Chiesa di San Lorenzo in Torino*, 1963; R. Wittkower: *Art and Architecture in Italy 1600–1750*, rev. ed. 1973. 410–13.

156A. S. LORENZO, TURIN. PLAN. (From Guarini, *Architettura Civile*, plate 4)

157. THE GALERIE DES GLACES. By Jules Hardouin Mansart and Charles Le Brun, 1678–84. *Versailles, Château*. (Photograph: Archives Photographiques, Paris)

The Galerie des Glaces and the two rooms at either end, the Salon de la Guerre and the Salon de la Paix, were built by Mansart by filling in the terrace of Le Vau's garden façade. For the decoration of the interior Le Brun made a vast number of preparatory drawings (most of them in the Louvre) and a few oil sketches: on the latter see J. Thuillier in exh. cat. *Charles Le Brun 1619–1690*, 1963, 109–10.

Lit: A. Blunt: *Art and Architecture in France 1500–1700*, rev. ed. 1973. 339–41.

158. THE GALERIE DES GLACES, VERSAILLES. By Sébastien Le Clerc, 1680. Engraving. *Paris, Bibliothèque Nationale*. (Photograph: Library)

The engraving forms the frontispiece to the first volume of the *Conversations par Mademoiselle de Scudéry* (1680).

Lit: C.-A. Jombert: *Catalogue raisonné de l'oeuvre de Sébastien Le Clerc*, 1774. i, 276–7; E. Meaume: *Sébastien Le Clerc 1637–1714 et son oeuvre gravé*, 1877. 137–8.

159. THE ATRIUM OF THE TEMPLE OF THE VESTALS. By M. Küsel after Ludovico Burnacini, 1674. Engraving. *New York, Metropolitan Museum of Art* (Harris Brisbane Dick Fund 1953). (Photograph: Museum)

Stage setting for the opera *Il Fuoco Eterno*, performed in Vienna in 1674 on the occasion of the birth of the Archduchess Anna Maria, daughter of Leopold I.

Lit: F. Biach-Schiffmann: *Giovanni und Ludovico Burnacini*, 1931. 112–13.

160. CLOCK. By Hans Coenradt Breghtel, c. 1660. Silver, partly gilt, 81 cm. high. *London, Victoria and Albert Museum*. (Photograph: Museum)

Lit: J. W. Frederiks: *Dutch Silver, Embossed Ecclesiastical and Secular Plate from the Renaissance until the End of the Eighteenth Century*, 1961. 65.

161. VIEW OF DORDRECHT. By Jan van Goyen, 1653. Oil on panel, 66 × 88 cm. *Stockholm, Nationalmuseum*. (Photograph: Museum)

The Gothic church, a familiar landmark in paintings by Van Goyen and Aelbert Cuyp, is the Grote Kerk of Dordrecht.

Lit: H.-U. Beck: *Jan van Goyen, 1596–1656*, 1973. ii, 156.

162. APOLLO AND DAPHNE. By Gian Lorenzo Bernini, 1622–5. Marble, 243 cm. high. *Rome, Galleria Borghese*. (Photograph: Alinari)

Commissioned by Cardinal Scipione Borghese, for whom the artist also made the *David* [49]. By a brilliant *tour de force* the young Bernini has achieved in this marble sculpture effects that had hitherto seemed to belong only to painting, above all the illusion of the transient moment. As Wittkower has pointed out, the pictorial quality of the work was even more apparent in its original setting, for the Borghese sculptures were placed against a wall so as to be seen from one point of view. The frightened face of Daphne reveals no awareness of the metamorphosis that has already begun.

Lit: Wittkower; *Bernini*. 6, 183–4; Hibbard, *Bernini*. 48–54. P. A. Riedl: *Gian Lorenzo Bernini, Apollo and Daphne*, 1960.

163. THE TRINITY IN GLORY. By Pietro da Cortona, 1647–51. Fresco. *Rome, S. Maria in Vallicella, dome*. (Photograph: Alinari)

The fresco decoration of the Chiesa Nuova (the dome, the apse and the ceiling of the nave) occupied Cortona, with interruptions, for nearly twenty years, from 1647 to 1665. For bibliography see no. 127.

THE TOMB OF ARCHBISHOP ANDREAS CRUESEN. By Lucas Faydherbe,
begun 1660. Marble, 160 cm. high. *Mechlin, Cathedral.* (Photograph: A.C.L.-
Bruxelles)

Faydherbe, who was one of Rubens's most trusted associates in his last
years, is known to have made small works in ivory from the master's designs.
The influence of the great Flemish painter is likewise evident in Faydherbe's
monumental sculpture: in the Tomb of Cruesen, for example, the figure of
Christ is modelled after Rubens's *Resurrection* in the Cathedral of Antwerp.

Lit: Brother Libertus: *Lucas Faydherbe, Beeldhouwer en Bouwmeester, 1617–
1697,* 1938. 26–8, 78–81. H. Gerson and E. H. ter Kuile: *Art and Architecture
in Belgium 1600–1800,* 1960. 39.

165. TIME THE DESTROYER. By François Perrier, 1638. Engraving. *Princeton
University Library.* (Photograph: Barbara Glen)

Frontispiece to Perrier's *Segmenta Nobilium Signorum et Statuarum . . .,*
Rome, 1638. The engraving (briefly discussed by E. Panofsky: *Studies in
Iconology,* 1939. 83) was copied by Salvator Rosa in his painting of *Mr Altham
as a Hermit,* where it appears as a relief on a plinth (see R. W. Wallace in *Art
Bulletin,* 1968. 21–2).

166. TITLE-PAGE OF H. GOLTZIUS'S ROMANAE ET GRAECAE ANTIQUITATIS
MONUMENTA. By Cornelis Galle after Rubens, 1632. Engraving. *Antwerp,
Museum Plantin-Moretus.* (Photograph: Museum)

Although the book was not published until 1645, Rubens's design for the
title-page was made no later than 1632, for it was in that year that Cornelis
Galle received payment for the engraving. The volume contains an explanatory
note on the meaning of the title-page, which was very probably written by
Caspar Gevartius.

Lit: H. F. Bouchery and F. Van den Wijngaert: *P. P. Rubens en het Plantijnsche
Huis,* 1941. 91–2, 147–9.

167. TIME VANQUISHED BY HOPE, LOVE AND BEAUTY. By Simon Vouet, 1627.
Oil on canvas, 107 × 142 cm. *Madrid, Prado.* (Photograph: Mas)

Painted in Rome, shortly before the artist's return to Paris. Crelly observes
that the figure of Beauty 'is almost certainly a portrait of Vouet's wife,
Virginia, whom he had married in 1626'. Vouet painted a second and very
different version of the subject in a canvas that once formed part of the decora-
tion of a cabinet in the Hôtel de Bretonvilliers in Paris and is now in the Musée
du Berry, Bourges.

Lit: W. R. Crelly: *The Painting of Simon Vouet,* 1962. 45–6, 111–12, 152–3,
177.

168. DEMOCRITUS IN MEDITATION. By Salvator Rosa, 1651. Oil on canvas,
344 × 214 cm. *Copenhagen, Royal Museum of Fine Arts.* (Photograph:
Museum)

This surprisingly large canvas has a companion piece representing *Diogenes
Throwing away his Bowl,* also in Copenhagen.

Lit: I. Bergström: *Dutch Still-Life Painting in the Seventeenth Century,* 1956.
185–6; L. Salerno: *Salvator Rosa,* 1963. 43, 110; R. W. Wallace in *Art
Bulletin,* 1968. 21–32.

169. DESIGN OF A MIRROR FOR QUEEN CHRISTINA OF SWEDEN. By Gian
Lorenzo Bernini, *c.* 1670. Pen and wash over chalk, 23 × 18.9 cm. *Windsor,
Royal Library.* (Photograph: By gracious permission of Her Majesty the Queen)

The mirror was made for Queen Christina's palace in Rome. A drawing in
Stockholm by N. Tessin shows that the finished work differed in some respects
from the preliminary drawing.

Lit: H. Brauer and R. Wittkower: *Die Zeichnungen des Gianlorenzo Bernini,*
1931. 151, 171; Wittkower, *Bernini.* 211–12.

170. SELF-PORTRAIT. By Rembrandt, c. 1667–9. Oil on canvas, 82 × 63 cm. *Cologne, Wallraf-Richartz Museum.* (Photograph: Rheinisches Bildarchiv)

It was suggested by W. Stechow that Rembrandt had here represented himself as the laughing Democritus painting a picture of the weeping Heraclitus (*Art Quarterly*, 1944. 233–8). More recently, however, J. Bialostocki has identified the shadowy figure as a sculptured bust of Terminus, on which, as x-ray photographs reveal, the artist originally rested his hand (*Wallraf-Richartz Jahrbuch*, 1966. 49–60); see also Bredius/Gerson. 552.

171. IN ICTU OCULI. By Juan de Valdés Leal, 1672. Oil on canvas, 235 × 230 cm. *Seville, Caridad.* (Photograph: Anderson)

Commissioned by Don Miguel Mañara for the Church of the Brotherhood of Charity in Seville, where it still hangs with its pendant, *Finis Gloriae Mundi* [Fig. 18]. (Photograph: Anderson). The two pictures represent the 'Hieroglyphs of the Four Last Things' – death, judgement, heaven and hell.

Figure 18. *Finis Gloriae Mundi*, 1672. Valdés Leal

Lit: E. du Gué Trapier: *Valdés Leal*, 1960. 54–8; J. M. Brown in *Art Bulletin*, LII, 1970. 265–77.

172. THE TOMB OF ALEXANDER VII. By Gian Lorenzo Bernini, 1671–8. Marble and gilt bronze, the figures over life-size. *Rome, St Peter's.* (Photograph: Alinari)

Commissioned by Pope Alexander VII shortly before his death in 1667 and executed, largely by members of Bernini's studio working from his designs and

bozzetti, from 1671 to 1678. In this late work Bernini develops and enriches
some of the motifs seen in his Tomb of Urban VIII (1628–47), also in St Peter's.
The figure of Death, for example, is also present in the earlier tomb, where he
inscribes the pope's name in a large book.

> Lit: E. Panofsky: *Tomb Sculpture*, 1964. 94–5; Wittkower, *Bernini*. 259–60;
> Hibbard, *Bernini*. 215–17.

173. THE TRIUMPH OF EUCHARISTIC TRUTH OVER HERESY. By Peter Paul
Rubens, *c.* 1625–6. Oil on panel, 87 × 92 cm. *Madrid, Prado.* (Photograph:
Mas)

> One of the oil sketches for the tapestry cycle, *The Triumph of the Eucharist*,
> commissioned by the Infanta Isabella Clara Eugenia for the convent church
> of the Poor Clares in Madrid (the *Descalzas Reales*). The most complete
> description of the cycle is E. Tormo: *En las Descalzas Reales de Madrid. Los
> Tapices: La Apoteosis Eucaristica de Rubens*, 1945. The panel with the *Triumph
> of Eucharistic Truth* has been enlarged by strips of wood along the top and
> bottom (the original height about 65 cm.). On the subject see F. Saxl, in
> *Philosophy and History, Essays presented to Ernst Cassirer*, 1936. 211–12.

174. THE TRIUMPH OF TRUTH. By Peter Paul Rubens, 1621–5. Oil on canvas,
394 × 160 cm. *Paris, Louvre.* (Photograph: Réunion des Musées Nationaux)

> On the Medici Cycle, see No. 107 above. An oil sketch for this composition
> is in the Louvre.
> Lit: F. Saxl: *op. cit.* 211; J. Thuillier and J. Foucart: *Rubens' Life of Marie de'
> Medici*, 1967. 92.

175. TIME RESCUING TRUTH FROM ENVY AND DISCORD. By Nicolas Poussin,
1641. Oil on canvas, 297 cm. diameter. *Paris, Louvre.* (Photograph: Réunion
des Musées Nationaux)

> Richelieu commissioned two paintings for the decoration of the Grand
> Cabinet in the Palais Cardinal – a *Moses and the Burning Bush* to be hung over
> the fireplace (now in Copenhagen) and *Time rescuing Truth* for the ceiling. The
> illusionism and pronounced foreshortening of the latter are unique in the work
> of Poussin. The artist painted another *Time rescuing Truth*, which has been lost;
> but copies show it to have been utterly different from the Richelieu ceiling.
> Lit: F. Saxl: *op. cit.* 212–15; Blunt, *Poussin*, 1966. 83.

176. TIME MOWING DOWN SLANDER AND VICE AND DEATH STRANGLING
ENVY. By Jacob Jordaens, 1650. Oil on canvas, 383 × 205 cm. *The Hague,
Huis ten Bosch.* (Photograph: Rijksdienst v/d Monumentenzorg)

> The first of the two paintings executed by Jordaens for the Oranjezaal,
> following the programme drawn up by Jacob van Campen. The much larger
> canvas with the *Triumph of Prince Frederick Henry* [110], which is signed and
> dated 1652, was a later commission.
> Lit: M. Rooses: *Jacob Jordaens, His Life and Work*, 1908. 168–9; J. G. van
> Gelder in *Nederlandsch Kunsthistorisch Jaarboek*, 1948–9. 124, 153.

177. AURORA. By Guido Reni, 1613–14. Fresco. *Rome, Casino Rospigliosi.* (Photo-
graph: Alinari)

> In his life of the artist Bellori correctly describes the subject as 'l'Aurora e'l
> sole nel Carro' (*Vite inedite*, 1942. 14–15). The fresco is a *quadro riportato*, i.e.
> it is treated as if it were an easel picture which happens, because of its 'celestial'
> subject, to be placed on a ceiling. There are preparatory drawings in the
> Louvre, the Albertina and Windsor Castle.
> Lit: C. Gnudi: *Guido Reni*, 1955. 23, 66.

178. AURORA. By Guercino, 1621. Fresco, *Rome, Casino Ludovisi.* (Photograph:
Alinari)

> Painted for Cardinal Ludovico Ludovisi during Guercino's brief period in
> Rome, 1621–3. Though the two subjects are not precisely identical, it can

hardly be doubted that Guercino's ceiling was conceived in response to the *Aurora* painted seven or eight years before by Guido Reni in the Casino Rospigliosi [177]. At the right end of the vault, the harbingers of Dawn are already breaking in on Night and her children [Fig. 19]. (Photograph: Anderson). The illusionistic architecture (*quadratura*) which establishes a con-

Figure 19. Detail of *Aurora*, 1621. Guercino

nection between the pictorial space and the real space of the observer is the work of Agostino Tassi.

Lit: N. B. Grimaldi: *Il Guercino*, 1968. 70.

179. DIANA AND ENDYMION. By Nicolas Poussin, *c.* 1631–3. Oil on canvas, 122 × 169 cm. *Detroit, Institute of Arts.* (Photograph: Museum)

J. Colton in *Journal of the Warburg and Courtauld Institutes*, 1967, 426–31, discusses Poussin's use of motifs (such as that of Apollo in his chariot) from antique sarcophagi and considers the possible relation of the painting to the illustrations of Gombauld's novel *L'Endymion* of 1624.

Lit: Blunt, *Poussin*, 1966. 107–8.

180. LANDSCAPE WITH ACIS AND GALATEA. By Claude Lorrain, 1657. Oil on canvas, 100 × 135 cm. *Dresden, Gemäldegalerie.* (Photograph: Alinari)

The two principal figures have been repainted, and the doves beneath them are not original. There is a preparatory drawing in Windsor. The pendant to this work is the *Landscape with the Metamorphosis of the Apulian Shepherd* (Collection Duke of Sutherland).

Lit: M. Röthlisberger: *Claude Lorrain, The Paintings*, 1961. i, 336–8.

181. THE MIRED CART. By Peter Paul Rubens, *c.* 1615–17. Oil on canvas, 87 × 129 cm. *Leningrad, Hermitage.* (Photograph: Museum)

Engraved by Schelte à Bolswert. The painting has been transferred from panel to canvas.

Lit: G. Glück: *Die Landschaften von Peter Paul Rubens*, 1945. 20, 56. J. S. Held: *Rubens, Selected Drawings*, 1959. i. 144.

182. TIME, APOLLO AND THE SEASONS. By Claude Lorrain, 1662. Etching, 25 × 18.2 cm. *Paris, Bibliothèque Nationale*. (Photograph: Library)

Clearly inspired by Poussin's *Dance of Human Life* [91]. There is a preparatory drawing in the Pallavicini collection, Rome (see M. Röthlisberger: *Claude Lorrain, The Drawings*, 1968. 327–8).

Lit: A. Blum: *Les Eaux-Fortes de Claude Gellée dit le Lorrain*, 1923. 27–8.

183. THE FOUR SEASONS. By Otto van Veen, 1607. Engraving. *Princeton University Library*. (Photograph: Library)

From Van Veen's *Emblemata Horatiana*, Antwerp, 1607. 206–7.

184. SPRING: THE EARTHLY PARADISE. By Nicolas Poussin, 1660–64. Oil on canvas, 118 × 160 cm. *Paris, Louvre*. (Photograph: Réunion des Musées Nationaux)

See No. 105 above.

185. THE AVENTINE HILL. By Nicolas Poussin, *c.* 1645. Black chalk and brown wash, 13.4 × 31.2 cm. *Florence, Uffizi*. (Photograph: Soprintendenza alle Gallerie, Firenze)

Blunt suggests that Poussin may have had this drawing in mind when he painted the *Baptism* in the set of Seven Sacraments for Chantelou (Collection Duke of Sutherland, on loan to National Gallery of Scotland, Edinburgh).

Lit: A. Blunt in *Journal of the Warburg and Courtauld Institutes*, 1944. 155; Blunt, *Poussin*, 1967. 285.

186. THE MILL AT WIJK BIJ DUURSTEDE. By Jacob van Ruisdael, *c.* 1670. Oil on canvas, 83 × 101 cm. *Amsterdam, Rijksmuseum*. (Photograph: Museum)

A free rendering of the town of Wijk, showing the church tower at the right and the bishop's palace to the left of the mill. The mill itself no longer stands.

Lit: J. Rosenberg: *Jacob van Ruisdael*, 1928. 52–3; W. Stechow: *Dutch Landscape Painting of the Seventeenth Century*, 1966. 59–60. M. Imdahl: *Jacob van Ruisdael, Die Mühle von Wijk*, 1968.

187. THE MADONNA OF LORETO. By Caravaggio, *c.* 1604. Oil on canvas, 260 × 150 cm. *Rome, S. Agostino*. (Photograph: Alinari)

Also known as the *Madonna dei Pellegrini*. The Virgin may be understood as standing at the doorway of the Santa Casa, which was miraculously transported from the Holy Land to Loreto.

Lit: W. Friedlaender: *Caravaggio Studies*, 1955. 17, 189–90.

188. THE CONVERSION OF ST PAUL. By Caravaggio, 1601. Oil on canvas, 230 × 175 cm. *Rome, S. Maria del Popolo, Cerasi Chapel*. (Photograph: Alinari)

Commissioned in September 1600 by Tiberio Cerasi for the decoration of his chapel in S. Maria del Popolo. Caravaggio was to furnish two paintings on cypress wood representing the *Conversion of St Paul* and the *Crucifixion of St Peter* for the lateral walls. Final payment was made to the artist in November 1601. Both paintings in the Cerasi chapel are on canvas, a fact that has led some scholars to speculate whether the panel with the *Conversion of St Paul* in the Odescalchi-Balbi collection might not be Caravaggio's first solution for this subject, later replaced by the present picture. Over the altar of the Cerasi chapel is Annibale Carracci's *Assumption of the Virgin*.

Lit: W. Friedlaender: *Caravaggio Studies*, 1955. 3–28, 183–5; L. Steinberg in *Art Bulletin*, 1959. 183–90.

189. TWO NUNS OF PORT ROYAL. By Philippe de Champaigne, 1662. Oil on canvas, 165 × 57 cm. *Paris, Louvre*. (Photograph: Réunion des Musées Nationaux)

The miraculous cure of Champaigne's daughter, Soeur Catherine de Ste Suzanne, occurred at Port Royal on 7 January 1662. Only a few years earlier, in 1656, Pascal's niece, Marguerite Périer, had been cured of an eye infection by the application of the Holy Thorn, a relic belonging to the Abbey of Port Royal. Professor Olan Rand informs me, however, that the object held by Soeur Catherine does not appear to be the reliquary of the Thorn.

Lit: B. Dorival: Exh. cat., *Philippe de Champaigne*, 1952. 80–82.

190. DANAË. By Rembrandt, 1636, reworked c. 1650. Oil on canvas, 185 × 203 cm. *Leningrad, Hermitage*. (Photograph: Museum)

The subject was established by E. Panofsky in *Oud Holland*, 1933. 200–202. J. I. Kuznetzov has shown conclusively that the painting, which bears the date 1636, was later reworked by the artist (*Bulletin of the Hermitage* [Russian], 1966. 26; *Oud Holland*, 1967. 225–33). See also Bredius/Gerson. 593. The area most affected by repainting is the figure of Danaë, which is in fact a wholly new conception.

191. THE DREAM OF JACOB. By Jusepe de Ribera, 1639. Oil on canvas, 179 × 233 cm. *Madrid, Prado*. (Photograph: Anderson)

The subject probably has a typological meaning of the sort found in the *Biblia Pauperum*, where the Dream of Jacob is interpreted as a prefiguration of Paradise (see P. Heitz and W. L. Schreiber: *Biblia Pauperum*, 1903. pl. 49).

Lit: E. du Gué Trapier: *Ribera*, 1952. 162–5.

192. ST LONGINUS. By Gian Lorenzo Bernini, 1629–38. Marble, about 4.40 m. high. *Rome, St Peter's*. (Photograph: Alinari)

The only statue personally executed by Bernini of the four colossal sculptures in the niches of the piers beneath the dome of St Peter's. (The best account of the original conception and final disposition of these statues is I. Lavin: *Bernini and the Crossing of St Peter's*, 1968.) Longinus is represented at the moment of his conversion when, with the lance still in his hand, he looks up at the Cross and is transfigured by the heavenly light from above. A *bozzetto* for the figure is in the Fogg Art Museum at Harvard.

Lit: Wittkower, *Bernini*. 8, 196–7; Hibbard, *Bernini*. 80–88.

193. CONSTANTINE THE GREAT. By Gian Lorenzo Bernini, 1654–70. Marble figures, over life-size, before a painted stucco drapery. *Rome, Vatican, Scala Regia*. (Photograph: Schneider-Lengyel)

Originally planned as a counterpart to the Tomb of Countess Matilda in St Peter's (1633–7), and later redesigned to occupy the much larger niche on the principal lower landing of the Scala Regia, where it is seen from the portico of St Peter's.

Lit: Wittkower, *Bernini*. 251–4.

194. THE CATHEDRA PETRI. By Gian Lorenzo Bernini, 1657–66. Marble, gilt bronze and stucco. *Rome, St Peter's*. (Photograph: Alinari)

Wittkower has said of the Cathedra Petri that it 'signifies in every respect the climax of Bernini's career'. The evolution of this complex project, which began in 1656 with the decision to move the chair of St Peter from the Baptismal Chapel to the apse of the basilica, can be followed through documents and through Bernini's own drawings and *bozzetti*. The relic was placed in the Cathedra and the great work unveiled in January 1666. The Greek Church Fathers Athanasius and John Chrysostom stand at the rear; those in front are the Latin Fathers Ambrose and Augustine [Fig. 20]. (Photograph: Anderson)

Lit: R. Battaglia: *La Cattedra berniniana di San Pietro*, 1943; H. von Einem, in *Nachrichten der Akademie der Wissenschaften in Göttingen* (I. Philologisch-historische Klasse), 1955. 93–114. Wittkower, *Bernini*. 19–21, 235–7.

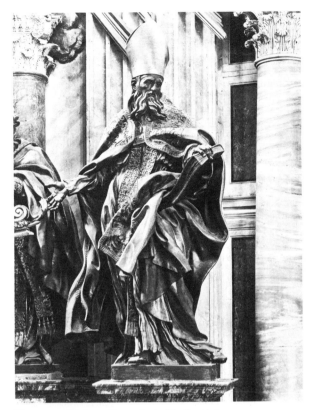

Figure 20. *St Augustine*, 1657–66. Bernini

195. THE TRANSPARENTE. By Narciso Tomé, 1721–32. Marbles and bronze. *Toledo, Cathedral.* (Photograph: Mas)

The work takes its name from the window through which the Blessed Sacrament may be seen from the ambulatory behind the high altar.

Lit: G. Kubler and M. Soria: *Art and Architecture in Spain and Portugal and their American Dominions 1500–1800*, 1959. 40.

196. THE BLINDING OF SAMSON. By Rembrandt, 1636. Oil on canvas, 236 × 302 cm. *Frankfurt, Städelsches Kunstinstitut.* (Photograph: Gabriele Busch-Hauck)

Sent as a gift by the artist to Constantijn Huygens, who as secretary of the Prince of Orange had obtained for him the commission to paint a series of pictures of the Passion of Christ. In a letter of 27 January 1639 accompanying the painting Rembrandt advised Huygens to hang the work in a strong light so that it could be seen at its best. Copies of the painting show that it was originally somewhat larger than it is today.

Lit: H. Gerson: *Seven Letters by Rembrandt*, 1961. 50–54; Rosenberg, *Rembrandt*. 191–2; Bredius/Gerson. 598.

197. CHRIST HEALING THE BLIND MEN. By Nicolas Poussin, 1650. Oil on canvas, 119 × 176 cm. *Paris, Louvre.* (Photograph: Réunion des Musées Nationaux)

Painted for Reynon in 1650. In 1667, by which time the work had been acquired by Louis XIV for the royal collection, it formed the subject of a lecture delivered by Sébastien Bourdon before the Royal Academy. Bourdon remarked

particularly on the significance of the light: Poussin, he said, 'a voulu figurer un matin, parce ce qu'il y a quelque apparence que Dieu choisit cette heure-là comme la plus belle et celle où les objets semblent plus gracieux, afin que ces nouveaux illuminés reçussent davantage de plaisir, en ouvrant les yeux, et que ce miracle fût plus manifeste et plus évident.' (H. Jouin: *Conférences de l'Académie Royale de Peinture et de Sculpture*, 1893. 66–86.)

Lit: Blunt, *Poussin*, 1966. 52–3.

198. CHRIST HEALING THE SICK (THE HUNDRED-GUILDER PRINT). By Rembrandt, finished 1649. Etching, drypoint and burin, second state, 27.8 × 38.8 cm. *London, British Museum.* (Photograph: Museum)

The work illustrates the nineteenth chapter of Matthew's Gospel. Episodes such as the woman carrying a child, the blind man guided by his wife, and the invalid lying on a wheelbarrow are reminiscent of Annibale Carracci's *St Roch distributing Alms* [58], which (as was noted by Münz) Rembrandt could have known through the print by Guido Reni. The detail reproduced here [Fig. 21] shows the shadow cast by the praying woman on Christ's garment. *Princeton University, the Art Museum.* (Photograph: Taylor & Dull, Inc.)

Figure 21. Detail of *Christ Healing the Sick*, 1649. Rembrandt

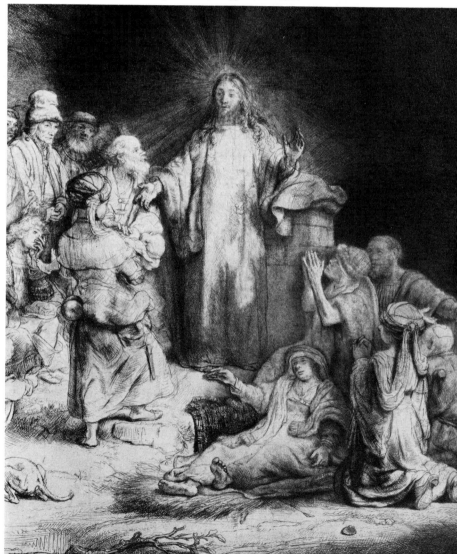

Rosenberg, *Rembrandt*. 182–3; C. White: *Rembrandt as an Etcher*, 1969. 64–70; C. White and K. G. Boon: *Rembrandt's Etchings*, 1969. 39–40.

199. PETER DENYING CHRIST. By Rembrandt, 1660. Oil on canvas, 154 × 169 cm. *Amsterdam, Rijksmuseum*. (Photograph: Museum)

The motif of the maid with the candle also appears in Gerard Seghers's *Denial of St Peter* of c. 1620, now in the North Carolina Museum of Art in Raleigh. It is possible that Rembrandt knew Seghers's composition through the print by Schelte à Bolswert. See M. D. Henkel in *Burlington Magazine*, LXIV, 1934. 153–9.

Lit: Rosenberg, *Rembrandt*. 226–8; Bredius/Gerson. 611.

200. THE ART OF PAINTING. By Jan Vermeer, c. 1666–70. Oil on canvas, 120 × 100 cm. *Vienna, Kunsthistorisches Museum*. (Photograph: Museum)

Long known as *The Artist in his Studio*. The best interpretation of the allegory is that by J. G. van Gelder: *De Schilderkunst van Jan Vermeer* (with a commentary by J. A. Emmens), 1958.

201. THE RISING OF THE SUN. By Charles de la Fosse, c. 1680. Oil on canvas, 101 cm. diameter. *Rouen, Musée des Beaux-Arts*. (Photograph: Réunion des Musées Nationaux)

A preparatory oil sketch for the ceiling of the Salon d'Apollon at Versailles. The chariot of Louis-Apollo is preceded by a *putto* signifying the morning star and by Minerva, who puts Falsehood and Discord to flight. The Four Seasons are distributed along the curving band of the zodiac. The ceiling painting as finally executed shows some significant changes, which were probably dictated by Le Brun; the effect of foreshortening is greatly moderated, as if to conform to the method of Guido Reni [177] rather than to that of Guercino [178]. The symbolism of the sun is followed out even in the carved decoration of the doors of the Salle de Vénus [115].

Lit: M. Stuffman in *Gazette des Beaux-Arts*, LXIV, 1964. 17, 70–76, 100.

202. LANDSCAPE WITH THE ARCH OF CONSTANTINE AND THE COLOSSEUM. By Claude Lorrain, 1651. Oil on canvas, 98 × 145 cm. Trustees of the Grosvenor Estate. (Photograph: Courtauld Institute of Art)

The pendant to this picture is the *Pastoral Landscape* in the same collection (Röthlisberger No. 124).

Lit: M. Röthlisberger: *Claude Lorrain, The Paintings*, 1961. i, 287–9.

203. HOMER. By Rembrandt, 1663. Oil on canvas, 108 × 82.5 cm. *The Hague, Mauritshuis*. (Photograph: A. Dingjan)

Commissioned by the Sicilian nobleman Antonio Ruffo, who had already acquired two paintings by Rembrandt. The picture has been cut down, probably as a result of damage by fire. The original composition is preserved in a preparatory drawing in Stockholm, which shows the poet dictating to a secretary.

Lit: Rosenberg, *Rembrandt*. 280–85; Bredius/Gerson. 596.

204. CASPAR GEVARTIUS. By Peter Paul Rubens, c. 1628. Oil on panel, 120 × 99 cm. *Antwerp, Koninklijk Museum voor Schone Kunsten*. (Photograph: A.C.L.-Bruxelles)

Jan Caspar Gevaerts (1593–1666), scholar and humanist, became Clerk of the City of Antwerp in 1621. An intimate friend of Rubens for almost twenty years, it was he who put the artist in touch with the French antiquarian Peiresc. The portrait was engraved by Paulus Pontius.

Lit: M. Rooses, *L'Oeuvre de P. P. Rubens*, 1886–92. iv, 186–7.

205. WOMAN WITH A CARNATION. By Rembrandt, c. 1665. Oil on canvas, 91 × 73.5 cm. *New York, Metropolitan Museum of Art (Bequest of Benjamin Altman 1913)*. (Photograph: Museum)

Figure 22. *Man with a Magnifying Glass, c.* 1665. Rembrandt.

The companion portrait is the *Man with a Magnifying Glass,* also in the Metropolitan Museum [Fig. 22]. *New York, Metropolitan Museum of Art (Bequest of Benjamin Altman, 1913)*. (Photograph: Museum). Attempts to identify the couple have not so far been successful. X-rays show the head of a child at the lower left of the female portrait, but this was painted out by Rembrandt himself.

 Lit: Rosenberg, *Rembrandt.* 86–8, 348; Bredius/Gerson. 575, 582.

206. THE CHOICE OF HERCULES. By Annibale Carracci, *c.* 1596. Oil on canvas, 167 × 237 cm. *Naples, Pinacoteca Nazionale (Capodimonte).* (Photograph: Villani)

 The canvas originally occupied the centre of the frescoed ceiling of the Camerino in the Farnese Palace in Rome. The figure of Hercules, who must decide between Virtue and Vice, alludes to the young Cardinal Odoardo Farnese and the virtuous way of life that he has chosen to follow.

 Lit: E. Panofsky: *Hercules am Scheidewege und andere antike Bildstoffe in der neueren Kunst,* 1930; J. R. Martin: *The Farnese Gallery,* 1965. 24–7; D. Posner: *Annibale Carracci,* 1971. i, 80–81; ii, 40–41.

207. ST CECILIA BEFORE THE JUDGE. By Domenichino, 1615–17. Fresco. *Rome, S. Luigi dei Francesi.* (Photograph: Gabinetto Fotografico Nazionale)

 The cycle of the Life of St Cecilia comprises five scenes. The frescoes were commissioned for the chapel of St Cecilia in S. Luigi dei Francesi by Daniel Polet.

 Lit: E. Borea: *Domenichino,* 1965. 51; J. Pope-Hennessy: *The Drawings of Domenichino in the Collection of His Majesty the King at Windsor Castle,* 1948.

81; R. Wittkower: *Art and Architecture in Italy 1600–1750*, rev. ed. 1973.
80–81.

208. THE INSPIRATION OF THE EPIC POET. By Nicolas Poussin, *c.* 1630–33. Oil on canvas, 184 × 214 cm. *Paris, Louvre.* (Photograph: Réunion des Musées Nationaux)

The painting belonged in the seventeenth century to Cardinal Mazarin and remained after his death in the cardinal's palace; it was seen there by Bernini when he visited Paris in 1665. It is not certain whether Poussin intended the epic poet to represent Virgil or a contemporary author.

Lit: Blunt, *Poussin*, 1966. 84–6; Blunt, *Poussin*, 1967. 83–5.

209. ST SUSANNA. By François Duquesnoy, 1629–33. Marble, over life-size. *Rome, S. Maria di Loreto.* (Photograph: Rigamonti)

Commissioned by the Bakers' Confraternity in Rome. The effect intended by the sculptor has been largely nullified because, instead of standing in the niche to the right of the altar, Susanna now occupies the niche on the left, where her attitude and gesture are meaningless. The right hand originally held the martyr's palm.

Lit: M. Fransolet: *Francois Du Quesnoy, sculpteur d'Urbain VIII,* 1942. 99–109; N. Huse in *Argo: Festschrift für Kurt Badt,* 1970. 324–35; R. Wittkower: *Art and Architecture in Italy 1600–1750,* rev. ed. 1973. 272–5.

210. THE DECAPITATION OF ST PAUL. By Alessandro Algardi, 1641–7. Marble, 282 cm. high. *Bologna, S. Paolo Maggiore.* (Photograph: Alinari)

Commissioned by Cardinal Bernardino Spada for the high altar of S. Paolo. According to Bellori, the cardinal intended the work to honour his late father, Paolo Spada, through an allusion to the name of the saint and to the sword (*spada*) of the executioner. (G. P. Bellori: *Le vite,* 1672. 391.)

Lit: R. Wittkower: *Art and Architecture in Italy 1600–1750,* rev. ed. 1973. 271–2. M. H. Ravalli: *Alessandro Algardi scultore,* 1973. 79–81.

211. APOLLO TENDED BY THE NYMPHS. By François Girardon and Thomas Regnaudin, 1666–72. Marble, life-size figures. *Versailles.* (Photograph: Archives Photographiques)

Girardon carved the figures of Apollo and the three nymphs in the foreground, the three at the back being the work of Regnaudin. The ewer held by one of the kneeling nymphs is decorated with a relief representing Louis XIV's crossing of the Rhine. The group was placed in the central niche of the Grotto of Thetis, see illustration 117. The Grotto was demolished in 1684 and in the late eighteenth century the sculptures were moved to a new setting designed by Hubert Robert.

Lit: P. Francastel: *Girardon,* 1927. 69–70. L. Lange in *Art de France,* I, 1961. 133–48.

212. THE APOLLO BELVEDERE. Roman copy of fourth-century Greek statue. Marble. *Rome, Vatican Museum.* (Photograph: Anderson)

213. 'ANTINOÜS'. Engraving from G. P. Bellori, *Le vite de pittori, scultori et architetti moderni,* 1672. *Princeton University Library.* (Photograph: Library)

The statue of Mercury (believed in the seventeenth century to represent Antinoüs) is in the Vatican Museum.

Lit: R. Wittkower in *Studies in Western Art* (Acts of the Twentieth International Congress of the History of Art), 1963. iii, 42–3.

214. THE COUNCIL OF THE GODS. By Peter Paul Rubens, 1621–5. Oil on canvas, 394 × 702 cm. *Paris, Louvre.* (Photograph: Réunion des Musées Nationaux)

The twelfth (and one of the three largest) paintings of the Medici Cycle (see No. 107). There is an oil sketch in Munich. Among the classical models used by Rubens for this composition are the *Apollo Belvedere* [212] and the

Ludovisi Gaul [215]. Others include the enthroned Jupiter, the goddess Ceres and the Fury at the extreme right.

Lit: J. Thuillier and J. Foucart: *Rubens' Life of Marie de' Medici*, 1967. 85–6; W. Stechow: *Rubens and the Classical Tradition*, 1968. 50–51.

215. THE LUDOVISI GAUL. Roman copy of third-century Greek statue. Marble. *Rome, Museo Nazionale.* (Photograph: Alinari)

216. THE RAPE OF THE SABINE WOMEN. By Nicolas Poussin, *c.* 1634–7. Oil on canvas, 154 × 206 cm. *New York, Metropolitan Museum* (Harris Brisbane Dick Fund 1946). (Photograph: Museum)

An earlier painting by Poussin of this subject is in the Louvre.

Lit: C. Sterling: *The Metropolitan Museum of Art. A Catalogue of the French Paintings, XV–XVIII Centuries*, 1955. 70–72; Blunt, *Poussin*, 1967. 151, 237.

217. THE RAPE OF THE SABINE WOMEN. By Nicolas Poussin, *c.* 1634–7. Pen and brown wash over black chalk, 11.4 × 19.7 cm. *Windsor Castle, Royal Library.* (Photograph: Courtauld Institute of Art)

A study for the right-hand section of the Metropolitan painting.

Lit: A. Blunt: *The French Drawings in the Collection of His Majesty the King at Windsor Castle*, 1945. 39; W. Friedlaender *et al.*: *The Drawings of Nicolas Poussin. A Catalogue Raisonné*, 1939– . ii, 10.

218. PORTRAIT OF CHARLES LE BRUN. By Nicolas de Largillierre, 1686. Oil on canvas, 232 × 187 cm. *Paris, Louvre.* (Photograph: Réunion des Musées Nationaux)

Submitted to the Academy by Largillierre in 1686 as *morceau de réception.* The face, seen in three-quarter view, closely resembles that in Le Brun's self-portrait in the Uffizi. The oil sketch representing *The Conquest of Franche-Comté* still exists in the Musée National at Versailles; the engraving under the statuettes reproduces *The Queens of Persia at the Feet of Alexander* [62]. On the floor at the left are casts of the *Belvedere Torso* and a female head; the same objects, as well as the *Antinoüs*, are included in another work by Largillierre, *The Painter and his Students in his Atelier* (Collection Walter P. Chrysler, Jr).

Lit: G. Pascal: *Largillierre*, 1928. 7–8, 63.

219. VENUS AND CUPID (THE 'ROKEBY VENUS'). By Diego Velazquez, *c.* 1649–51. Oil on canvas, 122.5 × 177 cm. *London, Trustees of the National Gallery.* (Photograph: Museum)

Perhaps painted in Italy during the period 1649–51. The derivation of the pose of Venus from the Borghese *Hermaphrodite* was first observed by C. Justi: *Diego Velazquez und sein Jahrhundert*, 1888. 368.

Lit: N. MacLaren: *National Gallery Catalogues. The Spanish School*, 1952. 75–8; J. Camón Aznar: *Velazquez*, 1964. ii, 743–53.

220. THE BANQUETING HOUSE, WHITEHALL. By Inigo Jones, 1619–22. *London.* (Photograph: Copyright A. F. Kersting)

Erected to replace an earlier Banqueting House, destroyed by fire in 1619. The ceiling paintings by Rubens glorifying King James I were put in place in 1635.

Lit: J. Summerson: *Architecture in Britain*, rev. ed. 1963. 69–72. O. Millar: *Rubens. The Whitehall Ceiling*, 1958.

221. THE COLONNADE OF THE LOUVRE. By Louis Le Vau, Charles Le Brun and Claude Perrault, 1667–70. *Paris.* (Photograph: Bulloz)

The task of designing the east façade of the Louvre was entrusted by Louis XIV to a council of three, consisting of Le Vau, Le Brun and Perrault. Which of these men played the leading role in the project is still a subject of discussion.

Lit: M. Whiteley and A. Braham in *Gazette des Beaux-Arts*, LXIV, 1964. 285–96, 347–62; A. Blunt: *Art and Architecture in France 1500–1700*, rev.

ed. 1970. 199–201; R. W. Berger in *Art Bulletin*, LII, 1970. 390–403; W.
Herrmann: *The Theory of Claude Perrault*, 1973. 115–17.

222. THE FRONTISPIECE OF NERO IN ROME. By Jean Le Pautre after Antoine Desgodetz, 1682. Engraving from Desgodetz: *Edifices antiques de Rome*, 1682. *Princeton University Library*. (Photograph: Barbara Glen)

The engravings in Desgodetz's volume are remarkable for their accuracy of measurement and detail. The ruins of the temple formerly known as the 'Frontispiece of Nero' stand in the Colonna Gardens in Rome.

Lit: W. Herrmann: *The Theory of Claude Perrault*, 1973. 79–80.

223. CABINET. By Domenico Cucci, 1681–3. Wood inlaid with *pietre dure*; marble; gilt bronze mounts. *Alnwick Castle, Collection of the Duke of Northumberland*. (Photograph: English Life Publications Ltd)

Lit: H. Honour: *Cabinet Makers and Furniture Designers*, 1969. 42–7.

224. PARADE HELMET OF LOUIS XIV. French, *c.* 1700. Bronze, partially gilt and silvered, 37.5 cm. high. *New York, Metropolitan Museum* (Rogers Fund 1904). (Photograph: Museum)

Lit: B. Thomas, O. Gamber and H. Schedelmann: *Arms and Armour, Masterpieces by European Craftsmen from the Thirteenth to the Nineteenth Century*, 1964. 85.

225. DESIGN FOR A DECORATIVE EWER. German or Flemish, mid sixteenth century. Pen and brown ink and ink wash, 27.7 × 17.1 cm. *Ann Arbor, University of Michigan Museum of Art*. (Photograph: Museum)

The drawing has been attributed to Matthias Zündt of Nuremberg or a close follower.

Lit: R. P. Wunder in *Architectural and Ornament Drawings of the 16th to the Early 19th Centuries in the Collection of the University of Michigan Museum of Art*, 1965. No. 4; J. D. Farmer in exh. cat. *The Virtuoso Craftsman*, 1969. 104–8.

226. EWER. By Massimiliano Soldani Benzi, *c.* 1695. Bronze, 79.7 cm. high. *London, Victoria and Albert Museum*. (Photograph: Museum)

The Neptune ewer is one of a pair of bronze vases, the other representing Galatea or perhaps (as Jennifer Montagu suggests) Neptune's bride Amphitrite.

Lit: K. Lankheit: *Florentinische Barockplastik, Die Kunst am Hofe der letzten Medici, 1670–1743*, 1962. 146–8; J. Montagu in exh. cat. *The Twilight of the Medici, Late Baroque Art in Florence, 1670–1743*, 1974. 128.

Index

Numbers in *italics* refer to illustration numbers.